TRACE AND TRANSFORMATION

TRACE AND TRANSFORMATION

AMERICAN CRITICISM OF PHOTOGRAPHY
IN THE MODERNIST PERIOD

JOEL EISINGER

UNIVERSITY OF NEW MEXICO PRESS
ALBUQUERQUE

For Barbara

Library of Congress Cataloging-in-Publication Data
Eisinger, Joel.
Trace and transformation : American criticism of photography
in the modernist period / Joel Eisinger.—1st ed.
p. cm.
Includes bibliographical references and index.
ISBN 0-8263-1623-9
1. Photographic criticism—United States.
I. Title.
TR187.E36 1995
770'.1—dc20 94-18753
 CIP

Design: Mary Shapiro

The author gratefully acknowledges the Carl Sandburg Family Trust for permission to reprint the prologue to *The Family of Man* exhibit.

CONTENTS

LIST OF REPRODUCTIONS VI

ACKNOWLEDGMENTS VII

INTRODUCTION 1

CHAPTER 1 **PICTORIALISM** 13

CHAPTER 2 **STRAIGHT PHOTOGRAPHY** 52

CHAPTER 3 **DOCUMENTARY PHOTOGRAPHY** 79

CHAPTER 4 **POPULAR CRITICISM** 116

CHAPTER 5 **SUBJECTIVISM** 138

CHAPTER 6 **AN INDEPENDENT VISION: MARGERY MANN** 201

CHAPTER 7 **FORMALISM** 210

CONCLUSION: **MODERNISM AND POSTMODERNISM** 245

NOTES 271

SELECT BIBLIOGRAPHY 294

INDEX 304

LIST OF REPRODUCTIONS

Edward J. Steichen, *Dawn-Flowers,* c. 1902. [p. 46]
Alfred Stieglitz, *Apples and Gable, Lake George,* c. 1922. [p. 62]
Edward Weston, *Shells,* 1927. [p. 66]
William Mortensen, *The Pit and the Pendulum,* 1934. [p. 73]
Dorothea Lange, *Woman of the High Plains, Texas Panhandle,* 1938. [p. 95]
Walker Evans, *Alabama Sharecropper's Wife,* 1936. [p. 101]
Installation view from the exhibit *Road to Victory,* 1942. [p. 106]
Aaron Siskind, *Chicago 10,* 1948. [p. 158]
Jacob A. Riis, *Police Station Lodger, Eldridge Street,* c. 1890. [p. 228]

ACKNOWLEDGMENTS

In its first incarnation, this book was my Ph.D. dissertation. For that stage of the project, I owe thanks to my dissertation director, Professor Sarah Burns, who let me go my own way and made a number of useful suggestions to keep me on track. I am also grateful to the faculty of the Department of Art History at Indiana University who enabled me to pursue my research with a Kress fellowship for 1986–87.

To my father, Chester Eisinger, veteran reader of dissertations, who gave me much needed encouragement and editing help on the dissertation, I offer my warmest thanks.

Mrs. Wanda Smith and Ted Smith generously shared otherwise unavailable material with me from Henry Holmes Smith's personal papers. John Szarkowski kindly took the time to respond substantively to my inquiries.

My gratitude goes also to Amy Rule at the Center for Creative Photography, Becky Simmons at the George Eastman House, Virginia Dodier at the Museum of Modern Art, and Mary Panzer at the National Portrait Gallery.

Without the interest of Dana Asbury, my editor, this book would have remained a dissertation. My appreciation to her for her steady encouragement and capacity to make the entire process run smoothly.

Carl Chiarenza read the manuscript closely and made numerous useful suggestions for revision. My colleagues at the University of Minnesota, Morris (UMM) awarded me a one-quarter leave to rewrite the manuscript. My thanks to them and to the UMM librarians who have responded tirelessly to every request.

I have also benefitted from the careful and thorough efforts of Anne R. Gibbons, copy-editor, who unsnarled numerous knots in my prose.

Last and most, I want to thank my wife, Barbara Eisinger, who has read this manuscript in both its versions and offered useful advice. More than that, she has patiently listened to and empathized with me through the ups and downs of the entire project.

TRACE AND TRANSFORMATION

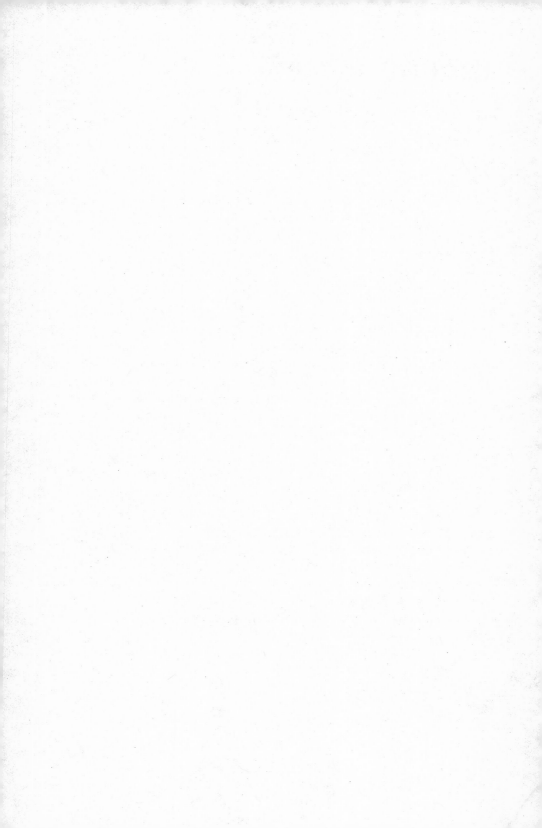

INTRODUCTION

This book is a historical survey of American theory and criticism of art photography from the development of Pictorialism in the nineteenth century through the formalism of the 1970s. This was a period in which people were still learning to write about photography, still defining the subject, identifying central questions, and searching for appropriate methodologies. The field was not a crowded one, and those who ventured into it had few landmarks and few companions as they groped and stumbled along, often clutching at dogma, often wandering into dead ends. Certainly, in comparison to the learned and self-assured discourse on photography since the 1980s, the writing of this earlier period looks sparse and often trivial. But the writers I am concerned with did raise important and enduring issues; they gave photography a place in the mainstream of our cultural and intellectual institutions, and in so doing, they laid the foundation for the present treatment of photography as a medium of unquestioned artistic and social significance.

There is considerable variation of thought in the period under discussion, but I have marked it out as a coherent period because it is consistently characterized by the basic approaches and assumptions of modernism. That this is so has become even more apparent since the emergence of postmodernism. In general, I have found postmodernist ideas helpful in revealing the shape of modernism, and throughout this book I refer to postmodernist thought so as to throw modernism into greater relief. Modernism, as I refer to it here, is distinguished by a concern for the unique and essential qualities of an artistic medium, by a conception of art as the expression of an individual whose aim is to say something new or profound about subjective experience, universal experience, or the nature of artistic form, and by the assumption that the artistic status of a work of art and the work's meaning are inherent in the work itself.

As anyone who is the least bit familiar with the history of photography might expect, theories of photography as art have had to answer the

old question, How is photography an art at all? From the first time that question was asked (which was virtually at the same moment photography became known to the public), the possible answers were thought to lie in an examination of the relationship of photographs to the world they represent. If photographs were merely a mechanical trace of nature, the result of nature copying itself through optical and chemical processes of which human beings were more witnesses than creators, then photography could not be an art, or at best could be only an extremely limited one. But if photography could transform the visible world under the deliberate control of the photographer, and if it could respond to the subjective vision of the photographer, then it could be an art of considerable range and depth. This duality of trace and transformation lay at the core of photographic theory and criticism for over a century.

The Pictorialists were the first proponents of art photography and the first theorists to build a case for the capacity of their medium to transform the world. As they made this case, the question arose as to what were the boundaries of legitimate photographic practice. Might a photographer assert the dominance of his or her subjective vision by throwing the lens out of focus, by making a print on rough paper, by locally varying the degree of development of a negative or print, or by drawing on the negative? Questions such as these about what constitutes legitimate manipulation of the photographic process led naturally to the question of what constitutes unmanipulated photography, what constitutes the medium of photography at its pure core. This is a particularly modernist question. A concern for the essence of any given medium runs throughout modernist art theory. There is a tendency toward reductionist thinking and the equating of essence with truth. Perhaps this tendency arose in art theory in response to the values of the scientific age. If art were shown to follow the patterns of thought central to science, it would gain a measure of legitimacy. That photography is in large part a product of science was a source of deep ambivalence to its art theorists, but the medium's scientific paternity may have made the analytic drive toward essence seem inescapable in photographic theory.

In any case, essence became a central value in modernist photography. To arrive at the essence of photography and to maintain it in absolutely pure practice was seen as inherently good. In addition, it was thought necessary to define the essence of photography to justify the medium's status as a high art. Only if the essence of photography could be shown to be unique could the medium be considered an independent art capable of contributing something new to the world of visual imagery. Only if photogra-

phy were proved to be unique at its core could one differentiate it from painting and state its special worth.

Although the debate over the essence of photography began with Pictorialism and continued through the entire modernist period, no lasting consensus on the issue was ever reached. Eventually the problem lost its trenchancy. The mandate of purity in artistic practice came to seem increasingly restrictive, and more profoundly, it began to appear that the essential nature of photography would remain undefinable because it simply did not exist. With the emergence of postmodernist thought, the pursuit of the essence of photography was dropped.

The very concept of photography as art necessitated that a given photograph exploit the medium's transforming capacity and embody the subjective vision of the photographer. For some time, embedded in this concept was the assumption that artist-photographers turned the medium into art by imposing their will on it, and if left to its own devices the medium would remain neutral and would produce mere records. Photography was thought of even by its art theorists as essentially a scientific process for making documents, capable of producing art only if pushed.

Even as this assumption was relinquished and modernist theorists began to recognize that every photograph is in some sense subjective, the relation of photography to the world was still regarded as flexible. Any photographer might bend that relationship one way or the other, toward trace or transformation, and the direction in which photographers pushed that relationship determined whether their photographs were art or something else. In other words, modernist theory maintained a distinction between art photographs and other kinds of photographs. Just as not all writing is literature, not all photography is art; some photographs are scientific records, others are snapshots, news pictures, advertising photographs. Furthermore, the distinction between art photographs and others was thought to be purely visual. The transforming work of art would reveal itself as such on the basis of its appearance, whereas the scientific record would reveal through its visual qualities that it is more trace than transformation. The status of the photograph in modernist theory lies in the visual properties of the photograph itself.

In addition, if a photograph is a work of art, the photographer, having shaped it through a subjective vision, will have embedded a portion of himself in it through a multitude of choices regarding equipment, composition, exposure, processing, and printing. This suggests that the photograph will bear the mark of a personal vision and will embody a personal interpretation of the subject matter, an insight into photographic form, or a

metaphorical meaning toward which the nominal subject matter is a springboard. In sum, the photograph carries within it a meaning that the photographer has put there, and this meaning will be visible in the photograph just as the photograph's status as art or science is visible in it.

If modernist theory took the meaning of photographs to be inherent in them and apparent in their visible properties, then the task of modernist criticism was to separate art photographs from nonart photographs and to explicate the meanings of art photographs—all on the basis of appearances. If the meanings of art photographs are subjective, then critics had to develop a vocabulary for explaining what constitutes the visible evidence of that subjective vision in any given picture. That evidence could be the choice of subject matter, but subjectivity must lie even more in the formal properties of the image. A photograph does not express a subjective vision as much on the basis of what has been photographed as on the basis of how it has been photographed. So it was the task of modernist criticism to develop a method of formal analysis. But contrary to what one might expect—especially during a period when the formal analysis of literature and painting were thriving—critics of photography had a difficult time doing this. Certainly they got no encouragement from the precincts of painting.

Clement Greenberg, the premier formalist art critic of the mid-twentieth century, announced in 1946 that the true nature of photography lay in its naturalism.[1] The critics of photography could not definitively contradict him. They wanted to undermine photographic naturalism, but they had tremendous difficulty getting down to the formal criticism that would allow them to do so because the weight of naturalism was so great. They felt they had to prove again and again in theoretical terms the transformative power of photography before proceeding to actual criticism. As a result, personal vision, although it was often emphatically said to exist (almost as a matter of faith), was for a long time inadequately treated as an object of analysis.

In addition to the force of subject matter, the difficulty of grasping visual meaning through the medium of language contributed to the problem of critical analysis. Modernist critics were convinced that the meanings of photographs are embodied in their visual properties, but this means that if critics are to explicate these meanings, they must be translated into words. This critical task led to a discussion of the relationship of language to vision and the question of which is more basic to cognition. Writers asked whether visual thinking precedes language and forms the basis of verbal expression or whether language gives order and meaning to inchoate visual perception. Whichever side they came down on in this debate, to

some degree all the modernist critics and theorists felt that to grasp all the visual meaning of a photograph in words was impossible. They all felt that certain aspects of photographs are utterly profound but utterly inexpressible. Some theorists, John Szarkowski and Nathan Lyons in particular, gave great weight to the disjuncture of words and images in their writing. Others, particularly Henry Holmes Smith, attempted to describe photography as a visual language with structures equivalent to verbal language and therefore readily translatable into words.

The postmodernists have not had the same uneasiness as the modernists about the relationship of photography to words. They have continued with great vigor and sophistication along the path Smith started: assimilating photography to language. But unlike Smith, the postmodernists have tended to think of photography not as an independent visual language that might be translated into words but as a conglomeration of visual signs that have no meaning except through words. The postmodernists have generally minimized or disregarded the purely visual aspects of art that were so important to modernism.

Modernist writing on photography, even writing that purported to be criticism, frequently contained more general theory than criticism of specific bodies of photographs. Eventually, critics became comfortable with formal analysis and adept at saying what constitutes a photographer's subjective vision and style. But just as this facility was developing, postmodernist thought began to undermine the very concepts of style and subjectivity. Postmodernists see individuals as embedded in and shaped by the culture into which they are born, so much so that the most subjective aspects of individual identity are considered nothing more than a collection of quotations from a preexisting pool of ideas. No truly individual, subjective vision is possible in art because no person is truly an individual. And just as the individual is embedded in and shaped by culture, so too is every photograph or any other work of art.

Postmodernists argue that one cannot consider a photograph solely on the basis of what it looks like, as the modernists proposed to do. The circumstances of its making, its presentation, and the viewer's own experience inevitably shape what one sees in any photograph. Therefore, in postmodernism the meanings of photographs and the very status of photographs as art arise from the relation of photographs to their cultural context. The modernist idea that meaning is inherent in photographs is completely overturned by postmodernism, and as a consequence, formal analysis loses its centrality in postmodernism and the distinction between art photographs and other kinds of photographs is severely challenged.

To this point, I have treated the discussion of trace and transformation in modernist theory as an either-or proposition. A photograph that emphasizes the trace is a record; the photograph that emphasizes transformation is art. But in actuality theorists were not so simplistic. Eventually they began to recognize, with varying degrees of clarity, that a photograph is both a trace and a transformation. There was an increasing awareness that photography is a paradoxical medium a bit like the light that makes it possible—light reveals itself to be structured either as waves or particles depending on how one's experiments are designed. But paradox is a tremendously difficult basis on which to theorize, so most photographic theorists, while nodding to its presence, emphasized one side of this paradox or the other.

An excellent case in point may be found in an exchange of articles in *Critical Inquiry* from the mid-1970s. On the one side, Rudolf Arnheim argued that although photography is a "middle ground on which the two formative powers, man and world, meet as equal antagonists and partners," the medium is nevertheless "limited in its range of expression as well as in the depth of its insights" because of its intimate physical connection to the world.[2] On the other side, Joel Snyder and Neil Walsh Allen insisted that although photographs are made with light reflected from objects and in accordance with natural laws, the physical tie between photographs and the world is so malleable that it simply is not the central issue in photography. These authors say that physical objects "do not have a single 'image' . . . but, rather, the camera can manipulate the reflected light to create an infinite number of images."[3] This power of manipulation makes photography every bit as rich a picture-making medium as any other.

Throughout the modernist period, the pendulum of emphasis on trace or transformation swung back and forth both in response to the internal conditions of art photography and the larger social context. The Pictorialists of the turn of the century established a theory of photography as an art on the grounds that someone with an artistic vision might impose a subjective transformation on the photographic representation of nature. The Pictorialists were working in an era they felt to be dominated by spiritually devastating industrialization and materialistic values. By using photography as an instrument of subjectivity, they thought they were taming one of the offspring of industrialization, thereby coming to terms with the modern world.

This reconciliation with urban and industrial modernity takes different and contradictory forms in Pictorialism. For Sadakichi Hartmann it is a triumph of humanity and spirit over the product of the industrial monster; it

is the establishment of an aristocracy of taste and sensibility at the very heart of crushing materialism. For Charles Caffin this reconciliation goes hand in hand with a democratization of taste made possible by the proliferation of the products of industry. The democratization of taste, in turn, is the foundation for a new kind of democratic society based on universal and universally understood aesthetic principles.

The straight photographers and their critics in the twenties rejected the intense subjectivity and transforming procedures of the Pictorialists on the grounds that they had violated the purity of photography and had subjugated it to painting. Straight photographers favored an open embrace of photography's scientific nature and what they saw as its natural objectivity. At the same time, they wanted to retain enough subjectivity in their work to warrant its recognition as art.

The straight photographers' turn to objectivity was part of the general American rejection in the 1920s of European modernism and abstraction. It was an expression of the desire to know America: its cities, its industry, its landscape, and its soul. In addition, straight photography was the expression of a belief that if one could just see clearly enough, then one might see the evidence of universality within the human and natural worlds and even a transcendent spirit immanent in all the visible world. This is the idea of the equivalent, first advanced by Alfred Stieglitz in the twenties and later taken up by Minor White in the fifties. An equivalent is a straight photograph, precisely representational, but it stands for more than what it represents in that it serves as a metaphor for subjective experience, or intersubjective experience, or even mystical experience. In general, straight photography performed a difficult balancing act as it embraced objectivity and attempted to retain subjectivity, as it pursued the clearest and most literal kind of representation but insisted on metaphor.

The Great Depression intensified the need to know America, specifically the need to know what had gone wrong with it. The Roosevelt administration seized this opportunity to use photography to explain and bolster its program for recovery. Soon after, the government and the picture magazines enlisted photography to help sustain the war effort. The documentary photographers of this period relied heavily on the presumed authenticity of the photographic trace for the effectiveness of their work, but they were conscious of photography's transformative properties and used them subtly. Those who wrote about photography in the thirties and forties were not so subtle. They demonstrated a remarkable naïveté about documentary photographs by treating them as purely objective. The period is marked by a disjuncture between the theory of the photographers and that of the critics.

In the late 1940s and the 1950s, the popular press dominated photographic criticism. Popular critics advanced a simplified mixture of the values of documentary and straight photography. These critics were at the service of the photographic industry, both the equipment industry and the picture magazines, and their aim was to convince a mass audience to consume photography. One of their strategies was to glamorize the medium through the creation of stars: fashion photographers or photojournalists wrapped in cults of personality. Edward Steichen and Margaret Bourke-White are notable examples. Another strategy was to engage the amateur audience in photographic practice by selling the illusion of empowerment through the command of fancy technology. The popular press also sold comfort and distraction from turmoil through the promise of a facile engagement with social and psychic reality—formulas for understanding the world and the self through photography. As more serious criticism emerged in the fifties, popular critics either scoffed, thus revealing the intensity of their anti-intellectualism, or they attempted to assimilate simplistic versions of the new critical ideas. In general, they reacted with fear to what they perceived as a threat to their hegemony.

The new criticism of the fifties took a turn toward subjectivism and the consideration of the photograph as the expression of interior experience. Minor White and Henry Holmes Smith, the two leading subjectivist theorists, recognized the paradoxical nature of photography more clearly than anyone before them, but they chose to return to an emphasis on the photograph as a transformation of the world and an independent object. Minor White revived Stieglitz's idea of the equivalent.

Subjectivism flourished in academia during the post–World War II cultural boom, a time when American academic art expanded in all its aspects. At the same time, subjectivism responded to contemporary currents of alienation in the Beat movement and Abstract Expressionism. The subjectivist photographers retreated, as did the Beat writers and Abstract Expressionist painters, from the social engagement of the thirties in response to the failure of the left and in stunned reaction to the overwhelming violence of the war, the nuclear threat, and the oppressive fear of the McCarthy era. They looked inward in scornful rejection of the materialism of the fifties, seeking meaning in transcendence or the human psyche. White and Smith pursued their work through the sixties and the turmoil of the Civil Rights movement and the war in Vietnam, and both thought about the relation of their art theory to the times. White, who was thoroughly apolitical, asserted the moral superiority of transcendence over activism. Smith, who was acutely sensitive to social issues, sought to understand specific strife in universal

psychological terms. The subjectivism of White and Smith was allied to liberalism, but did not arise from or encourage activism.

John Szarkowski, most active in the sixties and seventies and the leading formalist theorist, accepted the subjectivists' view of photographs as expressive images existing independently of the world they represent. But for Szarkowski, the independence of the photograph was even more important than it was for the subjectivists and more important than issues of expression. In Szarkowski's view, the history of photography is an internal affair that proceeds according to laws of formal evolution. Photographers are essential to this history because they are the agents by which it moves. But they are also incidental to this history because photography itself, not the photographers, is its content. In his radically formalist engagement with the photographic medium to the exclusion of all else, Szarkowski was a voice for the social status quo of the sixties and seventies. By not admitting social considerations into his theory, he implicitly accepted the status quo.

Some special difficulties arise in setting out to write about the theory and criticism of art photography from before the 1980s. One of the most striking is that much of what was written was simply bad: uninformed, poorly thought out, clumsy. This paucity of good writing has been a major theme of the theorists and critics themselves. One example from the countless statements bemoaning this situation is the opening sentence in John Ward's 1970 book, *The Criticism of Photography as Art:* "The literature devoted to a critical discussion of photographs is meager and, for the most part, superficial and vague."[4] As a consequence, a certain amount of theory and criticism in this book is included more because of its existence than its profundity. This is particularly the case with the popular criticism of the forties and fifties. This criticism was undeniably shallow, but the popular press was a significant historical phenomenon in American photography. It shaped the attitudes of a large audience and served as a formidable obstacle to those who considered photography a matter of serious intellectual investigation. One cannot understand the development of subjectivist criticism in academia in the fifties without understanding the popular press.

Another problem is that for much of the period under consideration there were no professional critics of photography who were not also, or primarily, something else: photographers, historians of photography, critics of painting or literature, museum curators, journalists. Given that there is no group of writers on photography clearly defined by professional commitment, status, or historical tradition, I have had to invent a canon. I have deliberately kept that canon small. I prefer to investigate my subject by

digging narrowly and deeply rather than widely and more shallowly. As a result, I have undoubtedly left writers out of this book whom some readers will think worthy of consideration. Also, because of the motley crowd that has written about photography, I have had to organize the chapters in a variety of ways. Only sometimes have I found it useful or even possible to organize a chapter solely around theorists and critics.

I have organized the book chronologically, beginning with a chapter on Pictorialism, the first theory of photography as an art. Many historians identify Pictorialism only as a movement of the turn of the century, but I prefer to see it as including all the developing theory from the public debut of photography in 1839 to the second decade of this century. Accordingly I have included a brief discussion of the development of photographic art theory in Europe in the second half of the nineteenth century. The bulk of the chapter, however, deals with Charles Caffin and Sadakichi Hartmann, the two major Pictorialist critics who worked in the circle of Alfred Stieglitz and the Photo-Secession, and with Alfred Stieglitz himself who wrote little theory but cannot be ignored in any discussion of Pictorialism or straight photography.

The second chapter on straight photography deals largely with the photographers who defined the movement and attracted the most critical attention: Alfred Stieglitz, Paul Strand, Edward Weston, and Ansel Adams. These photographers were themselves theorists of considerable importance. Their critics were a varied group, who generally did not accumulate a significant body of criticism and whose writing gains interest only as it revolves around the work and ideas of these artists. I have given some brief attention to the Newhalls in this chapter even though they were historians rather than critics or theorists. Both of them wrote criticism of Adams, and Beaumont Newhall's history of photography lends unambiguous critical support to the straight photography movement.

Chapter 3 deals with documentary photography of the 1930s and 1940s, the main episodes of which concern the Farm Security Administration, World War II, and *Life* magazine. I have included in this chapter a discussion of the Photo League, the vibrant New York based group of left-leaning photographers who had close ties to the documentary film movement. Walker Evans, the photographer who attracted the most critical attention in this period, and Elizabeth McCausland, the most committed critic of documentary photography are also included in this chapter. Chapter 3 ends with a section on the relationship of photographs and words as the issue was considered by Nancy Newhall, McCausland, and Wilson Hicks, an editor at *Life*.

Popular photography is the subject of the fourth chapter. Here I consider Edward Steichen in his later incarnations as fashion photographer and curator, roles in which he became the darling of the popular press and the grand popularizer of photography at the Museum of Modern Art (MOMA). The chapter continues with a discussion of Jacob Deschin, photography reporter for *The New York Times,* and ends with a discussion of Bruce Downes, editor of *Popular Photography* and the most dominant voice in the popular press. I also give attention to the writing on Robert Frank and Aaron Siskind, two harbingers of subjectivism who were especially problematic for popular criticism.

Chapter 5, on subjectivism, begins with a section about "Photography in the Fine Arts," the Metropolitan Museum's clumsy embrace of art photography. There follows a discussion of the writing of Minor White whose multifaceted career—involving his own art, criticism, teaching, and the editing of *Aperture*—was held together by the thread of a mystical quest. A major aspect of White's theory is the idea of reading photographs that he developed in theory and practice along with Henry Holmes Smith, Walter Chappell, and others. After White, I deal briefly with Ralph Hattersley and his theory of photography as psychological analysis and spiritual practice, and then turn to Nathan Lyons, originator of the Visual Studies Workshop and *Afterimage.* His theory of photography as an ideographic language arose from his work as photographer, teacher, and innovative curator of contemporary photography. The chapter ends with a discussion of Henry Holmes Smith, a photographer better known for his teaching and writing than his art. Smith worked on the idea of reading photographs and articulated a concept of the essential nature of photography, which he derived from European Constructivism and which was at odds with the dominant theory of straight photography.

Chapter 6 reviews the writing of Margery Mann, a teacher, a photographer whose work is virtually unknown, and a distinctive critic who does not fit easily into any scheme of twentieth-century photography. Mann's distinctiveness is due partly to the fact that she did not articulate any theory that might ally her with documentary photography, straight photography, subjectivism, or any other movement. She was unique among important critics in that she wrote almost exclusively about photography on the West Coast and did so from a consciously West Coast point of view. One major theme in Mann's criticism was the necessity for young photographers to break away from the dominating tradition of West Coast landscape photography. Another abiding attribute of her writing was her social conscience.

The seventh chapter discusses John Szarkowski, the single most pow-

erful voice of formalism, who sat in what Christopher Phillips has called the judgment seat of photography: the chair of the photography department at the Museum of Modern Art. Through his historical writing, his curatorial work, and his theoretical essays, Szarkowski established what has become known as the snapshot aesthetic, which links the small camera photography of such masters as Garry Winogrand and Lee Friedlander to the vernacular tradition of amateur photography. Szarkowski also articulated a formalist aesthetic that he used to incorporate photographs from the vernacular tradition into the canon of high art. I have included a discussion of *New York Times* critic Gene Thornton in the chapter on formalism although Thornton was more of a humanist than a formalist. But he worked in a climate of formalism, having to respond to it in photographers' works and Szarkowski's theory at every turn.

The conclusion is a brief discussion of postmodernist theory and criticism. By design, postmodernism is oppositional to modernism, and for this reason is relevant to this book as a set of ideas that will give clearer shape to modernism. I see Szarkowski's formalism as marking the conceptual end point of modernism, although chronologically this end point is overlapped by the emergence of postmodernism. I begin the conclusion, therefore, with a discussion of the early writing of A. D. Coleman, active since the late 1960s and one of the few pure critics (that is, not also a photographer, curator, historian, and so on) in the book. Coleman was a severe critic of Szarkowski and Minor White and might be considered either as a transitional figure between modernism and postmodernism or as the first postmodernist critic. The book ends with brief discussions of other writers who were among the first to define postmodernism in photography: Susan Sontag, Allan Sekula, Douglas Crimp, and Abigail Solomon-Godeau. By outlining the theories of these writers who seek to overturn modernism, I hope to have set the stage for an assessment of the modernist heritage as it persists, evolves, or fades in the future.

CHAPTER 1
PICTORIALISM

When the public first encountered photography in 1839, they were not at all certain what kind of invention it was nor how it was to be used. Was it to be a source of scientific information, an aid to artists, an art form in its own right, or a medium of totally unforeseen consequences?[1] To many people, photography appeared to be a nearly miraculous, automatic, and literal system for recording appearances. Photographers were simply operators of the system, and photographs were pure traces of nature. Early commentators described photography as "a chemical and physical process which gives Nature the ability to reproduce herself," as "Nature herself reflecting her own face," "perfect transcript[s] of the thing itself," or simply "Nature herself."[2] This view of photography as a purely natural and automatic phenomenon was not, especially in the nineteenth century, conducive to the development of theory and criticism of photography as art. Photographic art theory and criticism could only arise from a vision of photography as a process that transforms the world rather than one that merely traces it directly, and this process of transformation had to be seen as subject to the deliberate and expressive control of the photographer.

To be sure, some things could be said critically about photographs by those who thought of them as the product of a literal, mechanical process. It was possible, of course, to comment on a photographer's technical prowess. For example, the jury of the international daguerreotype competition at the world's fair of 1851—held in the Crystal Palace—praised the gold-medal-winning pictures of M. M. Lawrence as "remarkable for clear definition and general excellence of execution. . . . Notwithstanding their large size, they are, throughout, perfectly in focus, and are beautifully finished in all details. These are two of the best pictures in the American collection."[3] This is hardly momentous criticism, but we do see here the articulation of universally accepted technical standards for a good photographic record, and it is worth noting that these standards of clarity and full detail are very different from those that were soon to be established for artistic photography.

While seeing the photograph as a literal copy of nature, one could also develop a critical approach that focused on the photographer's choice and handling of subject matter rather than the handling of the photographic process. The celebrated American daguerreotypist, Albert Sands Southworth, who thought of photographs as presenting "a reality and vividness almost equal to nature itself," insisted that although technical excellence was indispensable to good photography, "that which is necessary and requisite to fit one for the disposition of light and shade, the arrangement of the sitter, and accessories for design and composition of the picture, is of a far higher order in the scale of qualifications."[4] Such emphasis on an arranged subject, of which the photograph is simply a faithful record, is reminiscent of what A. D. Coleman was much later to call the directorial mode of photography, a concept that embraces a wide range of contemporary work from the records of Vito Acconci's self-inflicted tooth marks, to the playlets of Duane Michals, and the self-portraits of Cindy Sherman.[5]

In the nineteenth century, critical comments on the handling of subject matter often revolved around the question of whether a photographer adopted an artistic or a scientific ethos, whether he treated the subject matter as a specimen to be observed objectively or as something to be arranged with an aesthetic sensibility. This issue was most revealingly dealt with in the context of portraiture. Many photographers turned to painting for guidance in the arrangement of poses, lighting, and settings; others were inspired by science.[6] Early writers sometimes praised or criticized one approach or the other, although without much elaboration. The London *Journal of Commerce,* for instance, commended Antoine Claudet for emulating painting in his photographic portraits through "the introduction of beautiful backgrounds, producing the most picturesque effect."[7] On the other hand, the jury of the daguerreotype competition at the Crystal Palace appreciated a scientifically objective approach, noting that Mathew Brady photographed his sitters "in bold relief, upon a plain background." They continued approvingly, "The artist, having placed implicit reliance upon his knowledge of photographic science, has neglected to avail himself of the resources of art."[8]

Of course, the simple question of importing the conventions of painting into photography was not the only issue for critics. Sometimes they commented on how these conventions were used. When mid-century portraitists, in the heat of commercial competition, routinely carried the imitation of paintings to excess, there were objections. One of the more memorable of these was the wry observation that while columns are plausible in paintings, "the manner in which they are applied to photography is absurd, for they usually

stand on a rug. But as everyone knows, marble or stone columns are not commonly built with carpet as their base."[9]

One of the fullest discussions of artistic photography written in terms of the treatment of subject matter is *The Camera and the Pencil* (1864) by Marcus A. Root, a successful American portraitist and proprietor of daguerreotype studios in several cities. Root considered photographs to be literal copies of nature and thought that if a photographer were to transcend the status of a mere mechanic to become an artist, he must handle his subject matter in such a way as to reveal its perfect, ideal essence.

The Camera and the Pencil is a jumble of everything Root knew about photography and art. It includes a technical description of actinism; personal anecdotes from the portrait studio; an anthropocentric analysis of nature symbolism; a meditation on the meanings of names; a quasi-philosophical discussion of beauty, with references to Plato, Raphael, Reynolds, Burke, Alison, Ruskin, and others; a chapter devoted to "Miscellaneous Remarks from Various Authors"; a manual for hand coloring photographs; a discussion of microphotography; and a brief history of photography in the United States. Such a mixture might be expected of a pragmatic American businessman who had absorbed some imported European aesthetic ideas in the typically haphazard manner of an autodidact. That this book is at all significant is a good indication of the anemic condition of American aesthetic thought of the time.

Root's stated purpose in his book was to advocate that photography "is one of the fine arts, and in its *capabilities* is, at least, the *full equal* of the others bearing this name."[10] Accordingly, he attempted to integrate photography into a mixture of romantic and academic painting theory. He repeated the romantic linkage of art and divinity, saying that to make art is to participate humbly in the creative work of God and that to appreciate art is to appreciate God. He endorsed the academic concept of the ideal in nature, that "nature aims ever at the highest beauty, the utmost perfection" without ever achieving that perfection in individual instances. Following Joshua Reynolds, Root concluded, "In striving, then, by art to rectify deformities or imperfections, we do not *contravene* and impeach, but rather *coöperate* with and *justify* nature. That is, by help of powers furnished by herself, we do somewhat towards bringing to view that ideal of beauty which nature aimed at and would have attained, had she been dealing with that more ductile and tractable material of which the *spiritual body* is compounded."[11]

In the practical application of his theory to photography, Root sometimes approved of coloring-in what the photographic process failed to supply by way of the ideal, but for the most part he was concerned with

perceiving the ideal in one's subject and capturing it unaltered on film. He thought of photographs as literal records of nature; what made them works of art was the ability of the photographer to coax a glimmer of the ideal from his subject.

Root was himself a portraitist, and his book deals almost exclusively with portraiture. It was in the treatment of his sitter, then, that a photographer brought his "genius" to bear and proved himself an artist. Indeed, Root demonstrates a remarkable sensitivity to the psychology of the confrontation of photographer and subject. It was his aim always to coax his sitter into revealing his or her "genuine, essential self" for the camera, and toward that end, he offered exhaustive practical advice on how to decorate a studio waiting room to put sitters at their ease (caged song birds are one recommendation); how to flatter a sitter with clothes appropriate to that person's complexion, size, and social status, how to behave toward a client with unflagging patience and courtesy; and in general, how to put a sitter into just that mood which will "make his face *diaphanous.*"[12] Root conceived of his readers as harried businessmen working under the pressure of a flow of demanding clients and as painstaking artists. He saw no contradiction between art and business—as did later artist-photographers—so it is no surprise that his concept of the genuine, essential self was coincident with the most flattering image of a sitter.

Root thought of his portrait work as being dependent on scientific perception as well as artistic sensibility. He was a follower of Johann Kaspar Lavater and a true believer in the pseudoscience of physiognomy. He thought a person had both an original character, determined by the hard bone and cartilage structures of the head, and an acquired character, reflected in the changeable features of the soft tissues of the face. Revealing what by today's standards would be a high degree of implicit prejudice, he explained the meanings of lips—thin lips are a sign of asceticism and thick lips a sign of sensuousness, good nature, and generosity—and the meanings of noses—Roman noses are courageous and "Cat" noses, vindictive. Applying the fruits of physiognomic "science" to the studio, he instructed his readers on such matters as how to pose sitters so as to minimize "blemishes" such as flaring nostrils. Root even went so far as to say that if a culture specialized in a particular activity down through the generations, then that activity would shape the physiognomy of the entire people. In a remarkable feat of backward reasoning, he explained that because the Greeks and Italians were traditionally devoted to the arts and lived for generations within view of the finest works of art, they "have the most ideal faces and heads in the world."[13]

Despite its shortcomings, Root's theory of criticism, based on the analysis of subject matter, had potential. This is certainly demonstrated by some twentieth-century writing such as James Agee's commentary on Helen Levitt's photography:

> In the kind of photography we are talking about here, the actual is not at all transformed; it is reflected and recorded, within the limits of the camera, with all possible accuracy. The artist's task is not to alter the world as the eye sees it into a world of aesthetic reality, but to perceive the aesthetic reality within the actual world, and to make an undisturbed and faithful record of the instant in which this movement of creativeness achieves its most expressive crystallization.[14]

The notion of recording "aesthetic reality within the world" is reminiscent of Root's idea that a portraitist tries to capture a sitter's genuine essential self. In addition, some postmodernist writing has developed the analysis of subject matter by focusing on the meanings of photographic representation while treating the medium of that representation, the photograph, as a "message without a code." But nineteenth-century theorists and critics did not vigorously pursue the analysis of subject matter. It was the consideration of formal issues and the photographic medium itself that produced the first aesthetic theory of photography and laid the foundation for full-bodied photographic criticism. Only when Pictorialism established that one could use photography as an interpretive medium, rather than a literal one, did art theory begin in earnest.

A consideration of subject matter was certainly a part of Pictorialism. In their pursuit of painterly photographs, Pictorialists chose subjects laden with artistic associations—contemplative nudes, picturesque views, and staged allegorical tableaux—but subject matter was less central an issue for them than the nature and use of their medium.

Pictorialism can be described as a group of photographic styles and theories of varying sophistication and completeness, articulated in Europe and America between the 1840s and the 1920s, the purpose of which was to establish photography as an art by assimilating it to one or more of several styles and theories of painting. Elements of academicism, Barbizon naturalism, Impressionism, Aestheticism, and Symbolism were all part of Pictorialism at one time or another. Despite its many manifestations, there was the central idea in Pictorialist theory that photography is an elastic medium and that a person of artistic sensibility can use it to interpret nature in the same indi-

vidualized manner as a painter and in response to the same aesthetic impulses.

Although Pictorialist theory reached its maturity in the 1890s, the ideas out of which the movement grew were brewing long before then. In fact, the inclination to integrate the formal aspects of photography with theories of painting appeared concurrently with the former's public debut. In 1839 the realist painter Paul Delaroche wrote a report to the French government on the potential value of daguerreotypes in which he spoke of them in the same terms in which he might have spoken of one of his own works: "Nature is reproduced in them not only with truth, but with art. The correctness of line, the precision of form, is as complete as possible, and yet, at the same time, broad energetic modeling is to be found in them as well as a total impression equally rich in tone and in effect."[15]

By pointing out the presence of both truth and art, precision and "a total impression," Delaroche was evoking the central points of contemporary realist art theory, which held that realist paintings, while truthful, were by no means mindless copies of nature but interpretations or impressions of it.[16] By referring to "effect" in daguerreotypes, Delaroche was aligning them with eighteenth- and nineteenth-century academic painting theory. According to this theory, effect referred to the emotional atmosphere of a painting as it was created by the artist's handling of tonal masses. If these masses had coherent structure, they produced an effect.[17] Delaroche was suggesting, then, that the "broad energetic modeling" in the daguerreotypes he had seen gave them an interpretive character, a mood.

Daguerreotypes are intensely detailed images, but in academic art theory too much detail was considered to be destructive of effect, destructive of a painting's coherence and atmosphere. As photographers began to think more about the artistic potential of their medium, they began to see a conflict between the tremendous capacity for detail in the daguerreotype and the tonality necessary for effect. In sum, they began to see detail as the mark of the scientific and mechanical application of photography and tonality as the mark of artistry.

In contrast to the mirror clarity of the daguerreotype, the calotype (invented virtually at the same time as the daguerreotype) was a soft image printed from a paper negative, the texture of which unavoidably obscured detail and emphasized tone. As a result, the calotype became an early locus for the development of Pictorialist theory. David Octavius Hill, the great Scottish calotype portraitist of the 1840s, noted the artistic nature of his medium when he wrote, "The rough and unequal texture throughout the paper is the main cause of the calotype failing in details before the

Daguerreotype . . . and this is the very life of it. They look like the imperfect work of man . . . and not the much diminished perfect work of God."[18]

The art theory of the calotype was most developed in France where Francis Wey, a writer of realist novels, was perhaps its most enthusiastic, if briefly engaged, proponent. Between February and October of 1851, Wey wrote twenty-two articles for *La Lumière,* a photographic journal committed to the cultivation of refined sensibility. Wey reviewed and defended his favorite photographers, among whom were Gustave Le Gray, Charles Nègre, and Maxime Du Camp, and articulated what was known as the theory of sacrifices, a theory that held that the art of photography lay in the selective sacrifice of detail. Wey integrated this theory into the current French debate in painting between classicising draftsmanship and romantic colorism, and he sided with the colorists, seeing in calotypes the same envelope of light and atmosphere that he saw in Delacroix's painting and, therefore, the same stimuli to the imagination.

By contrast, sharp photography that manifested the same sensibility as Ingre's intensely detailed paintings, was too literal and "dry." As Wey put it, calotypes were admirable for being "fugitive and vaporous, yet precise." Elaborating on this dual attraction of the accurate yet soft image in a discussion of Hippolyte Bayard's direct positive prints on paper, Wey wrote, "One contemplates these direct positives as if through a fine curtain of mist. Very finished and accomplished, they unite the impression of reality with the fantasy of dreams: light grazes and shadow caresses them. The daylight itself seems fantastic and the peculiar sobriety of the effect renders them monumental."[19]

The year before Wey wrote this rhapsody on the romantic allusiveness of soft photographs, Frederick Scott Archer had published a description of his sharp and detailed collodion process. In a few years, this process, which uses glass negatives, had shoved aside both the daguerreotype and the calotype. As collodion became the dominant photographic process, its sharpness became identified with the inherent nature of photography. If photographers were to continue to consider softness and sacrifice of detail as the mark of photographic art, they now had to create those effects deliberately and, seemingly, against the grain of their medium. This made photographic art both more problematic and more overt. No longer were the attributes of art inherent in the photographic process as they had been with the calotype. Now photographic art became a matter of twisting the medium to one's will as proof of one's artistic domination over its otherwise mechanical and scientific nature.

In 1853 the painter Sir William J. Newton set the course for the con-

tinued association of photographic art and softness in an influential lecture to the Photographic Society of London. Newton suggested that whereas scientific photographers ought to pursue a maximum of detail in their pictures, those making photographs as references for painting ought to render their subjects "a little *out of focus,* thereby giving a greater breadth of effect, and consequently more *suggestive* of the true character of nature."[20]

As Pictorialist theory developed, softness—in all the various ways it could be produced in photographs, from soft-focus lenses to gum-bichromate printing—continued to be seen as the mark of the shaping hand of the artist-photographer, and it became the most distinctive stylistic trait of Pictorialist photography. Because Pictorialism assimilated photography to a variety of styles of painting, the suppression of detail served a variety of expressive functions. Depending on whether one was alluding to academic painting, naturalism, Impressionism, or Symbolism, softness could indicate the ideal, human perception, atmosphere, or mystery.

Softness was not the only way Pictorialists proved their domination over the mechanical nature of photography. Oscar Gustave Rejlander and Henry Peach Robinson both used combination printing—a process by which they made one print from parts of different negatives—to do the same thing. In fact, Robinson was, for some time, the dominant British theorist of Pictorialism. For him, the essence of art resided in "pictorial effect" that "satisfies the eye without reference to the meaning or intention of the picture."[21] Effect for Robinson was, of course, a function of tone, but also, and of greater importance, laws of composition.

Robinson's aesthetic theory was an early and academic version of formalism. At the core of the theory, which he set forth in a number of books, the most important being *Pictorial Effect in Photography* (1869), was the idea that "immutable laws exist in all good works of art, whether that art is exemplified in the lowest subjects, or the highest; that the same laws of balance, contrast, unity, repetition, repose, and harmony are to be found in all good works, irrespective of subject; and that the arrangement of the general form of nearly all pictures in which true art is visible is based on the diagonal line and the pyramid."[22] Photographers could elevate their work above mechanical imitation to the dignity of art by following these laws in several ways. They could find subjects in nature that conformed to them, or if nature proved intractable, they could arrange subjects to conform to them, or they could use combination printing to the same end.

Despite the fact that combination printing was regularly used by landscape photographers to make images with consistent exposures of sky and land (which could not be obtained on just one, overly blue-sensitive collo-

dion plate), the technique as Robinson and Rejlander used it was not widely approved of. One vehement opponent of combination printing was Peter Henry Emerson—a theorist of Pictorialism of the first order—who objected to the technique on the grounds that it violated the truth of nature by giving objects a hard outline. To fail to represent nature truthfully was as unacceptable to Robinson as it was to Emerson, but the two men disagreed on just what the representation of nature entailed both theoretically and in terms of photographic technique. While Robinson saw truth as embodied in essential and immutable law, Emerson, a fierce advocate of naturalism, saw truth in the experience of nature, in what he called the "true impression" of nature.

Emerson was born an American but belongs more to the history of British photography. Actually he was born in Cuba of an English mother and an American father, a fourth cousin of Ralph Waldo Emerson. He eventually moved to England and took British citizenship. A man of massive energy and wide interests, he became a physician (nonpracticing), a writer, a naturalist, a folklorist, an occasional advocate for the oppressed East Anglian peasants, a passionate photographer, and a polemicist for photography as an art. His most important statement on the latter issue is *Naturalistic Photography* (1889).[23]

This book is confused and idiosyncratic (Emerson, like Root, was an autodidact), but it has a consistent theme of naturalism, that is, of valuing truth to nature above all else. To Emerson, naturalism was not an aesthetic position so much as it was the conviction of a scientist who had turned to aesthetic issues. He could not understand why any culture would shun mimetic art, and he saw in the schematism of Byzantine and medieval art only a sign of cultural decadence.

Emerson's purpose in *Naturalistic Photography* was to demonstrate that photography could produce naturalistic art. To do so, he had to show that photography could accurately record nature and, simultaneously, interpret it. This is an inherently contradictory task, but in Emerson's defense, it should be said that it is not a task he invented or even one unique to photography. The same contradiction between visual truth and imaginative interpretation is at the heart of all nineteenth-century naturalistic art theory, particularly Ruskin's, with which Emerson was familiar.[24]

Emerson went about trying to achieve his contradictory aim by piecing together bits of ideas gathered from Barbizon painting, Whistlerian Aestheticism, and a scientific theory of perception. He began with the premise that no method of picture making, including photography, can avoid interpretation and produce a perfectly objective image of nature. The

stigma attached to photography was that it could not interpret at all, so Emerson was turning the tables with one stroke by insisting that all images are interpretations. The question then became what is a truthful interpretation. Emerson set up the problem as follows: "Instead of it being an easy thing to paint 'a mere transcript of nature,' we shall show it to be *utterly impossible.* No man can do this either by painting or photography, he can only give a translation, or impression . . . but he can give this impression truly or falsely."[25]

It is the slippery idea of the "true impression" that lies at the heart of Emerson's theory. On the one hand, this impression has something to do with subjectivity and the mystery and poetry of nature—Whistler's presence is detectable in these sentiments; on the other hand, it had better not stray any farther from conventional mimesis than Millet, one of Emerson's favorites. Even the French Impressionists were too outré for Emerson who called their art "a passing craze."[26]

Predictably, Emerson's benchmark of artistic truth was science ("all good art has its scientific basis," he said), and the scientific measure for the truth of photographic impressions was provided by a theory of perception derived from Hermann von Helmholtz. According to this theory, one can see clearly only what one looks at directly while all else appears blurred. By these rules, then, the Pre-Raphaelites were misguided realists who falsified nature, whereas the Barbizon painters' atmospheric landscapes were right on the mark. In terms of photography, Emerson's theory meant that "the most scientifically perfect images obtained with photographic lenses" are falsifications of nature, and that to photograph a true impression, "a picture should not be quite sharply focussed in any part, for then it becomes false; it should be made just *as sharp as the eye sees it and no sharper.*"[27]

Emerson emphatically denied that he was recommending fuzzy photographs, just slightly out-of-focus ones. In sum, he echoed the idea of making photography into art by suppressing detail. By softening the focus, a photographer could interpret nature on the basis of subjective perception, retain something of the poetry of nature and, at the same time, remain true to the biological attributes of perception as determined by science.

Emerson's book became tremendously influential and shifted the balance of Pictorialist theory toward naturalism and away from the academicism represented by Robinson. Emerson replaced Robinson's adherence to rules, to pyramids and diagonals, with a concern for a more flexible vision in sympathy with one's subject. And through his opposition to combination printing and his advocacy of soft-focus, Emerson heightened the debate about the proper use of the photographic medium. For Robinson,

photography was a plastic medium that could be used in any way one wished to achieve the appropriate forms of composition. For Emerson, the proper use of the medium was an integral aspect of aesthetic theory. Soft-focus was true to nature and perception, combination printing was not. The common practice of retouching photographs was a violation of photography itself. "Retouching," wrote Emerson, "is the process by which a good, bad, or indifferent photograph is converted into a bad drawing or painting."[28] By synthesizing technical practice and aesthetic theory, by stating a definite boundary to acceptable photographic practice, and by drawing a distinction between photography and painting, Emerson clarified the shape of Pictorialist debate and helped direct that debate into the channels of early modernist art theory. Interestingly, later in his career, Emerson renounced his own theories and denied that photography could be art, but his renunciation came too late; he had already made his mark.

Writers such as Robinson and Emerson laid a theoretical foundation for the criticism of artistic photography, but Pictorialism and its attendant criticism were not simply theoretical and aesthetic movements; they were also social movements. By the 1860s there were many amateur photographic societies in Europe and the United States, but as Root noted with some frustration, the idea of photography as an art had not yet become institutionalized: "As we have repeatedly hinted before, the public at large, and the professors of fine arts, and (what is still stranger and more to be regretted) the scientific amateurs of heliography, have habitually looked upon this art, rather as a mere chemical and mechanical process, than as belonging to the category of painting and sculpture, governed by the same laws as these, and capable of producing kindred effects."[29]

This situation began to change in the 1880s when the complexity of photographic chemistry, optics, and mechanics increased dramatically, and the control of photographic technology passed from the hands of craftsmen/amateurs into the firm grip of industry, which standardized the technology, made it easier to operate, and thus made it available to many more amateurs than ever before.[30] Most among the new wave of amateur photographers were content to be led by Kodak, but there were others, particularly in Europe, who responded to ideas about the democratization of aesthetic sensibility propounded at that time by the Aesthetic movement. This movement was the most recent manifestation of resistance in the decorative arts to what was considered an intensification of vulgar materialism brought on by the rapid industrialization of Europe. It represented an effort to combat that materialism by democratizing elevated taste through the encouragement of artistic dilettantism among the middle class.[31]

As a mechanical process, photography was not the most obvious way of promoting Aestheticism. Many of those who had earlier resisted the values of industrialization—most notably William Morris—wished to eschew the use of machinery in the arts altogether and renew high standards of hand craftsmanship. But others, such as Henry Cole and Owen Jones, saw the possibility for wedding refined taste and industrial methods of production. It was this latter line of thinking that made possible the association of photography and aesthetic democracy, and it was the amateur photographers who in responding to this line of thought institutionalized artistic photography.

According to some recent historians, such as John Tagg, the industrialization of photography marks the juncture at which art photography, far from coming into its own, was rendered irrelevant to the history of the medium. With industrialization, particularly with the advent of photomechanical reproduction, photographs became so ubiquitous and disposable that they lost the aura of unique and precious works of art. Henceforth, the real life of photography was led in the portrait industry, the publishing industry, and in those institutions, such as schools or prisons, that shape and maintain social order.[32] From this point of view, the emergence of Pictorialism was an exercise in absurdity, a retrograde attempt to cling to older, aristocratic social structures that industrialization had all but wiped out.

Indeed, at the same time the artist-photographers of the turn of the century responded to the democratic aspect of Aestheticism, they also responded to the romantic notion of the artist as a member of a tiny elite of rarified geniuses forever set off from the Philistine masses. The art movement in photography, then, had both a democratic and an elitist motivation. It was a movement spawned by the urge to save Western civilization from the soullessness of materialism by spreading aesthetic sensibility to the entire middle class, but those in the middle class who took up the movement saw themselves as an aristocracy of sensibility. These new artist-photographers dissociated themselves from other serious amateur photographers, whose interests were primarily scientific or commercial, and they sought to establish themselves through new societies, new magazines, juried exhibitions, and the sanction of their photographs by traditional art institutions.

In American photographic societies, artistic aspirations were slower to develop than in European ones, but the move in that direction was nevertheless underway in the 1880s. An article on leading American amateur photographers of the decade commented: "Mr. Dumont does not value the criticisms of professional photographers whom, as a class, he considers narrow-minded and bigoted, but has sought after and been guided by the

criticisms of artists and sculptors, men of acknowledged ability, among whom he has a large acquaintance."[33] The passage is not only a bald statement of the effort to establish ranks among photographers, but it also demonstrates that the relation of Pictorialism to painting was as much a matter of social association as it was of common aesthetic impulse. The passage is reminiscent of Leon Battista Alberti's recommendation to fifteenth-century painters that they associate with poets and orators. Just as Renaissance painters attempted to raise their status through association with more respected kinds of artists, so did the Pictorialists.

The trend toward the aestheticization of photography came to a head in Europe at the Vienna Salon of 1891. Before this event, a photographic salon would ordinarily show the work of scientific, commercial, and artistic photographers, and medals would be awarded for merit in a variety of categories. The Vienna Salon, however, had a jury that refused to hang photographs of scientific or professional interest, disdained medals on the grounds that to exhibit was privilege enough, and in general, applied the narrowest aesthetic standards to the acceptance process. After Vienna, the salon movement appeared in London in 1892 with the formation of the Linked Ring. It then swept across western Europe and arrived in the United States with the first Philadelphia Photographic Salon at the Pennsylvania Academy of the Fine Arts in 1898.

One of the jurors for the Philadelphia Salon was Alfred Stieglitz who had exhibited in the Vienna Salon and become deeply involved in artistic photography while in Europe during the 1880s. When he returned to the United States in 1890, his interest in art photography had become a crusading zeal. In his essay "A Plea for Art Photography in America" (1892) Stieglitz bemoaned the fact that American art photography languished far behind that of the British. He then launched into nationalistic cheerleading:

Have we Americans not the same innate sense for the beautiful? have we not the same skill to reproduce what we see? have we not the same material to work with? We have all this, and still look at the difference existing between our work and that of our English cousins. Every impartial observer and unbiased critic will grant that we are still many lengths in the rear, apparently content to remain there, inasmuch as we seem to lack the energy to strive forward—to push ahead with that American will-power which is so greatly admired by the whole civilized world, and most of all, by the Americans themselves.[34]

What American photography lacked was originality, simplicity, and above all "tone," by which Stieglitz meant "those exquisite atmospheric effects which we admire in the English pictures." That tone was absent from American work was "a very serious deficiency, inasmuch as here is the dividing line between a *photograph* and a *picture*."[35] Tone is clearly synonymous with effect, and in emphasizing it as the distinguishing mark of art photography, Stieglitz was consistent with the rest of Pictorialist theory.

In other essays of the 1890s, such as "Pictorial Photography," Stieglitz rehearsed the tenets of Pictorialist elitism, advertising the struggle of art against commercialism and an intractable mass of public indifference and hostility. He drew a sharp distinction between amateur photography and professional work according to which the latter is done merely for money—a motive that restricts it to the most perfunctory efforts—whereas the former is done purely for love and is therefore capable of attaining the highest artistic expression. He explained that the public cannot appreciate art photography because they cannot distinguish it from their own snapshots. Thinking of photography as a facile mechanical process, a condition Stieglitz referred to as photography's "fatal facility," the public considers all photographs to be equal. But, said Stieglitz, not all photographs are the same; the technology of photography is pliant and responsive to the judgment of the photographer. In the hands of someone with an "artistic instinct" and aesthetic judgment developed through years of effort, the medium can be made to produce art.[36]

Not surprisingly, the particular aspect of photography's pliancy that interested Stieglitz in "Pictorial Photography" was its tonality. Because photographs cannot match perfectly the tonal scale of nature, photographers are forced to interpret their subjects tonally. The best means for doing this, Stieglitz thought, was to use localized development of the negative and the platinum and gum-bichromate printing processes. The latter was also appealing in that it allowed one to print on textured papers or in layers of monochromatic pigments. Stieglitz himself, it is often noted, practiced a relatively unmanipulated form of photography even at this point in his career, but for a time he endorsed these highly intrusive techniques and the work of those who used them. In the 1890s anything that demonstrated the maximum plasticity of the photographic medium made the case for photographic art.

Although Stieglitz did not practice the most manipulative of the techniques he endorsed, his interest in such techniques was of a piece with his general concern for extending the technical range of art photography. In an

essay of 1897 on the importance of the hand camera, he suggested that contrary to the widely held opinion that such cameras were merely toys or gadgets for hobbyists, they were actually suitable for serious artistic work, versatile not only in portability but also in terms of the lighting in which they could be used.[37]

Later theorists would recognize the hand camera's ability to reveal new compositional ideas through its mobility, but Stieglitz had not yet come to this. He thought of mobility only as a convenience. He still conceived of composition in essentially academic terms: one must choose a view to photograph and then wait, perhaps for hours, for the world to arrange itself within that view in accordance with a preconceived notion of balance. Then one seized the moment. Stieglitz did not yet think of composition as something one might arrive at through the interaction of the eye, the camera, and the visible world.

Stieglitz's early career was marked as much by his organizational and editorial efforts to legitimate photography as an art as it was by any aesthetic theory. In 1893 he had become editor of *American Amateur Photographer* where he published European Pictorialist images and theory, holding them up to Americans as models for emulation. In 1895 he had called for an American salon based on the principles of the Vienna Salon and the Linked Ring, and in 1896 he helped the New York Camera Club and the Society of Amateur Photographers to merge. He then took over the newsletter of the resulting Camera Club of New York and founded the quarterly *Camera Notes*.

In all the organizations he joined Stieglitz and his allies stirred up considerable turmoil as they attempted to wrest control from photographers who were not sympathetic to Pictorialism. Stieglitz also did not hesitate to undermine his Pictorialist friends when they threatened his leadership. Most notable is an episode of 1899 when he refused to cooperate with F. Holland Day in his efforts to establish an American Association of Pictorial Photographers in Boston. Such a group threatened Stieglitz's hegemony in New York.

In 1902 a power struggle at the Camera Club of New York prompted Stieglitz to leave that organization and abandon *Camera Notes*. When a similar struggle had erupted in the Philadelphia Photographic Society in 1901, Stieglitz and his associates boycotted the Philadelphia Photographic Salon. This was the yearly salon held in the Pennsylvania Academy of Fine Arts that had begun in 1898 and for which Stieglitz had served as a juror. The Pictorialists' loss of control over the Philadelphia Salon prompted Stieglitz to form his own exhibition group, the Photo-Secession, which

first came together in an exhibit at the National Arts Club in New York in 1902. The Photo-Secession at first had no organization, but Edward Steichen, who was then very close to Stieglitz, prevailed upon him to formalize the group. As a result, Stieglitz became the director and a list of fellows and associate members was drawn up. Despite these gestures the Photo-Secession remained a loose alliance of Stieglitz's cronies.

From Stieglitz's point of view, the Photo-Secession was a revolutionary organization fighting not only the Philistine public for the recognition of photography as an art but also the conservative forces in the photography establishment. Stieglitz saw himself and his allies as the champions of high standards in craft, aesthetics, and exhibition practice, and the conservatives as respectable but uninspired scientists, commercial hacks, dilettantes, slaves of academic painting, or flat-footed literalists. For their part, the Pictorialists' opponents saw Stieglitz and his friends as elitist and obscurantist, enamored of fuzziness, gloom, and impenetrable symbolism.

The accusation of elitism has gained support among revisionist historians. Ulrich Keller has argued at length that this was the primary motivation of the Photo-Secessionists. Rather than being the victims of an intolerant, conservative power structure in the photographic community, the Pictorialists were the aggressors. The conflict between the Secessionists and other photographers, says Keller, had little to do with style and everything to do with politics, a point underlined by the fact that the Secessionists were not the least bit original in their work, and drew from many sources in painting and even the nonart photography they spurned, including commercial architectural and topographic work. Keller suggests that if one compares the gravures in *Camera Work* (Stieglitz's celebrated journal that followed *Camera Notes,* published from 1903 to 1917) to "all the other profusely illustrated photo magazines of the time, one's senses are soon numbed by a torrent of almost identical pictures, save for minor differences in composition and execution."[38] In brief, Keller's view is that the Photo-Secession was an elitist social club "permeated with esoteric avant-garde ceremony."[39] Far from being artists, the members were poseurs, well-to-do young people who could afford to turn up their noses at commercialism in pursuit of their romantic fantasies about the aesthetic life.

From the point of view of the Pictorialists, however, there were important distinctions between their work and that of other photographers. Stieglitz and his group were promoting art over science, dedication to aesthetic experience over the pursuit of profit, and a Symbolist aesthetic over literalism or academic allegory. The "minor differences in composition and execution" between Pictorialism and other photography made all the

difference in the world because these constituted the dividing line between a work of art and a mere picture. Furthermore, a cohesive group of like-minded photographers was essential if photographic art was to flourish, for only such a group could create the atmosphere necessary for ongoing thought, experimentation, creation, criticism, exhibition, and publication.

Charles Caffin

One critic who flourished in the atmosphere created by Stieglitz and his Pictorialist friends, and became one of the most significant critics of photography in the United States was Charles Caffin. Caffin's preeminence arose from a number of factors not the least of which was that he was one of very few writers before the middle of the twentieth century to show a sustained critical interest in photography; he wrote about the medium for nineteen years. Also, when he started writing about photography he was already an established art critic and able to lend the authority of his position to the status-hungry photographic community. His association with Stieglitz's circle enhanced the status of that group and gave Caffin considerable visibility as well. Finally, through his sound theoretical capacity, Caffin was able first to integrate Pictorialist theory into early modernist art theory and then to go beyond Pictorialism by helping establish the theory of straight photography.

Caffin was born in 1854, the son of a minister of the Church of England. But his origins notwithstanding—and following a pattern common among middle-class Englishmen of his time—he maintained no religious affiliation as an adult, preferring to search for moral and spiritual sustenance in Culture, which he acquired for himself through a liberal Oxford education.[40] After college, he spent some time wandering in Europe, first teaching and then working in the theater as an actor and stage manager. He came to the United States in 1892, did a brief stint in design work for the 1893 Chicago Columbian Exposition, and eventually turned to criticism. Over the course of his career, he wrote for a number of newspapers and magazines, among them the *New York Sun,* the *New York American, Harper's Weekly,* and *International Studio.* He also published more than twenty books. Most of these concern painting, but he also wrote a book on drama, one on architecture, one—coauthored with his wife—on dance, and a major treatise on photography. Caffin had an inclusive vision of the arts and a vision that led him outside the traditional boundaries of high art. His catholic tastes undoubtedly account, in part, for his interest in photography.

He was also probably open to the consideration of photography as an

art through his sympathies with the Arts and Crafts movement. In 1899 he published a series of six articles in *Harper's Weekly* in which he endorsed that movement's expansive view of aesthetic possibilities. He affirmed its underlying principle "that nothing is too insignificant to merit the labor of an artist. . . . It is not in what medium a man works, but how far he has a feeling for beauty and succeeds in expressing it in form or color."[41] Caffin clearly concurred with that branch of the movement represented by Owen Jones (and at odds with those who followed William Morris) that sought to reconcile machinery and art.[42]

In 1898 Caffin had written a laudatory review of the Philadelphia Salon, and this had attracted Stieglitz's attention. Soon after, Stieglitz invited him to contribute to *Camera Notes;* eventually Caffin became one of the most prolific contributors to *Camera Work,* publishing fifty-six articles and reviews there over the course of its fifty-issue history.[43] Caffin was also admitted to the inner circle of Stieglitz's associates and participated in their celebrated lunches at the Holland House in the Prince George Hotel.[44]

Caffin was faithful to Stieglitz and the Photo-Secession and willingly acted as their propagandizer in the popular press and in Stieglitz's own publications. He appears in that role in a 1907 issue of *Camera Work,* stressing the Photo-Secession's originality, progressiveness, and regal self-confidence:

> The [Photo-Secession], springing from a somewhat obscure source in a tiny trickle of adventure, gathered to itself the force of its own convictions, until it is now rolling on in considerable flood, pushing forward its course with something of the indifference that the Mississippi exhibits to the workers and loafers along its banks. The stream is broad, there is room for many kinds of craft, and each under its own form of motive power has the freedom of the river, provided its bow is set with the stream in the direction of the deep, wide ocean. For no putting back up-stream is tolerated.[45]

In addition to this kind of undisguised promotional writing, Caffin also did some adept criticism of Photo-Secessionist pictures. Regarding Steichen's portrait of Rodin with "Le Penseur" he saw, "in the dark mass of the figure a very remarkable interpretation of force and introspective depth; and, on the other hand, in the delicate half-tone modeling of the statue, which forms the background of the head, an equally remarkable sug-

gestion of subtlety."[46] This may not be a brilliant passage, but it is a solid, relatively early, and surprisingly rare example of a direct critical treatment of a photograph in largely formal terms, giving it the same kind of attention that would have been accorded a painting.

The most important service Caffin performed for the Photo-Secessionists was that of integrating their photography into his art theory. Caffin was not at all shy about establishing a close association between painting and photography. He thought artists working in different media could legitimately use the same principles of pictorial expression as long as they did not lapse into superficial imitation. In the event, Caffin found many Pictorialists guilty of that error. He also found that they suffered from a general confusion of purpose, producing "mysterious blurriness" or taking "shelter in muzziness." But he gave a perceptive and generous explanation for this situation having to do with the pressures of trying to establish the artistic status of photography under the glare of public attention in a competitive society. All this drove young photographers to intense technical experimentation, flamboyant self-assertion, and a certain amount of ill-conceived photography.[47]

Caffin's art theory, into which he integrated photography, is a representative version of early modernism. Caffin responded to Impressionism, Whistler, Symbolism, Japanese art, and eventually Matisse. In the manner of other modernists, he rejected what he saw as the excess baggage and artificialities of older forms of art. He was critical of academic art on the grounds that it was "a thing separate from and superior to nature."[48] He was against literary art, insisting that a picture be judged only "by those qualities which are peculiar to itself."[49] He was antiallegorical, insisting that allegory is vacuous especially in comparison to allusions of a Symbolist nature, which, despite their relative lack of precision, are full of vitality.[50] Caffin could be amusingly snide about contemporary efforts at allegory. He once wondered if the viewer could recognize "in a lady, holding a toy ship, an adequate suggestion of the vastness and complexity of modern commerce; or, when the artist requests her to slip off her clothes, and hold a mirror, discover in this allegory of Truth some incentive to more honorable living in our own day."[51]

Consistent with the modernist endeavor from Baudelaire to Kandinsky, Caffin based his art theory on a search for essence: the essence of nature, spiritual essence, and the essential structures of art. He perceived ultimate unity in the realm of essence. By finding the essence of nature, the subjective individual may touch a realm of universal spirituality. By understanding the essential formal principles of art, the artist may lay out principles for life.

The unity of art and life and the relevance of art to the good life became an issue of major significance to Caffin. It is a concern that reveals his responsiveness to Ruskin and probably Robert Henri as well, and it distinguishes Caffin from other early modernists of a more formalist bent such as Roger Fry and Clive Bell.[52]

Caffin wrote about art and life in a book published in 1913, *Art for Life's Sake,* the central thesis of which was that the principles of art may be used to build a good society, or as Caffin put it, a "New Democracy." This was not, as one might expect, a democracy to be based on ethical principles. Caffin thought that any system of ethics unavoidably reflected the bias of those who formulated it. In fact, such a system had made the United States an inherently unequal society dominated by a "bourgeois aristocracy." Caffin's democracy was to be based on science and art: "It will be a democracy founded not upon theories of the rights of man, or the rights of the governed or what not, but upon knowledge derived from the facts of Nature—inanimate Nature and the Nature of man. It demands for its consummation the union of two vital operations: Science and Art. Science, which is the mastering of the facts and relations of Nature; and Art, which is the organizing of the knowledge and power acquired by Science, so as to further the efficiency of the worker and his happiness."[53]

According to Caffin, contemporary society had been unable to find its way to this ideal democracy because it had misused the potentially liberating power of science and technology for narrow, materialistic ends. If science were redirected through education so as to restructure society according to the universal principles of art, then the American spirit would be free to soar. Caffin named the principles of art he was talking about: "Selection and Organization; the latter based upon Fitness, Unity, Balance, Harmony, and Rhythm, with a view to Efficiency."[54]

This appeal to a positivist conception of science and social engineering, and this emphasis on efficiency were meant to free Caffin's theory from the bias of class and endow it with objectivity and universality. But, as is so often the case with theorists who attempt to define universality, Caffin's search for universals and essentials revealed his own cultural bias. This is most obvious when he speaks of a major obstacle (in addition to the fixation on materialism) to the unity of art and life and to the liberation of the American spirit. Surprisingly, the obstacle is the heritage of the Italian Renaissance:

For, whatever may be the particular strain which each of us carries in his blood we are very largely of one race and this is the

northern, as contrasted with the races of the Mediterranean. Yet it is from the latter that for some three centuries our northern race has derived its culture. Meanwhile, in the conduct of Life our race has ever been animated with the spirit of adventure and the love of liberty. The result, therefore, of borrowing an alien culture is that we have never really fitted it to our practice and ideal of living. This has been one of the fundamental causes of the great divide between Art and Life which has characterized our civilization.[55]

By present standards, Caffin undermined any chance of pointing the way to a new democracy through his adherence to a simplistic and exceptionally narrow concept of national character.

Photography had little to do directly with Caffin's social vision. His involvement with the medium predated the full development of that vision, and by the time Caffin wrote *Art for Life's Sake,* he had lost interest in photography. Nevertheless, his theory and criticism of photography are important in the formative stages of his larger theory. They were a demonstration of Caffin's belief in the unity of art and science, and they forced Caffin to focus on the relation of art to nature and the significance of artistic form. It was imperative that he work through these issues before he could arrive at the conclusion that the formal principles of art might be applicable as principles of social organization, independent of and well beyond the function of representing nature.

Caffin's fullest statement of his photographic theory is his book of 1901, *Photography as a Fine Art,* a work that may be seen as a manifesto of American Pictorialism. The book begins with the standard distinction between artistic photography and commercial photography, and a lament over the obscuring of photographic art by commercial values. The artistic photograph, Caffin said, must primarily be beautiful rather than utilitarian, and it must reveal "evidence of [the photographer's] own character and purpose, as an oil-painting may do in the case of the painter."[56]

Caffin's idea of what that purpose might be encompassed both the Impressionist subjectification of nature and the Symbolist concept of form. The artistic photograph must not be a baldly objective rendition of nature. It must "record facts, but not as facts; it will even ignore facts if they interfere with the conception that is kept in view."[57] Caffin also said, in a more Synthetist manner, emphasizing a unity of form and expression: "In a word, like artists in other mediums, [the photographer] aims not only to represent the concrete fact, but also to suggest impressions of abstract enjoyment through the qualities of the technic."[58]

Unfortunately, photographic technique, in the state aspiring artists received it, the state that Caffin implicitly took to be the natural state of the medium, had what he described as certain "limitations" or obstacles to its use for artistic purposes. It was literal, and impartial to the degree that most photographs are "so crowded with facts as to lack the simplicity and synthesis of pictorial composition," that is, they lacked effect. To make art, a photographer must overcome these limitations: "In short, if he has the equipment of an artist and an artistic individuality, the photographer can surmount or evade the limitations of his mechanical tool, the camera, and produce work which, barring colors, may have the characteristics of a beautiful picture."[59]

The way to evade the limitations of photography was to eliminate detail: "The painter obtains his synthesis by elimination of the unessential and massing of the important features. The photographic artist does practically the same. . . . Having made his negative, he is able in the process of development and printing to control the result—strengthening this part or reducing that until he . . . reaches synthesis."[60]

The way Caffin conceived of photography as art raised the question as to whether he was still conceiving of photography as true photography. Caffin implicitly thought that photography is implicitly objective in essence, but this assumption clashes with the idea that art is a subjective interpretation of nature. If it is possible to make art with photography, that is, if one may use one of the many Pictorialist techniques to subvert the seeming objectivity of the medium and interpret nature subjectively, then one must necessarily be violating the true, objective nature of the medium. In sum, Caffin defined photographic art as counter to the nature of photography. This would not have been a problem had Caffin not cared whether photographic art was true to the essence of the medium. But that special modernist concern for finding and remaining true to the essence of an artistic medium, having migrated into the discussion of photography from Ruskin and the Arts and Crafts movement, and been given attention by Emerson in the 1880s, had by 1901 become too important for Caffin to ignore.[61] It was an issue that caused Caffin and generations of photographic theorists after him no end of trouble.

When he wrote *Photography as a Fine Art,* Caffin had not yet defined the essence of photography explicitly for himself, and he had not yet made up his mind as to the importance of that essence in photographic art. One sees him mulling over the matter in the course of the book as in a discussion of Stieglitz in which he presented two opposing views on the question of whether one ought to remain true to the essential nature of photography.

Stieglitz represented the modernist position: "His [Stieglitz's] attitude upon this subject is that the photographer should rely upon means really photographic; that is to say, upon those which grow out of and belong to the technical process." To do anything else, according to Stieglitz, is implicitly immoral, a subterfuge. Caffin goes on, putting words in Stieglitz's mouth, "The arts equally have distinct departments, and unless photography has its own possibilities of expression, separate from those of other arts, it is merely a process, not an art; but granted that it is an art, reliance should be placed unreservedly upon those possibilities, that they may be made to yield the fullest results."[62]

On the other side, an imaginary friend argues, in the way H. P. Robinson might have, that photography is simply a means to the end of making art and may be used in any manner one wishes. After presenting these two sides of the issue, Caffin declares that he wants to remain "noncommittal."

Later in the book, Caffin comes to the question of which techniques are appropriate in art photography and which are not. The context is a discussion of Frank Eugene and Joseph Keiley who used glycerine development to create the texture of brush strokes in their photographs or to remove areas of the image. Eugene also drew dark hatch marks on his negatives. These practices prompted Caffin to make a distinction between "straight" and "manipulated" photographs. Stieglitz was a straight photographer: he worked "chiefly in the open air, with rapid exposure; leaving his models to pose themselves, and relying for results upon means strictly photographic." Eugene and Keiley, said Caffin, represented "the opposite to the 'straight photograph.' They largely 'manipulate' their negatives or prints to secure the desired result." Caffin explained, "The [straight photographer] only *modifies* the result; the [manipulative photographer] reserves the right to *alter* it."[63]

Even more important, the straight photograph "is substantially nature's image," whereas the manipulated one is "a twisting of nature into the groove of the artist's own impression." It is this twisting, this violation of nature, not the violation of photography, that Caffin finally objects to in manipulated photographs. He asks, "If nature is the source of beauty (and few of us will question it, particularly in the case of landscapes), can we derive as much pleasure from an interpretation of nature evolved out of a man's brain, however poetical, as from one studied from nature direct?"[64] The answer, of course, is a resounding no.

In *Photography as a Fine Art,* Caffin struggled with the problem of truth to medium but did not come to terms with it. He did not take a firm

stand on whether one ought to be true to the essential nature of one's medium; he did not define the essential nature of photography explicitly nor the techniques that would be consistent with that nature; and he did not resolve the contradiction in the idea of photographic art by reconciling the concept of art as subjective interpretation of nature with the implicit assumption that photography is, in essence, objective. In the end, Caffin sidestepped the problems of truth to medium and made his judgments about proper techniques for photographic art in terms of truth to nature, much as Emerson had done. Caffin concluded that one may use a photographic technique that modifies nature but not one that violates it. The boundary between modification and violation remained unclear.

Consistent with his tendency to pursue essences, Caffin was interested in more than the representation of the outward appearance of nature in art and was responsive to Symbolist ideas about the evocation of an essential, spiritual truth in nature. Near the end of *Photography as a Fine Art,* this sense of spirituality emerges in a discussion of Steichen's photographs: "We admit the beauty of nature and that the artist renders this beauty through faithful study of what he sees; therefore, the 'obvious,' that which confronts his actual vision, might seem to be the truth of nature and accordingly desirable. Unquestionably it is the truth but a truth that is only the outworks, as it were, of a greater truth. . . . So, latent within the forms and colors of the landscape, is an essence or spirit."[65]

Caffin's pursuit of this spiritual essence eventually led him to question the materialism of Western culture and to look for a way in which art might lessen that materialism. In the process, he moved away from naturalism and photography and toward his social vision. In a two-part article "Of Verities and Illusions" published in *Camera Work* in 1905 and 1906, Caffin contrasted the spirituality of Japanese culture with the materialism of the West and concluded that Western culture was in trouble: "For spiritual ideals we have substituted the ideal of success; for the Golden Rule the consecration of the Self to itself; until the brutal lust of Individualism has become so rampant, so defiant of religion, ethics, and law that we are in danger of being devoured by the Minotaur we have bred and petted."[66]

Western naturalistic art, based on the materialistic worldview, was in an equally sad condition:

> For it is a new mind that is needed, if the vitalizing of painting is to be renewed; a new point of view, a new *raison d'être,* a new fundamental principle. Our old one of the supreme importance of matter is about exhausted; . . . the theme of appearances is pretty

well worked out. . . . If painting is to maintain a hold upon the intelligence and imagination, as music does, and possibly poetry, and to grow forward in touch with the growing needs of humanity, it must find some fundamental motive other than the *appearances* of the world. . . . It must take on something of quality which is the essence of music—the *abstract*.[67]

The example of abstraction was not only to be found in music, but also in Japanese painting, which Caffin saw as emerging from a culture that subordinates the individual and the idiosyncratic to the universal and spiritual. For Caffin, the abstraction of Japanese art carried the spiritual content of the culture. To make abstraction the fundamental principle of Western art would not only revive that art, but also revive the spirituality of Western culture.

The actual course of the development of abstraction in Western art took Caffin by surprise, and it caused a profound shift in his understanding of painting and the relationship of painting and photography. Caffin had initially understood abstraction as being based on perception, on the interpretation of what one sees. But after a visit to Matisse's studio in 1908, he was forced to confront conceptual abstraction, that is, abstraction based on the imagination or on the formal needs of a picture. Caffin explained Matisse's art as follows: "He too is an impressionist, but with a difference. It is not the ocular but the mental impression that he is intent on rendering, which again has a ring not unfamiliar. But his difference consists in the big gap which appears between the ocular and the mental impression. . . . His simplification is not for the purpose of rendering more vividly the actuality of form; it is to secure a unity of expression in the interpretation of an abstract idea."[68] Caffin was uneasy with Matisse's art because it violated the truth of nature, but he could not dismiss it because it was too compelling and, no less significant, Matisse clearly was a man of solid character, not a charlatan.

Caffin's theory began to shift to accommodate the new direction in painting represented by Matisse. In an article in *Camera Work,* "The Camera Point of View in Painting and Photography," he grouped together all representational art, whether painting or photography, under the rubric of photographic vision. He then defined a category of art reserved for painting: "There is, however, that other field of art which is occupied, not with facts of sight, but with ideas of the imagination. This is outside the range of the photographic point of view. The camera is as powerless to explore it as is the photographic method of painting. Its problems and their

solution are alike evolved from the imaginative consciousness of the artist."[69] Having thus split painting and photography at a fundamental level, Caffin was free to drop the Pictorialist problem of the subjective interpretation of nature. Now he explicitly accepted photography as essentially objective and scientific, no longer seeing objectivity as a quality to be overcome. He was now committed to a concept of straight photography.

The shift in Caffin's view of photography was probably not entirely motivated by theoretical considerations. By 1909 he was beginning to tire of Pictorialism, finding it stagnant, and this must also have contributed to his readiness to see photography change course. In any case, Caffin's change of view had a profound effect on his criticism. In a review of the International Photographic Exhibition of 1909, held in Dresden, he lambasted the Pictorialist photographers:

> Instead of jealously preserving the integrity of the photographic record, they adopt endless devices to elude it; in place of relying on the scientific precision of their medium, they resort to the slipshod of accident and to the trickiness of personal interference. . . . They prostitute the scientific integrity of their art to the specious pretext of personal expression.
>
> But the student of pictorial photography may easily find a graver charge of inadequacy based upon a failure in respect to the qualities of photography that are fundamentally photographic. Need I repeat that these are the product of the essentially scientific nature of the process, and of the precision of the photographic record?[70]

Judging from this passage, truth to medium had now become paramount for Caffin, even more important than truth to nature. Of course, he did not define the limits of the scientific nature of photography, and we do not know that he would not have defined them by appealing to truth to nature. Nevertheless, his emphasis on precision was new; no longer was he talking of overcoming indiscriminate rendition of detail to achieve expression in photography.

In the review of the Dresden exhibition, Caffin did not attack his friends in the Photo-Secession as harshly as other Pictorialists, but the Secessionists did not go unsinged. Caffin wrote that they were showing "a certain exhaustion of vitality. The very search for 'quality' that has been the distinction of these prints, seems to be tending toward an indifference to other features of value, notably interest of subject and freshness of observation and treatment."[71] Now Caffin no longer praised the Seces-

sionists for suggesting impressions of abstract enjoyment. He wanted photographers to confront their subjects directly.

In subsequent writing, Caffin continued to applaud the general accomplishments of the Photo-Secessionists, but clearly he was looking for something new. Even in the midst of praise, he spoke of photography's unrealized potential.[72] When Stieglitz exhibited Paul Strand's straight photographs at "291" in 1916, Caffin saw what he was looking for.[73] Unfortunately, Caffin's uncritical acceptance of the apparent objectivity of Strand's pictures left his criticism limp. In his review of Strand's show, Caffin enumerated the objects in the pictures, praised Strand's selection of subject matter, and exclaimed twice at the vitality of the images, but he did not analyze the pictures in the formal terms he had used for Pictorialists such as Steichen.[74] For Caffin, as for many who came after him, the capacity to analyze photographs critically was a casualty of the emphasis on truth to medium and the unquestioning acceptance of photographic objectivity as the essence of that truth. Caffin had been a major theorist of Pictorialism. He also helped undermine Pictorialism and establish the theory of straight photography. He was, however, unable to see deeply into that theory. His review of Strand's show was his last published word on photography.

Sadakichi Hartmann

In addition to Caffin, there was one other major critic of photography in this country at the turn of the century: Sadakichi Hartmann. The two men had much in common as critics, although Hartmann was by far the more complex and flamboyant personality. Both men had European backgrounds and were intellectually shaped by Europe, and both were engaged in nurturing the nascent American artistic identity. Both were prolific writers with wide-ranging interests. Each had some experience in the arts, although Hartmann had far more than Caffin. Hartmann was a serious writer of drama and poetry; he also painted, drew in pastel, did some photography, danced, and, late in life, played a small role in a Hollywood movie.

Hartmann was as responsive to modern art as Caffin, if not more so. He wrote about Whistler—whom he called one of the century's greatest artists—and was aware at an early date of Gauguin and Maurice Prendergast. He wrote perceptive criticism on French Cubism and on the cubist work of Max Weber. He also wrote approvingly about the emerging skyscraper architecture of "iron and glass," and on the aesthetics of the cinema. For the most part, Hartmann was eager to participate in the accelerating change of the

modern world. Looking backward, he announced with relish: "The whole last century has been one uninterrupted revolution—restless, pitiless, shameless, gnawing into the very intestines of civilized humanity. Nothing has resisted its devouring influence, nothing, absolutely nothing has remained of the good old times; they have vanished with their customs and manners, their passions, tastes, and aspirations; even love has changed; all, everything is new."[75]

Hartmann, like Caffin, was closely allied with Stieglitz and his circle, and intensely aware of the social dynamics of the tight-knit world of art photography. Although he had a much stormier relation with Stieglitz than Caffin and was much less faithful to him, Hartmann nevertheless publicized the Photo-Secession in the popular press and was a major contributor to *Camera Notes* and *Camera Work*. He also had a significant influence on Stieglitz's views on art, reinforcing Stieglitz's belief in the value of individual, subjective self-expression.[76]

As did Caffin, Hartmann integrated Pictorialism into his art theory. He felt the same tension as Caffin between the painterly subjectivity of Pictorialism and the idea of objective straight photography, and he responded to this tension with considerable ambivalence. He wanted photographers to learn from painting and to be independent of it; he wanted photography to be art in the traditional sense and, at the same time, to define itself autonomously. When he eventually began to envision a straight style of photography beyond Pictorialism, he saw more deeply into its possibilities than Caffin.

Hartmann looked to literature to enrich his understanding of photography, and in so doing he established a pattern that was to be repeated by critics of photography from mid-century to the present. His taste in literature was decidedly Symbolist, but he was ambivalent about Symbolist photography. This made him even less tolerant than Caffin of the "excesses" of Pictorialist manipulation.

Both Hartmann and Caffin were concerned with the expression in art of a reality beyond quotidian experience. Caffin drew on Japanese culture and art for a model of spirituality. Hartmann's sensibility might best be characterized as psychological rather than spiritual. To articulate his sense of immanent reality, he looked to Symbolist writers, in particular Maeterlinck, whose suggestive style was a model for his own writing. It is interesting that neither Caffin nor Hartmann were interested in American Transcendentalism although it was close at hand (and Maeterlinck was influenced by Ralph Waldo Emerson). This lack of interest was probably due to their European intellectual orientation.

Hartmann and Caffin both saw American society as being at odds with

the spiritual artistic values they wished to encourage, and indeed it was. American pragmatism, the anti-intellectual strain of populism, and the Protestant heritage that discouraged religious art or any broad artistic investigation of the spirit or the imagination, all made for a climate unreceptive to Symbolism and Eastward-looking Aestheticism. Caffin cited materialism as the root of the problem; Hartmann pointed to the nation's Puritan heritage. He wrote, "Half our difficulties in public and private life are due to the Puritanic spirit. And the former belief of predestination to eternal damnation has changed into a rigid sense of propriety that is prohibitive, dismal, and destructive to art and all higher intellectual pursuits."[77]

Hartmann was more pessimistic than Caffin about the future of art in American society. Consistent with the thinking of the Arts and Crafts movement, Caffin did not consider art to be the victim of social circumstance, but saw it as an active and democratic social force. Hartmann thought of art as isolated expression touching only a tiny elite:

> No, this talk about universal art worship is contrary to all rules of sound reasoning. Democracy in art is the most illogical formula of reformatory ideas. . . . Every art expression . . . has its peculiar technique, and without a certain knowledge of the technique appreciation is difficult, instinctive or accidental. . . . The more individual a work of art is, the more precious and free it is apt to be; and at the same time, as a natural consequence, the more difficult to understand. . . . And if suddenly the unforeseen should occur, and the majority should actually have climbed to a higher level of culture than heretofore, the art of the day would already have soared beyond their horizon.[78]

Hartmann's aesthetic elitism may have been intensified by his status as an ethnic curiosity in America. Being half German and half Japanese, he must have seen himself as quite distinctive judging by the attention of his associates (he was photographed by almost every serious photographer in New York) and, more significantly, his ultimate isolation. Certainly his aesthetic elitism was consistent with the rest of his character. He was a mercurial personality, often brilliant, often something of a con man and poseur. He was fitfully successful in conventional terms, but too bohemian to build a stable career, and he was plagued by disabling asthma that often made work impossible and reduced him to poverty. At times he lived on his friends' patronage, which in later years he came to expect as his due.[79]

Hartmann was born in 1867. His father was a German merchant who lived on an island trading colony in Nagasaki harbor, and his mother, who died in his infancy, was Japanese. When he was still a youngster, Sadakichi's father sent him and an older brother to Germany to be raised by an uncle. He was later shipped to another aunt and uncle in Philadelphia.

Hartmann showed an early interest in the arts, which was encouraged by his German uncle. When he became independent in this country as a teenager, he went to work in lithography shops and then in a photography studio as a negative retoucher. After he discovered his ambition to write, he cultivated an acquaintance with Walt Whitman. During the 1880s and 1890s he made four trips to Europe to study painting and literature. On one of these trips, he met Stephane Mallarmé with whom he subsequently maintained a correspondence.

Hartmann's writing is varied. His oeuvre includes a series of Symbolist religious dramas: *Christ, Buddha, Confucius, Mohammed, Moses,* and *Baker Eddy.* For his first effort, *Christ,* he was fined and jailed briefly on obscenity charges. His second script, *Buddha,* contains directions for a light show. He published a number of books on art, including one on Japanese art, one on Whistler, and a two-volume history of American art that became, for a time, a standard text. His career as a critic included among other things an ambitious but unsuccessful collaboration on a daily literary journal—the publication lasted just thirteen days. Hartmann's writing on photography is vast. His output includes two books on composition, a flood of articles for the popular photographic press, and substantial contributions to Stieglitz's publications.

That Hartmann was interested in photography can be attributed to his aesthetic omnivorousness and perhaps to his sense that photographic criticism was a fertile field, free of the established, conservative critics who had shut him out of mainstream publications.[80] In addition, his Symbolist sensibility—his interest in subjectivity, mystery, indirectness, and a degree of abstraction—all drew him to Pictorialism. "Accuracy is the bane of art," he wrote.[81] The ideal of all the modern arts was to achieve a level of nonliteral expressiveness equivalent to that of music. Through suggestive indefiniteness the best pictorial artists endeavored to "perpetuate particular moments of human happiness, vague currents of the 'unsounded sea' which at rare intervals lash our feeling into exquisite activity. And to realize this is indisputably one of the most deserving ambitious tasks a modern artist can set himself."[82]

Hartmann considered much of Photo-Secession photography to be evocative of an inner, personal realm in a way he approved of. He described

the soft and misty Secessionist photographs as having a "general tenden-cy towards the mysterious and bizarre" with meanings and intentions that are hard to discover.[83] He described the ethos of the "true" Secessionist artist:

> With every human being a new world is born which did not exist before he saw it, which will never exist again when death closes his eyes. To represent the world, which is nothing but life as seen by the individual, is the aim of the artist. They are the story-tellers of some foreign land which they alone have seen and which they alone can depict for the benefit of others. To listen to the inner voice, to be true to themselves, to obey nobody, that is their law; and only those who in this fashion work out their own individuality, their own innermost convictions which they share with no one else; those who work it out in a convincing manner, without looking out to please or to succeed; they alone are true Secessionists.[84]

Steichen apparently met these qualifications. Hartmann wrote in *Camera Work* that he "is a poet of rare depth and significance, who expresses his dreams, as does Maeterlinck, by surface decoration, and with the simplest of images . . . [he] can add something to the consciousness of life."[85] In the same issue, Hartmann responded to two Steichen prints with two of his own poems, one of which, "Dawn Flowers," he dedicated to Maeterlinck.[86]

Hartmann's support for Pictorialism and the Photo-Secession was by no means unequivocal. In fact, his position was deeply ambivalent, never perfectly consistent or static, always shifting and evolving. But even his harsh criticism must have been welcomed by photographers if only as a sign of public recognition. As Hartmann himself suggested, we "live in an age of advertisement" in which even unfavorable public notice is of value.[87]

Hartmann had no more patience for allegorical images than Caffin. He wrote of F. Holland Day and Gertrude Käsebier that they were "eminently fit to represent that class of human beings who wear slouchy drapery instead of tailor-made costumes, and carry sunflowers, holy Grail cups or urns, filled—I presume, with the ashes of deep thoughts—in their hands."[88] He had a strong sense of the blunt literalness of photography, which he was unwilling to suspend in the case of allegories or staged genre pictures, remind-ing photographers that the camera records everything it is pointed at whether they see all of it or not. He often criticized the Pictorialists for their blatant

imitations of painting—"But what satisfaction can there be in repeating in a new medium what has been done so much better in another?"[89]—and for violating his keenly felt sense of the inherent properties and boundaries of photography. He rejected retouching and any other form of "trickery" that imitated print-making processes. By 1899 he was already espousing the idea that to become an independent art photography must assert its unique qualities. What he named as the unique property of the medium was its capacity to record spontaneous action.[90] (In this he anticipated the judgment of some mid-twentieth-century writers.) But Hartmann did not fully accept the literalness of photographic instantaneity, complaining in one essay that the postures of pedestrians caught in midstride were unnatural.[91]

In his early peripatetic musings on photography, Hartmann produced several ideas of interest, which he either never developed or later backed away from. One such idea—later articulated by Walter Benjamin and his followers—had to do with the absurdity of precious, limited editions of photographs in light of the medium's potential for infinite and inexpensive duplication.[92] Such an attack on preciousness, which Hartmann did not pursue, would have undermined the privileged status of art photographs that the Pictorialists were intent on establishing.

Just as he backed away from his attack on preciousness, Hartmann eventually moderated his complaint against the Pictorialists' imitations of painting. Twelve years after his initial comments, he offered a "just defence" for such imitation, saying that a photographer may repeat an accepted theme in a new medium, thereby giving that theme new life.[93] The softening of his position was probably the result of his coming to terms with the general discrepancy between his aspirations for Pictorialism and his assessment of its modest aesthetic accomplishments. As long as he felt that the potential of art photography was high, he was willing to go on the offensive to spur on the young artists, but as he realized their severe limitations, he decided it was best to protect what gains they had made. In the end, Hartmann's assessment of Pictorialism was not glowing. Summing up the movement in 1911 he wrote, "One can hardly say that photographic picture-making up to this day has revealed much of spiritual gravity."[94]

Hartmann never constructed a rigorous critical theory, but in his typically self-aware yet desultory manner, he did write about the practice of criticism. His most extensive comments appear in "Random Thoughts on Criticism" published in 1900. Here he rejected academic, or as he put it, didactic criticism that is concerned with laying down universal rules for an art form. He did not object to such criticism in principle, but he thought photography too young an art for such universal laws to be apparent.

In the absence of law, a more relative form of criticism must prevail, and accordingly Hartmann claimed that it is the critic's duty to measure an artist's work against his intentions—intentions of which the artist himself may be unconscious.[95] How Hartmann conceived of intention is not altogether clear. It does not appear likely that he thought of it as the state of mind of the artist at the time of creation or that he conceived of it as the purposeful action of artists as it relates to the entire context of their personal and historical situation. Most likely, he thought intention involved the artist's answer, in the form of a work of art, to a complex of more or less clearly identified aesthetic problems. For a Pictorialist photographer, such problems might have to do with how to establish a mood of ineffable mystery in a portrait or how to make a photograph that looks like a unique and precious object. In any case, Hartmann clearly did not equate intentional criticism with biographical criticism; he insisted that whatever he was going to get from someone's art had to come from the art itself.[96]

Whatever Hartmann meant when he spoke of intentional criticism, in actual practice, his criticism had less to do with the artist's intent than with sensitivity to his own responses to art. He most closely described his actual critical method when he said "it is the critic's business to tell his own impression frankly, without personal subterfuge, to his readers."[97] Hartmann was an impressionistic critic in the manner of Walter Pater whose book on the Renaissance Hartmann would undoubtedly have read, considering that it was the bible for young aesthetes at the turn of the century. It was Pater who said that the "first step towards seeing one's object as it really is, is to know one's impression as it really is."[98]

At its best, Hartmann's impressionistic criticism is well written and richly evocative, as in this sentence from an essay on Steichen: "Steichen's nudes are a strange procession of female forms, naive, non-moral, almost sexless, with shy, furtive movements, groping with their arms mysteriously in the air or assuming attitudes commonplace enough, but imbued with some mystic meaning, with the light concentrated on their thighs, their arms, or the back, while the rest of the body is drowned in darkness."[99] No more eloquent and sympathetic description of Steichen's nudes has been made.

Hartmann's ambivalence about photographic aesthetics, the failures of Pictorialism, in-fighting in the Photo-Secession, and Stieglitz's domineering personality, all brought him to a crisis with the Secession in 1904, which resulted in a break with Stieglitz that lasted four years. The details of this crisis are described elsewhere, but in brief, Hartmann praised the Secession in *Camera Work,* while in *Photo-Beacon,* under the pseudonym

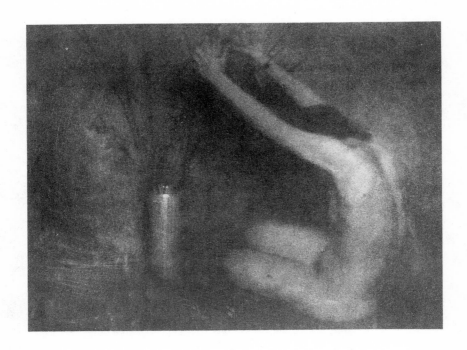

Edward Steichen, Dawn-Flowers, *c. 1902, plate 4 from* Camera Work 2 *(April 1903), photogravure. Courtesy of the Museum of Modern Art, New York. Copy print copyright © 1994 by the Museum of Modern Art.*

of Juvenal, a first-century Roman satiric poet, he attacked the Secessionists as "Little Tin Gods on Wheels."[100]

In 1904 he also published "A Plea for Straight Photography," an article of the utmost significance in Hartmann's oeuvre. In this article he accused the Photo-Secessionists of overstepping the legitimate boundaries of photography and of mixing their medium with the techniques of painting and the graphic arts. He acknowledged that these excesses were the result of the Secessionists' efforts to establish photography as an art, and he conceded that the Secessionists had made their point. Photography in general had benefited from their effort. Nevertheless, in the end, he said, the Secessionist movement was extremist and the pendulum must swing back to normal. Obviously, this raised the question as to what is normal, and Hartmann spent much of his essay trying to answer that question. In doing so, he rejected the values of mystery and indirectness he had previ-

ously endorsed in Pictorialism and articulated much of what was to become the doctrine of straight photography, a doctrine based on compatibility between the assumed objective nature of photography and art.

Through most of the article, Hartmann circled around the central problem of defining straight photography: a photograph should look like a photograph, he said; a photographer should use only photographic techniques. Some manipulation is allowable, he conceded, since it had been employed by even the straightest photographers, but it is justified only "where it is indicated on the negative" and not when used "willfully, wherever it happens to look well." He was begging the question, of course. What is the line between what is indicated and what is willful? Finally, Hartmann approached the problem directly:

> "And what do I call straight photography," they may ask, "Can you define it?" Well, that's easy enough. Rely on your camera, on your eye, on your good taste and your knowledge of composition, consider every fluctuation of color, light, and shade, study lines and values and space division, patiently wait until the scene or object of your pictured vision reveals itself in its supremest [*sic*] moment of beauty. In short, compose the picture which you would intend to take so well that the negative will be absolutely perfect and in need of no or but slight manipulation. I do not object to retouching, dodging, or accentuation, as long as they do not interfere with the natural qualities of photographic technique. Brush marks and lines, on the other hand, are not natural to photography, and I object and always will object to the use of the brush, to finger daubs, to scrawling, scratching, and scribbling on the plate, and to the gum and glycerine process, if they are used for nothing else but producing blurred effects.[101]

In this passage, Hartmann states some of the enduring principles of straight, or pure, photography. He identifies straight photography with truth to the medium, with "the natural qualities of photographic technique," and he clearly indicates that these natural qualities emphasize reliance on the eye and the camera, not hand work on the negative or print. He also points to the idea that one must conceive of one's final results before taking a picture. This crucial practice of straight photographers was later to become known as previsualization.

Although Hartmann admits that some hand work is necessary, he emphasizes that when it interferes with the photographic nature of the

work, it is illegitimate. However, neither Hartmann nor subsequent theorists of straight photography ever resolved the problem of exactly what practices do interfere with the photographic nature of a work or exactly what constitutes allowable, "slight manipulation." From its very conception to the present, the concept of straight photography has been inherently ambiguous and arbitrary precisely because it has not been possible to say definitively what the essence of photographic technique is and where the boundary between purity and impurity lies.

Furthermore, the arbitrary and consensual boundary between purity and impurity has changed over time. Not all of what Hartmann accepted as straight photography remained acceptable. The glycerine and gum processes, which Hartmann accepted only with the strict provision that they not be used simply to produce blur, were eventually rejected altogether as was anything else that reduced the rendition of a maximum amount of acute detail.[102] But the flaws at the heart of the concept of straight photography are not so much the issue here. More important is the clarity with which Hartmann stated the concept and the fact that, unlike Caffin, he made no ultimate appeal to nature as a standard by which to measure photographic practice. Photographic practice was to be measured only against photography itself. In this respect, Hartmann's definition of straight photography was closer than Caffin's to orthodox modernism and to what became the orthodox doctrine of straight photographers.

After the essay of 1904, Hartmann wrote one other essay of significance to the emerging concept of straight photography: "On the Possibility of New Laws of Composition," which was published in *Camera Work* in 1910 after a reconciliation with Stieglitz. In this article Hartmann suggested that the photographer necessarily composes analytically, in contrast to the painter, who composes synthetically. The photographer, he said, "practices *composition by the eye.*"[103]

Composition by the eye has several important implications. One is that there is an unbridgeable gulf between the photographer and his or her subject, that the photographer can stare across this gulf, arrange his or her body and the camera on one side of it, but never reach across it to construct, arrange, or direct subject matter. Certainly early theorists of photography, such as Root, saw no such gulf, nor did Pictorialist photographers who made posed allegorical photographs, figure studies, or genre scenes. But the distance between photographer and subject was to become an essential tenet of straight photography. In actuality, the giants of straight photography regularly violated the taboo against interacting with subject matter, while their followers often tied themselves in knots trying to take

the dictum seriously. In any case, the ethos of straight photography upheld the taboo of interaction.

Another implication of composition by the eye, as Hartmann understood it, was that there can be an objectivity in the photographer's gaze, in sharp contrast to a vision shaped by preconceived formulas. A painter, composing synthetically, may impose a preconceived compositional formula on a picture, whereas a photographer, composing analytically by the eye, cannot easily do this. Straight photographers who want to follow a compositional formula must find and photograph only that narrow range of subjects that fit that formula. But with other photographers, the "very lack of facility of changing and augmenting the original composition drives [them] into experiments."[104] These photographers are liberated from formulas, are free to look at anything, and as Hartmann suggests, free to allow each subject to make its own composition. Composition by the eye, then, in addition to creating a gulf between the photographer and subject, also leads to an objective, flexible, and inclusive photographic gaze. These ideas were also to become central to straight photography.

In general, the passage from Pictorialism to straight photography may be seen as a technical and aesthetic shift from subjective values to objective ones. The softening, subjectivity-enhancing techniques of Pictorialism were exchanged for a technique that maximized clarity. Mystery and private experience were devalued; confrontation with the external world became desirable.

In many ways the objectivity of straight photography allowed greater artistic freedom than Pictorialism. It not only allowed photographers a broader range of subjects but also allowed them to make positive artistic values of aspects of photography that had not been so valued before. They could celebrate the recording of infinite detail and the rendition of infinite tonal gradation. They could turn to subjects that exploited the camera's capacity to stop motion, or they could take advantage of the camera's mobility to render the world from unusual vantage points.

The new values of objectivity were not purely liberating, however. They also served to constrict the kind of technical experimentation that Pictorialism had fostered. Combination printing, hand-coloring, multiple exposures, noncamera photography, photomontage, and so forth were all taboo under the regime of straight photography. On another level, the objective values of straight photography may be seen as an expression of alienation. Objective photographers look at the world but cannot touch it; they are compelled to skim the surface of the world without interacting with it.

Hartmann raised the issues of objectivity, freedom, and detachment in the context of the urban, technological environment. "On the Possibility of New Laws of Composition" is a discussion of the modern city as a source of new photographic subject matter and a stimulus to new photographic composition. In his hands—and in the hands of Paul Strand, Charles Sheeler and, to some degree, Stieglitz—the straight photographic aesthetic may be seen as a response to the modern, urban, and technological world. It is an ambivalent response, an effort to accept technology by embracing photography in all its scientific precision and by using photography to confront and order the technological world. At the same time it is an effort to protect oneself from the technological world through detachment, by looking and not touching, by putting the camera between oneself and that threatening and confusing world.

In 1900, in "A Plea for the Picturesqueness of New York," Hartmann had urged painters and photographers to use urban subjects, but in that article, he expressed a vision of the city very much softened by Impressionism. In "On the Possibility of New Laws of Composition," he suggested a more confrontational but less certain approach to the city: "The main thoroughfare of a large city at night, near the amusement center, with its bewildering illumination of electrical signs, must produce something to which the accepted laws of composition can be applied only with difficulty. Scenes of traffic, or crowds in a street, in a public building, or on the sea shore, dock and canal, bridge and tunnel, steam engine and trolley, will throw up new problems."[105] Hartmann was enthusiastic about the new aesthetic problems cast up by the city, but the city was also a source of anxiety; it was "bewildering." Elsewhere he referred to New York's "exuberant, violent strength," and to "an infinitude of art and beauty in all this mad, useless Materiality."[106] The solutions to the visual problems of this confusing and violent urban environment, Hartmann suggested, were likely to come accidentally, perhaps through the instinctive and groping work of amateurs who have no artistic aspirations but who "by sheer necessity will work unconsciously in the right direction."[107]

Hartmann conceived of straight photography as a means to find one's way in the modern world by confronting it and embracing its technology in the form of the camera, and by giving over a large measure of control to the camera, trusting it to serve as an agent of the unconscious capacity for adaptation. The frame of the viewfinder would reveal a new order as an antidote to confusion and anxiety; at the same time the camera would act as a buffer against the crushing power of the crowds and traffic.

The advocates of straight photography, including Hartmann and Caffin,

believed that in embracing objectivity, they were allowing photography to become an independent art. They thought they were finally breaking the relationship between photography and painting that had been central to Pictorialism. By becoming objective, photography could define itself in relation to its own properties and the world, rather than to painting. In fact, the relationship between photography and painting continued in many respects. American painters and photographers of the 1910s investigated abstraction, using Cubism or Kandinsky as a model. Both groups of artists evoked the aura of science in their art, taking abstraction to be parallel to scientific analysis. They saw abstraction as a way to resolve the world into fundamental visual forms as physics resolves the material world into atoms.[108]

Painters and photographers turned to urban and industrial subject matter. Painters responded to photography and photographers to painting. Charles Sheeler worked in both media. Independence for photography was an unrealistic ideal. The painters and photographers lived in the same world, faced the same task of making pictures, and responded to that task in similar ways. But the myth of photography as an independent and therefore fully modern art was a sustaining one that lasted through most of this century.

After 1912 Sadakichi Hartmann stopped writing for *Camera Work*. He began to spend more time working for the popular press, writing about commercial portraitists and salon photographers. Some of these articles are of interest, but they make no substantial contribution to photographic criticism. In his later years, Hartmann drifted away from photography completely, but he had left behind some of the best writing on Pictorialism as well as the foundations of the theory of straight photography on which others were to build a new, dominant critical theory.

CHAPTER 2
STRAIGHT PHOTOGRAPHY

In the eyes of the proponents of straight photography, Pictorialism was anathema. Pictorialism denied and distorted the true nature of photography, shamelessly imitated painting, and exuded a sticky mist of moody subjectivity. Straight photography was clear, objective, autonomous, and unabashedly founded on scientific processes. At the same time, straight photography was still high art.

As art, straight photography actually had far more in common with Pictorialism than the straight photographers were willing to admit. Even though the straight photographers divorced themselves from the intense subjectivity of Pictorialism, they were still interested in personal expression and in making photographs that rose above the quotidian to embody something variously described in terms of intensity, perceptiveness, or spirituality. Straight photography and Pictorialism also shared a common enemy in commercial photography. By 1950 photography in the United States was dominated by a mass commercial press, and the majority of serious photographers were working for it as journalists or advertisers rather than making their own art for exhibition. Straight photographers, however, in the manner of the Pictorialists before them, strove to separate themselves from commercial motives. They treated their individual prints as precious objects, hung them in galleries or disseminated their images through high-quality book reproductions, and in general, directed their art toward a tiny, appreciative audience, rather than the mass public.

The straight aesthetic represented an effort to define the unique and essential characteristics of photography and to assert the medium's autonomy so as to align it with the central tenets of modernism. The straight aesthetic was also an effort to create a synthesized scientific and aesthetic worldview. Straight photographers embraced their medium as objective and analytical in keeping with the values of science. For some, like Sadakichi Hartmann, straight photography was a means to come to terms with the modern, urban, and technological environment. For others it was a way

to know nature. But both groups tended to conceive of their art as rising from its base in science and technology to transcend the material world and attain a realm of universal spirit. The Pictorialists had also pursued spirituality, but had done so through idiosyncratic, inner visions; the straight photographers pursued spirit through investigations of the outer world. Those who faced the modern scene believed they were using photography to infuse with the spirit of humanity what was otherwise hostile and inanimate materiality. The others sought the essential spirituality of nature.

Seen in a sympathetic light, straight photography is virtuosic in its craft and stirring in its insights into the modern condition or the religious power of natural beauty. Seen in a critical light, the straight aesthetic is seriously flawed. First, there is no logical reason why the straight technique should be accepted as an expression of the true essence of photography. The technique varied over time; it varied from one artist to another; and in general, the boundaries between what was considered pure photography and what was considered manipulation were always amorphous and arbitrary. Why, for example, was it acceptable to burn-in an area of a print with light and a cardboard mask but not with a brush and developer?

To be sure, not all straight photographers were totally blind to the inherent contradictions of their technical canon. Edward Weston, probably the least dogmatic of the major straight photographers, recognized the arbitrariness of the straight technique while still defending it when he wrote, "Can anyone be worse than a puritanical Purist! . . . I just think— *today*—that there is nothing so beautiful as a sharp, long scale, glossy photograph. But tomorrow?"[1] But Weston's honest expression of taste was not typical of straight photographers. As a whole, the movement projected a stiff-necked even self-righteous certainty.

A second problem with the straight aesthetic is that it ran afoul of the same contradiction between the seeming objectivity of photography and the necessary subjectivity of art that had plagued the Pictorialists. The Pictorialists had wished to overcome the objectivity of photography to make art. Straight photographers embraced the objectivity of photography, but they still wanted to make expressive art. The more forcefully they made claims for objectivity, the more difficulty they had reconciling their photography with expressiveness, and the more they stumbled over the deep paradox in photography between the objective trace and the subjective transformation.

A third problem with the straight photographic aesthetic has to do with the claims of straight photographers to transcendent and universal visions, visions that escape the specific time and place in which the artist works to

achieve a special insight into a universal realm. The theme of the transcendental artistic vision is part of photography's modernist heritage. The idea has a long history in modernism, having entered the literature through such avenues as Clive Bell's concept of the aesthetic emotion that he describes as lifting one above the stream of life.[2] The most concerted attacks on the modernist impulse toward transcendence have arisen in recent decades from the Marxist-inspired desire of postmodernists to locate art in the web of social relationships. One of the postmodern criticisms of artists who aspire to transcendence is that they ignore the social contexts in which they live and work. As Walter Benjamin put it in a passage that is seminal for the postmodernist position, art photography "raises every tin can into the realm of the All but cannot grasp any of the human connections that it enters into."[3] His point is that if one ignores social and political reality, one implicitly perpetuates the status quo and all the exploitative relationships therein. Translating this position into the history of American photography, one might say that in the 1930s Weston photographed landscapes and vegetables and did nothing to address the trauma of the Depression, unlike Dorothea Lange who used photography in an effort to better the conditions of migrant farm laborers.

Another postmodernist objection to the pursuit of transcendence is that while an artist's images may be infused with universal, spiritual meaning, the material work of art is bought and sold as a commodity. A number of questions arise from this observation: Is it the function of a work of art to bear an exalted message or to be traded as a precious object? Can a work of art legitimately be both a precious commodity and the vessel of transcendence and universality, or is the message of universality automatically undermined by an affixed price and ownership? If a precious artwork can carry a cargo of transcendent meaning, who is entitled to it? Only the wealthy who can afford it? If transcendent art is made available to everyone, is this only a distraction from social inequalities, a sedative that keeps the oppressed from political action? Is transcendence a wrongheaded and destructive goal for art?

Before attempting to answer these questions, one might consider that any claim to a transcendent and universal artistic vision is also open to the postmodernist criticism that such a vision is simply not possible because artistic visions are the products of specific people who are shaped by the specific time and culture (or subculture) in which they live. Postmodernists accept that in any culture some shared aesthetic assumptions may appear universal, but they point out that from a sufficient distance, these assumptions are invariably revealed as local.

The shortcomings of straight photography are easily seen from the perspective of the present, but in the early decades of the twentieth century it was an attractive alternative to Pictorialism. Unfortunately, as Pictorialism declined, so did the institutional supports for the entire photographic art community in the United States, leaving straight photographers in a precarious position. The Pictorialist movement had become enervated by 1907 and Stieglitz, who had given the movement energy and shape, lost interest in it. From that time on, he increasingly turned his attention to modern painting and sculpture, giving photography only a small place in *Camera Work* and at his gallery, "291."

Stieglitz did give straight photography a boost as it emerged in the 1910s in his own work and in that of Strand and Sheeler. His own exhibit at "291" in 1913 was intended to define straight photography in relation to the modern painting then on exhibit in the Armory show. In 1916 he exhibited Strand's straight photographs and devoted two issues of *Camera Work* to them. Stieglitz said of Strand that he was the first original photographer since the demise of Pictorialism, and he described Strand's photographs as "pure" and "direct . . . rooted in the best traditions of photography."[4] Stieglitz also planned to publish Sheeler's photographs in *Camera Work,* but the second Strand issue proved to be that periodical's last.[5] Ultimately, Stieglitz was not able to give straight photography the stable institutional support he had given Pictorialism. In 1917, financially shaky, feeling isolated by the dispersion of his allies to their own projects and to the war, exhausted and discouraged by his uphill struggle against American philistinism, Stieglitz closed "291" and discontinued *Camera Work.* He thus deprived photography of what had been its most important critical and theoretical forums.

After 1917 the best photographic criticism was no longer found in the photographic press. Without a centralized core of support for art photography, this press was left to the interests of the industry and its professional and amateur clients. There were a few short-lived avant-garde cultural magazines, run by people close to Stieglitz, that paid attention to photography. *Seven Arts* appeared from 1916 to 1917, and *MSS* lasted for six issues in 1922–23. There was also sporadic serious discussion of photography in magazines that dealt with American culture in general, such as *The New Republic, The Nation,* and *The Dial,* but these publications were by no means committed to photography and not about to support full-time critics. Aside from Paul Strand, who published criticism of photography wherever he could, the people who wrote about photography in the major cultural journals were primarily interested in other aspects of art and culture.

Paul Strand

Strand was the most insistent defender of straight photography in the 1910s and early 1920s, setting a trend, which lasted into the sixties, in which photographers themselves wrote much of the important theory and criticism of their medium. Strand harped on the misguidedness of Pictorialism and insisted that the straight approach truly represents the essential nature of the medium.[6] In "Photography," he made his strongest positive statement of the straight doctrine, pointing to objectivity as the unique quality and essence of photography: "Photography, which is the first and only important contribution thus far, of science to the arts, finds its *raison d'être,* like all media, in a complete uniqueness of means. This is an absolute unqualified objectivity. Unlike the other arts which are really antiphotographic, this objectivity is the very essence of photography, its contribution and at the same time its limitation." Strand went on to explain how this essential objectivity is best manifested: "This means a real respect for the thing in front of [the camera], expressed in terms of chiaroscuro (color and photography having nothing in common) through a range of almost infinite tonal values which lie beyond the skill of human hand. The fullest realization of this is accomplished without tricks of process or manipulation, through the use of straight photographic methods."[7]

Despite his claims for the objectivity of photography and his demand that the photographer respect the thing in front of the camera, Strand still thought of serious photography as expression, as something guided by intuitive knowledge, and as a force that might ameliorate the materialism of science. He was faced, therefore, with the perennial problem of photographic theory, namely, the reconciliation of objectivity and expressiveness. He attempted to solve the problem by suggesting that straight photographers manifest expression in their objective photographs through formal structure, "either by movement of the camera in relation to the objects themselves or through their actual arrangement." This is what Strand referred to as the organization of objectivity, a process into which "the photographer's point of view toward Life enters . . . and where a formal conception born of the emotions, the intellect, or of both, is as inevitably necessary for him, before an exposure is made, as for the painter, before he puts brush to canvas."[8] The organization of objectivity is an expressive process, but as such, it utterly compromises the "absolute unqualified objectivity" that Strand says is the essence of photography. Without realizing it, Strand had run head first into the paradox of trace and transformation.

It would be a mistake to dwell too long on the logical conundrum of

Strand's argument because his photographic theory was ultimately more polemical than systematic. Objectivity was a good catchword in his fight with Pictorialism. Strand thought that the Pictorialists, in their pursuit of art, had lost sight of both photography and the exterior world. He thought they distorted the photographic process and were unable to see the world directly and simply. Objectivity was a good antithesis to Pictorialism and, relative to Pictorialism, straight photography appeared objective.

Besides being a battle cry in Strand's assault on Pictorialism, objectivity was also important as an expression of his desire to associate photography with modernity. To use photography to see the world objectively was to see the world independently from painting; to see photography as an objective medium was to see it as a product of science. If photography could be embraced as a product of science, Strand believed, it could play an important role in modern society by humanizing technology. In a manner similar to Caffin and Hartmann, Strand thought that technology had become a heartless and destructive god.[9] Only by "establishing spiritual control" over the machine could technology be tamed—made "an instrument of intuitive knowledge"—the hostility between the aesthetic and scientific worldviews eased, and the two realms synthesized. Photography, Strand thought, was the perfect instrument for effecting this synthesis.

Strand's vision of the synthesis of art and science, as he expressed it in his essays of the late teens and early twenties, was more a spiritual vision than a social one. Strand did have a social conscience (which had been stirred early on by one of his mentors, Lewis Hine), and he eventually became a Marxist. His film work of the thirties most clearly manifests his political ideas, and even some of his later photography was meant to hold up certain third world countries, such as Ghana and Egypt, as models of socialist societies that had achieved a humane mixture of industrialization and traditional culture.[10] But in the earlier essays in which he defined straight photography, Strand was less interested in the political and economic structure of society than in the celebration of vitality. "Photography," said Strand, "is only a new road from a different direction but moving toward the common goal, which is Life."[11]

Strand's concept of life was similar to that of the vitalist movement, which held that life cannot be understood in terms of chemistry and physics, in terms of the analysis of the forms and relationships of the inanimate materials of the body, but rather that it is the property of an autonomous, nonspatial, mindlike entity—an entelechy—that animates the body.[12] In a similar way, Strand conceived of works of art as having a life

that is mysterious, glorious, and beyond formal analysis. Creating such aesthetic life was the purpose of art for Strand. It was, in a sense, a process of transferring his own life to a work of art. "And if you can find out something about the laws of your own growth and vision as well as those of photography you may be able to relate the two, create an object which has a life of its own, which transcends craftsmanship."[13]

The Pictorialists, with their eyes on the formulas of painting and other pictorial photographs, produced only dead things. The only way to living art was to proceed on one's own: "If you let other people's vision get between the world and your own, you will achieve that extremely common and worthless thing, a pictorial photograph. But if you keep this vision clear you may make something which is at least a photograph, which has a life of its own, as a tree or a matchbox, if you see it, has a life of its own. An organism which refuses to let you think about art, pictorialism, or even photography, it simply is."[14]

Another of Strand's concerns in his early essays was cultural nationalism. He shared the common American anxiety about artistic dependence on Europe and wanted independence and international respect for American art. He believed that American photographers had achieved that independence. In their capacity to face the modern world directly, they had created a living body of photography that was worthy of the international stage. American photography, said Strand, has expressed America "in terms of America without the outside influence of Paris art schools or their dilute offspring here." American photography had grown from direct experience, and represented empirical solutions to new problems confronted head-on: "Everything [the photographers] wanted to say had to be worked out by their own experiments: it was born of actual living. In the same way the creators of our skyscrapers had to face the similar circumstance of no precedent, and it was through that very necessity of evolving a new form, both in architecture and photography that the resulting expression was vitalized." Along with David Octavius Hill, said Strand, the American photographers of the Stieglitz circle "will be the masters no less for Europe than for America because by an intense interest in the life of which they were really a part, they reached through a national, to a universal expression."[15]

Although Strand said a good deal about the aims of photographic art, he said very little about critical method. In one essay, he expressed annoyance with any criticism that employed broad statements of acclaim or denunciation, and he suggested that a more objective critical method would involve the examination of a work of art in relation to "social and psycho-

logical factors."[16] He lamented the fact that no such photographic criticism was being written, but went no further in the development of his idea.

Strand's critics in the twenties certainly did not probe into the social and psychological context of Strand's photography. For the most part they were caught up with the usual question of how a straight photograph could also be an expressive work of art.

Harold Clurman approached this problem head-on. He emphasized, on the one hand, the unsentimental, stubborn self-containedness of Strand's subjects: "They are they: forever and ever immutable, solitary, inexorable and magnificent. Our part is but to contemplate them."[17] On the other hand, Strand's presence was detectable in his pictures. Somehow, through "a sort of sensuous sympathy" Strand had "become one" with his material.

Notwithstanding the apparent unity of Strand and his material, Clurman's prevailing impression was that Strand saw nature as "so indomitably beyond man that he can never hope to master it or even fully to enter into it." To Clurman's sensibility, this "clear-eyed and aware" vision was chillingly lonely, but stoic, "hopeless without despair."[18] Here, perhaps, Clurman was sensing the quality of alienation in straight photography, the barrier between the photographer and the world, and he was seeing in it something that might later have been described as existential heroism.

Lola Ridge expanded on Clurman's idea that Strand had become one with his material, claiming for him a mystical vision that transcended personality and achieved an awareness of the unity of creation. Ridge confessed, "Technically, I know little of the art of photography and can hazard no opinion as to how Paul Strand achieves his effects." But she was sure that Strand had "apprehended and made manifest the fierce rhythms of this earth."[19]

Another critic, Elizabeth Luther Carey, had much less to say about the meaning of Strand's vision than Clurman or Ridge, but she recognized the constructed nature of Strand's style more clearly than they. Carey avoided the problem of trying to reconcile objectivity and expression and simply treated Strand's photographs as art. Furthermore, she understood perfectly well how Strand had made them art. Through selection, by paying careful attention to the camera position and to what he allowed into the frame, Strand had constructed unified and simple images. "By the study of form and composition," Carey said, "Mr. Strand produces a work of art in the manner of artists."[20] She even saw some relation between Strand's handling of textural contrasts and Cubist collage. Here was a critic who had not accepted the claims for straight photography's objectivity and its independence from painting.

Alfred Stieglitz

For Alfred Stieglitz, objectivity was much less a central issue in straight photography than it was for Strand. Stieglitz did adopt a semiscientific stance with regard to the rigor of his photographic technique, and once he began to practice straight photography, he became passionate about "straight, sharp, untouched—very sharp" negatives and prints. He also had a superficially scientific attitude toward measuring viewers' responses to pictures. He often spoke of his galleries as laboratories for artistic ideas. When gallery visitors saw the same things the artist had seen in the modern paintings on the walls, or when several people from different walks of life saw similar things in his own photographs, this was scientific proof to him that art was a clear language that people were learning to read in the same way as written language.[21]

At the same time, however, Stieglitz maintained that what artists were attempting to say in their work was ungraspable and beyond definition. He responded deeply to the ideas of Henri Bergson and Wassily Kandinsky.[22] Central to Bergson's philosophy is a distinction between the ways we experience the world through the intellect and the intuition. The intellect, he said, evolved for purposes of action, and this has made it analytical; it divides the world into discrete and static parts for analysis. The intuition, by contrast, is concerned only with pure knowledge. It experiences the world directly as it really is, in constant flux. In general, the intuition allows us direct knowledge of the world, whereas the intellect stands outside what it analyzes and produces symbolic knowledge once removed from the thing it knows. Bergson says that intuition is an act "by which one is transported into the interior of an object in order to coincide with what there is unique and consequently inexpressible about it."[23]

Kandinsky wrote of the capacity of the formal properties of art to bypass the intellect and affect the soul directly. As he put it in *On the Spiritual in Art,* a book from which Stieglitz printed excerpts in *Camera Work,* "Color is the keyboard, the eyes are the hammers, the soul is the piano with many strings. The artist is the hand that plays, touching one key or another purposively, to cause vibrations in the soul."[24]

For Stieglitz, Bergson's and Kandinsky's ideas meant that the visible aspects of the material world are linked to a deeper and truer reality that can only be felt. He believed that he could use photographs and their formal properties as conduits between the material world and his experience of this intuited level of reality. He explained to a viewer of one of his photographs, "what you see—is not an apple tree nor raindrops nor a barn. It is shapes in relationship, the imagination playing within the surface.

Perhaps the raindrops are tears. And perhaps that dark entrance that seems to you mysterious is the womb."[25] It was the associative power of formal relationships in his photographs that led Stieglitz to call them "equivalents of my most profound life experience, my basic philosophy of life."[26] It was Stieglitz's hope that as an artist he could convey his own most profound experience to others. Of even greater importance was his hope that in doing so he could touch a level of absolute experience. When apprehended by others, this experience of the absolute would free them from their emotional repression. Ultimately, it was Stieglitz's aim to cure the spiritual ills of America. Americans, he thought, were afraid of their own feelings, and through art, he wanted to teach them not to be.

Those critics who were sympathetic to Stieglitz interpreted his work as he wished it to be interpreted. They faced the same problem Harold Clurman faced in dealing with Strand's photographs, but with a reverse emphasis: Clurman claimed that Strand's photographs were unrelentingly objective and yet somehow expressive; Stieglitz and his critics claimed that his photographs were deeply subjective, and yet straight, sharp, and objective. If Strand photographed a machine as a machine and a plant as a plant, and somehow infused the images with his personality, then Stieglitz photographed a cloud as his inner being although the picture is still an unmanipulated depiction of water vapor and sunlight.

Much of the early criticism of Stieglitz's work was written in response to a major exhibit of 145 pictures held in 1921 at the Anderson Galleries in New York. Strand, Herbert Seligmann, and Paul Rosenfeld, all friends of Stieglitz, wrote similar laudatory reviews.[27] Rosenfeld's is perhaps the most interesting. It should be noted that Rosenfeld was twenty-six years younger than Stieglitz and was his admiring protégé more than his friend.[28] His review, then, may be seen as essentially Stieglitz's review of himself, with Rosenfeld as a willing mouthpiece.

To begin with, Rosenfeld made the usual attack on Pictorialist imitation of painting and claimed that Stieglitz dealt more objectively with the objects before the camera in the here and now. Nevertheless, Rosenfeld claimed that Stieglitz's pictures of specific instants are powerful symbols. His prose soars as he speaks of the vitality, individuality, and universality of Stieglitz's vision: "Before Stieglitz's work we are made to think perforce of the writing of a needle sensitive to the spiritual gravity of a man, to the temperature of his passion, the pressure of his blood, as the seismograph is sensitive to the minute vibrations of the crust of the earth." His work testifies that he "has always been willing to live every moment as though it were the last of his life." His portraits of O'Keeffe are of "every

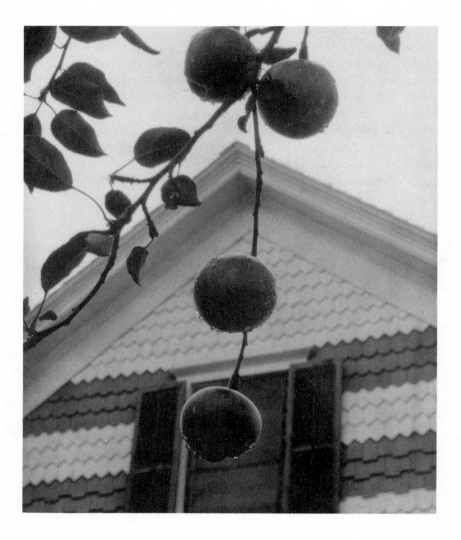

Alfred Stieglitz, Apples and Gable, Lake George, c. *1922. Courtesy of the National Gallery of Art, Washington, D.C., Alfred Stiegliz Collection. Copyright © 1994 by the Board of Trustees, National Gallery of Art, Washington, D.C.*

Chapter 2

woman speaking to every man," they reveal "something of what human life always is."[29]

In a later essay, Rosenfeld attempted to explain more explicitly how Stieglitz's instantaneous images could be universal symbols. With references to Schopenhauer, Goethe, Beethoven, Santayana, and Bergson, Rosenfeld wrote of the power of intuition in the man of genius and how such a man uses his intuition in a selfless way to penetrate "the inward realm of life itself, the region of the truth." There the intuition "finds something that is both distinct and universal, momentary and eternal, of the many and the one."[30] The genius then communicates this something to the world through art.

Rosenfeld thought, as did Strand, that photographic art had the therapeutic potential to humanize technology, particularly in America where society had been enslaved by machinery, the body had been sacrificed to business, and the soul had been set aimlessly adrift. Despite these dire circumstances, America was still the land of possibility; it was the cultural frontier, and therefore, the place both to struggle with and come to terms with modern materialism. Stieglitz was the savior. By embracing the camera "to make it a part of his living, changing, growing body," he liberated the medium, and in liberating the medium, he not only liberated himself but also "provided a perennial means by which all others of his time, who so desired, can help free themselves for the life of the spirit, the life of art." Rosenfeld did not see Stieglitz as immersed in or in any way shaped by the materialistic culture against which he struggled. On the contrary, Stieglitz was the special heroic individual able to set himself "free from the restless flux of mediocrity and chaos," and to show the way of escape to others.[31]

The special irony in casting Stieglitz as the universal genius leading America out of the wilderness of materialism is that he was very much a product of American business and materialistic values. His father had been a successful importer of woolens, and it was precisely because of his father's business success and his generosity toward his son that Alfred was able to forgo a life in business for a life of art and the spirit.

If Rosenfeld's claims for Stieglitz's genius seem excessive and even desperate, one should remember that the American art world in the 1920s was constantly on the defensive. The vitality of French art engendered a sense of inferiority in Americans even as it inspired them. And outside the tiny perimeter of the New York art world, American art faced indifference and hostility. In 1923, for example, a librarian in New Bedford, Massachusetts, removed *The Dial* from all the public libraries, because he thought the modern art reproduced there would have an evil influence on

the young. Such actions produced a siege mentality in the art world succinctly expressed by Henry McBride when he said, "But there are so many of them and they represent such a stolid, immovable front against the things of the spirit."[32] No wonder Rosenfeld wanted to see a culture hero in Alfred Stieglitz.

Like Rosenfeld's essay, much of the writing about Stieglitz in the twenties served the purpose of legend making. By 1927 the process of canonization had gone so far that Waldo Frank could nominate Stieglitz for a place in the great pantheon of the Western world: "Such a photographer as Stieglitz has never been. If you say Shakespeare is the greatest dramatist who ever lived, someone may dispute you by mentioning Aeschylus or Sophocles or even the French Racine. But if you say Alfred Stieglitz is the greatest photographer who ever lived, you're on sure ground."[33]

Not everyone, however, was willing to mention Stieglitz and Shakespeare in the same breath. Thomas Craven, a conservative critic, granted that Stieglitz was probably the most accomplished photographer in the world, but he meant it as no compliment. Stieglitz, said Craven, shared the "delusions of the laborious old botanical copyists" in claiming that his pictures carry "emotional freightage identical with that of creative art." Craven thought Stieglitz's claim to symbolism in his equivalents was merely a cover for his realization of his own shortcomings. Photography in Craven's view was an entirely mechanical and objective process capable only of recording the inherent aesthetic qualities of objects in the world. But there was nothing special about this process for Craven. "As emotional creation," he wrote, photography "is comparable to the activity of a sentimentalist before a beautiful sunset."[34]

Henry McBride was also critical of Stieglitz but in a gentler manner than Craven. He recognized the Stieglitz aura for what it was. If Stieglitz exhibited old shoes, he quipped, followers would declare them wonderful, and new shoe sales would suffer. Clearly McBride was attuned to the extra-aesthetic forces in the New York art market. He also chided Stieglitz for his democratic pretensions and his aristocratic character. Noting Stieglitz's statement in an exhibition catalogue to the effect that he intended to make many reproductions of his prints so as to sell them at the same price as a daily newspaper, McBride expressed serious doubt that Stieglitz would ever actually do such a thing, especially since he was just then offering a print at five thousand dollars for which he had destroyed the negative.[35] Stieglitz the straight photographer confronted the same conflicts encountered in Pictorialism between the democratic qualities of photography and the elitist concept of art.

Edward Weston, Ansel Adams, and Beaumont Newhall

In the 1930s Edward Weston and Ansel Adams began to draw critical attention to straight photography on the West Coast. Weston received the more interesting criticism—much of it written by friends and published in obscure places—while Adams proved to be the more forceful theorist.

Weston first received significant critical attention for his series of close-ups of shells, vegetables, and nudes that he began when he returned to the United States from Mexico in 1926. These photographs convinced his critics that Weston was very much a realist, that he used straight photography to show the world as it is, but that he also intensified and heightened reality to reveal something essential in it. His critics spoke of a sense of "elemental necessity" in his work or of the "foundation shapes and structures" of nature. Weston himself said it was his aim to "record the quintessence of the object or element" before his lens.[36]

This critical discussion paralleled one then taking place in Germany among critics of *Neue Sachlichkeit* photography. The Germans' concern for essential natural form descended from Goethe and his Platonic concept of *Urformen*. Goethe posited the existence of primal natural forms that are manifest in natural objects in a myriad of variations, but that, in their essential state, are the stable building blocks of all natural form. According to Goethe, to perceive these primal forms is to discover the secret principles by which nature functions.

Weston's critics frequently described what they saw in his work as "significant form," but they used the term in a very different manner from Clive Bell, with whom it originated.[37] Bell described significant form as a quality of art that provokes a purely aesthetic experience in the viewer, that has *only* to do with form and *nothing* to do with representation of the objective world. The experience can be produced by representational art, but representation, as such, is always irrelevant to it. Weston's critics did not think of significant form as having to do with form in and of itself; rather they used the term to refer to a heightened sense of realism brought about by the sharpness, the sense of hardness, the clarity of detail and texture in Weston's images. It is the unexpected intensity, the shock of seeing something new, sensuous, and monumental in so common an object as a vegetable that Weston's critics must have been referring to when they spoke of significant form.

For all their sense of reality and the apparent purity of perception, Weston's photographs often tempted his critics into free association. They saw his vegetables and shells as suggestive of human shapes or other works of art. Frances McMullen saw torsos in green peppers or even "a modernist conception of a man's struggle to evolve from lower forms."[38] Arthur Millier

Edward Weston, Shells, *1927. Courtesy of the Center for Creative
Photography, Tucson, Arizona. Copyright © 1981 by the Center for
Creative Photography, Arizona Board of Regents.*

saw suggestions of Brancusi in Weston's nudes. The critics were ambiva-
lent about such associations. McMullen let her fancy loose temporarily but
soon reined it in with the admonition that "Weston is a stern realist." Unlike
Paul Rosenfeld, who was happy to see "primitive sculpture" in Stieglitz's
renditions of breasts and arms, or Lewis Mumford, who saw "the complete
range of expression between man and woman" in Stieglitz's cloud pictures,
Weston's critics were generally cautious about associations aroused by his
images.[39]

Weston encouraged this cautiousness. On one occasion, when some of
his friends saw sex acts in his photographs of shells, he vehemently denied
any intent to make such references:

Why were all these persons so profoundly affected on the physi-
cal side? For I can say with absolute honesty that not once while

working with the shells did I have any physical reaction to them: nor did I try to record erotic symbolism. I am not sick and I was never so free from sexual suppression—which if I had, might easily enter into my work. . . . No! I had no physical thoughts—never have. I worked with clearer vision of sheer aesthetic form.[40]

Why did Weston resist metaphorical interpretations of his work so adamantly? In theory, he thought of life as a unity. "Life is a coherent whole," he wrote, "rocks, clouds, trees, shells, torsos, smokestacks, peppers are interrelated, interdependent parts of the whole. Rhythms from one, become symbols of all." This passage seems to invite a metaphorical reading of his imagery and a great mingling of all the aspects of life and art. But in reality, Weston compartmentalized his life, especially his sex life and his art. In his *Daybooks* he wrote of how his only thought in making a study of a nude woman was the exquisite form, and he expressed disgust at those who "will only see an ass!" And yet he did not hesitate to have sex with the same woman on a day "not meant for work."[41] Fay, the model, was good for either art or sex but not both at once. Art had to be pure and rise above sex.

This segregation of art and sex has been the norm in American culture. So, despite his friends' perceptions of sexual references in his work, Weston probably feared, rightly, that to admit to such implications publicly was to risk misunderstanding and disapproval. It was the same fear that undoubtedly drove Georgia O'Keeffe to deny the obvious sexual references in her paintings of flowers.[42]

There is also the possibility that for Weston a frank acceptance of metaphor would have looked like a capitulation to the impressionism and symbolism of Pictorialism and a betrayal of the "honesty" of straight photography. And Weston may have rejected associational interpretations of his work because he was uneasy with the idea of the subconscious. When Nancy Newhall suggested that his late, satirical photographs were Surrealistic (this work included such images as a nude in a gas mask or a man sticking one leg out a second-story window with a frying pan and a doll in his hands), Weston not only rejected the suggestion out-of-hand but also claimed not to understand it.[43]

Despite Weston's protestations of objectivity, Ansel Adams took him to task for the psychological quality of his work. Adams granted that Weston did not deliberately make images with psychological overtones, but he said that Weston might have done so unconsciously. Seizing on Weston's own statement that his aim was "to photograph a rock, have it look like a rock, but be *more* than a rock,"[44] Adams accused him of super-

imposing "secondary implications of form on the basic structure" of subject matter. This was a violation of proper photographic vision. Weston was guilty of making "his objects *more* than they really are in the severe photographic sense."[45] Weston squirmed under this accusation, explaining that to make something look like more than itself is not to make it look different from itself. The point, he said, is simply to intensify form and texture.[46]

Weston was frustrated by the effort to explain himself to the world and particularly to Adams whom he respected and whose disapproval stung him. Above all, he wanted to make his art and not worry about theoretical issues. He told Adams, "But, after all, Ansel, I never try to limit myself by theories; I do not question right or wrong approach when I am interested or amazed—impelled to work. I do not fear logic, I dare to be irrational, or really never consider whether I am or not."[47]

Adams and Weston were good friends. In the thirties they were both members of Group *f*/64, the celebrated if ephemeral association of West Coast photographers committed to the straight aesthetic. In 1945 Adams wrote to Weston that he was "one of the greatest artists of our time" and "top man in photography."[48] But the friendship did not prevent Adams from articulating a sharp difference between his and Weston's approach to nature. In a 1955 interview he said, "Weston's nature poses for him. He approaches almost every object in an abstract sense, and makes it pose according to a preconceived concept of form. I work on quite a different basis; I have a great belief in what happens out there. I would like to see it develop its own form."[49] Adams implies that his vision was more objective than Weston's, that Weston's self was too involved in his vision. In truth, both artists were attempting to say similar things. As Adams himself wrote to Nancy Newhall in 1948, "the note I have been trying to sound is somewhat expressed in the Beethoven song, 'The Adoration of God in Nature.'"[50] If Adams thought of himself as more objective than Weston, it was because he thought he saw the exalting, universal spirit in nature more clearly.

Adams did not talk openly of his nature mysticism in his early writing. His public pronouncements about photography sound as obsessed with objectivity as Strand's. In 1934 he wrote, "Photography is an *objective* expression; a record of actuality. The photographer who thoroughly comprehends his medium visualizes his subject as a thing-in-itself."[51] Expression in photography is not interpretation but "emotional amplification" achieved through point of view, organization, and most important, tonal relationships and texture.[52] Adams was essentially repeating in different words Strand's idea about organizing objectivity, and his effort to

reconcile objectivity and expression is no more logical than Strand's. Ironically, Adams's emphasis on tonal control as a source of expression in photography is reminiscent of the idea of effect, which was central to Pictorialism and which Adams utterly rejected.

Beaumont Newhall (who was soon to become a close friend of Adams and a great supporter of straight photography) reviewed Adams's first book, *Making a Photograph*. At the time, Newhall thought the aesthetic potential of photography lay in its capacity to reveal what the unaided eye cannot see or fails to notice. The photographer might probe the visual world either by rendering a subject with a maximum of detail or by using a fast shutter speed to arrest movement. Adams had said, similarly, that photography is best characterized by its capacity to define sharp detail, and although this was consistent with Newhall's concept of the revelatory nature of photography, Newhall took issue with the statement in his review because he found it too limiting. Adams failed to account for the capacity of photography to stop motion. In fact, Newhall said, Adams's own photography had a static quality that was "not necessarily a criterion of pure photography." Furthermore, said Newhall, in Adams's "mania for definition," he insisted that all the planes in a photograph be rendered sharply. This Newhall could not accept. He saw no rationale for excluding shallow depth of field from the tenets of straight photography; a shallow depth of field is as conditioned by the laws of optics as a deep one.[53] Despite Newhall's sound reasoning, it was Adams's position that eventually prevailed in the canon of straight technique.

Newhall's disagreement with Adams in no way dampened his enthusiasm for straight photography. He once characterized his ground-breaking exhibition of 1937 at the Museum of Modern Art as a crusade for pure photography, prompted by his admiration for the work of Stieglitz, Adams, and Weston.[54] The catalogue for this exhibition—later editions of which became *The History of Photography*—is a historical survey, but it can also be read as a justification of contemporary straight photography.

Perhaps the most important thing Newhall did for straight photography in his catalogue was to establish an aesthetic of detail. Photography had always had two technical traditions, Newhall pointed out, one based on detail and the other on tone. The origin of the former is the daguerreotype, whereas the calotype is the root of the latter. The Pictorialists, of course, had rejected the tradition of detail and established art photography only in terms of an aesthetics of tone. Newhall accepted the aesthetics of tone but insisted that there was an equally valid aesthetic of detail. When we look at nature, he argued, we must constantly refocus our eyes to see details at dif-

ferent depths, but the camera is able to resolve an infinity of sharp detail on a single plane. This gives us the pleasure of scanning a natural scene effortlessly. And, if the photograph is well conceived, this immediate access to detail may also produce an insight into the essence of the natural world.[55] For Newhall, this revelation of nature was what straight photography was all about; this was its unique contribution to the world of imagery.

Straight photography was not the only form of contemporary art photography that Newhall accepted. Although he thought Pictorialism was no longer valid, he did not think that the entire technical tradition of tonality was discredited. This tradition had been carried into the present by photographers who used small-format cameras and enlarged their negatives. Newhall considered such photography to be based on tonality rather than detail because one cannot produce nearly the degree of detail in an enlargement of a small negative as one can from a large-format negative such as the straight photographers used. But the real value of small-camera photography lay in the mobility of the camera and its unique capacity to freeze movement.[56] Straight photographers, with their big, cumbersome cameras, were limited to static subjects, but small-camera photographers could probe the world of fast action. Newhall saw both straight photography and small-camera photography as equally vital traditions of photographic art, each of them based firmly in the essential and unique nature of the medium.

But these were the only two traditions Newhall fully accepted. In true modernist fashion he thought that photographic aesthetics should arise only from pure photographic technique, and that the techniques, aesthetics, and even terminology of any other medium should be diligently excluded from photography. He even considered it absurd to refer to photographs as prints because this evoked the language of traditional printmaking. In accordance with his theory he made it a point in his catalogue to attack the traditions of Pictorialism and European formalism for being unphotographic. Interestingly, he did not accuse these movements of using illegitimate techniques. He conceded that the soft-focus lenses and gum bichromate prints of the Photo-Secessionists and the negative prints, and photograms of Laszlo Moholy-Nagy and Man Ray, leaders of European formalism, were legitimate. He rejected these movements because they adopted painterly aesthetics.[57] Apparently, for Newhall, legitimate technique was the only source of proper aesthetics but not necessarily the source of such aesthetics, especially in the case of those techniques which deviated from the mainstream of straight photography and small camera photography. The marginally legitimate techniques were far more susceptible to the influence of painting than the mainstream ones.

Newhall's insistence on the intimate relation of photographic technique and aesthetics gave him a narrow vision of photographic history that unnecessarily severed photography from the rich web of cultural connections in which it has always existed. His motivation for taking such a view, however, was not to be tight-minded but to be solidly grounded. Newhall wanted to justify photographic art by showing that photography could contribute something to aesthetic experience that no other medium could; he wanted to give photography value by proving that it was unique. To do this, he felt he had to pare away everything from photography and its history that was not essential, not purely photographic. Having identified what he considered to be the unique qualities of photography, he was determined to keep the medium uncontaminated by outside influences because of what he—and the other theorists of straight photography—took to be the lesson of Pictorialism: borrowing from painting might win attention for photography but at the price of dependence and eventual loss of vitality.

Perhaps fear of Pictorialism should have been a dead issue in the 1930s, but it was not because there was at the time a resurgent Pictorialist movement. Led by such men as Frank R. Fraprie, F. J. Mortimer, Pirie MacDonald, and William Mortensen, latter-day Pictorialism swept the country as a conservative response to straight photography and to small-camera photography. The latter, generally referred to as candid photography, had just recently been introduced from Europe and was filling the new and rapidly growing mass publications. The Pictorialist reaction was manifested in a boom in the number of amateur photographic salons and in a renewed effort to dominate the photographic press.

Newhall, Adams, and other proponents of straight photography felt threatened by the new Pictorialism and fought back. With a sense of outraged righteousness, Nancy Newhall announced in one essay, "It is very important that we root this confusion out of our minds once and for all."[58] Adams was moved to carry on a running battle in the pages of *Camera Craft* magazine with William Mortensen, the suave and successful practitioner of a particularly theatrical Pictorialist style. The issues of their debate were predictable: Mortensen attacked straight photography as dogmatic and arbitrary purism; Adams attacked Pictorialism as a particularly tasteless distortion of true photography.[59]

Mortensen made some excellent points against the purist position. He grasped the contradiction between claims for both objectivity and expression in straight photography, making particular use of Adams's emphasis on tonal control as a source of expression:

That tone has . . . emotional qualities I do not deny: but how came such an untamed maverick as emotion to stray into the chaste pastures of the purists? Emotion is a subjective quality, and is strange, not to say dangerous, company for "pure objectivity. . . ." If tone is granted to be subject to control, why not line also, which has equal emotional significance? And if line, why not shapes and forms? And if shapes and forms, why not elision or emphasis of detail?[60]

More profoundly, Mortensen rejected the very premise of straight photography, that is, the modernist concern for purity in art:

Aside from the pedantic desire to neatly divide the field of art into airtight compartments, there is no inherent reason why one sort of art should *not* resemble another, why painting should not resemble sculpture and etching resemble painting. To cite a couple of instances, consider the sculptured aspect of Michelangelo's paintings and the painted aspect of Rembrandt's etchings. Here are two scandalous cases of impurity; yet Michelangelo is one of the greatest of painters and Rembrandt one of the greatest of etchers.[61]

Adams was frustrated with Mortensen. He hated being accused of intolerance, but he was totally convinced of the rightness of his position and felt he had logic on his side. Most galling was that he saw how utterly trite, worn, and falsely sentimental Mortensen's photography was. It infuriated him to be embroiled with such a bad artist in a theoretical discussion he could not win decisively, and he vacillated between pressing his arguments and insisting that the art should speak for itself.[62] Eventually he became so infuriated with Mortensen for remaining confident, witty, and formidable in print while producing such execrable pictures, that in a letter to Weston he wished him dead.[63]

Adams's claims in print to objectivity and purity and his immense technical mastery gave him a public persona that tended to obscure what he thought his art was really about. He was more open with his feelings in his letters to friends. To them he revealed how motivated he was, even more so than Weston, by the desire to return to nature. He wrote of the "self-deception and bunk" of the modern world in the face of the eternal openness and beauty of the mountains. The Sierras, and more generally "the serenity of the earth," were not only an escape from civilization but

William Mortensen, The Pit and the Pendulum, *1934, bromoil print. Courtesy of the Center for Creative Photography, copyright © by Deborah Irmas.*

"the only thing left to cling to."[64] In nature, Adams found physiological, psychological, and, above all, spiritual health.

Following consciously in Stieglitz's footsteps, Adams also saw art as a source of universal symbols of life and eternity. As he put it, "Sometimes I think I have a Prophet complex, because I am constantly looking for the quality of prophecy in Art. That thing which is concerned more with life and the world in both Now and in the time to come—not just the Now. I guess I get that to a certain extent from Stieglitz."[65]

One reason these attitudes did not surface in public was that Adams considered the power of art, in either its spiritual or aesthetic aspects, to be above close scrutiny. He sometimes wrote as if it were sacrilegious to attempt a verbal analysis of his photographs:

This personal expression can not be subject to analysis; what is conveyed in the print should be self-evident. The relationships of form and substance, the illusion of light, the selection of the point-of-view, the significance of the subject itself, may be discussed in mechanical or technical terms, but the unified emotional state-ment of the photograph defies analysis. If the spectator responds, the photograph "works"; if he does not, the photograph does not work—for him, at least.[66]

And in a 1959 article he said, "There is nothing more sacred than the inner self, both of the [perceiver] and that of the spectator. To verbalize an image is to blight it."[67] This essentially Crocean view of an artwork as an unanalyzable, expressive whole protected Adams from criticism, for any critical analysis was a violation of the art.

In the 1940s and early 1950s Adams received very little critical atten-tion, and, not surprisingly, the attention he did receive barely touched on the important issues in his art. Christina Page wrote two brief articles about him for *Time,* the first of which merely emphasized the superior naturalism of photography over painting.[68] In the second, Page mentioned the more interesting idea that Adams had combined objective realism with rever-ence in his renditions of Yosemite.[69]

Nancy Newhall took up this idea in her review of *My Camera in Yosemite Valley.*[70] Actually, much of Newhall's review was given over to considerations of bringing fine photography to a large public. She com-mented at length on the design of the book and the quality of the repro-ductions, and she spoke of how unusual it was for an American publisher to want to produce a book of fine photographs. Newhall mentioned only

briefly Adams's "poetic and spiritual" interpretation of Yosemite, claiming that the combination of power and delicacy in the photographs was "exactly consonant" with the character of the valley itself. Newhall was attempting yet another synthesis of the objectivity of straight photography with personal expression. She was suggesting that Adams's poetic sensitivity vibrated in perfect accord with the genuinely transcendent quality of his subject, and that it had all been captured objectively on film.

This harmony of the individual soul with the sublimity of nature may describe exactly what Adams experienced in the mountains and wished to communicate in his photographs, but his revelation of the sublime and the transcendent in the Sierras was not an ahistorical act of insight into ultimate truth as Newhall suggests it was. Adams's vision of the mountains is his creation as much as his discovery, and it is a creation made possible by culture and history. Adams's vision was shaped, in part, by a transcendent impulse in American religion and natural science according to which nature gives one direct insight into the divine. Adams was familiar with this tradition through the writing of such men as John C. Merriam and John Muir.[71] He was able to make art out of his spiritual perception of mountain scenery partly because of the precedent of late eighteenth-century Romantics who began to regard mountains as sublime wonders rather than the "Shames and Ills . . . Warts, Wens, Blisters, [and] Imposthumes" seen by previous generations of Europeans.[72] The romantic tradition of sublime mountain scenery was strong in nineteenth-century American landscape painting (in the work of Thomas Moran and Albert Bierstadt, for example), and it had a profound impact on the nineteenth-century landscape photography of Eadweard Muybridge and William Henry Jackson with which Adams was familiar. His vision of Yosemite vibrated in consonance with his culture as well as with the spirit of the mountains.

In 1963 Nancy Newhall wrote an essay for *The Eloquent Light* and finally dealt at length with the issue of transcendence in Adams's art. Here, both in her own words and with copious quotes from Adams, Newhall let forth trumpet blast upon trumpet blast about timelessness, the religious nature of art, seeing beneath the surface, the union of the internal and the external, and affirmation of life. The issue of objectivity is virtually absent from this essay. Newhall no longer represented Adams as thinking of the photograph as a record of actuality; now he saw the photograph as a transformation of the visible world, as "an entirely new and different experience which is remote from actuality in many ways."[73]

Although Adams no longer thought in terms of objectivity, his primary concern, as Newhall described it, was that he not be too subjective, that he

not be too caught up in impressions or self-revelations. His desire was to make universal statements, to come before reality with sufficient humility that his photographs would prove to be general, not personal, affirmations of life. Newhall now saw Adams's photographs as sacrificing objectivity and bypassing literal reality to touch a deeper, truer, universal reality. The ideas here are reminiscent of the mystical aesthetic theory of classical Chinese art, according to which the painter neither contradicts reality (one does not make a man larger than a tree, for example) nor adheres too closely to its specifics (hence the Chinese predilection for universal perspective rather than one-point perspective). Instead, painters grasp the inner reality of the landscape by bringing themselves and their work into harmony with *chi,* the universal cosmic spirit that infuses all things with a vital force.

True to the spirit of mysticism, Newhall and Adams were convinced that the ultimate sense of what Adams's photographs were about could not be fully expressed but only experienced. Newhall ends her essay in *The Eloquent Light* with a quote from Adams: "Expressions without doctrine, my photographs are presented here as ends in themselves, images of the endless moments of the world."[74]

Images that are meant to be ends in themselves, that are meant to evoke endless moments of the world are not meant to have a specific social and historical setting; thus they raise a question about their social value. This was a matter that deeply troubled Adams because he had a social conscience. Despite that conscience, he felt that socially directed photography was self-conscious and unaesthetic, that it sacrificed artistic power in the service of ideology. He found documentary photography, as it was practiced in the thirties, too consistently negative. Nevertheless, his uneasiness prompted him to find a social purpose in his own transcendent art. In the middle of the Depression, he wrote to Weston, "Both you and I are incapable of devoting ourselves to contemporary social significances in our work. . . . I still believe there is a real social significance in a rock—a more important significance therein than in a line of unemployed. . . . Humanity needs the purely aesthetic just as much as it needs the purely material."[75]

A few years later, he had changed his position. During World War II, Adams worked with Dorothea Lange on a documentary project for the Office of War Information, and he made a documentary book on the interned Japanese Americans at the Manzanar relocation camp. After the war, he planned a book on African Americans with Nancy Newhall.[76] But the wartime involvement with documentary photography did not last; Adams's need for nature was too strong to be interrupted for long. As he said himself, "The War can't prevent Man from returning to Nature."[77]

Even as he returned to nature, however, Adams became involved in its political status. He was a staunch conservationist and a member of the board of directors of the Sierra Club from 1934 until 1971. He lobbied the federal government for the development of Kings Canyon National Park and fought overdevelopment in Yosemite. Late in his career, he met with Presidents Johnson, Ford, Carter, and Reagan to discuss environmental issues. Adams called his involvement with the Sierra Club "one of the most important activities of my life."[78] He considered one of the greatest accomplishments of his photography the attention it drew to the issue of conservation.[79]

Ultimately Adams's political activity and his drive toward transcendence were united. Just as he saw social significance in a transcendent image of a rock, he saw his political conservation work as a way to preserve that rock as part of the natural foundation for transcendence. If the natural word is overrun, it cannot be used to seek contact with eternity.

Adams's struggle to preserve a space for transcendent experience encompasses a painful irony: his transcendent vision of the American wilderness was made possible by the very forces that threaten to destroy it. The technological civilization that made it necessary to establish parks and protect wilderness, the same civilization Adams sought to escape from and fought to limit within the parks and that threatens their existence with pollution and development, is the same civilization that placed Adams on this continent and made it possible for him to reach the wilderness and photograph it. Adams yearned for a return to nature through the very agency that is engulfing and destroying nature.

Adams sought to make a universal art based on the universal spirit of nature, but there is a serious question as to whether the spirit he felt and communicated to others can be universal. Adams's transcendent vision of the American West was born of European conquest of the continent, technology, the Christian idea of an Edenic American wilderness, romantic pantheism, and the environmental movement. Can this vision, emerging from a specific history and body of beliefs, be the same as the one felt by the Paiute Indians who gave the name *Tote-ack-ah-noo-la* (rock of the supreme one) to that famous Yosemite landmark now known as El Capitan?[80]

This question is not intended as a condemnation of Adams's art. But if the conditions of our transcendent experience are always shaped by social and historical contingencies, is it possible to have transcendent experience at all? Is that experience tainted by the history that brings us to it? Is transcendence an indulgence we cannot afford in the face of our social obli-

gations? Or is transcendence still a necessity we must strive for under any circumstances, no matter what its social foundations, if we are to remain sane? Is it possible to experience transcendence while maintaining an awareness of the conditions from which it rises?

Questions such as these are certainly not provoked by documentary photography, the preeminent force in American photography of the Depression and the war years. But with the emergence of subjectivism in the 1950s, they surface once again.

CHAPTER 3
DOCUMENTARY
PHOTOGRAPHY

Documentary photography was one manifestation of a tremendous effort to record and give shape to the American experience brought on by the depression and further impelled by the Second World War. There are significant examples of documentary photography from before the depression—notably the work of Jacob Riis and Lewis Hine from the 1880s and 1900s respectively—but not until the 1930s did currents in journalism, film, and the popular press come together with technical innovations in small cameras, flash illumination, and improved magazine printing techniques to make a definitive documentary movement possible.

The desire to document the American crises of the thirties and forties put a tremendous emphasis on the authenticity of photography and its unequaled power to capture reality. In this atmosphere, issues of individual expression, which had been paramount for the Pictorialists and straight photographers, were entirely eclipsed. The central theoretical issue in documentary photography was that of truth. But the discussion of photographic truth in the thirties and forties was very narrow. It was limited to questions of outright fakery and more often questions of what was shown and what was not, whether the public was being shown the whole truth or the partial truth.

Those directly involved in documentary photography understood not only the degree to which they selected the truth but also the degree to which they inflected it. Such inflection comes about, in part, through the unavoidable choices of camera angle, length of lens, lighting, and so on, choices every photographer makes all the time. But the documentary photographers also shaped the truth by directing human subjects and arranging inanimate subject matter. Documentarians, however, did not write about these aspects of their work until years later, so it was not something the public or the critics of documentary photography were aware of. In general, contemporary writing on documentary photography hardly questioned the assumption that photographs show an unambiguous truth.

From one point of view, the impulse toward documentation in the thirties can be understood as spontaneous and democratic. In *Documentary Expression and Thirties America,* William Stott describes that impulse as having emerged from a groundswell of public anxiety over the fate of the country. He says that the all-pervasiveness of the depression, coupled with the official ignorance and dishonesty about it in the Hoover administration and the mainstream press, led to a ubiquitous and intensely felt need among common Americans to find out for themselves what was going on in this country. As Stott says, "The Depression stimulated, even compelled, a documentary approach."[1] The fact that documentation emerged in many different media and contexts supports Stott's view. So does the photographic work of the Photo League, an organization that had indirect ties to the Communist Party but one whose members, for the most part, felt themselves to be independent and working out of humanitarian concern and political commitment.

Seen as spontaneous and democratic, documentary photography was an art movement as were Pictorialism and straight photography, although documentary photography was a movement of socially conscious art. As such, it may be related to the general rejection of modernism and the turn toward realism in American painting and literature that emerged in the twenties and continued through the thirties. This realist impulse was, in large part, an effort to free American art from European influence and to explore the special qualities of the American experience. As Alfred Kazin put it, this movement asserted that "the American was here; he belonged; he was a character in the gallery of the world's great characters even if he did nothing more than sell Ford cars and live in a clapboard house."[2] Documentary photography drew energy from this broad realist movement in the same way that Pictorialism had drawn energy from Impressionism and Symbolism, and straight photography from early modernism.

The realism of literature and painting in the thirties was universally recognized as stylistic construction and part of an aesthetic movement, but realism in photography was only recognized as a style by those who practiced it. To the public and the critics, the apparently inherent realism of the photographic medium obscured the stylistic qualities of documentary photography. It was common not to think of documentary photography as having anything to do with other art forms or with broad movements in American art, but to see it as a unique way of getting at social reality that might also be a form of art.

Documentarians were content with this situation. They did not wish to avoid the perception of their work as art, but they felt it best to avoid some

qualities commonly associated with art while embracing others. If their work was to appear to the public as art, it was to do so because of its capacity to dramatize the actual or to capture particular truths while simultaneously transcending them to reach a level of universal truth. But documentary work was not to become art on the basis of personal vision or artifice. Although documentary photography was, in fact, deeply personal and full of artifice, these qualities were considered too subjective, too manipulative (and for the more leftist documentarians, too laden with associations of privilege) to serve social truth at a time of crisis.

If there was a degree of uneasiness among documentarians regarding art, so were the artists uneasy about documentation. Ansel Adams, for example, was uncomfortable with the mixing of art and politics and often found documentary pictures too socially self-conscious and aesthetically stiff to be good photography. He also had little patience with the critical leftist vision of American culture that was predominant in documentary work. He complained that Walker Evans's *American Photographs* gave him a hernia, and he said, not altogether coherently, "I am so *goddam* mad over what people think America is from the left tier. Stinks, social and otherwise, are a poor excuse and imitation of the real beauty and power of the land and of the people inhabiting it. Evans has some beautiful things but they are lost in the shuffle of social significance."[3] In addition, Adams found most documentarians to be indifferent technicians, and this, he thought, undermined the "message of the print as a thing in itself."[4] He was not at ease with the idea that a serious photograph might be justified not as a highly crafted object, but as a social tool.

In some ways, the lines between documentary photography and art photography were completely obscure. Writers in the thirties implicitly thought that categories of photography, such as news photography or art photography, were determined by the inherent and stable qualities of photographs themselves, that they were an aspect of the appearance of pictures and independent of the way in which the pictures were used. But they also recognized that the same photograph might fit into several different categories. This was the source of a theoretical confusion that was perfectly expressed by Dorothea Lange when she wrote, "Documentary photography stands on its own merits and has validity by itself. A single photographic print may be 'news,' a 'portrait,' 'art,' or 'documentary'—any of these, all of them, or none."[5] Lange did not say what makes the same print art or news or both, nor did she explain how an object that stands on its own can have such a mercurial identity.

In actuality, documentary photographs did not stand on their own at

all. The texts that accompanied them and the conditions in which they were made and displayed worked to define documentary photographs as news and art. That all photographs are by their nature specific and that these particular ones were made and used by the government in response to the economic crisis of the thirties, gave them the currency of news. But as Maren Stange has demonstrated, they were often captioned in ways that diminished their relationship to particular, detailed, circumstances and that emphasized their general significance and broad appeal, thus giving them a universality associated with art.[6] Also, they appeared in a wide variety of contexts that sometimes signified news and other times art. Farm Security Administration (FSA) pictures appeared, among other places, in government pamphlets, in *Survey Graphic, Look, Life, Time, Fortune, Nation's Business, The New York Times, Literary Digest,* and the 1936 *U.S Camera* photographic salon, as well as in a traveling exhibit of the same year sponsored by the College Art Association.[7]

Sometimes the failure to make clear distinctions between documentation and art led to considerable tension. Dorothea Lange and Walker Evans thought of themselves as artists, although they did documentary work for Roy Stryker at the Farm Security Administration. The situation was uncomfortable for both photographers. Stryker was a government bureaucrat who had to manage a group of photographers, get them to produce a body of work that fit a specific political agenda, and justify his expenditures to his superiors. Evans, more than anyone, chafed at Stryker's demands. He refused to let Stryker know where he was as he traveled; he neglected to produce detailed captions for his pictures; and he would not or could not work at the speed Stryker expected. Evans thought Stryker's requirements violated his artistic freedom. Stryker admired Evans's work, but no doubt found him trying.[8]

Recent scholars, focusing on the tension between Evans and Stryker or Lange and Stryker, have given greater emphasis to Stryker's power than to the independence of the artists' visions. They have emphasized the Roosevelt administration's stake in the documentation of the depression and its consequent control of the FSA photographs. Maren Stange has argued that the FSA project demonstrates the application in the Roosevelt government of the principles of scientific management, developed in the burgeoning corporate world of the 1920s by Frederick Winslow Taylor and his followers.[9] Specifically, Stange sees the federal government's use of the FSA photographs as a form of mass advertising meant to engender broad support for government efforts to rehabilitate the rural poor and their land through a centralized agricultural policy. James Curtis makes a similar

interpretation. Both Stange and Curtis acknowledge the aims and accomplishments of artists such as Lange and Evans, but unlike Stott, they see the message of the FSA photographs not as that of concerned, independent artists but as that of a government propaganda campaign.[10]

Occasionally, a critic in the thirties would consider the government's role in shaping the image of the depression through the FSA photographs, but usually such a critic was in sympathy with the government and would raise the issue of propaganda only to find a way to justify it. Hartley Howe, for example, attempted to define a middle ground between propaganda and information:

> There are undoubtedly points in the FSA photographic program open to legitimate dispute. How far, for example, should a government agency go in using publicity—whether pictures or text—to further its own policies? A line must be drawn somewhere between no publicity at all—which would make those in office unable to show the public what they are doing and why—and the propaganda of a totalitarian state. It seems as if government-sponsored publicity which is accurate, and which tells about policies and problems rather than individuals and parties, is not only harmless but desirable. Certainly FSA photographs come well within this category.[11]

Unfortunately, Howe's conclusion did not lead to a penetrating analysis. Neither he nor other critics in the thirties discussed the specific aspects of the government's message, the way it was put together and presented, or the way it fit specific government policies.

In addition to the federal government, picture magazines played an enormous role in shaping documentary photography and the public experience of it. Modern picture magazines, with their photo stories and candid photographs, were invented by the Germans in the late twenties and early thirties. Henry Luce introduced the genre to America in 1936 when he began to publish *Life*. The magazine proved to be an immediate and legendary success. It not only sold out regularly for two years, but sold so much better than anticipated that its production costs outstripped its advertising revenues, and the venture actually lost money until 1939.[12] Over the next decade, picture magazines proliferated, prospered, and became a dominant American institution.

As a leader of that institution, Luce certainly did not intend to stir theoretical or critical debate about the meanings of photography. He used *Life*

to entertain, reassure, give vicarious thrills, and pull heartstrings, all in an entirely accessible and believable manner. As an advertisement in *Life* put it, the photo story "makes the truth about the world we live in infinitely *more exciting, more easily absorbed, more alive* than it has ever been made before."[13] In addition, Luce thought (before World War II, at least) that the truths photography was best suited to reveal were happy ones. In a way that words could not, photographs could counteract the "horrors of drought and dying cattle" with dramatizations of "the good, which, for present purposes, I may define as the normal and calm as distinct from that which is disruptive or fantastic."[14]

The Second World War changed Luce's approach to photojournalism. Luce was a passionate supporter of American involvement in the war from early on, and *Life* virtually became a war magazine. It served as the prime source of war imagery for many people and even, as Pauline Kael has remarked, seemed to embody the whole spirit of wartime America.[15] If it embodied that spirit, it also created it. *Life*'s involvement in war coverage became so deep and its impact on public opinion so great that it was recognized as a major "instrument for public education" by the military and often given special treatment by the censors.[16] Luce not only took what was given but exerted deliberate pressure on the Roosevelt administration regarding coverage of the war. He fought to be allowed to publish pictures of American war dead, chastising the government for waging a "happy war" in which "you don't let out any more bad news than you can help."[17]

The issue of propaganda was dealt with far more straightforwardly with regard to war imagery than it was with regard to the FSA photographs. Everyone knew and largely accepted the fact that the government kept tight control over all war information. Actually the United States was more open with its populace than any other major combatant, but censorship still remained broad.[18]

Even after the administration reversed its policy and permitted photographs of American dead to be published, anything that revealed their identities was still obscured. Pictures of Americans whose bodies were not intact, who had lost limbs or were spewing intestines, were confined to a secret file of censored documents dubbed the Chamber of Horrors. Also censored were pictures of American psychiatric casualties and GIs killed in accidents or by friendly fire. Conflicts between American and allied soldiers never reached the public nor did images of racial conflict on U.S. military bases. The decision in 1943 to release photographs of dead Americans was not motivated by a policy of truthfulness so much as a feeling that the American public would no longer accept a thoroughly sani-

tized war. Before 1943 the government reasoned that to show pictures of American dead would have a demoralizing effect on the home front. Later, conventional wisdom decreed that concentrating only on victorious images would breed overconfidence. Showing the dead at this point, it was felt, would strengthen resolve.[19] This is what most government censorship was about: the manipulation of morale on the home front to ensure a continued willingness to work and sacrifice for victory.

The image of the war in this country was created by many factions with different agendas and different attitudes toward openness. The military generally tried to preserve its habitual secrecy about everything; the African-American community (with a degree of encouragement from the Roosevelt administration) attempted to use their participation in the military and war related industry to lay the foundation for greater postwar equality; the administration tried both to demonize our enemies and soften such dehumanization in anticipation of postwar alliances; Luce used *Life* to arouse sympathy for the Chinese victims of Japanese aggression as part of an effort to gain government support for Chiang Kai-shek, and so on. But despite the variety of agendas and some bickering, the government and press generally projected a consistent image of the war, one that portrayed virtuous allies united against an evil foe. And the public readily accepted this image. As John Steinbeck put it, censorship for journalists

> was partly a matter of orders, partly traditional, and largely because there was a huge gassy thing called the War Effort. . . . To a large extent judgment about this was in the hands of the correspondent himself, but if he forgot himself and broke any of the rules, there were the Censors, the Military Command, the Newspapers, and finally, most strong of all in discipline, there were the war-minded civilians, the Noncombatant Commandos of the Stork Club, of *Time* Magazine and the *New Yorker,* to jerk a correspondent into line or suggest that he be removed from the area as a danger to the War Effort.[20]

Writers on war photography knew they were looking at propaganda but generally accepted it as such because it was for a good cause. Speaking of *Road to Victory,* Edward Steichen's patriotic wartime exhibit at the Museum of Modern Art, Edward Alden Jewell described the message of the show as so moving that it could "make 'propaganda,' often misused, a thing of exalted as well as timely pertinence."[21] But just as Hartley Howe had failed to analyze the message he was approving of in the FSA pho-

tographs, so did Jewell and others fail to analyze what they saw in pictures of the war. No critic was about to point out such things as the dehumanization of the Japanese in journalistic photographs or the fact that Americans were almost never shown crying over war losses, whereas European allies and the Chinese were. These are the kinds of things that have only now become the substance of discussions of war photography.[22]

Furthermore, unlike the case of the FSA photographs, writers who commented on war photography never considered that what they were looking at had elements of art such as personal style. Although writers were aware that they were not being shown everything there was to see, they accepted what they were shown as uninflected truth. The war photographers, on the other hand, were well aware of the importance of personal style. In an interview of 1986, George Silk compared his romantic style to Carl Mydans's "purer style of documentation." Then, recognizing that even Mydans's documentation was a style, Silk concluded, "There's no such thing as being unbiased. You'd have to be a neuter to be unbiased."[23] Edward Steichen deliberately established a style for an entire group of photographers who photographed naval operations in the Pacific under his leadership. Wayne Miller recalled: "It was Steichen's prime concern—don't photograph the war, photograph the man, the little guy; the struggle, the heartaches, plus the dreams of this guy. Photograph the sailor."[24] Steichen created a unified vision out of the work of the various photographers he commanded. He decided which negatives were to be printed and how they were to be cropped, he exercised strict control over the tonal quality of the prints produced by his lab, and he decided which prints would go into the photography unit's picture file and which would not.

The photographers, bureaucrats, and editors who documented the depression and the war understood what they were doing, although they did not explain themselves to their public at the time. Perhaps because their audience expected them to be utterly objective, they became even more aware of the limits of their objectivity and of the inevitability and the political necessity of their biases. Their outlook was very different from that of the straight photographers, who felt pressure to be expressive even while they practiced what they considered to be an objective photographic technique. The documentary photographers, despite the pressure to be objective, tended to recognize that they were not making factual documents so much as working in what Walker Evans called the documentary style.

Some writers on documentary photography occasionally focused on the fact that photographs of the depression and the war were propaganda, but they never took the opportunity to raise a serious challenge to accepted

notions of photographic truth. They never asked whether all photographs are in some sense inherently biased, nor did they make any examinations of the way in which context shapes the meaning of a photograph. The common assumption was that almost all photographs are essentially truthful and have stable meanings independent of their use.

The Farm Security Administration

In 1935 the Roosevelt administration established the Resettlement Administration (RA) to address the problems of rural relief and land use. Rexford Tugwell, who was then Roosevelt's assistant secretary of agriculture, was named to head the new agency, and he hired his former student and protégé from Columbia University, Roy Stryker, to run the photographic project in the Historical Section of the RA's Information Division. In 1937 the RA was put under the aegis of the Department of Agriculture and became the Farm Security Administration. Tugwell left, but Stryker stayed as director of the now famous photographic project.

Stryker thought of his mission at the FSA as the production of a historical record, and to a large degree that is what he made, but his task was also to make propaganda for the government. The Roosevelt administration saw great value in photography as a way to justify its agricultural recovery policies. It used photographs to convince the country how badly land had been managed, how badly funds were needed for sanitary camps for migrant workers, and how well its employment projects were working. That they served these purposes did not mean that Stryker and his photographers lied or deliberately distorted the record. They told the truth as they saw it, but they made and presented photographs to the public so as to tell a specific and palatable version of the truth. As James Curtis has put it, "That Stryker and his staff made calculated appeals to [their] audience should come as no surprise. What is surprising is the degree to which they manipulated individual images and entire photographic series to conform to the dominant cultural values of the urban middle class."[25]

In his attempt to control what his photographers recorded and what the public saw, Stryker required his photographers to work from shooting scripts that pointedly avoided any politically touchy subjects. For example, the photographers stayed away from subjects that suggested the dangerous idea of socialist cooperation, even as they documented Greenbelt, a town designed by the Resettlement Administration as a cooperative community. Pictures of the rural poor with smiling or angry expressions were also generally avoided—the former might convey too little suffering and the latter a threat to social stability.[26] To underline hardship, photographers would

often choose the most dilapidated setting available, even if it was not representative of the actual living conditions of their subjects, and as David Peeler has observed, the photographers tended to concentrate on women and children as the innocent victims of the depression, knowing that they would most readily arouse the sympathies of the middle class.[27] But the details of hardship and travail were never to be overwhelming. Stryker has pointed out that, "probably half of the file contained positive pictures, the kind that give the heart a tug." The cumulative message was to be an optimistic one, one of survival and dignity in the face of hardship. The photographs were about "dignity versus despair," said Stryker. "Maybe I'm a fool, but I believe that dignity wins out."[28]

The photographers did not own the pictures they made; these went into a central file over which Stryker had complete authority. He had the option to suppress or even destroy images he deemed politically inappropriate, and of 270,000 negatives made for the file, Stryker punched holes in about 100,000.[29] He was also in a position to control the captions that accompanied any photographs he released for publication or exhibition and thereby ensure that viewers would be directed toward desired interpretations of the pictures.

Given the degree to which Stryker and his photographers molded the record they made, they not surprisingly subscribed to a theory of documentary realism that acknowledged the selective and expressive aspects of documentary truth. They understood that documentary truth was created rather than found and that documentation often involved considerable artifice. Stryker had begun to form his ideas about documentary photography in the early twenties while working with Tugwell at Columbia as the illustration editor of an economics textbook, *American Economic Life and the Means of Its Improvement*. On this project, Stryker had not been in charge of the making of documentary photographs but had learned to manipulate photographs through cropping, layout, and caption so that they might function not simply as raw images of reality but as symbols capable of shaping thought and feeling.[30]

When Stryker went to the FSA, he applied what he had learned to the production of photographs. On this issue, Stryker wrote in 1949, well after the heyday of the documentary movement, "There are times when you simply have to pose your model. The difference is in the *kind* of posing. It can be honest and dishonest, interesting and as wooden as a cigar store Indian."[31] The general purpose of such a procedure was to portray what the photographer saw as an essential truth in a widely apprehensible, even symbolic, form.

The photographer Arthur Rothstein, Stryker's protégé at the FSA, expressed a concept of documentation very similar to that of his boss. He said, "Provided the results are a faithful reproduction of what the photographer believes he sees, whatever takes place in the making of the picture is justified." Rothstein understood a documentary assignment to be very much like producing a documentary film. He explained that the photographer must "become not only a cameraman but a scenarist, dramatist, and director as well."[32] Rothstein used a number of techniques to obtain the results he desired. Sometimes he asked a third party to engage a subject in discussion so as to distract him or her from the camera. Other times he restaged a scene, which initially happened spontaneously, giving explicit directions to the subjects as a movie director would. Often these restaged scenes were moved to a position with a more "suitable" background than the one before which the scene had initially occurred.

It was not by chance that Rothstein likened documentary photography to filmmaking. He had responded strongly to Pare Lorentz's documentary film on the Dustbowl, *The Plow That Broke the Plains*.[33] Lorentz's film was a dramatization in ten episodes of the history of the Great Plains, which made use of actors and stock footage as well as the on-location camerawork of Paul Strand, Leo Hurwitz, and Ralph Steiner. Influenced by Russian documentaries of the twenties (particularly those of Sergei Eisenstein) and, in Strand's case, by the films of Robert Flaherty, the three cinematographers all thought of documentary film as a form of art that ought to "have the highest possible aesthetic content and dramatic impact." They thought that if documentaries are to put across a political point successfully, they must be carefully crafted. As Steiner said, "there can be no effective propaganda without good art."[34]

Hurwitz and Steiner had developed their ideas at the Film and Photo League in New York, a leftist organization with a mission to document the struggle of the American worker.[35] Their theories had faced some serious opposition at the league. A number of the members thought of documentary film in primarily political terms, seeing artistic interests as totally irrelevant. For this group, newsreels were the best kind of documentary film because they were current, true to the realist nature of the photographic medium, and they carried the weight of the actual events depicted. This was enough, they thought, to engage an audience even if such films lacked polished technique. In their opinion, art missed the critical moment because it took too long to produce, and was, in any case, too precious.[36] In 1934 Steiner, Hurwitz, and Irving Lerner split from the league over this theoretical controversy and formed Nykino. In 1935 the

group changed its name to Frontier Films and expanded as Strand and Ben Maddow joined.

The Frontier Films concept of documentation as a form of art had a powerful influence on the whole documentary movement from the Photo League, to the FSA, and even the mainstream newsreels and mass circulation picture magazines.[37] Henry Luce is reported to have told the directors of his journalistic *March of Time* films that they were to use "fakery in allegiance to the truth" whenever necessary.[38] Similar directorial practices became standard at *Life.* Wilson Hicks, one-time photo editor and then executive editor at *Life,* explained that in rearranging and directing a subject, the "photographer's purpose is to re-create an actuality in substance and in spirit in such a way as to make clear the ideas which the photographs are intended to convey and to give coherence to their compositions."[39]

The general public never understood that a directorial concept was operative in much documentary photography. This was dramatically demonstrated in the thirties by the famous incident of Rothstein's photograph of the sun-bleached skull. Rothstein was in South Dakota documenting the parched prairie when he found a steer skull that he seized on as a perfect object with which to dramatize the economic price of land mismanagement and drought. As he photographed the skull, he moved it into several different positions; in some pictures it is seen against the parched earth, in others it rests in sparse grass. Later, Stryker released one of the most dire looking of these images to publicize a Roosevelt trip to the plains, but the hostile Republican press discovered that there were several other less devastating versions of the picture and made a stink. That Rothstein had moved the skull was considered a serious breach of documentary integrity, and the FSA was rocked by charges of fakery and propaganda.[40] The public was not prepared to accept a news photograph as the creative interpretation of reality.

The Photo League

Because of its independence from the government and the mass press, the Photo League was the one locus of documentary photography in the thirties that had the potential to serve as a forum for a discussion of the nature of photographic truth. The Photo League had initially been a part of the Film and Photo League, which was established in 1930 as a cultural unit of the Workers' International Relief, an arm of the Communist International. Because of the theoretical dispute among the filmmakers discussed above, the organization split in 1936, and the Photo League became an independent organization of still photographers. Although the Photo

League maintained ties to the Communist Party through some of its members, not all members were Communists by any means, and not everyone who dealt with the league was even aware of its Communist roots. Still, the league was deeply motivated by leftist political aims.

The Photo League was as vibrant in its approach to photography as it was politically committed. Under the leadership of Sid Grossman and Sol Libsohn, the group started a gallery, built a darkroom, held classes, brought in lecturers—including such people as Adams, Strand, and Stryker—and formed production groups that made documentary photo essays. The league also performed a major service to photographic criticism by publishing *Photo Notes*. Started in 1935 as a simple bulletin, *Photo Notes* developed into a modest, typewritten and mimeographed sheet sent free to league members, galleries, and museums. *Photo Notes* was obscure. In fact, it was so obscure that when the Visual Studies Workshop reprinted it in 1977, only single copies of some issues could be located, and it was by no means certain whether other undiscovered issues might exist.[41] Nevertheless, *Photo Notes* was an influential and spirited little publication that served in the thirties and forties as the only forum dedicated to a discussion of documentary photography.

The aesthetic of Photo League photographers was based on a balance between the document as a social record and a work of art. As Anne Tucker has explained, the members sympathized with the filmmakers of Frontier Films who favored technical sophistication and aesthetic subtlety in documentary work.[42] The still photographers of the league wanted to create a documentary style that went beyond the kind of flat-footed recording of socially trenchant subjects, the kind one might see in a typical news photograph, to reach a level of drama and sensitivity associated with art. In their statement of purpose in 1938, they announced that the league intended to carry on the tradition of photography exemplified by artists such as Stieglitz and Weston. As straight photographers, these men could teach league members something about the aesthetics of direct photographic vision.

The league had no patience with art photographers who did not practice straight photography. Their statement of purpose declared, "Photography has long suffered, on the one hand, from the stultifying influence of the pictorialists, who photographically have never entered the 20th century, and, on the other, from the so-called 'modernists' [artists such as Moholy-Nagy and Man Ray], who retired into a cult of red filters and confusing angles much beloved by the manufacturers of photographic materials."[43]

To the more leftist members of the league, such purely aesthetic pur-
suits were a sign of upper-class privilege totally at odds with the struggle
for social justice. Even as the leftist militancy of the league softened in the
course of the thirties, its aesthetics remained wedded to an overtly social
vision. When Aaron Siskind showed his *Tabernacle City* at the league in
1941 (these were photographs of details of rural architecture in Bucks
County, Pennsylvania) he was severely criticized for not including people,
for being too arty, and for failing to uphold the cause of the worker.[44]

Unfortunately, the discussion over aesthetics in documentary work at
the Photo League generally did not find its way into criticism written by
league members. For example, in a review of *U.S. Camera Annual 1940,*
Albert Fenn praised the relative absence of "Fuzzie Wuzzies" and the in-
creased number of "straightforward, meaningful prints." Of particular note,
he said, were Edward Weston's photographs. But having said this much,
Fenn declined to analyze Weston's work, with the excuse that they speak
so well for themselves that such analysis would be a "thankless task."[45]

Photo League reviews of documentary photography were no more
penetrating. This was probably because the league critics tended to sym-
pathize closely with the work they were reviewing. The league was in
basic agreement with the Roosevelt administration regarding the serious-
ness of poverty in the United States and the government's role in the eco-
nomic crisis, and later, league members were eager to support the war
effort. As the league's statement of purpose said, "Our primary aim will be
to further the type of photography exemplified by the T.V.A. and the
Resettlement Administration. From these two projects have come not only
homes and electricity but the first true pictorial record of the lives of
Americans."[46] Such a position provided little incentive to analyze the con-
struction of this true pictorial record.

Morris Engel gave a typical assessment of the Photo League opinion
of FSA photographs:

> These photographs made for the U.S. Government and captioned
> with appropriate remarks by many people have the intense reality
> and vitality of life. All tell a story. Honestly and sincerely they
> picture men, women and children suffering and struggling. . . .
> The subject is important, but more important is their approach to
> the subject. They leave the false sentimental and shallow inciden-
> tal photography to others. Their[s] is the photography of today,
> requiring the masterly combination of brilliant technique, feeling,
> spirit and social consciousness.[47]

Engel insists on the importance of the FSA photographers' approach to their subject but says little about that approach other than to point out its technical mastery, its sincerity, and its foundation in social conscience. Clearly, Engel was moved by seeing in the FSA work a reality that had been denied and that was now confronted directly. At last there were pictures—no matter how palatably constructed—that publicly acknowledged the crushing blow of poverty, the importance of forgotten people, the ugliness in America. The sense of relief at seeing these things revealed and the indignation these sights aroused gave the pictures the force of truth. But apparently Engel's desire to emphasize the force of this truth took precedence over any inclination to examine how that truth was put together, its nuances and its style. Engel said nothing about the precise meanings of the FSA pictures as determined by the relationship of their subject matter to the formal structure of the images or the relations of the pictures to a larger political agenda.

Engel undoubtedly could have produced such an analysis had he so desired. He was a member of Aaron Siskind's Feature Group, the most productive and aesthetically aware of the Photo League's documentary units.[48] Siskind was acutely sensitive to the artistry of documentation and the relation of formal issues to the meaning of a documentary photograph. Carl Chiarenza has pointed out that the group carefully critiqued the formal structure of each others' work in the most specific terms.[49] And in an essay in *Photo Notes,* Siskind summarized the group's approach, putting an emphasis on aesthetic awareness:

> We learned a number of things about the form and continuity of a picture-story; but, mostly, we came to see that the *literal representation of a fact* (or idea) can signify less than the fact or idea itself (is altogether dull), that a picture or a series of pictures must be informed with such things as order, rhythm, emphasis, etc., etc.—qualities which result from the perception and feeling of the photographer, and are not necessarily—(or apparently) the property of the subject.[50]

Taking a position similar to Siskind's in an article on Paul Strand that appeared in *Photo Notes,* Leo Hurwitz complained that in too much documentary work, "What is photographed is often more impressive, more moving than the photograph itself." The value of Strand's work lay in "the formal unity, the expressiveness, the functional relation of treatment to idea and feeling."[51] Yet Hurwitz, in the same manner as Engel and Fenn,

said nothing specific about the unity or other such formal qualities in any of Strand's individual photographs.

The Critics

Although the members of the Photo League understood the aesthetic qualities of documentation, they wrote about them only in the most general terms. The war photographers and those at the FSA only spoke about the constructed and personal nature of documentary styles years after the height of the documentary movement. Walker Evans even found it in his interest to be misleading about his documentary practice. When doing documentary work, he said, "you don't touch a *thing*. You 'manipulate,' if you like, when you frame a picture—one foot one way or one foot another. But you're not sticking anything in."[52] As James Curtis has amply demonstrated, Evans did not adhere to this standard in his own documentary work at all. He removed, added, and rearranged objects as a matter of course.[53] In the thirties and forties the exigencies of the political situation—the commitment to the dispossessed or the need to win the war—(and in Evans's case, perhaps a sense of artistic mystique) prevented a full and candid discussion about the documentary style. Given this situation, it should not be surprising that most critics of documentary photography treated it naively and superficially.

Most of the writers on documentary photography had very little experience with photography and could not have had a deep sense of it. But even the experienced ones often wrote as if photographs could be utterly objective, utterly styleless. Elizabeth McCausland, an important critic of documentary work, referred to by one veteran of the Photo League as the only theoretician among them, could write of a spirit of realism in photography that "looks now at the external world with new eyes, the eyes of scientific, uncompromising honesty."[54] McCausland was aware that "the camera can lie," but she apparently thought that certain photographers could suppress their personalities, avoid all artifice, and record pure external facts.

Pare Lorentz, the director who worked with Strand and Hurwitz on *The Plow that Broke the Plains,* also wrote as if documentary photography could be transparent. Speaking of Walker Evans's work, he said, "The photographer has put us on record. That is important. But it is we—our clothes, our faces, our homes, and habits—who write the record."[55] In a similar vein, he said of Dorothea Lange, "One cannot say 'that is a Dorothea Lange picture' because of any technical stylization. On the other hand you can usually spot any of her portraits because of the terrible real-

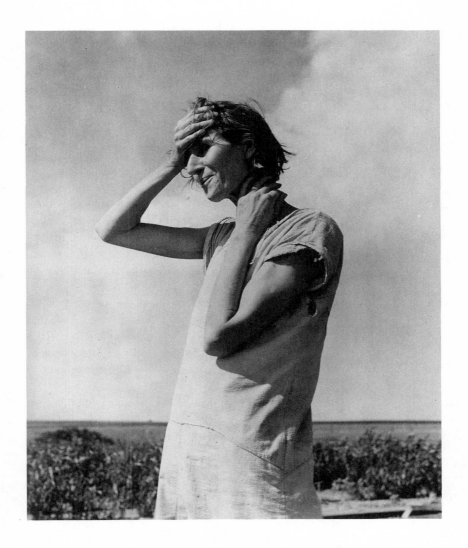

Dorothea Lange, Woman of the High Plains, Texas Panhandle, *1938. Courtesy of The Oakland Museum. Copyright © the Dorothea Lange Collection, The Oakland Museum, The City of Oakland. Gift of Paul S. Taylor.*

ity of her people; in short, she is more interested in people than in photography."[56] Lorentz seems to give Lange credit only for her ability to disappear so that reality may shine through. But, of course, Lange used the expressive capacities of photography to shape reality.

Her depression portraits are marked by the frequent placement of figures against a very simple background, a low camera angle, and strong side-lighting. These stylistic elements are well suited to arouse compassion for the suffering of good, hard-working, rural folk. The simplicity of the composition is consistent with the idea of the simplicity of rural life; the low camera angle makes the subjects loom above us heroically; and the lighting emphasizes their weather-beaten skin. Lorentz knew better than to believe in the transparency and stylelessness of photography, because he himself was an accomplished practitioner of the dramatic construction and manipulation of documentary images in film. Perhaps he was dissembling with regard to Evans and Lange out of loyalty to the Roosevelt administration for which he worked. Perhaps Lorentz saw no political advantage in calling attention to an artist's presence in documentary work, knowing that without doing so this presence would escape the eye of most viewers. Possibly his comment on the power and reality of Lange's portraiture had a personal motivation, reflecting a genuine admiration for her ability to deal with people in contrast to his own limitations in that regard and his greater interest in the landscape.[57]

Typical of the more naive commentators on documentary photographs was Norman Cousins. He wrote in a review of *You Have Seen Their Faces*, "What Miss Bourke-White's camera says in this book is beyond argument," an assertion that begs the question.[58] If Cousins saw clear evidence in Bourke-White's pictures of the suffering of southern sharecroppers, the reviewer for *The New York Times,* Robert van Gelder, saw in the very same photographs evidence of beauty, "ease, sometimes of contentment, of courage, even happiness." Van Gelder—who tells us that blacks are easier to control than whites and less likely to break under frustration—took Bourke-White's pictures as proof that southerners were "living about as completely as most of us in the richer North."[59] Far from speaking definitively, then, Bourke-White's photographs said one thing when seen through Cousin's ideology and quite another when seen through Van Gelder's. For her part, Margaret Bourke-White said, "I believe, too, that photographs are a true interpretation. One photograph might lie, but a group of pictures can't. . . . In the last analysis, photographs really have to tell the truth; the sum total is a true interpretation."[60]

William Carlos Williams made his contribution to the chorus of naive

realism when he wrote of Walker Evans's photographs: "The composition is of secondary importance in these clear statements. . . . The composition isn't a particular feature—but the pictures talk to us."[61] He did not see that it was precisely the composition that made the pictures appear to talk clearly. For Williams, the subject matter did all the work; it did not matter *how* the photographer saw, only what.

Unlike Williams, some critics were interested in how a photographer achieved an objective style. Willard van Dyke thought it was a matter of mind set, and he attempted to explain Dorothea Lange's objectivity in terms of the deliberate achievement of a tabula rasa: "Her attitude bears a significant analogy to the sensitized plate of the camera itself. . . . Her method is to eradicate from her mind before she starts, all ideas which she might hold regarding the situation—her mind like an unexposed film." And yet, he continued, "she drives to a place most likely to yield subjects consistent with her general sympathies. . . . [H]er deeply personal sympathies for the unfortunates, the downtrodden, the misfits. . . provide the impetus for her expedition. . . . Suddenly out of the chaos of disorganized movement, the ground glass becomes alive . . . in the sense that only a photographer can recognize." Van Dyke's language contradicts his notion of the photographer's perfectly receptive mind. If Lange searches for subjects that fit her deeply personal sympathies and recognizes a "live" composition on her ground glass, she certainly is not working with a mind that is void of "all ideas which she might hold regarding the situation."[62]

Hartley Howe recognized that objectivity has as much to do with formal issues as with mind set, but he discussed the formal qualities of an objective style as if they are somehow transparent, as if they dissolve in the process of presenting the subject itself. Writing about the FSA photographs, Howe explained that the "emphasis on what is taken, rather than how it is taken, has led to an extremely simple technique." He continued, "Pictures are made from the viewpoint which shows the subject most clearly; unusual angle shots or trick lighting effects are extremely rare. Actuality always wins in any contest with artistry."[63] But what, one might ask, is the viewpoint which shows the subject most clearly? Is a frontal view of a face or a building necessarily clearer than a three-quarters view? It could be said that every photograph shows its subject from the clearest viewpoint because, to some degree, the point of view determines what the subject is. A frontal view of a house in which the facade fills the frame has a different subject from the oblique view that shows the relation of the house to the street. Howe is right to suggest that some points of view or some kinds of lighting would be considered unusual or gimmicky. I do not

mean to say that no distinction can be made in photography between objectivity and distortion, between a straightforward vision and mannerism, or that there is no truth in any photograph. But even the most rigorously objective vision is constructed, is the result of choices and conventions, and therefore, even the most objective vision shapes its subject. Howe writes of photographic objectivity as an emphasis on what is taken rather than how it is taken, but he fails to see that the how never becomes transparent, never becomes a passive conduit for actuality. It is always *operative* and always shaping what we see and understand.

One notable exception to the general naïveté about documentary truth was Beaumont Newhall. He wrote an article published in 1938 in which he pointed to the parallels between the aesthetics of documentary still photographers and those of the documentary filmmakers John Grierson and Paul Rotha. He also suggested that documentary photography was closely allied to the document-novels of Zola, and he said that documentary photographs are made with definite and conscious purpose, that they are not only records of the world but also records of a photographer's emotions.[64]

Walker Evans

Of all the documentary photographers, Walker Evans attracted the greatest attention. The issue his critics were most concerned with was that of the styleless style. This was appropriate because Evans strove for the appearance of stylelessness. It was a concept he had gotten from reading Flaubert during his time in Paris in the mid-twenties. Evans said he admired Flaubert's "realism and naturalism both, and his objectivity of treatment; the non-appearance of the author, the non-subjectivity." He did not take Flaubert's apparent objectivity literally, however, nor did he have any pretense to objectivity himself. What Flaubert showed Evans was that art could adopt a style that mimicked the objective manner of strictly utilitarian documents without sacrificing aesthetic taste. Evans could adopt a documentary style without giving up his standards of formal design. "I can't stand a bad design or a bad object in a room," he said, and when something was wrong, he changed it.[65] He also occasionally arranged people into what appear to be candid compositions, and when shooting interiors, he often used a flash, although he disguised its effects in his prints.

Evans's critics in the thirties were fooled. They were ready to believe that he had achieved a truly styleless style. Lincoln Kirstein, who helped organize a major show of Evans's work at the Museum of Modern Art in 1938 and who also wrote the afterword for the accompanying book, *American Photographs,* led the way in establishing the myth of Evans's

stylelessness. The greatest photographers, Kirstein said, achieve a "large quality of eye and a grand openness of vision" that, rather than giving their work the mark of individual distinction, gives it a generalized look as if it were all the creation of the same person "or even, perhaps, the creation of the unaided machine." In Kirstein's estimation, Evans was precisely this kind of great photographer. He recognized the futility of developing "sensibility for its own sake," and he saw the importance of subject matter. In fact, said Kirstein, it is the "creative selection" of subject matter that really counts in photography, and in Evans's work, "the wave-length of his vision is exactly equalled by the radiation of the images which attract and repel it."[66]

Kirstein went on to discuss the frontality that gives Evans's work such a powerful sense of objectivity: "The most characteristic single feature of Evans' work is its purity, or even its puritanism. It is 'straight' photography not only in technique but in the rigorous directness of its way of looking. All through the pictures in this book you will search in vain for an angle-shot. Every object is regarded head-on with the unsparing frankness of a Russian ikon or a Flemish portrait. The facts pile up with the prints."[67] In fact, there are a few angle shots in *American Photographs,* but the point is well taken. Evans's frontal views appear clinical.

Other reviewers of *American Photographs* echoed Kirstein's assessment. Thomas Dabny Mabry, an associate director at the Museum of Modern Art who had helped organize Evans's show there, wrote, "Seemingly he arranges nothing, changes nothing, implies nothing. . . . The purity of Evans's work is not only apparent in the straight, unadorned technique, but in the point of view. . . . [The photographs] are never staged. He shows in all his work a reverence for the inviolable history of the object before him."[68] Martha Davidson described Evans as "almost always coldly objective" and his pictures as "free from falsification, exaggeration or distortion."[69]

Kirstein acknowledged, in passing, the influence on Evans of Stendhal, Flaubert, Degas, and Seurat, and in so doing he hinted that Evans had deliberately created his style. But the brief suggestion of an artistic personality was quickly obscured by a return to the theme of unvarnished truth: "The pictures of men and portraits of houses have only that 'expression' which the experience of their society and times has imposed on them."

Kirstein also saw a moral component in Evans's work. He described Evans as "a member revolting from his own class, who knows best what in it must be uncovered, cauterized and why." The societal sores Evans saw were the same wounds of industrialization that Stieglitz and his circle

had protested. Kirstein wrote of the "exploitation of men by machinery and machinery by men," and of the vulgarity of mass culture.[70] Although this tone of social criticism is unmistakable in Evans's pictures, his book is not a call to action; it is not a book that points to problems that can be solved by abolition of the sharecropper system, the establishment of work projects or migrant labor camps. It is rather, as Kirstein suggests, a book that testifies to waste, selfishness, and internal cultural rot. For Kirstein, testifying to these ills was, in itself, a moral act.

This was not a view shared by everyone. For Edward Alden Jewell, Evans's testimony appeared so clinically detached as to be purely aesthetic and not moral at all.[71] Jewell apparently saw in Evans something akin to the aesthetic vision described by Roger Fry, a vision that takes in everything with complete equanimity, without moral responsibility, completely "freed from the binding necessities of our actual existence." Any moral implications drawn from Evans's pictures, said Jewell, are the spectator's, not Evans's.

Lionel Trilling also addressed the issue of Evans's moral vision in a review of *Let Us Now Praise Famous Men*, a book of photographs by Evans and Agee that presented Evans's photographs without any captions, followed by Agee's lengthy text detailing the lives of three families of white, Alabama tenant farmers. Trilling's review of the book is one of the few that gives equal weight to Evans's photographs and Agee's text. The question he asks regarding both is how is the middle class to feel about the underprivileged? Trilling concludes that Agee, motivated by guilt, ennobles and thus falsifies the image of his subjects. He is able to acknowledge some of their very obvious faults, such as their racism, but he cannot acknowledge any of the more subtle manifestations of meanness of spirit that Trilling is certain are present in these people, just as they are present in any group of people. Trilling does not suggest that Evans does reveal the sharecroppers' meanness, but he judges Evans to be more truthful than Agee and more tasteful, by which he means more tactful, just, aware, and respectful.

Trilling is unusual in that he claims no objective detachment for Evans: "You cannot be cool about misery so intense," he writes. Unlike other critics, he sees that Evans's rendition of the truth is a product of his intense interaction with his subject and not the result of a clinical eye. Trilling confesses that he cannot analyze Evans's taste and cannot say what the morality of his vision is made of in technical and aesthetic terms, but he does, nevertheless, point out one significant aspect of Evans's moral vision. Referring to the portrait of Mrs. Gudger, which impressed him

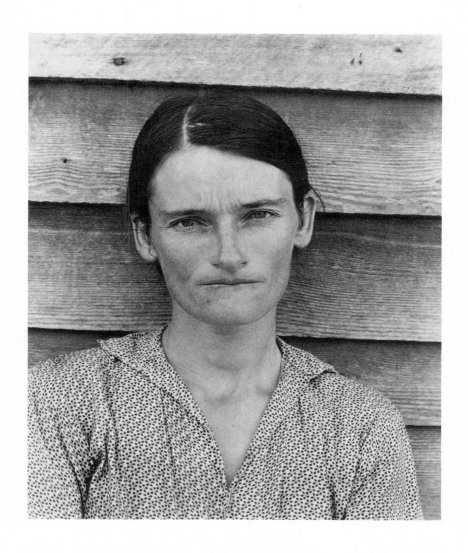

Walker Evans, Alabama Sharecropper's Wife, *1936. Courtesy of the Yale University Art Gallery. Copyright © Walker Evans Archive, Metropolitan Museum of Art, New York.*

more than any other, Trilling explains that by allowing his subject to compose herself before the camera, Evans allowed her to defend herself against it—as she would not have been able to do had the picture been candid—and in so doing, she gained dignity. Trilling wrote, "With all her misery and perhaps with her touch of pity for herself, [she] simply refuses to be an object of your 'social consciousness'; she refuses to be an object at all—everything in the picture proclaims her to be all subject."[72] For Trilling, Evans enhanced the sense of truth in his art not through the illusion of the styleless style, but by acknowledging his presence, by showing his hand.

In addition to the morality of clear vision, Kirstein recognized in Evans's pictures a set of permanent symbols of the culture. Kirstein was not claiming for Evans's photographs the transcendent universality that Stieglitz's critics claimed for his pictures, but he did see Evans's work as transcending the moment. Evans, said Kirstein, "elevate[d] fortuitous accidents of juxtaposition into ordained design," and he elevated "the casual, the everyday and the literal into specific, permanent symbols." Kirstein saw Evans's pictures as quintessential examples of synecdoche such that "the single house, the single street, strikes with the strength of overwhelming numbers." The work is a "monument to our moment."[73]

There were a few critics who were unconvinced by Evans's vision of America. Ansel Adams was one. Another was S. T. Williamson who complained, in much the same manner as Adams, that the pictures in *American Photographs* showed "bumps, warts, boils and blackheads" of the American physiognomy, and that these were the characteristics of a "submerged fraction" of the culture rather than representative of the whole.[74] Williamson did not question the truthfulness of any of the individual pictures Evans published, but he did imply that Evans's choices of subjects revealed a political bias. But Williamson's has been a minority view. As John Szarkowski wrote in 1971, "Beyond doubt, the accepted myth of our recent past is in some measure the creation of this photographer, whose work has persuaded us of the validity of a new set of clues and symbols bearing on the question of who we are. Whether that work and its judgment was fact or artifice, or half of each, it is now part of our history."[75]

Elizabeth McCausland

Elizabeth McCausland was a newspaper art critic by trade, writing for the Springfield, Massachusetts *Springfield Republican*. She wrote about all the arts but had a special interest in photography. She was on the advisory board of the Photo League and, for a brief time, the advisory committee of the Department of Photography at the Museum of Modern Art. Her partic-

ular passion was documentary photography, and she became the single most dedicated critic of that genre.

In 1939 *Photo Notes* published an essay in which McCausland defined documentary photography. In her view, photography as a whole was not, by nature, a subjective or impressionistic medium but a medium tied to reality. Art photography, therefore, in its efforts at subjectivity was misguided and sterile. McCausland welcomed the documentary spirit because it promised to cleanse photography of the pretensions and distractions of art movements and dedicate the medium to clear communication of content based on reality. Documentary photographers submerged their personalities in the face of fact and eschewed the modernist "cult of non-intelligibility" represented by Laszlo Moholy-Nagy and Man Ray. The documentary photographer was dedicated only to the "profound and sober chronicling of the external world."

For McCausland, as for so many others in the thirties, the part of the external world that mattered was American society and the depression:

Today we do not want emotion from art. . . . We want the truth. . . . That truth we get from reading a financial page, a foreign cable, an unemployment survey report. That truth we receive, visually, from photographs recording the undeniable facts of life today, old wooden slums canting on their foundations, an isolated farmer's shack, poor cotton fields, dirty city streets, the chronicles written in the faces of men and women and children.[76]

In a later article in 1942, she reemphasized her dedication to documentation over expression: "At this date in history, we do not need to argue about the purpose of the arts. War has swept non-intelligibility into historical discard. . . . Indeed, communication is the use—and the only justification—of all the works produced in the various arts."[77] She thought that Hollywood and the photographic press (the Hearst press in particular, but by no means exclusively) were censoring that truth. The government, by contrast, even if it was doing too little, was the "best sponsor of knowledge" through the FSA photography section and the Federal Art Project (FAP) that supported such undertakings as Berenice Abbott's documentation of New York.

McCausland wrote the text for *Changing New York*, the book Abbott published as the result of her work with the FAP. She also wrote several articles on Abbott's urban photographs. The best of these, published in 1935, shows how McCausland's social concerns emerged from a background of

rather typical straight photographic criticism. Echoing Stieglitz's admirers of a decade before, McCausland wrote of Abbott's effort to possess life on an epic scale and her passionate love for America. Sounding like Harold Clurman on Paul Strand, she identified in Abbott's manner a classical, intellectual coolness mixed with tenderness. In an effort to clarify this observation, she thrashed around in the contradiction between detachment and expression, making a murky distinction between a "psychical montage by which the personality of the artist is superimposed on the personality of her subject" and "the subject as having been filtered through the personality of the artist."[78] Abbott's photographs represented the latter case.

McCausland also described Abbott's pictures as timeless in their capacity to transcend their specificity and stand for the spirit of the age. Here, as she anticipated Lincoln Kirstein's comments on Walker Evans, McCausland's social point of view began to appear. Through their descriptions of the physical structure of New York, said McCausland, Abbott's photographs describe the social conditions of urban America in general. The photographs depict little workmen dwarfed by towering, inhuman, steel structures; they show abrupt contrasts of wealth and poverty; they show vertiginous views from tall buildings that describe "a world about to fall over from its own sheer lack of balance."

McCausland clearly detected some common leftist criticisms of capitalist society in Abbott's work—the alienation of the worker and the unequal distribution of wealth—but she handled these themes gingerly. She suggested that Abbott's social comments were not deliberate but the by-product of direct observation, and she went to lengths to explain that Abbott is not "too sociological" because her work contains humor and "a spontaneous pleasure in the human comedy,"[79] as if humor and pleasure are foreign to sociology.

Five years later, when she wrote about Paul Strand, McCausland was no longer shy about making a social analysis of photographs. Tracing Strand's growth from his early, candid street photographs and his exploration of abstraction through an investigation of natural form and landscape, McCausland celebrated his arrival at a mature humanism in his pictures of Mexico of 1933. In these, said McCausland, Strand synthesized all the lessons of his earlier work to speak not of a "great impersonal struggle," but of "the immediate urgent struggle for survival of a whole society." Assured by the overtly leftist viewpoint of Strand's documentary film work, begun in 1933, McCausland read the social messages implicit in his still images:

These ruined haciendas, what are they but symbols of the struggle between *ricos* and farmers, the battle for existence of the landless against the landed? What are these dark clouds hovering over the desert but the cosmic mark of human tragedy? . . . In the photographs of *bultos* the tragic tension of life under a primitive society is symbolized; the crucified Christ is the figure of every peasant broken and bleeding in his daily war for bread.[80]

In 1942 McCausland reviewed *Road to Victory,* Edward Steichen's first wartime exhibit at the Museum of Modern Art. Unfortunately, in this review, she lost all critical perspective in her eagerness to proclaim the social value of photography and to lend her support to the war. But so did almost everyone else who reviewed the show. Edward Alden Jewell wrote in *The New York Times,* "It would not at all amaze me to see people, even people who have thought themselves very worldly, nonchalant or hard-boiled, leave this exhibition with brimming eyes."[81] Even the reviewer for the leftist *Daily Worker* gushed with patriotic fervor: "It is the most sensational exhibit of photographs that ever was shown in these parts. What a country to fight for!"[82]

Steichen conceived of *Road to Victory* as his contribution to the war effort. In 1940, sensing the United States' imminent entry into war, Steichen had tried to join the army, but he was rejected because he was sixty years old. Nevertheless, he continued to look for ways to get involved. In the fall of 1940, David McAlpin, who had helped establish the photography department at the Museum of Modern Art, suggested that Steichen organize an exhibit for the museum to be called *Panorama of Defense.* While the show was still in preparation, the Japanese attacked Pearl Harbor, the show's title was changed, and Steichen coaxed his way into the navy as a lieutenant commander in charge of a photographic unit.

Road to Victory opened in May 1942. The installation set the tone for Steichen's curatorial style. Designed by Herbert Bayer, formerly of the Bauhaus, it was like a three-dimensional *Life* picture story. There was a text by Steichen's brother-in-law, Carl Sandburg, and photographs culled from the archives of Time-Life, the Associated Press, the Tennessee Valley Authority, the army and navy, the Departments of Agriculture and the Interior, United States Steel, and the FSA file. The display prints were of widely varying sizes—one as large as twelve by forty feet—and they were hung at different levels on the wall, hung free of the wall, or mounted on free-standing floor panels. The whole was arranged in a narrative sequence, designed by Steichen, that began as a paean to the good American earth, industry, and common folk, and ended as a call to arms against the Japanese. As the show

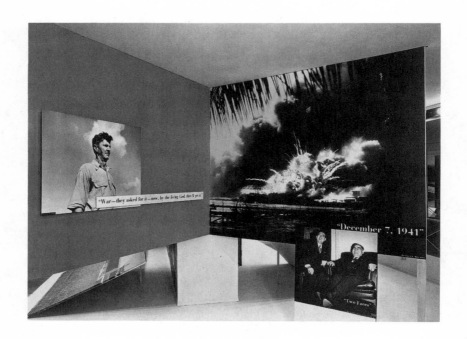

Installation view from the exhibition Road to Victory, *from May 21 through October 4, 1942. Courtesy of the Museum of Modern Art, New York. Photograph copyright © 1994 by the Museum of Modern Art.*

reached its crescendo, a picture of a Texas farmer faced a picture of laughing Japanese diplomats, the latter overlapping an image of the attack on Pearl Harbor. The Texan was captioned, "War—they asked for it—now by the living God, they'll get it." Nearby, scenes of American war planes bore the caption, "Smooth and terrible birds of death—smooth they fly, terrible their spit of flame, their hammering cry, 'Here's lead in your guts.'"[83]

Beaumont Newhall, who was then curator of the fledgling photography department at MOMA, was upset with this display. He wrote to Ansel Adams, "Between you and me the show, for all its spectacular timeliness, has nothing whatever to do with photography, and may be more harmful than good. It's like a Stokowski orchestration of a Bach fugue: very spectacular, very tuneful, very popular but it ain't Bach and it ain't good taste."[84] Part of what annoyed Newhall was that the design of the show was so intrusive that it directed attention away from the individual visions of the photographers represented and toward sentiment and Steichen himself as an impresario.

Unlike Newhall, McCausland had no qualms about Steichen's popularizing approach to photography because she saw photography as an essentially popular art. Furthermore, this show demonstrated to her that art need not remain above the political fray, that it could take sides with "the American people, and against the defeatists, the fifth columnists, the spiritual saboteurs." Her review proudly recounts the story line of the exhibit matching Sandburg's rhetoric with her own: "Our road now is the road to victory, as the exhibition says. Millions of American men are marching along this road today, in the Pacific theater and soon, perhaps, in Europe. Our bombers and our battleships are ready."[85]

In her enthusiasm for the show's message, McCausland swept aside all formal considerations: "Minor differences of opinion as to what size the photo-murals should be or whether the text should be more or less concrete and factual are not very important when we consider the orientation and meaning of the exhibition." She concluded that the general aesthetic lesson of the show is that artists (all artists) would do best by putting "real content" into their work, for this is what will have "real appeal for people."[86]

McCausland did herself an injustice with this review. She was a more perceptive observer of the culture than she demonstrated here and more sensitive to the formal issues of photography. She should have known better than to sweep aside such matters as the design of the exhibit and the relation of the text to the images. After all, she had written the text for Berenice Abbott's book on New York, and a few months after she published her review of *Road to Victory,* she published an article on the very subject of the relation of texts and images in photographic books. But girding for war made all else seem irrelevant.

Photographs and Words

The question of the relationship of photographs and words was an important one for people who thought about documentary photography, because documentary photographs usually appeared with text. In fact, documentary photography encouraged the blooming of a genre of picture book in which words and text were combined in an examination of some aspect of the American scene. Some of the better known of these books are *You Have Seen Their Faces* by Erskine Caldwell and Margaret Bourke-White (1937), *Land of the Free* by Archibald MacLeish (1938), *An American Exodus* by Dorothea Lange and Paul Taylor (1939), *12 Million Black Voices* by Richard Wright (1941), and *Let Us Now Praise Famous Men* by James Agee and Walker Evans (1941).

Most often, reviewers of these books touched haphazardly on the theoretical problems of combining written language and photographs. McCausland addressed the matter more thoroughly in her article of 1942. In 1952 Nancy Newhall wrote an essay on the same issue, dealing mostly with the context of the magazine photo story. Also in 1952 Wilson Hicks published *Words and Pictures,* an insider's view of the theory and operation of the picture magazine.

The relation of words and photographs is a complex and difficult matter, an inquiry into which may lead, in one or two quick leaps, to the questions of whether we experience images in purely visual terms or in a way that is saturated with language; whether we think in language, picturelike mental images, both, or neither; and even whether language is derived from a foundation of coherent sense perception or gives coherence to otherwise chaotic sense perception.[87] McCausland, Newhall, and Hicks did not write about photographs and text on the basis of highly developed cognitive or linguistic theory; their comments skate over the surface of these issues in a way that only suggests the depths below. Nominally, the central problem in their discussion was how to reconcile the two very different media. As Hicks pointed out, making reference to Suzanne Langer, language is discursive and photographs are not. Language is comprehended in a linear order through time, whereas photographs are understood in a much less orderly and more immediate manner. How, then, can these media be brought together to achieve unity of effect and to make a single expressive statement? How are words and photographs to be balanced so that neither is dominant or superfluous; how are they to be used so as to avoid redundancy or non sequiturs?

Despite the stated concern for balance and synthesis, implicit in each writer's handling of the issue was the assumption that either words or pictures are inherently more important than the other. Newhall saw pictures as more immediate, more in touch with actuality than words. In her view, which is similar to that of Gestalt psychologists, language is founded on sensory experience and therefore one step removed from the world.[88] To favor the relative abstractness of words over nonverbal perception is to lose touch with the world. To appreciate a photograph properly is to appreciate it nonverbally. Newhall would have approved of James Agee's paraphrase of Goethe: "It is good to think, better to look and think, best to look without thinking."[89]

In the contrasting point of view of McCausland and Hicks, a preference for words is based on the assumption (à la Piaget) that language represents the highest developmental level of cognition and that at this level,

one can perform tasks not possible at the lower, perceptual level. Hicks and McCausland wanted to assimilate photographs to the descriptive and explanatory roles of journalism and social critique. They both pointed out that alone, without the help of language, pictures cannot convey the proper kind of information to fulfill these roles. As McCausland said, photographs convey mood, but in doing so, they are at once too general and too specific. They can show a person but cannot tell us who she is; they can show an example of a social situation but not how widespread it is. She wrote, "when we turn to photography as a second language of communication, we find that the function of conveying *fact* or information becomes dominant. We want to know where something happened, as well as its typical aspect. We want to know who the people are in the photograph, as well as their broad human nature."[90] The desired kind of information is supplied by language. Language not only identifies but also explains relationships. If photographs are to be integrated thoroughly and meaningfully into their social context, they must be accompanied by words.

McCausland's position is reminiscent of Walter Benjamin (although she was not as far to the left as he) who had demanded that a photographer "put such a caption beneath his picture as will rescue it from the ravages of modishness [that is, socially detached aestheticism] and confer upon it a revolutionary use value."[91] McCausland made it clear that historical circumstances necessitated that the modernist purity of the visual image no longer be sacrosanct. Now, the task of art was to communicate, and if this meant mixing media, then so be it. Furthermore, she said that when mixing photographs and words in books, availability must be given priority over aesthetics. If photographic books are really to be vehicles of broad communication, they must be inexpensive. Reproductions, therefore, cannot be of the highest quality: "This may involve reeducation of photographers, for subtleties of the f.64 School are out. A broad style which will not suffer too much from loss of tones in reproduction is therefore indicated."[92]

Hicks was a print journalist for whom photographs were an accretion on the basic discipline, but a useful one that could make it more immediate and compelling. In particular, he was a champion of the photo story as it was formulated at *Life*. Although Hicks gave ample credit to the Germans for their pioneering work with picture magazines, he thought of the photo story as most directly descended from ideas developed at Luce's other publication, *Time*. At *Time*, news was conceived of as a coherent narrative, flowing from one topic to another. The magazine used photographs to make particular points within this narrative. Photographs in *Time* were not used as decoration, aesthetic objects, or for the establishment of mood.

Life adopted *Time*'s idea of the journalistic narrative and expanded the role of the photograph so that it became part of the substance of the narrative rather than punctuation along the way. As Hicks said, the question became "whether the nondiscursive photographic medium can be put to discursive use."[93]

In Hicks's view, it could, and the key to doing so successfully in the picture story was to subordinate all considerations to a central idea. At *Life,* that idea was conceived of and developed by a writer and editor. This process included the preparation of a shooting script that included specific hypothesized pictures for the photographer to look for. Often a reporter would precede the photographer to the shooting location to smooth the way and then stay to collect written information. It was considered too great a burden to expect the photographer to both shoot the story and do the written reporting. After the story was photographed, the editor and others (often in the absence of the photographer who might be away shooting another assignment) would edit the photographs and design the story, and the writer would write the text.

The people at *Life* recognized from the start that photographs, like words, are malleable and that photographs can contain a variety of meanings, but they were certain that if a photograph were captioned properly, the "intended central point or idea [would] find its way intact into the reader's mind." In a photo story, this central idea governs the selection and arrangement of the pictures. Hicks says that a poorly composed photograph that fits the narrative structure is preferable to a better composed one that fits less well. When the photo story works as it should, the reader/viewer, properly guided by the captions and layout, expands the implications of each individual picture through memory and imagination until the whole "take[s] on something of a motion picture's fullness and fluidity."[94]

Nancy Newhall thoroughly objected to this subordination of photographs to words. She thought that "the power of the photograph springs from a deeper source than words—the same deep source as music." In addition, she thought of images as being prior to words in the development of our cognition and, therefore, more immediate: "Long before we learn to talk, sounds and images form the world we live in. All our lives that world is more immediate than words and difficult to articulate." Photography is best used, then, not to explicate the world of social activity, but to touch the realm of ineffable feeling. The art of photography lies in evoking nonverbal connotations, "as a poet uses the connotations of words and a musician the tonal connotations of sounds."[95] Words applied to photographs are "crutches" for those who cannot read photographs directly.

Newhall did not object to all associations of words and images, and

she distinguished between several kinds of relationships, expressing particular interest in one poetic type that she called the additive caption. This kind of caption, she explained, "combines its own connotations with those in the photograph to produce a new image in the mind of the spectator—sometimes an image totally unexpected and unforeseen, which exists in neither words nor photographs but only in their juxtaposition."[96] She cited examples of books that employ the additive caption: her own collaborative effort with Paul Strand, *Time in New England* (1950); Archibald MacLeish's *Land of the Free;* and Barbara Morgan's *Summer's Children* (1951). The latter, a collection of photographs of children at summer camp, is in Newhall's opinion, the most successful of the group. Nevertheless, she concluded that the additive caption is still a new, barely explored medium, "like a continent descried from a ship."

More familiar than this poetic form is the photo story that she described, only partly in jest, as internecine warfare among editors, writers, researchers, art directors, and photographers, each maneuvering to protect his own turf and creative effort. Newhall does her best to portray both sides of this battle fairly, but in the end, she depicts the photographer as heroically impatient with words, seeing them as a nuisance, redundant, and distracting. She portrays everyone else as insensitive to the photographer's creative vision. The bureaucratic structure of a picture magazine casts the photographer as an underdog in the struggle for control over the final, published product, and Newhall sees this as an injustice. "Why not make him responsible for the whole photo story in its preliminary state?" she asks. "Then editor, writer, and art director will have an integrated whole, however raw, to polish and perfect, instead of a jigsaw puzzle to initiate and assemble."[97] A primary aim in any publishing project for Newhall is the preservation of the integrity of an individual photographer's vision.

Newhall's characterization of the abused photographer in the bureaucratic jungle of the picture magazine could easily have been based on Hicks's description in *Words and Pictures* of a hypothetical editing session. The scene is the office of the managing editor where he and a group of ten or so subordinates examine photographs of the devastation caused by an avalanche at a ski lodge. Hicks's scenario underscores the importance of the bureaucratic hierarchy time and again. The M.E. (managing editor) is given a mystique that even warrants the detailed description of his office. No one dares speak in his presence unless spoken to: "There is a sense not of restraint, but of repression, in the air. If anybody has anything to say it had better be brief and to the point. The M.E. is in a state of complete concentration. He moves slowly back and forth before the

table, surveying the pictures. The sound most plainly heard is his steady breathing."[98]

In the middle of the session Mr. Luce himself appears, the underlings melt away "in less time than it takes to tell it," and the bigshots confer in private. Then everyone is summoned to return. Onto this scene, the photographer arrives "a little bashfully" (the production man, by contrast, enters the office with "a firm step") and stands in the crowd while a researcher answers the M.E.'s questions about his photographs. The M.E. gives the photographer no special consideration in the editing process. Indeed, in an aside, Hicks tells us that his judgment cannot be trusted because it is too colored by emotion and personal attachment to the photographs. The photographer asks meekly for a double truck, the group laughs, and he blushes apprehensively until the M.E. "soothingly" tells him the double truck is a possibility.

Eventually it becomes apparent in Hicks's book that the low status of the photographer, so graphically described in the fictional editing meeting, has to do with something beyond the primacy of verbal ideas in the picture story. It is an issue of professional status and even class. Writers, and by association editors, have a much longer and illustrious professional tradition than photographers, and perhaps more important, editors are college educated whereas photographers (in 1952) generally are not. Hicks hopes that in the future, more photographers will go to college. Then, he says, they could become editors someday.[99]

The Rise of Popular Journalism
Nancy Newhall spoke for photography as a purely visual medium and a high art, and McCausland spoke for politically self-conscious photography. But from the mid-forties through the fifties, the dominant form of photography in this country was popular photojournalism, and people like Hicks commanded the greatest authority. Popular photojournalism reigned everywhere: in the mass press, the photographic press, and in the Museum of Modern Art, the single museum to give an important place to photography.

As popular photojournalism rose in importance, politically conscious photography came under attack. Stryker's photography project was ultimately destroyed by budget cutbacks at the FSA that were part of a conservative backlash against what was seen as the organization's "bleeding heart and long-hair" policies designed to undermine the interests of the commercial farming industry. There was also at least one accusation that an FSA bureaucrat was a Communist. Some members of the government even wanted to destroy Stryker's photography file. To save his project,

Stryker moved his unit out of the FSA to the Office of War Information. Then he began to lose his photographers to the draft. Ultimately, he had to scramble to preserve his file from destruction or dispersal by transferring it to the Library of Congress. In 1943 Stryker finally resigned from the government, and very soon thereafter, he went to work on a photographic project for Standard Oil of New Jersey.[100]

The Photo League was destroyed by Cold War hysteria. In late 1947 Truman's attorney general, Tom C. Clark, placed the league on a list of "totalitarian, fascist, communist or subversive" organizations. There it was in the company of the Communist Party, the Ku Klux Klan, veterans of the Abraham Lincoln Brigade, and the Civil Rights Congress. When news of Clark's move reached the league, the members met, and Paul Strand delivered an impassioned and eloquent speech in which he declared that although all present were shocked, they had, in fact, been given the honor of being placed in the vanguard of the defense of free speech and American democracy. Strand went on to make an excellent statement of the political force of artistic truth:

> No use in trying to run away and be afraid and say, "Please, I am a good boy." It won't do any good. We have been picked out because we are articulate people. The artist himself, if he is really an artist, has to tell the truth as he sees it. He can't help himself. As soon as he stops telling the truth, he ceases to be an artist. The reactionary forces are quite aware that we, the photographers, the painters, radio commentators, film writers who have a craft and medium by which to express ourselves, will tell the truth, once we see it. And artists have a good sense of the truth. And that is why they want to silence us.[101]

The league lingered on after Clark's blow, but was seriously damaged by the increasing tension of the Cold War and finally disbanded in 1951.[102]

As the popular photojournalism of the mass press became dominant, political commitment was replaced, in part, by a cult of personality. Photographers became celebrities, their photographs were considered as trophies for feats of daring or seduction. An excellent early example of these attitudes—applied to work of the thirties that presented itself as reform-minded social documentation—is an article about Margaret Bourke-White and her photographs for *You Have Seen Their Faces.* First published in the *New York Post,* the article was reprinted by James Agee at the end of *Let Us*

Now Praise Famous Men as an example of the exploitative and sensational treatment of the rural poor that he had so painstakingly avoided.

May Cameron, Bourke-White's "critic," begins with a discussion of Bourke-White's expensive red coat: "This famous photographer, just past thirty, can well afford Hollywood's best," she tells us. After more of the same, Cameron eventually comes to the issue of photography: "And this is the young lady who spent months of her own time in the last two years traveling the back roads of the deep south, bribing, cajoling, and sometimes browbeating her way in to photograph Negroes, share-croppers and tenant farmers in their own environments."[103] The description of Bourke-White as brow-beating and cajoling is probably accurate, but it is not offered in criticism. Her subjects are strange creatures who deserve no better. The star of the show is Bourke-White who was brave enough to mix with these types and clever enough to bribe one to get a picture. The article ends by describing Bourke-White's interests in the tango, theater, swimming, ice skating, skiing, horseback riding, and the movies.

The Museum of Modern Art was right behind the mass press in encouraging the shift toward popular photography. As early as 1942, the museum had shown signs of its intention to treat photography as a popular art when it invited Steichen to mount his *Road to Victory* exhibit. In 1943 the Museum opened a Photography Center. John Abbott, executive vice-president of the museum, made it clear in a statement in the museum *Bulletin* that the point of the center was not to nourish a scholarly approach to photography but to garner the support of the photographic industry and the medium's "vast and devoted following" so as to become a focal point of activity in "the most democratic and widely practiced of the arts."[104] In the same *Bulletin*, Alfred Barr, who was then director of the museum, explained that the success of the photo magazines had firmly established photography as a "popular art, an art of, by, and for everybody." The new Photography Center, he said, was meant to encourage the amateur photographer.[105]

Also in 1943 Willard Morgan was appointed Director of the Department of Photography at MOMA. Beaumont Newhall, who had helped found the department, was away in the air force at the time, and Nancy Newhall was working as acting curator in his place. Morgan held his position as director for only a year, but his appointment was another indication of the direction the museum was choosing. Morgan was not a scholar. He came to MOMA from two years as an editor at *Life*. Barr wrote of him, perhaps in a defensive tone, "Although his activities have been chiefly in the technical, journalistic and popular fields, he has a lively regard for the history and study of photography as a fine art."[106] Morgan himself said, "It

is not my intention to force photography in a narrow or precious direction, but here at the Photography Center to encourage its varied possibilities and affirm its simple honesty."[107]

After the war, MOMA offered Steichen the directorship of its photography department. He and Tom Maloney, the editor of *U.S. Camera,* had a plan to solicit one hundred thousand dollars from ten manufacturers of photographic equipment with which to run the department and build an exhibition space.[108] Beaumont Newhall was to work as curator under Steichen, but feeling he had been undermined, Newhall resigned from the museum and eventually took a job setting up the photography museum at the George Eastman House in Rochester. Under Steichen, the popular journalistic aesthetic became thoroughly entrenched at the museum. As Milton Brown lamented in a *Photo Notes* review of one of Steichen's shows, "The magazines seem to have captured photography, box, film and tripod."[109]

CHAPTER 4
POPULAR CRITICISM

From the mid-forties through the fifties, American photography was dominated by a popular aesthetic of which three major components were photojournalism for the mass press, advertising photography, and amateur photography. Common to all three of these, and at the heart of the popular aesthetic, was an emphasis on intellectual and emotional accessibility and consumerism. The guardians of photographic history were now the magazines, and the spokesmen for photography, the magazine editors. Thus it was perfectly in character for the fashion magazine *Vogue* to print a series of articles on the history of American photography in 1941. M. F. Agha, art director for Condé Nast publications, breezily explained their purpose: "Now that everybody photographs everything—now that half the population is at one end or the other of a camera, we thought that our readers might like to know about the curious, twisting trail of American photography in general and *Vogue*'s photography in particular."[1] Agha went on to explain that photography is the most modern form of art, an "instantaneous art for busy people, simplified art for people without artistic training, mechanical skill and genius for mass production turned to art."[2]

Amateur and commercial photography were shaping the culture, Agha said. Eighteen million families were taking six hundred million photographs a year and spending more than $100 million. The millions of commercial photographs reproduced in magazines were "the daily aesthetic diet of an American who is too busy to go to exhibitions and museums; they have formed his taste, educated his eye, broadened his 'visual culture.'"[3]

The mass press not only defined photography for its public but also served as the only significant outlet for professional photographers. Irving Penn, a premier fashion photographer, was moved to declare in 1950, "The modern photographer stands in awe of the fact that an issue of *Life* magazine will be seen by 24,000,000 people. . . . He then works for publication, he has become in fact a journalist. . . . Whatever vehicle he chooses, for the modern photographer the end product of his efforts is the printed page,

not the photographic print." The photographic print, of course, could be treated as a precious work of art, whereas the printed page could not, but for Penn, art was not the main point: "The modern photographer does not think of photography as an art form or of his photograph as an art object In modern photography that which is art, is so as the by-product of a serious and useful job, soundly and lovingly done."[4]

Penn's comments reflect a renewal of the debate, started by the Pictorialists, about the relationship of commercial photography and art photography. Unlike the Pictorialists, Penn and his fellow commercial photographers at midcentury saw no incongruity between commerce and art. In fact, Penn said, "The fashion magazine is one of the few contemporary media in which commercial success and the highest esthetic standards are not incompatible."[5]

One who dissented from this view was the art historian Milton Brown. Writing in *Photo Notes* in 1948, Brown accused magazines of destroying serious photography. They had destroyed documentary photography by promoting a form of photojournalism that adopted the seemingly artless style of documentary work, but had nothing of the social purpose that had given documentary photography its power. They had undermined art photography by publishing innumerable fashion photographs that were nothing but empty pastiches of serious aesthetic explorations. In Brown's words,

> the news magazines have spawned a legion of cameramen who point their lenses and click their shutters with frantic repetition and the naive hope that they are creating a documentary picture of our times. . . . Without . . . social purpose the documentary style of the cameramen who work for *Life, Look, Fortune,* etc. is left only with a dry skin of pointless and dull recording of accidental and fragmentary facts of human activity, without meaning, taste or esthetic quality.
>
> On the other hand, the men who work for the fashion magazines—*Vogue, Harpers' Bazaar,* etc.—have become "esthetic" in the worst sense of the word. They have borrowed from the generation preceding the documentary group and from the latest schools of painting a whole set of superficial tricks and attitudes which gives to their pictures an air of sophistication and modernity that is the special hallmark of the class publication. The intense and honest search for an esthetic language based directly on the character of the photographic medium has been perverted into a bag of clever tricks.[6]

James Agee and Lincoln Kirstein also attacked popular photojournalism, describing it as a purveyor of visual habit that dulls the mind. Agee wrote of the popular press as a "prodigious apparatus" grown up to feed a never satisfied appetite for visual facts, an apparatus of standardized forms that acts as a "contraceptive on the ability to see."[7] Kirstein saw the press as having produced a body of visual material that "drugs the eye into believing it has witnessed a significant fact when it has only caught a flicker not clear enough to indicate a *psychological* image, however solid the material one."[8] Several writers, including Kirstein, blamed the superficiality of photojournalism on the idea of the "candid camera," an idea they felt encouraged photographers to grab at moments that revealed the atypical, contingent, and shocking image rather than the typical, profound, and true one.[9] In a world of candid photographs, the public had lost its capacity to see, and could only glance and glimpse.

Edward Steichen

One thing the public (and the critics) could see quite clearly was the glamour of certain photographer-celebrities, and the king of these was Edward Steichen. Steichen had several successful careers in photography. He was a member of Stieglitz's Photo-Secession; he was a war photographer in both world wars; in the twenties and thirties, he was a successful fashion and celebrity portrait photographer, working for Condé Nast at *Vanity Fair* and *Vogue;* he was an occasional curator at the Museum of Modern Art during the Second World War; and after the war, he became Director of the Department of Photography at MOMA, a post he held from 1947 to 1962.

By the thirties, Steichen had rejected the separation of art and commerce upheld by the Pictorialists and straight photographers, and had become a vocal proponent of the aesthetic integrity of commercial work. He said:

> I welcome the chance to work in commercial art. If I can't express the best that's in me through such advertising photographs as "Hands Kneading Dough," then I'm no good. . . . As a matter of fact, the great art in any period was produced in collaboration with the particular commercialism of that period—or by revolutionists who stood clear and clean outside that commercialism and fought it tooth and nail and worked for its destruction. In the twilight zone of the "art for art's sake" school all things are still-born.[10]

Steichen's sentiments drew strong criticism from Paul Rosenfeld and Paul Strand, spokesmen for the artistic tradition of straight photography

who felt that Steichen was betraying the values of that tradition. To work for money rather than an impulse stronger than oneself, said Rosenfeld, is to deny spirit and to give in to the irresponsibility and jobbery of advertising that is the enemy of art. Rosenfeld thought that Steichen had violated the precious autonomy of art and its freedom from any material purpose.[11]

Strand also took as a given that advertising cannot be good art nor can anything that is mass produced. In a passage that mockingly describes what has actually become the serious activity of appropriationist artists and historians of material culture, Strand envisioned the possibility of taking advertising seriously:

Get busy with your scissors on the back numbers of *The Cosmopolitan* and the old *Masses* with a special eye to Harrison Fisher and Robert Minor! Or if you are not a true collector, but occasionally buy what you spontaneously enjoy, don't purchase anything! Get gratis the passionate penetration of life gleaming on the billboard of the young Adonis who would walk a mile for a Camel! And you who care for poetry or prose need not acquire the books of Joyce or even of Sandburg, all art for art's sake stuff. The living thing is there, free, in streetcar and magazine: those profound and moving songs which celebrate the major tragedies of "B.O." or the infinite pathos of "No Sox Appeal."[12]

At the heart of Strand's criticism of the union of art and advertising was the observation that in such a relationship capitalist values and corporate structures would set the agenda for art. "[W]e are moving more and more into the corporate age," he wrote, "and big mergers in the industrial fabric have their intellectual and moral counterparts."[13] None of this fazed Steichen whose star was rising so quickly that the press soon dubbed him "De Lawd of Modern Photography."[14]

Considering his importance, one might expect Steichen to have received considerable serious criticism as Stieglitz, Strand, and Evans had, but for years the writing on Steichen as a photographer was almost entirely biographical and anecdotal, and his critics, if we may call them that, did little more than shower him with adulation. His brother-in-law, Carl Sandburg, compared his versatility to that of Benjamin Franklin and Leonardo da Vinci.[15] He was regularly referred to as the world's greatest living photographer, although no one explained exactly why. Articles never failed to mention his handsome appearance; the great sums of money he charged for an assignment; his derring-do in the military: "dangling from the fuselage

taking pictures from a height of twenty thousand feet"; the fame of his portrait subjects; and his glamorous persona as a fashion photographer: "He often appears to—and probably does—fall in love with his sitters, but the moment the last plate is exposed his ardor abruptly cools."[16] Steichen began to attract serious criticism only when he became a curator.

Steichen was not a narrow-minded curator. He exhibited many photographers who stood outside the mainstream of journalism and fashion, among them, Frederick Sommer, Harry Callahan, Aaron Siskind, and Robert Frank. He mounted shows with a historical bent, including "Roots of Photography: Hill-Adamson, Cameron," and "Roots of French Photography" (both in 1949). He also did a show in the same year featuring five women photographers: Margaret Bourke-White, Helen Levitt, Tana Hoban, Hazel Larsen, and Frieda Larsen. In 1951 he mounted "Abstraction in Photography." Steichen's forte, however, was as an impresario of popular photojournalism. Shows in this manner included "Power in the Pacific" (1945), "The Exact Instant" (1949), "Korea," "Memorable *Life* Photographs," and "Photographs as Christmas Gifts" (all in 1951). His grandest hour at MOMA came in 1955 with the *Family of Man*, an exhibit done in the three-dimensional, magazine photo-story manner that he had first explored in *The Road to Victory*.

The Family of Man

Working with a budget of $125,000, Steichen and his assistant, Wayne Miller, produced a show of 503 pictures by 257 photographers, which the designer, Florida architect Paul Rudolf, mounted in an elaborate display (including a picture mounted on the ceiling) that led the viewer through a narrative sequence from birth to death, promoting democracy on the way. Steichen described the exhibit as "a mirror of the universal elements and emotions in the everydayness of life—as a mirror of the essential oneness of mankind throughout the world."[17] Carl Sandburg's prologue for the exhibit proclaimed,

> There is only one man in the world
> and his name is All Men.
> There is only one woman in the world
> and her name is All Women.
> There is only one child in the world
> and the child's name is All Children.[18]

In addition to the prologue, the pictures were accompanied by quotations from sources ranging from Lao Tzu to James Joyce.

The Family of Man was an astonishing success. More than a quarter of a million people saw it in New York during its three and one-half months there. It later went on a national tour, breaking attendance records, and then, under the aegis of the United States Information Agency, it was sent on an international tour that included a stop in Moscow. In all, it was estimated that more than two million people saw the show, and according to Hilton Kramer, it received "heavier press coverage than any comparable 'artistic' event in our history."[19] The catalogue of the show, a best-seller, was also widely reviewed.

Despite the show's overwhelming popularity, much of the press coverage was negative. This was in sharp contrast to the way the press received Steichen's earlier blockbuster production, *The Road to Victory*. Of course, that was a patriotic show that appeared during the war, circumstances that made it very difficult for writers to be critical of it. *The Family of Man* appeared in a time of less national unity.

George and Cora Wright published an article in *Aperture* in which they asked whether Steichen's show belonged at the Museum of Modern Art, whether an art museum ought to be mounting shows that dealt with social themes, or whether it was the museum's responsibility to deal with photography itself. George put the issue in a particularly formalist way when he wrote, "a museum has the function of demonstrating that a photograph is more than a mechanical slice of space-time. It has an intrinsic value beyond the facts it happens to record. Isn't this the real crux of the matter?"[20] In addition to the intrinsic value of photographs, the Wrights were also interested in the expressive visions of individual photographers, and Steichen, they thought, had subordinated the visions of 257 individuals to his own interpretation of his theme and to his own sense of dramatic presentation.

Other reviewers had similar criticisms of Steichen's dominating curatorial vision. Photographer Rollie McKenna, writing in *The New Republic*, said he was determined to resist Steichen's and Rudolf's presence in the show so that he could consider individual works of accomplished photographers, but he could not. The extreme blowups, the free-standing silhouettes, the photographs mounted on pink and lavender poles, the cropping of photographs to fit a prearranged space, and other such practices that "often are anathema to a photographer," all added up to a "display so elaborate that the photographs became less important than the method of displaying them."[21] Another reviewer commented that Steichen's conservative taste in photographic technique excluded all technical deviations from conventional journalistic practices any of which might have emphasized an individual

vision.[22] Edwin Rosskam pointed out that many of the photographs were clearly chosen to fill a hole in the development of the theme and that their inclusion had nothing to do with their quality. As a consequence, much of the show was mediocre.[23]

Another issue the Wrights touched on had to do with the question of what kind of public the museum wished to cultivate. Was this major museum to serve mass taste and reflect mass culture, or was it to serve a tiny elite in the photographic art community? The Wrights entertained the idea that the museum might have some justification for mounting exhibits that looked like magazine spreads and that played to a mass audience on the grounds that such shows accurately reflected the way photography was being used in modern culture. They also toyed with the thought that any public exposure of serious photography was a good thing, even if the form of that exposure was flawed. But in the end, they rejected these ideas and concluded that the museum's mission should be to educate the public about photographic art. Alfred Barr had used MOMA to educate the public about modern painting, now the same should be done for photography.

Rosskam did not entirely agree. He thought that in other shows Steichen had given proper due to the "purely esthetic preoccupations of modern photography," and that now he was demonstrating that photography is a language that can be used to "talk about things of interest to everybody." Furthermore, by treating photography primarily as a medium of communication, as opposed to personal expression, Steichen was "identifying the special characteristics which give that medium its own and individual potential, and putting his finger on its peculiar and most current function in its time."[24] Rosskam thus invoked the old modernist cry of truth to the medium in a new context: the truth of photography is not form but narrative content. Clement Greenberg had already defined the essence of photography in very much the same terms in 1946.

Steichen's premise for *The Family of Man,* the universality of the human condition, provoked even more vigorous debate than the design of the show or Steichen's concept of photography. One reviewer rejoiced in Steichen's vision of unity, seeing it as therapy for the turmoil of the postwar world: "[the show's] *raison d'être* was the praise and appreciation of the human family in the silencing variety of its conditions—and the promotion of love. It came off. It was done with great imagination, begetting power and beauty, in order to warm and encourage this chilled and orphaned generation."[25]

Others saw Steichen's belief in unity as too glib and blind to the complexities and difficulties of the real world. Phoebe Adams, the reviewer for

the *Atlantic Monthly,* noted varieties of strife that Steichen minimized or neglected. There were no images of deliberate evil, little evidence of psychological turmoil, no hint of fanaticism. Steichen's vision was too sanguine. In addition, said Adams, he focused exclusively on superficial physical evidence of universality and neglected what accounts for the truly significant differences among people. It is our interior lives and our "intangible beliefs and preferences" that divide humanity.

Hilton Kramer concurred. Like the Wrights, Kramer was upset with Steichen for using his powerful curatorial position to direct photography toward journalism, but having chosen that path, Kramer expected Steichen to reveal something substantial. Instead, the show fell into what Kramer considered an embrace of "all that is most facile, abstract, sentimental, and rhetorical in liberal ideology." While Sandburg presented us with a "terrible parody of Whitmanesque sentiment," Steichen propounded the "Geneva spirit," an ideology that "takes for granted the essential goodness, innocence, and moral superiority of the international 'little man'. . . [and] conspires to urge wholesale acceptance of rhetorical solutions to critical issues."[26] Kramer insisted that the superficial universality of mankind is sundered by the political realities of actual life, and that for Steichen to ignore this was irresponsible.

It may be that Steichen wished to assert the unity of the human family on cultural and biological grounds that transcend political differences. Perhaps Kramer, blinded by the Cold War, was too quick to see political reality as the ultimate reality, and he missed Steichen's point. But if Steichen was making his case at a cultural and biological level, he was doing so without subtlety or sophistication. The psychologists, anthropologists, and ethologists who have made the case for universal human nature have accepted the tremendous variety of human culture and have searched for a unifying structure within that variety, but Steichen attempted to assert universality by assimilating diverse cultures to Western, middle-class standards of behavior; in other words, he essentially denied variety. Steichen betrayed his bias from the very outset of his project in the language he used in a published call for photographs. He wrote of his concern with "the individual family unit as it exists all over the world," and thus acknowledged the Western nuclear family but denied the extended family and tribal structures of kinship so common outside the Western middle class.[27]

A few of the critics of *The Family of Man* sensed Steichen's ethnocentrism. Edwin Rosskam noted that 163 of the 257 photographers represented in the show were Americans, and he wondered if this reflected the quality of photography from other countries or "a certain provincialism in

the selection."[28] Phoebe Adams noted that the show confined the subject of death to "easily comprehensible Western custom."[29] Much later, a number of other commentators added similar criticisms, among them Henry Holmes Smith, who called the show "white supremacist, anti-black, anti-third World. I mean, it was a shame beyond belief, that show. And that set the tone for what was to come in the late '50s."[30]

For all its shortcomings, *The Family of Man* rendered a service to the American photographic community simply by provoking serious discussion. Steichen's curatorial policy in general—his paternalistic treatment of photographers' work, his concern for the mass audience over the elite of the photographic art world, and his interest in popular themes over aesthetic issues—had the beneficial effect of reviving fundamental questions about photography that had lain dormant during the reign of documentary photography. Was the museum a place to articulate a social vision; what was the relative importance of photographic form and photographic subject matter; how should photographers and curators share control over the presentation of photography? Although the supporters of photography as a fine art felt stifled by Steichen's dominating presence, he gave them a centralized and clearly defined target, something they had not had in the previous two decades when the relationship between art photography and documentary photography was so ambiguous. The artists had no museum and no leader in a position to define photography for the public, as Stieglitz had done, but they did have something solid to push against in Steichen and what he represented at the Museum of Modern Art.

The Popular Press

Steichen was not the only force to stifle art photography in the fifties. Equally powerful was the popular photographic press that had emerged along with the picture magazines in the thirties. This press was an integral part of the mass-circulation magazine phenomenon in both its timing and its substance. The first issue of *Popular Photography,* which became the leading photographic journal in the United States, appeared just six months after the first issue of *Life* and three months after the first issue of *Look.* Two other popular photography magazines were started at about the same time: *Minicam,* later called *Modern Photography,* also begun in 1937, and *U.S. Camera,* begun in 1938. These new magazines were all directed at a different readership from the one attracted to already existing photography magazines. The older publications catered to salon photographers who practiced the resurgent form of Pictorialism, which required the mastery of complex techniques and a high level of craftsmanship. The popular press,

along with the photographic industry that supported it, sought always to simplify technical practice and to reduce the necessity for skilled craftsmanship. The salon photographers were generally suspicious of small cameras and candid photography. The popular press focused almost exclusively on small-camera photography. The salons, with their elaborate systems of judging prints for exhibition, appealed to a sense of elitism. The popular press took a vigorously democratic position premised on the idea that "photography belongs to everyone."

By the fifties, the popular press had created a seductive milieu. Holding out the goal of self-expression and the model of the successful professional, the press enticed amateurs to buy expensive equipment. It then instructed them in its use, making them feel at ease with it and empowered by it, playing on the camera's phallic allure. On the occasion of *Popular Photography's* fifteenth anniversary, the magazine crowed that it had "devoted many of its pages to lively how-to-do-it articles and spread the cheerful gospel that photography is a lot of fun."[31]

The combination of the democratic appeal, the fascination with high technology and pseudoprofessionalism, plus a dose of tepid cheesecake on the covers and in the advertisements, all made the new popular magazines major successes. By its second year, *Popular Photography* had reached a circulation of more than 164,000, a figure that dipped slightly during World War II and then rose again rapidly to almost 400,000 by 1955. *American Photography,* the largest of the older magazines, had a circulation of only about 18,600 in 1937, the year *Popular Photography* was launched.[32]

Jacob Deschin

One of the most widely read proponents of the popular aesthetic was Jacob Deschin, who made his career at *The New York Times* rather than one of the popular magazines. Deschin had begun his career with the magazines in the mid-thirties, but in 1941 he started a freelance column for the *Times,* and five years later, after an interlude in the military, he produced the column as a weekly feature. Deschin retired from his position as photography editor at the *Times* in 1970.

In his own words, Deschin chose "to be a reporter for, and not a critic of, photography."[33] He was a thorough and imaginative reporter. He covered exhibits, publications, lectures, technical issues, and equipment. He was aware of the salon world, the shows at MOMA, and the work of those art photographers who rejected the popular aesthetic. In 1954 he wrote a column bemoaning the dearth of photography galleries in New York, and he praised Helen Gee's Limelight Gallery as the only one "with a truly

responsible attitude toward the medium related to a continuing program for showing photographs."[34] He also wrote about the nascent efforts to teach photography in the universities. He visited Chicago in 1954 to report on the program at the Illinois Institute of Technology, and in 1956 he wrote about Henry Holmes Smith's plans for a summer workshop at Indiana University.[35] Always, Deschin was respectful of the people he wrote about. In addition, he was sensitive to the different audiences he addressed. He wrote of a Harry Callahan exhibit, "Highly subjective, his work is not for mass appreciation, but a delight for those who can respond to the subtleties of his intensely personal visual experiences."[36] The latter group, however, was not Deschin's true audience. He was far less excited by the renewal of art photography in the fifties, of which Callahan was a major part, than he was by the democratic vision.

Deschin wrote for his mass audience most directly in his books. *Say It with Your Camera* (1950)—Deschin's fifth book and his fullest statement on photographic theory—is addressed to the amateur photographer in the belief that "amateur photography as a medium of personal expression has now reached maturity."[37] Deschin obscured the obvious ties between photographic democracy and the photographic industry in *Say It with Your Camera.* In his newspaper columns, he often reviewed new equipment (much of which salesmen allowed him to examine months before it was available to the public in the knowledge that his published opinion would encourage sales), but in his book, Deschin minimized the importance of hardware in favor of his ideal of universal, personal expression. Over and over he enlisted the clichés of art to legitimate his encouraging message to the middle class that they have something of value in them, that they themselves are not standardized mass-produced items, that they are unique individuals, and that photography can be a form of art they may use and need not fear: "Dare to be individual. Speak your mind photographically. Don't turn away deliberately from the real things and real feelings that you know to be empty artificialities. Face your life and its realities. Try to understand them and learn to reveal them through your camera. In that way you will grow, both as a person and as a photographer. . . . Every picture is a self-portrait—or should be—of the kind of person you are."[38] He quoted Steichen: "Photography is a folk art. . . . Photography should be a means of free expression, motivated by the desire to record the insignificant and interesting aspects of daily life and unhampered by pictorial clichés."[39] Even Stieglitz, champion of the privileged sensibility, was enlisted in the democratic cause as a "stimulating example" of the lesson "that the photographer must rely on himself for originality, that he must depend upon

his own understanding and inventiveness, free himself from inner doubts of his own worth and from outside compulsions to copy the past and to ape the work of contemporary photographers."[40]

The irony of Deschin's message is that he did not truly intend to encourage freedom of thought and expression, but to give the illusion of such encouragement while telling his audience exactly what to do. He made it plain that good photography was not abstract and did not veer from essentially straight technique. Photograms (which had become a common pedagogical tool in nascent academic photography) or multiple exposures might, in Deschin's opinion, be useful as exercises or experiments, but they had no intrinsic meaning and were rarely successful as photography.

Good photography dealt with people and their artifacts: "When you get too far away from people, you lose the human touch essential to the finest opportunities photography has to offer." For Deschin, pictures of people were attractive for their spontaneity and their narrative content, and the "most revealing" pictures of people were candid ones made with a small camera.[41] In short, Deschin's ideal of amateur photography was a backyard version of documentary humanism, drained of social purpose and scaled to the experience of the middle class.

Bruce Downes

The most devout champion of the popular-photojournalistic aesthetic was Bruce Downes, editor of *Popular Photography.* Downes, whose real name was Arthur Busch, had begun his career as a newspaperman, writing about drama and literature under the pen name Michael March; when he began to write about photography, he invented Bruce Downes. Downes started at *Popular Photography* in the early forties as a contributor and then worked his way up through the editorial ranks. He left the magazine briefly in 1948 to start a new publication, *Photo Arts,* which failed. He then went to *Colliers* as picture editor but soon returned to *Popular Photography* where he became a contributing editor, then executive editor and publisher, and finally editorial chairman. Downes died of a stroke in 1966 in Korea while on a State Department–sponsored tour, lecturing on photography.

Downes was not a perceptive thinker or a good writer, and it would not be worth taking him seriously in a survey of criticism had he not had so much power in American photography as the chief spokesman for the major publication of his time. Since Stieglitz had ended *Camera Work* in 1917, there had been no stable forum for criticism of photography, and Downes found himself filling that vacuum. In a 1964 tribute to Downes,

Philippe Halsman complained of the absence of critics of photography and then asked where is just one dominant critic with the "constant presence and force of an arbiter" comparable to an Edmund Wilson, John Canaday, or Brooks Atkinson? He concluded, absurd as it may now seem, that only Downes fit the bill.[42]

Regardless of whether Downes thought of himself as a solitary giant in his field, he too was concerned with the paucity of photographic criticism, and he published a call for critics three times (in almost identical form) in 1943, 1951, and 1962: "Great art, said Walt Whitman, demands great critics. True criticism is the salt of aesthetics. In photography, however, there are not only no great critics, but even moderately competent critics are as rare as the doodle-bird." The problem with the criticism of photography was that it was too wrapped up in the technical processes of the medium: "There are plenty of carpers and darkroom lawyers, technicians, mechanical and chemical experts passing in the guise of critics. But there are not critics in the civilized sense of that word. Their stuff is mere shop talk."[43]

Downes was optimistic about the future of photography and its criticism. History was on photography's side: values were changing, a new order would form after the war, and photography, the truly democratic art, would then emerge as a dominant art. Photographic geniuses, great pictures, and great critics would all appear. "When the great critics emerge there will be a huge audience waiting to listen, to understand, to recognize, and to buy pictures for the walls of their homes." Downes continued with an interesting digression, "After the war modern architecture will sweep the country. Homes will be simple in design, cool, sleek, utilitarian. Photographs will hang on those walls as naturally as bark on trees. Photography and modern architecture complement each other perfectly."[44] For a moment here, Downes glimpsed a gleaming, Bauhaus-designed future, but this vision was fundamentally at odds with his more basic antimodernist sensibility, and it vanished as abruptly as it had appeared.

Despite Downes's efforts to "follow his own advice" and write criticism, he was never able to come to grips with any specific photographs except at the most superficial level. One of many examples of his shallowness can be found in a favorable review of Werner Bischof's *Japan* in which Downes's most penetrating comment is that the pictures "project the facts, the moods, the traditions, and the atmosphere of a strange and wonderful country." They remind us "how far beyond mere documentation a photojournalist can go, if he has the eye and heart and skill which were Werner Bischof's."[45] Downes said nothing about what facts, moods, and traditions Bischof revealed or how he treated them.

Much of Downes's problem with saying what he saw in pictures was a result of his determination to define photography as an independent art. This was not a definition born of a commitment to modernist values, however. It was more an expression of a basic anti-intellectualism. In Downes's hands, the independence of photography meant its isolation from the world of ideas.

Downes was aggressive about his anti-intellectual stance, attacking high art photography throughout his career. On the occasion of the establishment of the Photography Center at the Museum of Modern Art in 1943, he took the opportunity to praise Willard Morgan and to jab at the absent Beaumont Newhall: "Photography as a democratic art will gain in strength at the Center under Willard Morgan . . . whose catholic tastes and broad experience should yank the Museum's photography department from its tendency to lapse into precious, esoteric fogs."[46] As evidence of esoterica, he cited repeated showings of such photographers as Walker Evans, Ansel Adams, Edward Weston, Dorothea Lange, Man Ray, and Laszlo Moholy-Nagy. Faced with an exhibition of photograms, solarizations, multiple prints, and so forth by Moholy-Nagy, Carlotta Corpron, Gyorgy Kepes, and others, Downes was reduced to insults. He accused the photographers of "pretension and esoteric posings," "aesthetic boondoggling," and making pictures that are "perversely complicated and obscure."[47]

He had no patience for the socially conscious photographers, calling their work "lugubrious studies of sad-faced under-privileged children, fat women and old men."[48] When others criticized *The Family of Man,* Downes rushed to Steichen's defense, calling his detractors "obscurantist critics, cavilers." In mounting such a popular show, Steichen had accomplished exactly what he had set out to do, and he had done more to promote photography in two years "than Stieglitz and all his pious satellites ever accomplished in all the years of their precious coterie."[49]

In the fifties, when there began a profound shift toward subjectivity in art photography, Downes fought harder than ever. The renewal of subjectivity took two forms. One was a move away from the supposed objectivity of socially concerned photography toward an unabashedly personal approach to social issues. The other form was manifested in a renewed acceptance of abstraction in photography and an overt acceptance of a relationship between photography and painting.

At first Downes saw the move toward subjectivity in terms of technique and tried to reconcile himself to it. He lamented that "too many talented young photographers have come to disdain technique in favor of a loose kind of freewheeling approach."[50] He gently accused Steichen of fostering

the lack of respect for technique through his exhibits at MOMA.[51] But about ten years later, he conceded, that "however important it may be—and I come to this conclusion with deep reluctance—mastery of printing techniques does not appear altogether essential to solid achievement in photography."[52]

Downes eventually had to acknowledge that new technical standards in small-camera photography were intimately coupled with a new, critical, and subjective social vision. The purveyors of this vision were pariahs, "Photointellectuals, looking like beatniks, . . . appearing increasingly in such odd places as the rapidly spawning coffee-house picture galleries." (The reference is to the Limelight Gallery, which Deschin had praised and which supported itself with an adjoining coffeehouse.) The odious "Photo Bohemians" had beards, sneakers, and a "perverse penchant" for poverty, and worst of all, they refused to compromise with editors, photographed according to their own standards, and foolishly tried to find a market for their photographs outside the magazines.[53]

When Robert Frank published *The Americans* in 1959, Downes recognized it as the quintessential statement of all that he held in contempt. "They are images of hate and hopelessness, of desolation and preoccupation with death. They are images of an America seen by a joyless man who hates the country of his adoption. . . . [Frank] is also a liar, perversely basking in the kind of world and the kind of misery he is perpetually seeking and persistently creating. It is a world shrouded in an immense gray tragic boredom. This is Robert Frank's America. God help him."[54]

Downes's review of *The Americans* was one of seven published in *Popular Photography* under the collective title, "An Off-Beat View of the U.S.A." Most of these reviews were as fiercely negative as Downes's. Arthur Goldsmith said the book was not about Americans but about the "wild, sad, disturbed, adolescent, and largely mythical" world of the Beat Generation. James Zanutto called the book a "sad poem for sick people," and wondered if such a subjective statement, which had only to do with the personality of Robert Frank and nothing else, merited publication.

The howls of indignation over Frank's book arose partly from the fact that Frank thoroughly contradicted the critics' expectations. Most reviewers assumed that Frank was, or ought to be, a typical photojournalist. Indeed, Frank could produce the kind of traditional work that pleased *Life* or Edward Steichen; in 1951 he had won a second-place prize in *Life's* Young Photographers Contest, and Steichen had included his work in *The Family of Man.* But in *The Americans,* Frank rejected the familiar and comfortable patterns of sentiment and sensationalism, as well as the tidy technique (sharp focus, minimal grain, level horizons) that passed for professional

photojournalism, and he replaced them with an unabashedly personal and critical vision articulated in a rough and spontaneous technique.

Instead of recognizing his socially committed art for what it was, reviewers tended to see it as failed photojournalism. William Hogan wrote in the *San Francisco Chronicle* that Frank's pictures "lack sociological comment and have no real reportorial function. They remain merely neurotic, and to some degree dishonest."[55] Zanutto objected to the "relaxed, snapshot quality" of Frank's work. Les Barry, another of the reviewers in *Popular Photography,* voiced the most typical complaint when he said that Frank's vision was too biased and too narrow to carry such an inclusive title as *The Americans.*

What was seen as Frank's narrow bias was, in fact, his capacity to put his finger on some very sore spots in the American psyche. He looked directly at the nation's racism, excessive materialism, vacuous patriotism, and spiritual emptiness, and he did so at a time when these were not matters of broad public discussion. In the thirties, people had generally accepted the difficult material of documentary photography because the whole nation was in visible economic crisis, and documentary photography spoke of human dignity and triumph of the spirit. But Frank's vision was much darker and more biting. As Charles Reynolds whined in *Popular Photography,* "The only slight vestiges of nobility left in this wasteland of vehicles, jukeboxes, and American flags are possessed by Negroes and small children."[56] That was precisely Frank's point.

Frank's admirers, and there were some, saw the unsparing aspect of his vision as clearly as his detractors, but these critics accepted Frank's harsh insights. In addition, they often saw a quality of lyricism in his work. An unsigned review in the *New Yorker* spoke of his "brutal sensitivity" and pointed to "the mechanization . . . the clutter . . . the vulgarity . . . the flashes of beauty . . . and the space and lostness" in Frank's pictures.[57] Donald Gutierrez wrote that Frank revealed "a vast commercial squalor on the one hand and an actual physical and potential cultural beauty on the other."[58] Walker Evans, who had encouraged Frank to apply for the Guggenheim grant that had allowed him to carry out his project, saw Frank's vision as "positive, large, and basically generous."[59]

This was the way Frank saw himself. He was the fresh European eye seeing incisively into American culture with passionate commitment, honesty, criticism, and concern. Frank never intended *The Americans* to be a work of standard photojournalism, the products of which he called "anonymous merchandize." In his application for the Guggenheim grant he said that his project "is only partly documentary in nature: one of its aims is

more artistic than the word documentary implies."[60] And in a statement published in *U.S. Camera* in 1958, the year before *The Americans* appeared in the United States, Frank acknowledged that his view was personal and that he had ignored various facets of American life and society while seeing things invisible to others.

Frank was the personification of one kind of detestable Photo Bohemian for Downes. Aaron Siskind personified another variety and perhaps a more pernicious one because he enjoyed a modicum of support from artists and "photo-intellectuals," which Frank, at first, did not. In addition, Siskind deliberately pursued images and ideas that spoke of an open relationship with abstract painting, a sin that placed him on the same level of hell as the Pictorialists, for as Downes made abundantly clear, any overt relation between photography and painting was evidence of imitation and fakery. Downes saw Siskind's art as a repetition of the Pictorialist imitation of painting, but there was a quality to the relationship of Siskind's photography and painting that had not existed before in this country and that Downes did not recognize.

Earlier American photographers had informed their art with ideas that had already been well established in painting. The Pictorialists looked to Symbolism and Impressionism at a time when these movements were already passé. The straight photographers responded to Cubism much more quickly, but still, they responded to an established art movement. In Europe, photographers were part of the initial manifestation of Dada, Constructivism, and Surrealism, but nothing like that had happened in this country until Siskind, who developed Abstract Expressionism in photography at the same time painters were developing it in their medium. The criticism of Siskind from the mid-forties to the mid-sixties, which Carl Chiarenza has traced in detail, reflects this new relationship between American photography and painting, although it does so ambivalently and with less than clear understanding.[61]

Siskind himself announced concerns that placed him in congruence with modernist painting in 1945 in an essay in *Minicam Photography:*

> The picture—and this is fundamental—has the unity of an organism. . . . It came into being as an instant act of sight.
>
> Pressed for the meaning of these pictures, I should answer, obliquely, that they are informed with animism—not so much that these inanimate objects resemble the creatures of the animal world (as indeed they often do), but rather that they suggest the energy we usually associate with them. . . .

Photographically speaking, there is no compromise with reality. The objects are rendered sharp, fully textured, and undistorted (my documentary training!). But the potent fact is not any particular object; but rather that the meaning of these objects exists only in their relationship with other objects, or in their isolation. . . .

These photographs appear to be a representation of a deep need for order. Time and again "live" forms play their little part against a backdrop of strict rectangular space. . . . They cannot escape back into the depth of perspective. The four edges of the rectangular are absolute bounds. There is only the drama of the objects, and you, watching. . . .

I may be wrong, but the essentially illustrative nature of most documentary photography, and the worship of the object per se, in our best nature photography, is not enough to satisfy the man of today, compounded as he is of Christ, Freud, and Marx. The interior drama is the meaning of the exterior event. And each man is an essence and a symbol.[62]

Siskind's concern for abstraction, flatness, unity of composition, the independence of the picture from the world, his interest in animism and in speaking to people's psychological needs are all similar to the concerns of the New York School painters at the time. Much of what Siskind says here is reminiscent of Rothko's and Gottlieb's famous letter to *The New York Times* of 1943 in which they "reassert the picture plane" and "profess spiritual kinship with primitives and archaic art."[63]

Siskind's ideas went largely unacknowledged and were not well understood, but he acquired some visibility in the New York art world as he began to exhibit at the Charles Egan Gallery, one of the galleries that promoted Abstract Expressionism. On the occasion of his fourth exhibition at Egan in 1951, Elaine de Kooning, herself a painter, wrote about Siskind, calling him a painter's photographer because his audience was composed mainly of artists.[64]

The 1951 show at Egan attracted Bruce Downes's attention. He contrasted it with an exhibit of photographs of the Korean War then showing at the Museum of Modern Art. The war photographers, he said, were involved with a timely and important subject and showed evidence of considerable bravery in their effort to communicate the epic drama to their audience. Siskind, on the other hand, had isolated himself from the world to search for designs in a self-conscious effort to make art. Whereas the war pictures "need no explanations whatsoever," Siskind's pictures do; without explanation, they are likely "to escape the average spectator."[65]

Siskind's acceptance in the art community continued. In 1954 Alfred Barr, director of MOMA, included him in *Masters of Modern Art.* In 1959 Siskind published his first book, and Harold Rosenberg, one of the two major critics of Abstract Expressionism, wrote the introductory essay. Rosenberg's essay was laudatory but confused. For example, he failed to recognize the difference between mechanical reproductions of photographs and original prints, saying that unlike paintings, all the qualities of a photograph are present in reproduction. He even seemed to forget at times that the book contains reproductions of photographs, and he wrote as if the images on the page *are* photographs and, as such, reproductions of the real world. In one particularly ambiguous passage, he called Siskind's photographs paintings. "Instead of scenes that seem like paintings, Siskind's pictures ARE paintings as they appear on the printed page. . . . They are reproductions, though reproductions that have no originals. Or, if you prefer, they are reproductions of 'works' which came into being through the collaboration of anonymous men and nature."[66]

Perhaps more interesting here than the confusion over the status of photographs and mechanical reproductions of photographs is the issue of the tension in photography between representation and the independent image, between trace and transformation. Siskind hoped to master this tension, to use a straight, representational technique while creating an image independent of what it represents. Rosenberg meant to reaffirm Siskind's intentions. When he speaks of reproductions without originals (despite the superficial resemblance to Jean Baudrillard's much later concept of the simulacrum), he is saying that Siskind's pictures reproduce reality but do not reproduce works of art; they themselves are the independent works of art. He articulated the concept of the independent photographic image more clearly when he wrote, "Neither our delight nor our learning would be in any sense augmented if we were told that this blackness was a night sky or a piece of tar paper. . . . In each of these photos it is the separate and unique making, as well as the inspired selecting, that we experience; were the pictured boards or stretches of sand to be physically delivered to us, nothing in them could make up for the loss of Siskind's eye and mind."[67]

Despite Rosenberg's intent in this essay to praise Siskind as a legitimate and original artist, he could not quite see photography as the equal of painting. This may explain why he referred to the abstract photographs as paintings; he was unable to accept them simply as photographs. He made other similar comments, such as, "Siskind has used the camera to make a book on modern art. . . . Siskind almost makes us forget that these are not paintings." He did not say that this was a book *of* modern art. And why,

one might ask, is it a virtue for Siskind to have made photographs that make one forget that they are not paintings when the photographs say what they have to say as photographs?

Another important art world commentator on Siskind was Thomas Hess, editor of *Art News,* who in 1963 published an essay titled "The Walls." Hess began his essay unequivocally saying, "Aaron Siskind is The Photographer in the New York School of painters,"[68] and he went on to elaborate on this point at length. But by the end of the essay, he too, was uncertain about the nature of photographic representation and photographic art. He recognized that Siskind had evoked in photography the tension between illusionistic representation and abstraction that modern painters had worked with, but he was not confident that Siskind was successful in his handling of this tension or that any photographer could be. He was not sure that Siskind could dominate his subject matter sufficiently to pry his images away from the world. He wrote, "The painter can keep his appearances concrete, palpable, 'there' in front of you, while a photograph always tends to slip away from the photographer and change itself into one more frozen view. Siskind works with these pressures." Still, Hess wanted his readers to know that he was impressed with Siskind's work, and he ended the essay by saying that it has the "resonance, breadth of association and appearance of truth which are characteristics of major art."[69]

While the art world was responding to Siskind in the late fifties and early sixties, so was the photographic community. In 1957 Siskind's photographs were the focus of extensive efforts at interpretation in *Aperture.* In 1965 Nathan Lyons mounted a retrospective exhibition of Siskind's work at the George Eastman House. The exhibit catalogue contained an introduction by Lyons that outlined the evolution of Siskind's aesthetic ideas, a revised version of Hess's essay, and an essay by Henry Holmes Smith on Siskind's place in the tradition of straight photography.

Taking up the issue of tension between representation and the independent image, Smith explained that if straight photography was to grasp the full range of modern artistic expression, a way had to be found to reconcile the intensely descriptive capacity of the medium with a method of allusion: "These two resources [illusion and allusion] must be satisfactorily reconciled before photography could be used effectively as a twentieth-century art. For traditional photography, which had been too mechanical, crude, and truthful to fit nineteenth-century art standards, would find itself too heavily burdened with descriptive illusion and too lacking in a capacity for allusion to qualify for the twentieth century."[70]

Stieglitz had come close to solving this problem with his cloud pho-

tographs, but Siskind had finally done so decisively. By using "carefully composed details from nature," Siskind was able to "place the full power of descriptive illusion . . . at the service of allusion." His example "permitted the use of visual figures in ways analogous to the metaphors of language. . . . [U]nlike his less fortunate predecessors who had chosen to imitate the appearance of art and not its impulse, Siskind, straightforward as always, chose to base his work on an inner impulse in complete harmony with the feelings and outlook of the artists whom he knew so intimately in New York from the 1940s on."[71] Unlike Rosenberg and Hess, Smith is clear and confident about photography's capacity to both represent and create an independent image; he is confident about Siskind's achievement in having found a way to make photography do this; and he is confident that such photography is art as photography and not as painting or an imitation of painting. Siskind, said Smith, had brought photography into the twentieth century by allying it with modernist abstraction.

For Downes, the catalogue of the Eastman House exhibit was too much. Hess and Smith, he said, were writing nonsense, and for Smith to say that Siskind had finally brought photography into the twentieth century was "the height of academic frivolity" and "nothing short of canonization." It was a sneaky way of saying that Siskind has shown photographers, once more, how to imitate painting.[72]

Furthermore, Downes thought that for an opinion such as Smith's to appear with the sanction of a museum "points up the way in which museums tend to have a devitalizing effect on photography."[73] With this comment, Downes revealed a degree of disillusionment and even concession to his rivals. Initially, it had been Downes's hope that under Steichen's leadership at MOMA, photography would become thoroughly accepted in museums. He had boasted in 1959: "The old controversy as to whether or not photography is art is dead, and it won't be long before the long-haired curators of many of the nation's art museums wake up to the fact that Steichen's pioneering in New York was more than just the showmanship of a picture impresario, but actually was a courageous and imaginative response to the needs of his time."[74] But after John Szarkowski took over the Photography Department at MOMA in 1962, and as other museums and scholars began to pay more attention to photography, Downes's hope turned sour. Szarkowski's approach to photography was "precious" and his commentary "sheer nonsense."[75] With the celebration of people such as Siskind, Downes decided that photography would be better off without museum attention. Accordingly, he predicted that photography was "hardly likely ever to achieve major status in the world of museums," a world to which artists had withdrawn from reality.[76]

Downes's intellectual shortcomings were such that he ought to have been a peripheral figure in American criticism of photography, but he held such a powerful political position that he was able not only to promote the popular aesthetic but also to act as a substantial obstacle to the revival of expressive art photography. Today we sometimes hear criticism of the artist-photographers and scholars of the sixties for their concern with subjective expression and for their integration of photography into academic art history at the expense of a broader view of photography as it functions at all levels of society. In light of this criticism, it is useful to remember that to those artists and scholars, the alternatives to a fully expressive art and to the integration of photography into traditional academic forms were the commercial and anti-intellectual values represented by popular photography and its spokesmen such as Bruce Downes.

CHAPTER 5
SUBJECTIVISM

In 1944 M. F. Agha proclaimed the triumph of anonymous mass-media photography, the ascendancy of "group journalism," and the imminent death of individualistic art photography:

> Only experts know the names of masters of photojournalism, of commercial illustration: they are suppressed for the greater glory of group journalism, of the teamwork in the advertising field. The battle photographers are anonymous; the scientific photographers are anonymous; the news photographers are anonymous: their names are legion. The individualistic art photographer, swamped by the onslaught of collective straight photography, seems to be doomed to extinction.[1]

For the moment, photographers had been reduced to the level of craftsmen, and editors had gained almost complete control over published photography. But this situation was not to remain stable. Far from dwindling to extinction, the impulse toward individual artistic expression was to come to the fore once again in the course of the next fifteen years.

The desire for independent personal expression was never entirely beaten down, even in the world of team journalism. Eugene Smith became a hero as a photojournalist who bucked the system. He had a tremendously successful career at *Life,* but for each photo story he did, he walked a tightrope between his social and aesthetic principles and the commercial imperatives of the magazine.[2] After an on-again-off-again relationship with *Life* that lasted fifteen years, Smith finally resigned permanently in 1954 over a dispute concerning the artistic control of his essay on Albert Schweitzer.

The fierce independence and combativeness of the Smith persona struck a profoundly sympathetic chord in the community of photojournalists. In a eulogy for "The Vanishing Pro in Photography" published in 1964,

John Durniak described his ideal photojournalist. He did not mention Smith by name, but the description is clearly based on his image:

> My great-man-with-a-camera wasn't the easiest guy to get along with. He made an editor's job both easier and more difficult at the same time. He would challenge concepts, editing, and cropping until they were ready to murder him. Then, he'd go out on an assignment and make the editor look like a million bucks.
>
> The old-time art director usually hated his guts. . . . The photographer somehow became his equal in those bygone days, and they flailed away at each other unmercifully.[3]

Other photojournalists who resisted the domination of editors were those who formed the Magnum agency in 1947. Robert Capa, the driving force at Magnum, was motivated by his resentment of *Life* and the other magazines that not only determined what assignments a photographer got and controlled the use of a photographer's images but also retained ownership of his negatives. Capa wanted to form an agency that would be run by the photographers themselves, give them the freedom to shoot what they wanted, and allow them to retain ownership and control of their work. The original members of Magnum, in addition to Capa, were Henri Cartier-Bresson, George Rodger, David Seymour (Chim), and Bill Vandivert. They ran their organization as a cooperative, each person contributing a percentage of his earnings to run offices in Paris and New York. In return, the agency found assignments for the members, sold their work at good rates, and even allowed them to borrow money from the general pool. The five original members divided the world into several beats: Seymour took Europe; Cartier-Bresson worked in India and East Asia; Rodger worked in Africa and the Middle East; Vandivert took the United States; and Capa roamed all over.[4] Magnum was a great success partly because it remained an exclusive and prestigious club even after it expanded beyond the original membership.

The vast majority of photojournalists could not emulate Smith or join Magnum, and they remained in the editor-dominated system where many of them became increasingly discontented. In 1962 *Popular Photography* published an article called "We Asked the Pros" in which the magazine posed the question: "If you could pick a dream assignment, what would it be?" The answers consistently revealed frustration and longing for freedom of expression and public recognition. One professional said plaintively that his dream would be to have "complete freedom to shoot what I

see, where I see it, and how I see it and then be able to edit and lay it out as I see fit." Another said:

> Commercial objects are, in themselves limiting. For this reason, my dream assignment would be to have complete freedom to explore a product photographically. Not by putting it in impossible or improbable situations, but rather by showing this product as it is ordinarily found and used in everyday life, instead of in the slick, unrealistic situations in which it is usually photographed. Such photographs would be unique and interesting because, for a change, they would be real, uneditorialized statements about the subject.[5]

If commercial photographers were frustrated under the artistic control of magazine editors, they were absolutely furious at the economic control of the magazine corporations. In 1967 the American Association of Magazine Photographers published a bill of rights, which complained that photographers received no residuals from the reuse of their work and that magazines demanded that they relinquish ownership of their images as a condition for receiving an assignment. This "erosion of the legal, moral, and artistic rights of a photographer to his own work" could only lead to an ultimate "decrease of individuality and creativity."[6]

Subordination of the individual for the greater glory of group journalism, it turned out, was neither the inevitable nor desirable course for mass-media photography, as Agha had suggested, but a corporate ploy that strangled photographers economically and creatively. The awe with which Irving Penn had spoken in 1950 of the power of magazines to present one's work to 24 million viewers had worn off by the 1960s. Now photographers wanted to be paid in ways commensurate with the audiences they reached. And Penn's proud assertion that a photographer's images were the product of a useful job well done—rather than art—was no longer satisfying. Now photographers wanted to define their jobs themselves, as artists were doing.

Photography in the Fine Arts
One manifestation of the move back to personal expression in photography was a renewed effort to establish it as a fine art in the mainstream art institutions. A highly visible, if quickly forgotten, gesture toward that end was the Photography in the Fine Arts project of the late fifties and early sixties, organized by the professional photographer and printmaker Ivan Dmitri, and sponsored by *The Saturday Review.* PFA, as it was commonly called,

was an incredibly clumsy and intellectually shallow project, but it has historical interest, nevertheless, because it involved a four-year commitment by a major middle-brow magazine, and at one time or another, the directors of the Metropolitan Museum of Art, the Boston Museum of Fine Arts, the Minneapolis Institute of Arts, and the Baltimore Museum of Art, as well as curators at the Metropolitan, the Brooklyn Museum, the Art Institute of Chicago, and the Museum of the City of New York. The Art Establishment was taking photography under its wing.

Each year from 1959 through 1962, Dmitri solicited nominations of photographs from organizations such as advertising agencies, industrial picture libraries, picture magazines, Columbia University, MOMA, and eventually, the Professional Photographers of America (an organization for studio portraitists), and the Photographic Society of America (an organization for hobbyists). He then submitted the hundreds of nominated pictures to a large jury composed of museum directors, art critics, art directors, and print curators. The shows they selected usually opened at the Metropolitan Museum and then traveled across the country.

To publicize the project, exhibition jurors took turns writing ponderous articles for *The Saturday Review* in which they wrapped their endeavor in the aura of Art and weighty purpose. One such article begins, "On December 6, 1962, we assembled in Ivan Dmitri's large and well-lighted office-studio. . . . In the corner of the biggest room his old etching press, still in perfect working order, gave historical perspective and a sense of the wholeness of the arts."[7] But urbane pronouncements, such as this one on the wholeness of the arts, were window dressing rather than carefully considered guiding principles. In the end, the project was so ill-conceived, it so lacked any kind of substantial idea that would give it shape and direction that one juror had to concede, not without a hint of defensiveness, that it had been "organized as an expression of interest and good will rather than one of exact and precise study."[8]

Not surprisingly, the relation of PFA and the art photography community quickly soured. The first jury included Edward Steichen and Beaumont Newhall, but in the second year, both men refused to return, and Jacob Deschin turned down an invitation to join. The scant but formidable written criticism leveled at PFA by these men and their colleagues, and the defense of the project by the jurors and *The Saturday Review* constitute an exchange of some interest.

The critics had two major points. One was that the selection process for the exhibitions showed too little concern for the tradition of art photography; the other was that the shows had no coherent point of view.[9] It

was pointed out that the nominating organizations represented an unlikely mixture of interests and were therefore guaranteed to nominate a hodgepodge of pictures. Furthermore, it was said that photographers themselves should have been able to choose the prints they wanted to submit to the jury. And finally, it was pointed out repeatedly that although the jury knew painting, prints, and sculpture, they knew virtually nothing about photography. No one elaborated on these objections at any length. Nor did anyone suggest openly that they also had political objections to PFA. It was a matter of pride, reputation, or career for those in the photographic community to define art photography, and they resented watching print curators and directors of museums with no long-standing commitment to the medium acting as if they were its advocates. It was reported that Steichen was peeved at the Metropolitan's claim that it was proving with this project that photography is an art, because MOMA had been showing photographs for almost thirty years, but Steichen said nothing about this matter in print.

To the defenders of PFA, it was by no means self-evident that a juror for a show designed to establish photography as an art need be deeply knowledgeable about the medium. On the contrary, they suggested that if photography were to be a universal art and "communicate directly to human beings of all kinds" (and no one ever challenged this assumption), then it ought to be open to judgment by "sensitive laymen" or by people who understood art in general. As Dmitri put it, "These people are supposed to have an eye for pictures, and this show is a presentation of what they felt to be fine pictures."[10] In other words, photography was treated as having no history (either formal or cultural) and no particular qualities as a medium that might distinguish it in any significant way from etching or painting.

The selection process for the exhibits bore out Dmitri's point of view. The jurors were told, "The idea is to go through this collection of photographs and choose what we as individuals like best without expressing why to the next fellow."[11] Dmitri boasted, "The voting was done in secrecy and silence; not a comment was made which might have tended to influence another juror."[12] The implication is that these people, by virtue of their "long and successful association[s] with the art field," could somehow see the unspecific quality of Art in certain photographs and that this quality need not be questioned, defended, or even articulated. Any photograph that received a majority of votes was automatically accepted. Democracy replaced ideas.

In an effort to make sense of the inevitably incoherent mess this selec-

tion process produced, Margaret Weiss of *The Saturday Review* offered the tautological explanation that the shows answered the question: "What would museum and art experts choose if they were planning to hang photographs in their own institutions' galleries?"[13] Bruce Downes was on the mark, for once, when he summed up PFA as a promotional gimmick and accused the Metropolitan Museum of failing to approach photography with authority and respect.[14]

Minor White

Much more meaningful than PFA for the reemergence of expressive photography was Minor White. His writing first appeared on the national scene in 1951 as a series of articles in *American Photography.* The next year, he helped found *Aperture,* the most important photography journal in this country for several decades. From the beginning, *Aperture* stood for serious discussion of photography, high-quality reproductions, and respect for the visions of individual photographers. Despite its small circulation (by 1957 it had reached 600 and by 1970, 7,703), *Aperture* revived the atmosphere of art photography and serious criticism that Stieglitz had established at the turn of the century.

White was one of nine founders of *Aperture,* but he quickly made the magazine his own, steering it away from the belief in photographic objectivity, which had dominated American photography since the 1920s, and promoting a vision of photography as a deeply subjective medium.[15] When, after only two years, the magazine ran into serious financial trouble, a majority of its founders were ready to abandon it, but White fought on. He wrote to Ansel Adams, one of the other founders, "So I am depressed, and god damned mad, that the people to whom creative photography (in all its ramifications) is foremost are willing to let the Steichens speak for them."[16] The issue for White was a lack of commitment to serious photography. But in response to White's letter, Adams admitted that the reason he wanted to pull away from *Aperture* was his uneasiness with White's particular point of view. "But helping YOU is one thing," Adams replied, "and sponsoring a general concept in its entirety is another thing."[17] The "general concept" that made Adams uncomfortable was the implicit mysticism of White's editorial stance.

White was a thoroughly spiritual man, a *homo religiosis,* as one scholar has called him.[18] His spiritual quest began in earnest when he became a Roman Catholic at the age of thirty-five in 1943.[19] After he tired of Catholicism, he moved from one esoteric body of thought to another, taking up Zen, the *I Ching,* Tarot, and astrology, with side trips into Gestalt psychology and

hypnotism. White's most sustained inquiry into the nature of reality was as a follower of the Greek Armenian mystic, G. I. Gurdjieff (1877?–1949), whose idiosyncratic teachings began to flourish in this country in the 1950s.

White's interest in photography preceded and eventually merged with his spiritual odyssey. He first learned the basics of photography while studying botany at the University of Minnesota, but it was to be some time before he became serious about it. He also studied literature in college, and when he decided he was not a scientist, he turned to poetry. He wrote seriously for five years and then, after moving to Oregon in 1937, he became a photographer.

White was drafted in 1942 and spent the war in an intelligence unit in the Pacific. After his discharge, he went to New York where he met the Newhalls, Stieglitz, Weston, Steichen, and others. He also enrolled in the Columbia University Extension Division and took some courses in art history, including several with Meyer Schapiro for whom he wrote papers adapting Heinrich Wölfflin's ideas of formal analysis to photography.

In 1946 White took a job teaching at the California School of Fine Arts in San Francisco. There, as Jonathan Green has pointed out, he was surrounded by the emerging Beat movement in literature, and a witness to the rumblings of the avant-garde in painting. (Two soon-to-be Abstract Expressionists, Clyfford Still and Mark Rothko, were on the faculty of CSFA when White was there.) It is not clear that White had extensive contact with the avant-garde writers and painters in California, but he certainly responded, latently at least, to the ambience they created, for he eventually took up the same sources in Gestalt psychology and Eastern philosophy and religion as they, and manifested the same concerns for the intuitive, the contemplative, the universal, and the mystical. *Aperture,* says Green, was very much a product of the San Francisco renaissance.[20]

In a larger context, the magazine was also part of a general withdrawal of the American intellectual and artistic community from political and social engagement. Starting in the late thirties with the disillusionment with communism, this withdrawal had continued through the politically oppressive era of the Cold War. All across the intellectual and artistic spectrum, politics was replaced by a concern with transcendence and myth, which were seen as paths to the restoration of wholeness and well-being after the shattering experience of World War II, and in the face of the nuclear threat and the political repression of the war's aftermath.[21]

In 1955 White moved to Rochester, New York, where he had taken a job at the George Eastman House. It was here, feeling isolated and homesick for San Francisco, that he began to read seriously about religion and

to synthesize photography and spirituality. He came to agree with Evelyn Underhill "that it is the element of mysticism that animates all artists, poets, creative scientists and intuitive philosophers."[22] He acknowledged spirituality as the driving force in his life, and sought ways to let it permeate everything from photography, to eating, to teaching. He wrote to Henry Holmes Smith, describing with some humor one of his early efforts to meld meditation and photographic practice: "*Zen and the Art of Archery* was the catalyst. Another man and I are working on this idea. Walter Chappell is his name, and fascinating are the results. Trying to make photographs in a definite state of heightened awareness, deliberately brought about by an exercise, is troublesome indeed. Forget how to run the camera."[23]

As White became more confident about his mysticism, he began to introduce it explicitly into *Aperture* in a way he had not before. In 1957 he published an issue titled *The Way through Camera Work,* a spiritual manifesto that he referred to four years later as "the strongest statement of my own personal philosophy of photography that I have ever done. Since then I have continued to investigate this 'esoteric' approach and doubtless will always mine this vein because it seems to me the only way worth effort."[24] *The Way through Camera Work* contained some embarrassingly gauche stereotypes of Eastern thought (no better for possibly having been intended as humor), such as the imitation aphorism: "Photo like one chopstick, man looking at photograph other chopstick."[25] This was signed by Sam Tung Wu, White's pseudonym for his Chinese sage persona. We do get a hint here of White's critical concern for the creative role of the observer, but in a form that is hard to take seriously. Aaron Siskind referred to this kind of pronouncement as White's "pseudo-mystical-romantic baby talk."[26]

White approximated the manner of a sage more legitimately in person than in writing, relying on his powerful charisma. As Michael Hoffman has said, "What emerges sometimes as pedantic in his writings had an entirely different quality when he spoke. His voice was deep, resonant, emphatically asserting this truth or that experience as he comprehended it."[27] White's former student, Paul Caponigro, described "something admirable and infectious about Minor's exuberance and sense of adventure, something of a childlike aspiration." But he also said, "We were all enamored of the atmosphere created by the person, and it was without question one of beauty and honest work, but I seldom felt that the overall situation allowed for clarity. There were too many delicious garden paths down which to be led."[28]

In addition to being White's pulpit for mysticism, *Aperture* was part of his larger program for emulating Stieglitz and for reviving some of the

ideas and the sense of high purpose of the Stieglitz circle. White let it be known publicly that he was following in Stieglitz's footsteps with *Aperture* when he published an editorial in 1967 in which he rescinded a previous decision—which had not been made public—to cease publication of the magazine. Speaking of his earlier plans, White said, "A reference was made to the dates of Camera Work 1902–1917. The dates of Aperture 1952–1967 were intended to imply the completion of a cycle."[29]

White used *Aperture* as a forum in which to revive Stieglitz's idea of the equivalent, a photograph that is meant to subordinate or obscure its literal subject matter so as to work metaphorically. White wrote about equivalence in several places, defining the idea, giving it a history, and explicitly establishing himself as the inheritor of Stieglitz's tradition.[30] Stieglitz had spoken of equivalents as expressions of his "most profound life experience," his "basic philosophy of life."[31] White, not surprisingly, saw the true subject of equivalents as spirit. When one experiences equivalence, he explained, "that which seems to be matter becomes what seems to be spirit."[32] Making an equivalent can be like meditation; one attains an exalted state of mind, a feeling "akin to the mystic and to ecstasy. . . . One feels, one sees on the ground glass into a world beyond surfaces. The square of glass becomes like the words of a prayer or a poem, like fingers or rockets into two infinities—one into the subconscious and the other into the visual-tactile universe."[33]

White consistently asserted, as had Stieglitz, that any kind of photograph might function as an equivalent, but just as Stieglitz found pictures of clouds—in which one is easily distracted from the literal subject—to be the best equivalents, White too saw equivalence most often in pictures in which the perception of associative imagery is facilitated through the use of subjects and formal treatments that undermine the literal identity of the objects represented. As White put it,

> With constantly metamorphosing material such as water, or clouds or ice, or light on cellophane and similar materials, the infinity of forms and shapes, reflections and colors suggest all sorts and manners of emotions and tactile encounters and intellectual speculations that are supported by and formed by the material but which maintain an independent identity from which the photographer can choose what he wishes to express.[34]

Although it was not necessarily White's intention to do so, his revival of the idea of equivalence helped to reintegrate photography into the

mainstream of modernist art theory. Harking back to Baudelaire's theory of correspondences, Gauguin's Synthetism, or Kandinsky's synaesthetic experiments, equivalence justified the idea that the photograph itself, its formal relationships, not what it represents, can be the source of aesthetic experience.

White also followed Stieglitz and his circle in the effort to boost the status of photography. Stieglitz had gotten photography into the museums; White helped to get it into the universities, and *Aperture* was a part of that effort. The magazine's very existence was an open challenge to the popular press and an appeal to academically minded writers; it gave the latter virtually their only outlet for publication. As White caustically remarked, "If the critic cannot get hysterical about fun, he is rarely published."[35] White relished his role as part of an insurgent underground. "Considerable sacrifice of personal pride is necessary to accept a limited audience, but the rebels do," he declared. "Rebellious at the commercial command to stick to baby talk or clichés to the end of time, they seek out the few adults who will try to understand photography that tries to speak about what a man is."[36]

But there were drawbacks to speaking to a tiny audience. As long as the public at large remained "utterly blinded by identification," White feared that the development of photography as an art would be cramped. "The whole realm of mood evocation by design and symbol is denied the photographer; the whole realm of idea communication by the implications that can be read between the relations between subject and treatment is cut off."[37] As a consequence, White saw it as his task as a theorist and critic to alleviate this situation by combatting the literal-mindedness that had been reinforced by the popular press and photojournalism and educating an audience to the values of metaphorical photography.

Many of White's early reviews in *Aperture* were dedicated to this task. In a review of Werner Bischof's *Japan* (1954), for example, White saw a convincing record of social contrasts, but he complained, nevertheless, that Bischof "labored under the misunderstanding that imitation was the way to the naked truth." He compared Bischof to Paul Strand, pointing out that in Italy, Strand had found a different order of truth: "while recording facts [he] transcends the limits of the camera. He makes it record that something in each case that he could not see with his eyes but in his mind and heart knew was present. It is the latter quality which is lacking in the journalistic book."[38]

Unfortunately, White did not say how these different truths can be seen in Bischof's or Strand's photographs. In an earlier review of Henri Cartier-Bresson's *Decisive Moment* (1952), he did give some indication of

how a photograph might transcend literalness when he suggested that "an emphasis on form is sometimes the outward manifestation of a preoccupation with one's inner world." By contrast, a "preoccupation with content, with human, social or political significance" signals a dominant concern with the outer world.[39] But even in this review, White did not analyze specific photographs to make clear how one picture might emphasize form and another, content. This failure on White's part to base his critical opinions sufficiently on the close analysis of individual pictures is a consistent weakness of his published criticism, and for that matter, most of the criticism of his period. White's recognition of this problem undoubtedly stimulated his interest in what he referred to as reading photographs.

The tremendous desire to use his criticism to equate artistic photography with the pursuit of inner truth and to combat the fixation on the literalness of photojournalism prevented White from appreciating the new, intensely subjective movement in socially concerned photography led by Robert Frank and William Klein. White misunderstood Klein's and Frank's deliberate rejection of objectivity, and he failed to recognize the salience of the unpretty or unpleasant truths they depicted. As a consequence, he made the same mistake as many of Frank's other critics by measuring him and Klein against established journalistic standards. Klein, he said, "did not photograph a city; he matched with cheap sensational photography the vulgarity of life in all its ugliness."[40] Much in the same vein, he said of Frank, "No matter how true the fraction, when the jukebox eye on American life is presented as a symbol of the whole, a lie is the flower of truth. A gross lie is ground in with a vengeance."[41]

White's assessment of Frank put him in agreement with Bruce Downes, but the two men agreed about little else, and eventually, perhaps inevitably, White's convictions brought him into direct conflict with Downes. Downes wrote a definition of photography for the 1962 *Photography Annual* that so angered White that he wrote to Downes telling him that the article made him ashamed to be associated with photography. He then sent Downes a rebuttal, an "UNdefinition" of photography, which Downes published in *Popular Photography* but entirely on his own terms, printing excerpts from his previous essay beside White's text and interrupting White's text with his objections to it. In the exchange, White accused Downes of limiting photography to stop-action photojournalism, and Downes retorted that White limited photography to an esoteric game: "And if you want to see this kind of precious limitation at work, take a look at *Aperture,* the beautifully printed magazine, which [White] edits for a handful of cultish devotees."[42]

In one significant respect, White's view of photography was most decidedly limited. He had received the technique and doctrine of straight photography from Stieglitz, Weston, and Adams, and for much of his career, he accepted most of the attitudes of that doctrine. He shared the great fear of all straight photographers that their medium might become contaminated by painting. Even though he was concerned with the psychological sources and implications of art, with sexual themes, and with the problems of intersubjectivity and communication through abstraction—concerns that would seem to ally him with Surrealism or Abstract Expressionism—he did not openly acknowledge or pursue any association with those movements. Although he looked to Wölfflin and other art historians as sources of insight into pictorial form, he complained about using the formal language of painting to refer to photographs. He refused to apply the term abstraction to straight photographs because photographs are representational; he preferred "extraction."[43] Even as he used compositions inherited from Cubism, White claimed that he let subject matter compose itself; he never acknowledged the obvious formal similarities between his own pictures and abstract painting.[44]

True to the modernist tradition of straight photography, White policed the boundaries of photographic technique. In his own work, he used blur produced by motion, double exposures, and negative prints, techniques he justified as uniquely photographic. But other "derivations from unique photography," such as solarization, he arbitrarily condemned as falling into "a no-man's land between painting and photography" where "few have been able to perform with real joy."[45]

In one important respect, White did seek to broaden the concept of straight photography. Most often, straight photography had been defined in purely technical terms, but White attempted a definition of it that was meant to account for some of its intangible qualities. His purpose was to associate photographic theory more firmly with ideas and with art than with the technical recipes of hobbyists. His definition has its obvious tendencies toward universal spirit: he named as an "inherent" aspect of photography the "Concept of Essence," which refers to the capacity to reveal "that underlying strata [sic] of meaning from which all secondary characteristics radiate." But less tendentiously, and of more consequence, he named two other qualities of photography that underline the central contradiction in the straight doctrine between subjectivity and objectivity. On the one hand, he pointed out "The Sense of Presence and the Sense of Authenticity," which he described as the evocation of an illusion of reality "so strong that it seems to be your eyes gazing at the subject unhindered

by the glass eye of the camera and unmindful eye of the photographer."[46] On the other hand, he saw "The Concept of Experience," by which he meant that the straight photograph itself can be a source of experience that transcends the identity of the objects in it.

Theorists before White had equivocated over this apparent contradiction—the reader will recall Strand's idea of the organization of objectivity—but to White's great credit, he came to accept this contradiction as an ineradicable paradox at the heart of photography. It is the paradox of trace and transformation. No matter how allusive a photograph is, it is still a convincing picture of something that was in front of the camera, and no matter how convincing an illusion it is, it is still an artifact. White wrote, "the link between appearances and . . . photographs is both tight and loose. The link is like a line that is both broken and solid, dotted and implied all at the same time."[47] He also said, "The photograph must be experienced in two important, and opposite ways: for its linkages to what was in front of the camera, and above all, as a new experience without the slightest memory of the original subject."[48]

White's recognition of the paradoxical nature of the photograph's ontology, especially his growing understanding of the photograph as an artifact, eventually prompted him to relax his doctrinal views on photographic technique and the separation of photography and painting. By the late sixties, in response to the theory of Henry Holmes Smith and the groundswell of technical experimentation on the part of young photographers that was encouraged, in part, by Smith and Nathan Lyons, White was ready to repeal his position on photography's technical boundaries completely.[49] In a review of the catalogue for *The Persistence of Vision,* an exhibit curated by Lyons in 1967, he voiced his acceptance of mixing photography and painting, and two years later in the catalogue for *Be-ing Without Clothes* (a show he curated himself), he summed up with perfect equanimity what he took to be the young generation's wide-open manifesto of photography. Speaking for the young, he wrote:

> I have chosen photography as my medium. I will select the segment of its spectrum which fits my likes and ignore the rest if I wish. When I feel like painting, I will jiggle my camera, take out the lens, sandwich negatives or anything else that occurs to me. If I want to explore the unimagined images hidden in my negatives, I will solarize, reverse or combine in any way that suits me. Above all, I am as wary of these distinctions as camera is indifferent. It's all photography to me, including drawing and talking and loving

. . . . Anyone who accuses me of being unwilling to accept the discipline of unique photography simply doesn't know that photography can *be,* or that I embrace camera because it frees me to be.[50]

Another of White's concerns was the state of photographic criticism. This was an issue he approached with a sense of urgency and even anger. He was frustrated—as were many others—that there was no substantial body of professional criticism. He was utterly contemptuous of and even humiliated by the amateurish criticism that spoke for serious photography. He sarcastically commented on the "delightful reviewers who refuse to read books on criticism," and he suggested that the would-be critic at least "have enough information that at a cocktail party he can talk very knowingly to the other alcoholics who have also neither seen the exhibition nor read the book."[51]

The rampant ignorance about photographic history appalled White. Too many writers approached their work with the narrowest understanding of photography's possibilities. White pleaded with reviewers to recognize that photography is a protean medium and to educate themselves about its various manifestations and about art, criticism, and history in general. Photography could only become a complete art, he said, with the development of a body of committed professional critics who could "look at contemporary photography in the largest possible perspective."[52]

White referred to his own theory of criticism as reading photographs. Because he was a spiritual man and an artist, rather than an intellectual, perhaps it is not entirely fair to examine this theory as closely as I propose to do. John Szarkowski once wrote, "It would be gratuitous and evasive to judge White's contribution on the basis of the logic of his philosophical writings."[53] But White's concept of reading had great currency in the sixties and seventies. Every undergraduate and graduate student in art photography in that period knew something of it and took it seriously. In addition, the idea may be of interest to a contemporary audience because it reveals some of the stress points in the modernist theory of photography. Although White cannot be considered a postmodernist in any sense, he responded to these points of stress by proposing some ideas that sound very much like some aspects of postmodernism. His theory and criticism demonstrate that modernism was not the stable, monolithic formalism that it often appears to have been in postmodernist caricatures of it, and that some of the ideas now exclusively associated with postmodernism actually appeared within the modernist context.

The idea of reading photographs was originally Henry Holmes

Smith's. White had first met Smith in San Francisco in 1952 where the two men discussed the problems of interpreting photographs. Later, White read a brief essay by Smith called "Reading the Photograph" in which Smith suggested that photographs are like rebuses and may be interpreted in a similar manner.[54] White wrote to Smith and suggested that he expand his ideas in an article for *Aperture,* which Smith eventually did, publishing "Photographs and Public" in 1953.[55]

The reading project was the basis for a cordial relationship between White and Smith. Smith became a regional editor of *Aperture,* and White participated in a workshop Smith organized at Indiana University in the summer of 1956. Although as editor of *Aperture* White was the more visible of the two men and the apparent leader of the reading project, Smith was actually responsible for shaping much of it. It was Smith who suggested that it would be instructive to publish readings of the same photographs by more than one person, and it was Smith who introduced I. A. Richards's work on literary criticism into the proceedings.[56] As Smith said in a 1979 letter to *Afterimage,* he and White shared "a sense of excitement and delight in discovery" as they groped their way forward in an effort to figure out just what reading a photograph might mean.[57] Eventually, however, the two men's very different intellectual and personal temperaments drew them apart as Smith tired of White's mysticism and what he judged to be White's excessive self-involvement.

As White described reading, it was simply the process of making a close analysis of the form and content of any photograph. In practice, however, it came to stand specifically for the analysis of potential equivalents, and for a projective technique in which the reader treats the photograph more or less as a Rorschach image.

I. A. Richards's book *Practical Criticism* (1929) helped shape the concept and practice of reading. Richards, an English precursor of the New Criticism in the United States, was concerned with the close reading of poetry, with paying attention exclusively to a text without responding to what he saw as the distractions of extrinsic considerations, such as the place of the poem in the literary canon, the biography of the author, or the historical context in which the poem was written. Richards's idea of close analysis was attractive to White because if one were going to emphasize the subjective, metaphorical, and independent status of photographs, one had to adopt a formalist method of analysis. This was not happening in photographic circles to White's satisfaction. Even White and other writers seriously concerned with photographic art had difficulty bearing down on specific images in any sustained way; they were not confident about how

to do it. So White was glad to embrace Richards as an advocate of direct confrontation with the work of art.

In addition, Richards was interested in the psychological aspects of interpretation. He pondered the inhibitions among readers of poetry that prevented them from reading a text accurately or responding to it honestly, and he discussed the therapeutic value of interpretation. The latter he only hinted at in *Practical Criticism,* although in an earlier book, *Science and Poetry* (1926), he had maintained that poetry may serve our emotional need for myth and magic, give order to our emotional experience, and thus right the cultural imbalance brought about by the destruction wrought by science on our spiritual life. To what degree White was aware of the ideas in *Science and Poetry* is not clear. But he most certainly responded to Richards's discussion in *Practical Criticism* of the inhibitions of students, their irrelevant associations, stock responses, and sentimentality, any of which could cloud their capacity to engage a work of art. White even adopted Richards's method of the protocol whereby students analyzed poems (or photographs in the case of White's students) without having been given any information about them, and he spent considerable energy devising and conducting exercises designed to break down students' resistances to the projective technique of reading.

White's most thorough explication of reading may be found in an article of 1957, "Some Methods for Experiencing Photographs," which he coauthored with Walter Chappell, a friend who had considerable affect on the direction of White's spiritual quest. In the article, the authors explain that a potential reader of photographs should first attribute to a picture one of several broad purposes—documentary, pictorial (artistic), informational (scientific)—and then they should examine it in light of this purpose. At first glance, White's and Chappell's concern for categories of purpose makes reading look like a form of intentional and historical criticism, but it is not. The authors did not see the task of assigning a purpose to a photograph as necessarily bound to an investigation into the context in which the photograph was made.

They would not have objected to such an investigation, but the point is that they made the characteristically modernist assumption that the purpose of a photograph is inherent in it and visible to the sensitive critic. For example, they assumed that one may recognize a documentary photograph as such because it will embody a certain approach to form and subject that makes it look different from a work of art. As they said themselves, a documentary photograph will bear important clues to the socioeconomic status, and the racial, sexual, and national identity of the people who appear in it,

but such a picture would not transform the three-dimensional world into a tightly knit, two-dimensional composition in which every juxtaposition of form is pregnant with meaning. Only the pictorial photograph does this.

Within this modernist framework, in which the purpose of a picture is visually determined, one might expect White and Chappell to have respected equally the various categories of photographic purpose, but in fact, their article is designed to give precedence to art photographs and particularly equivalents. One strategy for doing this was quite subtle. The authors emphasized that reading photographs requires a suspension of judgment so that one might concentrate on *what* the photographer was attempting to say and *how* the photograph works. This apparent strategy of neutrality—which paralleled Richards's dictum to pay attention to the way a poem does what it does rather than why, or whether what it does is good—was actually anything but neutral. It was consciously addressed to an audience accustomed to the social and commercial concerns of photojournalism and popular photography, an audience that White rightly took to be either unsympathetic to or inexperienced with metaphorical photographs derived from subject matter such as seepage stains on concrete or isolated details of industrial architecture. The plea for neutrality, then, was a way of coaxing this audience to attend to pictures they might otherwise have little patience for.

A more important manifestation of the article's tendentiousness is that White and Chappell made it abundantly clear that when certain indefinable visual qualities are present in photographs, such that they become transcendent equivalents, all other categories of purpose are rendered null. For example, if a scientific photograph "somehow transcends its original and customary purposes" and "takes one heavenward," then this becomes the defining quality of the picture. When a photograph reveals itself as an equivalent, the scientific discipline in which it originated and the intent of the photographer become irrelevant. In fact, one of the crucial qualities of equivalents, according to White, is that they may appear without regard for a photographer's intent; in fact, they are often unintentional pictures that photographers "drop during their exceptional moments along the tideline between our everyday landscape and the ocean of our subconscious."[58]

In sum, White and Chappell were saying that whatever purpose a photograph might have, that purpose will be visible in the photograph and ought to guide one's analysis of it. And if the photograph has certain special properties—properties not necessarily put into the picture intentionally by the photographer—it becomes an exalted equivalent with "life-enhancing" powers that take precedence over all other visual qualities and all extrinsic

evidence of the intent with which the picture was made or the use to which it was put.

This concept of the equivalent put tremendous pressure on the central modernist assumption that the meaning of a photograph is inherent in it. How, exactly, does one recognize an equivalent, and who is qualified to recognize one? White and Chappell understood the difficulties presented by such questions, but they were speaking of the experience of an ultimate, transcendent realm and felt they could do nothing to make that experience concrete. Like Clive Bell's significant form (or like pornography, for that matter), equivalence could be recognized but not defined. In "Some Methods for Experiencing Photographs," White and Chappell apologized for their mysteriousness: "WE WISH WE WERE SURE OF A METHOD FOR EXPERIENCING EQUIVALENTS," they announced, and thereby deepened the mystery while implying, nevertheless, that they themselves, members of a photographic priesthood, had a grasp of the equivalent's esoteric essence.[59]

The indefinability of the visual qualities of equivalents is a good example of the kind of problem in modernist theory that eventually prompted some photographers to challenge the modernist assumption that the meaning of a photograph is embodied in its visual properties, and to demonstrate—à la Marcel Duchamp—that an art photograph attains its status and meaning through the will of the photographer and through discourse in the photographic community rather than through its inherent grace.

But as long as White could claim that equivalence was an inherent property of photographs and that this property was indefinable, he was free to appropriate any photograph, regardless of its original purpose, for consideration as a purely aesthetic object in the hopes that it might prove to be an equivalent. In their article, White and Chappell actually recommended treating scientific photographs in this manner, saying that after one examines a scientific photograph for its scientific information, the next step is to "bypass information and observe for aesthetic qualities."[60]

The aestheticization of photographs originally made for another purpose raises some dicey problems. For instance, what if one finds beauty in an image with morally abhorrent subject matter? Is this morally reprehensible? In their article, White and Chappell reproduced a World War II aerial reconnaissance photograph of an airfield plowed up by the Germans to prevent its use after capture by the Allies. They intended the picture to serve as an example of an informational photograph and included an extended caption that explains the image. But if we are to "bypass information and observe for aesthetic qualities," what implications does this have for our

understanding of the actual historical circumstances of which this picture is a part, for our understanding of the war?

A true mystic might find a glimpse of ultimate reality in any circumstance, even among the piles of Buchenwald cadavers. Certainly White never went this far, and to be fair, he did not even explicitly aestheticize the aerial reconnaissance photograph of the plowed air field; nevertheless he could not ignore the tension between his mystical vision and political conscience. It clearly bothered him that his mysticism could be construed as politically irresponsible, especially in the era of the Civil Rights movement and the war in Vietnam. Consequently, he tried on several occasions to give his vision an ultimate social morality. In an editorial of 1956, he suggested that the problem of racial segregation might be addressed at the highest level by photographers who express spirit: "Such persons need absolutely no other motivation. But the problems of desegregation need all the photographs there ever will be that affirm spirit. Anything that affirms spirit, whether human or divine, is the leaven for all races of men."[61]

Later, in 1968, when Margery Mann and Sam Ehrlich made a plea for fewer photographs of cracked mud and more pictures that acknowledge racial strife and the Vietnam War, White replied, "For the continuation of mankind on earth it is essential that a few people in the world realize that war, civil and otherwise, is mass insanity; and those who work to stay out of war are just as caught in the trap as their foes."[62] White went on to invoke, indirectly, the Taoist principle of nonaction, the idea that any direct political action is futile because it only intensifies strife. For White, the only solution to the world's problems was to turn away from them, to refuse to touch them. As he had said on another occasion, the world needed artist-monks who would devote themselves to man's spiritual salvation: "With over-population swelling at a disastrous rate we can release the gifted ones from the duty to society of child bearing to take up the responsibility to society of the artist-priest or the artist-monk. . . . We must demand that the gifted dedicate their lives to the continual pursuit of spirit even when it entails the denial of parents and abstinence from marriage."[63] By turning their cameras on "rocks, water, air and fire" such persons would "bring about the concentration of something without which man will blow out his heart."[64]

Although it would be foolish to argue that White should have been a political activist, his claim that all activism becomes ensnared in the evils it fights and therefore that his artistic activity was morally superior to activism is extravagant at best, even arrogant. Only a man living in safety and comfort who was not faced directly with the choice of whether to par-

ticipate in a war or with the daily reality of racism could caution that activism sucks one into an embrace of the evil that one is attempting to abolish. Certainly Martin Luther King, Jr., and Ghandi before him demonstrated that one may struggle intimately with hatred and violence without becoming violent and hateful. White, as he said himself, wanted very much to be in life but not of it—to be a kind of monk who set an example of peace, tolerance, and sanity in a world of strife and hatred. His efforts to set such an example would have been far more compelling had he not claimed moral superiority to those who engaged in direct political action.

White may have been able to assuage his political conscience, but he continued to be troubled by the problems of interpreting photographs and by the possibility that this activity might prove to be entirely subjective. If White was to continue to believe that the power of a photograph to communicate "in the rarified realm of feeling that transcends both subject matter and manner" was inherent in the picture itself, then he would have to demonstrate that a group of people who were sufficiently sensitive and sufficiently experienced with art photography would all see that same power in a given photograph and would interpret it in the same way. To that end, White, Henry Holmes Smith, Walter Chappell, and Kurt Safranski published an article in *Aperture* in 1957 titled "The Experience of Photographs" in which each man made readings of a series of five images by Aaron Siskind. Actually White wrote two sets of readings, each of which appeared under a different pseudonym.

Before presenting his readings, each writer first described his methodology. White's was meditational and projective. He explained that he stared at the pictures for long periods until "mildly mesmerized," letting images of faces come and go, waiting for the "chains of associations" to crystallize into words. His resulting interpretations are not entirely implausible, but they are intensely personal, anthropomorphizing visions expressive of White's own psychological and sexual concerns. Writing of *Chicago 10, 1948* he said: "Anthropomorphizing still further, the central shape turns into a woman. She bleeds internally: her visceral organs at least and her internal thoughts for certain. . . . But why, why her anguish? At first there seems to be no reason. Until the grey strip at the edge is anthropomorphized. Once that is recognized as a nude with the phallus in the position of impotence the reason is apparent."[65]

The other readers saw broadly similar imagery in this photograph: a female figure with a cat's head, an apparition with a cat's head, a woman and a cat's head. But the variations in the interpretations commanded the attention of White and his colleagues far more than the similarities. White

Aaron Siskind, Chicago 10, *1948. Courtesy of the Robert Mann Gallery, New York, New York. Copyright © Aaron Siskind Foundation.*

Chapter 5

worried the matter at the end of the article, confessing that reading photographs is an uncertain field in which only the most rudimentary knowledge exists. Neither photographers nor readers, he concluded, had learned very well how to communicate in "the area of suggestions."

Of course, the implication is that with practice, a more precise language of visual symbolism might be developed so that photographers could suggest exactly what they intend and readers would get the point. But at the same time White was implying this, he was also beginning to doubt the fundamental modernist premise on which reading was founded: that the photographer encodes a message into the photograph where it sits waiting for the reader to decode it. White was beginning to suspect that the meaning of an image might actually be a product of the encounter of the viewer and the image as well as, or even rather than, the result of the actions of the image's maker. He said in the midst of one reading, "In such a process one meets one's self so often that I am still wondering what happened to Siskind. I don't think that I met him once. Consequently I ask myself, seriously, whose pictures are they now, Siskind's or mine?"[66]

For his part, Siskind would have been glad to tell him whose pictures they were. When White later used one of Siskind's photographs in an article without permission and, of even more importance to Siskind, with a title White and not Siskind had given it, Siskind was ready to "puke in anger."[67]

In any case White continued his musings saying, "Nothing goes on in a photograph that we do not put there. . . . [A]nd no matter how firmly we believe this, being obstinate we continue to impute to the photograph activity that really goes on in our heads. . . . And we do so probably because what happens when we look at one photograph is different [from] what happens in our heads when we look at another. And it is easier to say it happens in the photographs than in our heads."[68]

White was beginning to sound like poststructuralists such as Hillis Miller, who has said that "reading [texts] is never the objective identifying of a sense but the importation of meaning into a text which has no meaning 'in itself.'"[69] He also sounded like Roland Barthes who conceived of the "writable text" for which there is no single meaning created by and anchored in the actions or person of the author and for which, instead, the reader is the focal point for an endless multiplicity of interpretations. As White's thinking developed in this direction, he eventually explicitly equated the authority of the viewer with that of the photographer, saying, "the audience can be as creative as the photographer, and in virtually the same way."[70]

By the time he had come to this point of view, White had turned his attention from the idea of reading photographs to what he called responses to photographs. He conceived of a response as immediate (that is, unmediated), ahistorical, and essentially psychological. He distinguished responses from criticism, which he described as historical and as having a responsibility to account for, coincide with, or at least not contradict, the concrete qualities of the photograph in question. A response has no such responsibility: "As a response what is said is a fact and true within the framework of [the viewer]; that is, what he says or writes is true of himself, but not necessarily true of the picture in spite of the fact that it was the photograph in question that aroused his reaction."[71] Ultimately, White backed away from such an extreme position, feeling that even responses ought not contradict the evidence of the photograph. But he still refused to see any single response as more accurate than another and regarded even contradictory responses as equally valid. In this respect, he is reminiscent once more of poststructuralist critics who reject the idea that any particular interpretation of a text is correct or better than another, on the grounds that any text is a collection of constantly shifting signifiers that are rearranged under the attention of each reader, ad infinitum. The meaning of any text is never pinned down, never determinate, so one interpretation of it cannot fit better than another.

Although he came to the conclusion that photographs do not contain their meanings, that viewers are the source of meaning, and that a single photograph may be given many meanings, White had not yet come to the conclusion that viewers' responses to photographs are without order. For a while in 1962 he toyed with the idea of building a theory to predict people's responses to photographs.[72] He was thinking along lines similar to those Roland Barthes was to follow two years later when he published "The Rhetoric of the Image." In that article, written in his structuralist period, Barthes spoke of a typology of responses to photographs. He wrote, "The variation in readings is not . . . anarchic; it depends on the different kinds of knowledge—practical, national, cultural, aesthetic—invested in the image and these can be classified, brought into a typology."[73] White, of course, was thinking of going a step further than a typology of responses when he spoke of a predictive tool. But he tired of the complex project of prediction almost as soon as he proposed it. And by 1968 he had come to the conclusion that "so few photographs actually convey but one 'meaning' that it is more realistic to accept the fact that everyone is going to get something different [from them]."[74] In other words, he had decided that predictable patterns of response simply do not exist.

If the meaning of a photograph is located in its viewers, if any viewer's response to a photograph is as valid as any other's, and if viewers' responses cannot be predicted, then the meaning of photographs is entirely indeterminate. White had arrived in 1968 at a position very much like that of poststructuralism.

Having said this, it must be emphasized that White was not an early poststructuralist and that there are profound differences between his point of view and poststructuralism. First, White rejected the modernist theory of inherent meaning in works of art because it conflicted with his sense of actual experience. The idea that a photograph has a single meaning did not hold up under investigation. The poststructuralists reject the possibility of actual, unmediated experience and focus on systems of signification that mediate experience, particularly language. Derrida rejects the idea of inherent and determinate meaning in texts not on the basis of the contradictory experiences of interpretation but on the basis of his concept of written language.

Second, the poststructuralist concept of the indeterminate meaning of a text and the poststructuralist view that the contingent meanings of a text are the creations of a reader are based, in part, on undermining the concept of the coherent, subjective individual. In his essay "The Death of the Author" Barthes asserts that no text is the original creation of its author, but rather a patchwork of words and phrases already in use, already bearing multiple meanings that come from the sea of language surrounding and predating any writer. When writers write, they do not create out of an isolated subjective self, but dip into that sea of language, choosing and rearranging bits and pieces of it and appropriating meanings. In fact, not only are one's works unoriginal, made of already existing signs and meanings, but one is oneself a product of the world of preexisting signs. Barthes says, "Did [the writer] wish to *express himself,* he ought at least to know that the inner 'thing' he thinks to 'translate' is itself only a ready-formed dictionary, its words only explainable through other words, and so on indefinitely."[75] In other words, we are born into a world already shaped by language, and that world of language shapes us. One might say that language is the substance of what we are. We do not simply use language as a tool with which to express ourselves; instead, the very self that uses language consists of language. There is no essential self.

For White, there is an essential self. For him, the multiplicity of meanings in a work of art are a function of our individuality and our separate psyches, which may have certain similar components but which have separate and different histories such that we respond differently and unpre-

dictably from within ourselves to the richly ambiguous symbolism of an evocative photograph. It was White's hope that a response to a photograph could bridge this gulf between separate selves. A response might be a window into another's private world, just as a photograph is. And if the two worlds do not match perfectly, at least there is in a response a gesture of intimacy, a gesture White coveted. "Occasionally I hunger only for that *bit of the man himself*, in response to my image," he said. "That packs the kind of energy that regenerates."[76] Ultimately, White hoped that certain photographs would allow us to break out of our isolation in a definitive way by provoking an experience of transcendence. Only there, on a transcendent plane of unmediated perception, beyond language, and beyond culture could people truly find common ground.

Poststructuralists utterly reject the possibility of experience unmediated by culturally determined systems of signification, and they reject any transcendent realm beyond the reach of same. As far as any common ground of communication is concerned, they seem to suggest that if we share a specific culture, we also share common language and other common sets of signs, and at the same time that this common ground of language and culture is illusory because the meanings of language and other signs are constantly shifting and have no anchor.

The search for transcendent communion with others, the effort to "get out of oneself," was finally for White what photography and criticism were all about, and in his later years his pursuit of transcendence came to dominate his teaching, writing, and curatorial activity even more than before. Triggered by a photograph, the transcendent communion White sought could have several outward manifestations: it could result in the making of another photograph, in dancelike movement, or in physical contact. With poignant openness, White described an experience of physical communion:

Imagine my delight when a friend, somewhat self-consciously, communicated his response to my photograph by describing his experience with his hands on my bare back. I was surprised at the forcefulness of the communication. And grateful, very grateful to learn how far an image out of my camera had moved him.

I had felt all along that the simultaneous meeting of picture, photographer, and beholder was and is a rare opportunity. But all previous encounters had been fearful. And strangely enough fearful of love surfacing in an embarrassing way. With his hands on my back, our private, psychological hours synchronized, a moment of recognition flared. We recognized the energy of the genitals

and watched it take the direction of respect and wonder. We stood in awe at the radiance encountered. Of evaluation there was none, unless a moment of being together exceeds all judgments of unions. An experience as full and open as the flight of swallows in the circle encompassing friend, photograph, and maker urge me to wish the same for all people.[77]

White never lost his faith that palpable experiences of transcendence and communion could be brought about through photography, but these experiences were rare. The constant uncertainty about when or if transcendence would ever come or come again was quite possibly the source of a fundamental anxiety in White's life. It may have been this anxiety that made him rush from Catholicism, to Zen, to astrology, to Gurdjieff. It may have been this anxiety that made him cry out from loneliness for a "bit of the man himself" in response to his photographs. White's anxiety was not only the philosophical anxiety of the mystic longing for relief from his existential loneliness through transcendent communion with others, but also the gut-wrenching anxiety of a homosexual living in the utterly homophobic culture of the United States in the 1940s, 1950s, and 1960s. White's anxiety was aroused both by the uncertainty of his spiritual quest and by the fear that his need for intimacy and love would never be fulfilled.

White disengaged himself from the issues of criticism at the end of his life, but the 1957 experiments with reading photographs in *Aperture* were tremendously stimulating to the photographic community. There were some who indignantly rejected reading on the grounds that photographs do not warrant close examination or that such an examination can ruin one's enjoyment of the art. There was also resistance to the projective technique of reading, which arose from a general fear of the psychological, a fear in which Henry Holmes Smith detected a scent of fundamentalism. But much of the photographic community received reading favorably, and the practice was widely adopted in one form or another.

One adaptation of reading may be found in the brief book *The Criticism of Photography as Art: The Photographs of Jerry Uelsmann* (1970) by John L. Ward, a professor at the University of Florida. Ward takes issue with the theory of reading for its stipulation that one must suspend judgment of a photograph to read it. He thinks one cannot analyze a work of art without simultaneously engaging in some kind of judgment. But otherwise, he articulates a critical approach similar to the one demonstrated in "The Experience of Photographs," the article in which White and others read images by Aaron Siskind. Ward says that his purpose is to "face

the picture without any other requirements than that it work, that it be forceful and meaningful." And he wrote, "No meaning matters in art unless it is directly or indirectly made known by a piece's experienceable properties."[78] He explicitly rules out the photographer's intent, the techniques by which the photograph was produced, and the historical circumstances in which it was made and used. White and his associates only implicitly barred such considerations from reading—and sometimes did so with ambivalence—so Ward's theory has the value of clarifying important aspects of this critical stance.

The idea of reading photographs was not confined to academia. It also showed up in *Popular Photography,* which devoted an entire issue to the subject. Most of what was said was typical drivel, but at the end of a chatty essay by Ralph Hattersley, a colleague of White's at the Rochester Institute of Technology, there appeared a trenchant point that cast reading in a new light. Much of our experience of the world, said Hattersley, takes place through photography, and in the process, photography molds us, often subconsciously. This is a cause for alarm: "When an entire nation will listen to and react to a language it little understands—and we now speak of the visual language—then can power-hungry men use this very language to persuade the people to surrender their most precious rights. . . . It is no longer popular to say 'It can't happen here,' for it certainly can and wise men know it."[79]

Hattersley was not thinking of reading in the same ahistorical, apolitical sense that White and Ward were. He was pointing out that photography operates in the social sphere, and we must learn to read it to protect ourselves from manipulation. It would be a mistake to portray Hattersley as a socially motivated critic—he later wrote a book called *Discover Your Self through Photography* in which he equated the practice of photography with religion—but here he recognized that photography has great power outside the artistic tradition, not as a truthful witness to society, as in photojournalism, but as an apparatus of social control. In this respect he hinted at the kind of analysis and history of photography to be written later by such scholars as Victor Burgin, who has analyzed the complex, culturally determined codes of connotation in advertising photographs.[80]

Hattersley briefly attempted to infuse criticism of photography with political urgency, but in the art and academic communities of the sixties, White's apolitical vision had become dominant. By mid-decade, White sensed the shift toward his way of thinking. In one essay, he described a "maturity of taste among at least one stratum of photographers that few thought we had yet achieved." And he concluded triumphantly, "There are

enough photographers today enraptured with the poetic image *regardless of subject matter* to keep half a dozen little magazines overflowing with images that not so long ago . . . were stored in boxes."[81]

Riding this current through the late sixties and early seventies, White expanded his activities. In 1969 he published *Mirrors Messages Manifestations,* a book of his own photographs and writings. He also began to organize theme shows, combining the works of many photographers and texts in the manner of Steichen, each show illustrating some aspect of White's mystical vision. *Light*[7] (1968) was the first of these exhibits, followed by *Be-ing without Clothes* (1970), *Octave of Prayer* (1972), and *Celebrations* (1974). For each exhibit White published a catalogue that appeared as an issue of *Aperture.*

White was becoming something of a cult figure in American photography. The theme shows contributed to his apotheosis among young photographers who saw them as opportunities to exhibit and publish in exalted company. Young people were also drawn into White's orbit as students, would-be students, or peripheral admirers. The stories of his teaching methods—his use of meditational exercises or movement exercises derived from Gurdjieff—became legendary.

Inevitably, as the White legend grew, he himself became the target of some serious criticism, the most substantial of which came from A. D. Coleman, a young photography critic for *The Village Voice* who had been reviewing the shows White curated. Coleman was tolerant of *Light*[7], and he praised *Be-ing without Clothes,* but *Octave of Prayer* enraged him. He published a scathing review of the photographs in the exhibit and promised a second review of the text in the catalogue, but his editor at *The Village Voice* objected to the "lack of perspective" and the length of the second essay and delayed its publication. Coleman charged the *Voice* with censorship, and in the squabble that followed, he resigned from the paper. Later, the full text of both essays and the text of a rebuttal by White were published in *Camera 35.*

Coleman attacked White vigorously on several points, his volatile prose dotted with such phrases as "proto-totalitarian," "abuse of power," "mystical pabulum," "pinnacle of inscrutability," "anti-intellectual and self-aggrandizing themes," "auto deification." Coleman utterly rejected White's spiritual purpose. He found it anti-intellectual, irresponsibly apolitical, foolishly sentimental, and the source of considerable gibberish. He judged that although *Octave of Prayer* presented itself as a celebration of universal spirit, it was actually no different from, and no less repugnant than, the proselytizing of fundamentalist Christians.

Worse than the "sticky-sweet" sanctimony of the project was that White

was operating a cult of personality through which he exercised considerable power over young photographers. Not only did he establish dictatorial control over the photographs submitted to him, utterly subordinating them to the thematic purpose of his show, but also, through his teaching and writing, he indicated precisely the kinds of photographs he would exhibit and publish, thus exerting tremendous pressure on the taste of young photographers. Coleman judged that many of the pictures in *Octave of Prayer* had been made to please White, and he concluded, "There was a time when I thought the inferior, derivative imitations of White so often produced by his former students were merely the unfortunate by-products of his teaching methods. It is apparent from *Octave of Prayer* that White does not regret his acolytes, but encourages them." Such imitation by young photographers was made that much worse by the fact that White saw no alternatives to it. Coleman quotes him: "Today we have come to that impasse of visual overproduction where breakthroughs are an idle fantasy and revitalization of the old is the task of artists and cameraworkers."[82] Having implicitly placed himself in a pantheon of unsurpassable masters, said Coleman, White was ready to receive others' mediocre photographs as homage, placing the ones he elected into the theme shows for which he took complete credit. White had come to believe his own legend. His "egotism, abuse of power, and irresponsibility" were monumental.

White may have been guilty of all the abuse of power Coleman accused him of, but his intent was certainly not sinister. From his point of view, there was no question about the value of spiritual issues in art and the value of encouraging others to deal with them. Also, he felt he had made a valid judgment about the historical impasse in photography and that more important than looking for originality in the work of young photographers was to offer his nonjudgmental acceptance of their sincere efforts, their expressions of eternal truths, and their sense of union with something larger than themselves. Furthermore, as an experienced teacher, he felt he had clearly established that many young photographers do not understand their own work. If he understood it, and if the work was striking, then there was no reason in his mind why he should not use it for his purposes as long as he had been given permission to do so.

Coleman, said White, had disqualified himself as a critic of *Octave of Prayer* because of his lack of sympathy for spirit. If one is unsympathetic to spirit, White reasoned, one cannot understand it and cannot criticize what is done in its name. Taken as a general principle, this argument implies that one must embrace even fascism to understand it, but White no doubt would have considered spirit a special and benign case.

White concluded his rebuttal of Coleman by invoking the subjectivity and indeterminacy of all efforts to understand photographs: "The persistence of personal projection applies equally to everyone in photography. Photographers cannot escape it; neither can the critic or picture editor, nor any member of the viewing audience. As the visual situation gets home to us, we get a glimpse of the potential madness of all photography. Anyone can accuse anyone of anything and hit some element of truth. The accuser stands accused by his own accusations."[83] Behind this impregnable wall of critical confusion, White made himself invulnerable to disagreement.

Coleman's attack on White had little immediate effect on White's reputation. By 1973, when their exchange took place, White was securely in command of his public image. It was an image of more than an artist, teacher, editor, curator, theorist, or critic. Although White was actually still as much a spiritual seeker as he had ever been, he projected an image of a thoroughly fulfilled man reaching the height of spiritual exaltation, one who, as White himself had put it years before, "has now only to move upward, ever upward, a little bundle of flaming excelsior in his hand to fire each wayside station on the way. We can trace his progress up the mountain by the lengthening string of bonfires until he disappears in a sunset of snow at the summit."[84]

Ralph Hattersley

Hattersley followed White in thinking of photography as a tool of spiritual growth. He wrote largely for *Popular Photography* using a breezy style full of "blarney," to use his own word. His cornball manner perfectly suited his forum and was no doubt genuine, but it also served as a sugarcoating for ideas he considered potentially threatening to his readers. Sometimes, however, the sugar dissolved as Hattersley approached his topic with absolute bluntness. This was often the case in his book *Discover Your Self through Photography* (1971), in which Hattersley took delight in explicitly contradicting the popular maxim that photography is fun. "If your life wasn't Candy Land before you bought your camera," he quipped, "it won't be afterward."[85]

Discover Your Self through Photography is a collection of greatly revised and expanded articles and lessons for amateurs that Hattersley published in *Popular Photography* in the mid- to late sixties, and it is his most significant statement of his photographic theory. The book may be hard to take seriously at first. The reproduced photographs, many of them showing pretty young people in various states of undress, are commonplace and without elegance to the point of blandness and cliché. Hattersley's analyses of these pictures are unexceptional: "It is far more likely that Bill

sees nudity as a symbol for, and a step toward, something else. . . . [The photograph] is telling him, 'Be nude in all things, not just in body.'"[86] The lessons pose suitable but unexceptional problems for beginning photographers, such as the assignment to examine something one has always considered ugly in order to photograph it as beautiful. In addition, Hattersley's confessional manner can become cloying after a while; how long, for example, must the reader sustain interest in his failed marriage? But despite all this, Hattersley's purpose ultimately comes through, and that purpose is to explain photography as a religious practice. At its core, the book is about the discovery of Self and the pursuit of Enlightenment as it is defined by a variety of traditions, including Sufism, esoteric Christianity, Zen, Vedanta, and the teachings of Gurdjieff. In this light Hattersley's exercises become spiritual exercises meant to loosen the creative faculties, break habits of perception, and prompt greater self-awareness, and the photographs become tools of analysis rather than aesthetic objects.

White's influence in all this is obvious but there is a glaring difference in the way these men link photography and the spiritual quest. For Hattersley, photographs are mere tools to be used in this quest. All issues of craft and aesthetics are secondary to it. For White, the craft and art of photography were the very vehicles and the substance of the quest for enlightenment. This difference notwithstanding, White reviewed Hattersley's book enthusiastically in *The New York Times.*[87]

Hattersley maintains that many arts can be used to pursue enlightenment—poetry, painting, music, archery, calligraphy, flower-growing—but he thinks photography is particularly suited to the task because both photography and enlightenment have a special relationship to light. Light is the central metaphor in enlightenment and the central agency of photography: "But how many of us have discovered that we entered photography because we, also, need light? This time let's call it Light or Enlightenment To photograph is to create with light or to witness such a creation. In our creating with light, are we groping to reflect the Will of the Creator of Light? Certainly, our concern to make our photographic creations beautiful and meaningful and ethical is very suggestive of this."[88]

Photography is a particularly apt way to pursue enlightenment, but the pursuit of enlightenment is the only real purpose of serious photography. By discussing photography as religion, Hattersley is trying "to get down to the central nut of what photography is really all about for those who take it seriously."[89] Even photojournalism can be seen as throwing up a smoke screen of objectivity used to hide the perpetual search for Self.

To be a normal, unenlightened human being in Hattersley's meta-

physics is to suffer from dividedness: one is divided from other people, one's conscious mind is walled off from one's unconscious, the male self in each individual is at odds with the female self and the overweeningly selfish ego is estranged from and fights to remain estranged from the universal Self, which is that aspect of our being that is capable of enlightenment and of understanding Love, the force that makes the universe go. The task is to use photography to identify these divisions, to outwit and trap the ego that perpetuates them, and to liberate the true Self.

It is in the arena of interpersonal relationships that Hattersley sees this process taking place. More specifically, he is concerned with family relationships, and primarily the relationship between husband and wife. Many of his photographic lessons have to do with photographing people: double expose a person on a natural form; photograph your parents while thinking about them as people with needs similar to yours. Many of his discourses have to do with intimate interaction. There is a lengthy analysis of eye contact and a discussion of the function of sexual energy as the means of propelling young couples into the real labor of marriage. It is Hattersley's assumption that if men and women can understand each other, their children, and themselves within the pressure cooker of the nuclear family, they will then be well on their way toward spiritual fulfillment.

The method for achieving fulfillment is what Hattersley refers to as necessary suffering, taking the path of blame, or giving the ego (the wolf, he calls it) a hard time. To liberate the Self, one must

> deliberately dredge up all the foul muck, bring it into the light of consciousness. It's a terribly painful process, naturally, for it means we must surrender all our dearly beloved illusions with respect to ourselves. But once we know, in all their dimensions, these negative depths of our beings, things get better. Once in the light, our negative drives gradually wither and die. We are rid of them once and for all and can look forward to a life of meaning and joy.[90]

Hattersley does not think our faults will disappear by themselves once we bring them to light, as he seems to suggest here, but that once we reveal them through the examination of our photographs, we can then deal with them rationally.

Hattersley's theory raises a number of questions, not the least of which is, does it work? Does revealing faults necessarily lead to their cure through rational examination? This is uncertain.

Another issue is the book's thoroughly autobiographical approach to

its subject. This can be a serious drawback in a work that proposes to lead people at large to their inner selves. The book is written entirely in terms of Hattersley's concerns as a heterosexual man. He makes small gestures toward writing for women and toward acknowledgment of homosexuality, but these gestures are overwhelmed by his own struggles with women. For Hattersley, women are frightening to men because they represent the femaleness in men that men fear to accept. Women are an impenetrable other, a complete puzzle in their emotional lives. Women bring out in men the worst impulses of selfishness, control, cruelty, and destructiveness. In marriage, a woman holds up a mirror to her husband that reveals all his flaws. One might legitimately ask how useful such a personal account of Hattersley's psyche might be to others. Not every man has the same drive to control women that Hattersley admits to.

Hattersley freely acknowledges the autobiographical nature of his book, but does not see it as a problem. He has no doubts about the validity of his psychic life for others; he says that anything deeply true of one person will prove to be universal.[91] In saying this, he invokes the long-standing tenet of modernist theory (which is found in the criticism of Stieglitz and *The Family of Man*) that human experience is ultimately unified and that the artist, playing the role of spiritual seeker, may reveal this unity. This belief has been attacked by postmodernists, who remind us of the very different psyches produced by different cultures and by one's place in a given culture in accordance with one's race, gender, sexual orientation, and so on. But such fragmentation of human experience should not be taken too far. Drawn to its ultimate conclusion, it would mean that we are not capable of understanding each other. And yet we do communicate, and we do see that our experiences follow patterns. Therefore, a middle ground between the glib universalizing of modernism and the Balkanization of the human psyche must be found, and this is where the value of Hattersley's autobiographical method may be assessed.

Nathan Lyons

Nathan Lyons is another theorist and critic of the sixties for whom it could be said that Minor White was a touchstone, although he also showed considerable independence from White. Lyons tells the story about how he became White's student shortly after they met, but only for about two weeks. When White asked Lyons how he was enjoying his workshop, Lyons was very critical. White's response was to tell him to teach the workshop himself the next year. Lyons did, and White attended every class and worked as earnestly as anyone.[92]

Lyons met White in Rochester, New York, in 1957 while on a pilgrimage to visit some major figures in art photography. He went to see White at the advice of John Wood, one of Lyons's teachers at Alfred University. He knew nothing about White at the time but already had a longstanding interest in photography. He had taught himself the basics of the medium as a teenager, had pursued photography on the side while in college, and during a hiatus in his college education, had spent four years as a photographer in the Air Force. None of this was entirely satisfying to Lyons, however, or fit with his educational pursuits, which involved journalism, poetry, theater, and exhibition design. In the late fifties, when Lyons came in contact with White and his circle in Rochester—Walter Chappell, Paul Caponigro, Carl Chiarenza, Ralph Hattersley—he was struck by their challenging approach to photography, and he decided to stay there.

The year Lyons moved to Rochester he was hired by the George Eastman House as coeditor of the museum's magazine, *Image.* In 1965 he became the associate director of the Eastman House and Curator of Photography. Convinced that it was not sufficient for the understanding of photography simply to exhibit photographs in museums and galleries and to encourage their collection, Lyons set out to strengthen the theoretical, historical, and critical foundations of the medium in as broad a way as possible. To this end, he instituted a publication program, mounted exhibits of contemporary and historical work, established internships, held conferences, workshops, and seminars. A notable product of his publication program is the invaluable *Photographers on Photography* (1966), an anthology, edited by Lyons, of essays and statements by major photographers. One of his seminars, held in 1962, produced the idea for the Society for Photographic Education.

When Lyons left the Eastman House in 1969, in protest over the firing of a colleague, he continued to teach in Rochester by starting the Visual Studies Workshop, a master's degree program with an aggressively interdisciplinary approach to photography. Lyons has described this approach as "not working towards a defined program; but that through the cycle of work and activity you're discovering other areas that need to be explored and worked on and developed."[93] This has led to the initiation of community programs, the exploration of film, video, and print making in addition to photography, to the publication of artists' books, and starting in 1972, the publication of *Afterimage,* a journal that covers all the workshop's various interests from an international perspective.

One of Lyons's abiding concerns throughout his career has been to keep an eye on the most contemporary developments in photography. Perhaps the

greatest service he performed for the photographic community in the 1960s was to mount a series of exhibits at the Eastman House, with accompanying exhibition catalogues, which traced the trends of that period. He said that his intent with these exhibits was to establish "a continuing directory of photographers entering the field, announcing their work, their ideas, their background within the medium."[94]

The first of these exhibits was *Toward a Social Landscape* (1966). It featured the work of Bruce Davidson, Duane Michals, Lee Friedlander, Danny Lyon, and Garry Winogrand. The catalogue for this show was crucial in bringing attention to all these now well-known photographers. In his introduction to the catalogue, Lyons suggested that part of the rationale for the exhibition was to expand the concept of landscape beyond the realm of natural form. If we think of the landscape as the environment with which humans interact and from which they draw meaning, then the realm of human structures and activities—the social landscape—is as worthy of investigation as nature. This was an idea that had recently been explored by Pop Art. Lyons, however, implicitly associated the photographers in his exhibition with the movement toward subjective social commentary of which Robert Frank was the figurehead. He explained that the subject matter and style of the photographs in the show might lead us to see them as documentary, but they might better be understood as visual expressions of ideas—bitter, humorous, affectionate, ambiguous—about the human condition. As did White, Lyons wanted to stress the subjective quality of photographic vision over realism, although he did so in the context of very different imagery.

The style of the photographs in *Toward a Social Landscape* was of particular significance to Lyons because it was based on what he thought of as one of the authentic photographic forms: the snapshot. Characterized by blur, unusual perspectives, imbalanced compositions, abrupt foreshortenings, and all the other mistakes of rank amateurs who have virtually no "picture awareness," the snapshot form, Lyons thought, provided a rich source of ideas about picture content and structure well worth the attention of artists. In allowing the snapshot to inform their work, consciously or not, the photographers in *Toward a Social Landscape* benefited from the snapshot's directness and authenticity.

Part of Lyons's delicacy in associating the photographers in his show with Robert Frank (he never actually mentioned Frank by name) arose from his recognition that these photographers did not see themselves as part of a group or movement. He explained in his essay that by naming the show as he did, he had no intention of establishing a new category of pho-

tography. Nevertheless, the show provided a useful label for a body of contemporary work, and the idea of the social landscape entered the general discourse on photography. Most curators would have been pleased at having codified an aspect of the contemporary scene in this way, but Lyons was very sensitive to what he saw as the possible artificiality of the curator's role if it became the role of tastemaker and gatekeeper. He felt strongly that he wanted to provide access to work but not sanction it.[95] Labeling art is an important aspect of the sanctioning process, so in his next exhibit and catalogue, *The Persistence of Vision* (1967), Lyons carefully chose a title that did not label the photographs. "I could not see anyone calling the photographers in the exhibition, 'Persistence of Visionists,'" he said.[96]

The Persistence of Vision included work by Donald Blumberg and Charles Gill, Robert Heinecken, Ray K. Metzker, Jerry Uelsmann, and John Wood. All these artists worked in synthetic techniques, ranging from multiple printing, to drawing on negatives or painting on prints, constructing montages and collages, printing magazine pages as paper negatives, and mounting photographs on stacked blocks of wood. The point of the show was to challenge straight photography and the assumption that the only valid photographs are based on clearly identifiable subjects in the physical world. In his introduction to the catalogue, Lyons argued that all photographs, through whatever technique they are created, are expressive statements, and as such, have equal validity because they have an equal relation to reality, whether the reality of external objects or the reality of interior experience.

Photography in the Twentieth Century (1967) dealt with the same ideas as *The Persistence of Vision,* but in a larger historical scope. This catalogue presented in perfect balance the work of straight photographers and those who used synthetic processes; thus it served as a counterpoint to Beaumont Newhall's standard history, which is so obviously partial to straight photography. Lyons did not mention Newhall in the introduction, but chose instead to do battle with Clement Greenberg over his claim that photography is essentially a literary art and, as such, should stick to the essential literary function of narrative. Lyons countered that photography does not tell a story about the world so much as record an individual's response to the world. "His camera becomes the biographer of his interaction with the world," he wrote, and that interaction may be recorded through any kind of conventional or unconventional means or images. Lyons concluded his essay saying,

It should be clearly stated that I am not suggesting the complete abandonment of the realistic picture. What I am suggesting is that

by photographic realism have we emphasized too stringently "speaking likeness," insisting upon honest real-life facts? The question which should arise is whether or not the photograph can become a thing in itself, finding for itself an independent existence which may not necessarily be a direct reflection of a traditionally realistic construct.[97]

Vision and Expression (1969), the last effort in Lyons's series on contemporary photography, is a large collection of work by little-known photographers. The brief introductory essay deals for the most part with Lyons's curatorial procedures. He explains that he culled the 154 plates from a total of 6,000 photographs submitted by more than 1,200 photographers. The only criterion for submission was that one's work not have been included in a prior survey of contemporary photography sponsored by the Eastman House. Although he freely acknowledged his responsibility for jurying *Vision and Expression,* Lyons designed his selection procedure so as to let the work set the show's agenda, rather than setting the agenda himself. He was implicitly contrasting his approach to the one Steichen had taken at the Museum of Modern Art.

Lyons explained that he judged each photograph in relation to other photographs submitted by the same photographer and in relation to the work by other photographers that he was considering. He prolonged the selection process so as to examine his decisions carefully and to try to overcome any set responses on his part that might inhibit his understanding of a photographer's concerns while passing judgment on his or her work. The selection procedure and Lyons's thorough description of it in the catalogue's introduction were meant as a demonstration of his commitment to the idea that the institution must act as a means of access to new work rather than a sanctioning body.

Beyond his interest in bringing contemporary photography to the public, Lyons developed a photographic theory, the themes of which appear in fragments in his exhibition catalogues, in a few published interviews, and other scattered essays. Lyons has been described as "supremely complex" and his pronouncements on photography have been called enigmatic. Indeed, Lyons's writing style often seems unnecessarily indirect; nevertheless a cogent theory does emerge from his less than hospitable prose.

At the base of his theory is his concern with the correspondence between the inner world of the imagination and the exterior world of objects. In a 1961 book review of *Form and Art in Nature,* he wrote about "the recognition that the mind and imagination are part of and not distinct

from nature, a striving toward a consciousness of meaning. . . . Sensed pre-occupations within imagination are affirmed as structure within the physical world. The world affirms itself structurally, exposing not only a new landscape but a space station of the mind."[98] This statement is ambiguous with regard to the way in which the mind and the physical world act on each other. Lyons does not indicate here which he thinks is dominant, whether the physical world shapes the imagination through perception or whether the imagination (the mind) shapes our perception of the physical world. He posed this very question himself in another essay of 1961: "Do we tend to see what we believe or do we tend to believe what we see?"[99] In that essay, Lyons emphasized the primacy of observation as the source of "significant expression." Much later, in an interview, he spoke again of the importance of direct observation as a form of knowledge.[100]

But in general, Lyons has not been as interested in puzzling over the exact relationship of perception and knowledge as he has been in using the correspondence between inner and outer reality to justify photography as a process of both perception and thought, of perception and expression. In an essay accompanying his own photographs in *Under the Sun* (1960) he wrote, "Photography is, when used with regard for its inherent directness, a unique and exacting means of isolating inner realities found in correspondence with the physical world."[101] Photography makes visible the link between concrete objects and the mind, and when the photographer consciously works with an awareness of "vision as a sense of selective observation," the resulting photographs transcend their literal content to become the expressions of ideas, metaphors.

In drawing a link between ideas and the visible world, Lyons's theory of correspondence is similar to White's concept of the equivalent, although Lyons has not been as interested in spirituality as White was. Lyons has also distinguished himself from White through his greater emphasis on empirical discovery. He has been critical of White and Walter Chappell for what he sees as their belief that photography can reveal already existing patterns of meaning. Lyons thinks that meaning has no archetypal structures and that photography may be used not to find but to construct meaning.[102]

As the site of correspondence between the mind and the physical world, Lyons has thought of the photograph as an independent reality, referring to both the mind and the exterior world it represents, but equal to neither. In fact, in their ubiquity, photographs create an environment of their own: "We have pictured so many aspects and objects of our environment in the form of photographs (motion pictures and television) that the

composite of these representations has assumed the proportions and identity of an *actual* environment."[103]

If photographs are their own reality and are independent of what they refer to, Lyons reasoned, they need not follow the rules of "traditionally realistic constructs." It was on the basis of such reasoning that Lyons supported any means of photographic image making, not just straight photography.

That Lyons thought of photographs as having an independent status led him to adopt a version of the traditional modernist position that the meaning of a photograph is inherent in it. In a 1963 essay he briefly considered the idea that a photograph's meaning may change if it is seen in different historical and cultural contexts.[104] But he did not develop this idea, and in a later essay, he stated, "In the final analysis the meaning of a picture must come from the picture itself." Nevertheless he did not completely abandon the idea of contextual meaning, for he went on in the same passage to say that our understanding of a photograph may be enhanced "in relation to other photographs the photographer has made, and even other photographs by someone else."[105]

Lyons's development of the idea that meaning arises from a group of photographs rather than a single, isolated one is perhaps his most important contribution to photographic theory. The idea is not unique to him. Minor White worked at length with the interactive meanings of photographs and the concept of the photographic sequence. His sequences are brief series of pictures, with a title but no other text, which he arranged and rearranged to draw out of them extended metaphorical statements. Before White, Robert Frank had worked with the book-length sequence of photographs in a number of unpublished efforts. *The Americans,* which is a careful structure of interwoven imagery, was his culminating statement in this genre. Lyons has pointed out that Moholy-Nagy discussed the photographic series as early as 1936.

Repeatedly Lyons has asserted that a photographer's ideas can be understood only if one examines as much of that person's work as possible. He has been very critical of the photographic community for failing to realize this and for generally not paying sufficient attention to the range of any given photographer's oeuvre. Too often the photographic community has based its knowledge of someone's work on only a handful of photographs that are reproduced repeatedly.[106] In an interview in 1974 Lyons said, "Too often somebody's work has been distorted, misinterpreted, not given a chance to develop itself fully . . . what I have been trying to suggest for a very long time is the question of authorship, where the issue of

the philosophy of one picture maker can be dealt with as a very full and total kind of an experience."[107] Unless we look at a substantial portion of a photographer's work, we cannot identify the major themes, we cannot see their subtleties, we cannot tell aberrations from the central vision. For that matter, we cannot even distinguish the accident from the deliberate statement.

All this would suggest that as a curator, Lyons would have favored one-person shows, but in his concern to map out the shape of broad areas of photographic practice, he tended to organize group shows. It is in the books of his own photographs, *Notations in Passing* (1974) and *Verbal Landscape, Dinosaur Sat Down* (1987), that Lyons has pursued the idea of sequential meaning.

Lyons has drawn a distinction between the photographic sequence and the photographic series: The series "is structured so that the relationship of terms is such that each successive term is derived from the one preceding it by application of a specific principle. A sequence is structured by allowing one image to follow another by an order of succession or arrangement which is not apparently thematic or systematic."[108] The *Life* photo story, then, would be a series, whereas White's constructions and Lyons's books of his own photographs would be sequences. In a series, the meaning is derived from a set of linear relationships as it is in language. These relationships are made explicit in a *Life* photo story through the captions. In a sequence, meaning does not depend on a linear structure and has little to do with verbal expression. The meanings of sequences depend on what Lyons has described as the purely visual, ideographic language of photography.

That photography is an ideographic language has been a compelling idea for Lyons. He has written about this concept in bits and pieces in a number of places, his most extensive and developed comments appearing in an essay he read in 1980 at the Symposium on Photography II in Graz, Austria. At the heart of his idea is the process of visual thinking, a process of forming and arranging ideas in purely visual terms. Lyons notes that thinkers such as Albert Einstein have spoken of a form of "combinatory play" with signs and images as an essential feature of their productive thought. Einstein described this play as preceding any connection with logical structures, words, or any other kind of sign that can be communicated to others. Only in a second, laborious stage are these images translated into a transmissible form.

Lyons is convinced that photography, as well as thought, can serve as a medium for combinatory play with images and that the visual ideas artic-

ulated by photographic images need no translation into another form to be communicated. He supports the idea of Mario Pei that language may be broadly defined as any transfer of meaning and, as Pei says, that "meaning may be transferred by devices that have nothing to do either with spoken language or with its written counterpart."[109]

In Lyons's concept of photography as an ideographic language, it is not only the sequence of images that conveys purely visual meaning but also each individual photograph, which thus functions as an ideogram. To understand a photograph as an ideogram, says Lyons, one must not see it as representing verbally identifiable objects (a process he equates with the identification of artistic motifs), rather one must see objects in a photograph as expressive marks and forms. "My concern here," Lyons said, "is to concentrate on the evocation of objects as 'factual' or 'expressional' as essential acts of mark making and [to] de-emphasize within this discussion interpretive issues involving 'the world of artistic motifs.' The concern is to replace the concept of 'artistic motifs' with that of mark making and in doing so shift our predilection toward an aesthetic determinism to a prelinguistic one."[110]

In response to Lyons's account of photography as a purely visual ideographic language one might ask, can this language be translated into words at all? If not, how does one learn such a language? How does one confirm whether one understands such a language, whether a message has been received and understood? Can we at least indicate with words in a general way the kinds of meanings communicated by this purely visual language even if those meanings cannot be directly expressed with words? From Baudelaire on, critics and artists have spoken of the musical qualities of color, qualities that can be pointed to with words, but not directly conveyed by them. Can the same be done with the visual qualities of photographs?

Lyons has said virtually nothing to indicate the content or the qualities of the prelinguistic meanings he sees in photographs other than to suggest that they are metaphorical. On the contrary, throughout his career he has made a number of statements that convey a deep distrust of any attempt to translate images into words. In one such statement in 1974 he said,

> We get confused about . . . clarifying our concerns, one of the earliest instincts seems to be to establish a verbal display that assures everybody what the work means. I'm probably now more interested in establishing more of a visual verification of those issues. I've spent a lot of time speaking with people, teaching and lectur-

ing. The thing you begin to sense is that it may be an inappropriate form for the exchange of certain ideas.[111]

On the other hand, Lyons also made a distinction between photographs that deal with verbally identifiable motifs and those that do not. The former, he called "content specific" and "literal visual statements" based on known and accepted symbols. The latter are not content specific and are "nonliteral," although they reveal content. The only way to deal with the content of nonliteral photographs, says Lyons, "is not exclusively in terms of meaning, but in *experiencing* the work."[112] Literal photographs, however, are accessible to language and embody meanings based on motifs or symbols embedded in a cultural context. Lyons did not say how one distinguishes between these two kinds of pictures. Perhaps he considers the distinction self-evident.

Lyons's ambivalence about the relationship of visual meaning and language is indicative of a deep conflict in photographic theory, which may be seen as a dividing line between modernism and postmodernism. Postmodernist theorists have generally ignored or denied the possibility of visual thinking and purely visual meaning in photography, wanting to see photographs as utterly infused with and dominated by language. Modernist theorists have tended to reserve an area of purely visual meaning in pictures that cannot be touched by language. Lyons, in speaking on one hand of a prelinguistic language of marks, and on the other of a language of culturally determined symbols, has adopted pieces of both positions.

Henry Holmes Smith

Henry Holmes Smith was less well known than White, but equally important for the development of subjectivist theory and criticism in the post–World War II period. Smith shared with White a commitment to the metaphorical tradition in photography, giving strong critical support to artists who worked in that tradition and engaging the theoretical problems it generated. He collaborated with White on the project of reading photographs, and he was determined, even more than White, to establish art photography in academia.

Smith yearned to see American photography enjoy the kind of semi-scientific certainty and sense of purpose that had characterized the Bauhaus program. He wanted academics and art photographers to seize control over the history and discourse of their medium, thereby acquiring the power to determine which questions are important, which photographs are art, and which ones are good art, all without reference to the realm of popular pho-

tography and public opinion that Smith regarded as thoroughly in the grip of the photographic industry. In the absence of cohesive professional institutions and consensual standards, photographers would remain in thrall to that industry. "Lacking motives of this [professional] order," he complained, "most photographers behave like lackeys and peddlers, and photography is hardly worth calling an art and cannot be called a profession."[113]

In his brief essay, "XI Zero in Photography" (a title referring to the name of an atomic particle), Smith wrote of how he hoped to see photographers take a cue from nuclear physicists, whom he perceived as conducting their research entirely within the confines of a knowledgeable, professional community. By calling on photographers to establish an equally self-contained community, Smith's intent was not to sever the discussion of photography from its broad social context, but to assert that photographers must "stop thinking like . . . member[s] of the general public," learn to subject the work of their peers to rigorous analysis, set professional standards, and learn to conduct most of their activity "photographer to photographer, just as the scientist makes his studies within his own group."[114]

Smith slowly fashioned his own career into a model of the kind of professionalism he hoped would flourish in his medium, mixing artistic practice, scholarship, teaching, and organizational activity. He began his undergraduate education at Illinois State Normal University, where he studied art and journalism.[115] Dissatisfied there, he left to spend some time at the Art Institute of Chicago, but there too he was gravely disappointed by what he considered his teachers' nearly irrelevant curriculum and rote methodology. In 1933 after six years of searching futilely for satisfying schooling, he received a bachelor's degree in art education from the Ohio State University. Later he summed up his formal education as "typically American, life crunching, puritanical, demeaning, formula ridden."[116]

Smith had begun to photograph in high school and continued in college, gravitating toward any examples of advanced work that came his way through such sources as *Vanity Fair, Creative Arts,* and *Theater Arts Monthly.* The latter is where he saw Francis Bruguière's dramatically lit photographs of cut-paper abstractions, which became an important touchstone for his own art.

In addition to making photographs, Smith painted and drew cartoons, some of which he sold to the *Chicagoan* and the *New Yorker.* He might have become a professional cartoonist but chose not to. After college he slid into a modest and not very satisfying career in journalism, working for the American Ceramic Society and *Minicam,* the latter of which he resented for what he considered its mindless commercialism.

In 1937 Smith's career took an important turn when he was invited to teach at the New Bauhaus in Chicago by the school's founder, Laszlo Moholy-Nagy. Smith already considered Moholy-Nagy the "true master" he had been searching for, but until 1937 he had known him only through his book *The New Vision,* which Smith had first seen four years earlier at Ohio State.[117] Smith had spent a year and a half trying to assimilate Moholy's confident empiricism and his lessons about the necessity of art for fundamental psychological and physical well-being. Finally, he had screwed up enough courage to write to Moholy in Germany, but the letter came back, and Smith was convinced Moholy had become a victim of the Nazis. When Moholy arrived in Chicago in 1937 and announced the establishment of a new school, Smith was, needless to say, astonished and delighted. "Consciously or unconsciously," he wrote, "my life centered on this enterprise and this man."[118] Unfortunately for Smith, the New Bauhaus closed after he had taught there a year. Although he was invited to join Moholy once again when he opened the School of Design, Smith never did.

In 1947 after having spent much of the war in the Pacific, Smith went to Indiana University where he taught until his retirement thirty years later. At Indiana, Smith established the photography department, one of the few in the country at the time, introduced the first history of photography course to be taught in an American university, and eventually began a graduate program. By virtue of his writing, two summer workshops involving major figures in the photographic community, and the burgeoning reputations of his former students, Smith raised his department to the level of national significance and kept it there. In 1963 Smith became one of the founding members of the Society for Photographic Education (SPE). He served on the board of directors and as a vice-chairman of SPE until 1973.

Smith's reputation as a writer and teacher has always eclipsed his efforts as an artist. He was a charismatic teacher, although he had a mixed persona as both wise mentor and ogre. Nevertheless he often inspired an intense devotion in his students that they carried with them wherever they went. In 1986 when Smith died, Jack Welpott wrote of his tutelage with him forty years earlier: "He knew when to let us stumble; he knew when to pick us up. He knew when to knock us down. He knew when to leave us alone. He didn't have any axes to grind. For him the real goal was our goal, even if we didn't know what it was. And he deployed his energy to help us reach that goal—whatever it might be."[119]

As powerful a personality as Smith was, he had the capacity to allow others to be themselves. Typical of his efforts to stimulate discussion in the photographic community, was *Photographer's Choice,* an exhibition he

organized in 1959. The show was assembled on the basis of invitations to specific photographers made by several people of stature, including Ansel Adams, Minor White, Pirkle Jones, Aaron Siskind, Smith himself, and Helen Gee, owner of the Limelight Gallery in New York. The fifty-four invited exhibitors—of whom some were famous and others obscure—were themselves allowed to determine which of their pictures would be exhibited. Today, such an exhibition sounds entirely unremarkable, but at the time, it was an innovation in art photography.

Smith welcomed the interaction of photography with the modernist tradition of painting. He particularly admired Aaron Siskind for bringing photography into that tradition through his use of straight technique to make abstract, metaphorical images. Smith's recognition of Siskind's achievement rested on his comprehension of the photographic paradox. As he understood this paradox, "both fact and artifact are present in every photograph." Every photograph is both an "image as witness" and an "image as image," but the balance between the two may vary from one photograph to the next.[120] Siskind, by practicing a rigorously straight technique, honored the power of the photograph as witness, but by choice of subject, point of view, and composition, he emphasized to the fullest the independence of the photographic image from its source in the world.

Siskind's achievement with straight photography was of the utmost importance to Smith, but in many ways the straight tradition aggravated him. Smith saw its proponents as often arbitrary, narrow-minded, and oppressive in their quest for purity. In a review of the permanent exhibition at the George Eastman House, he indirectly but unmistakably accused Nancy Newhall, the curator, of avoiding visual adventure and fresh insight while attempting to keep photography pure and uncontaminated by "the arts of painting and drawing (and also music, literature, theater, motion pictures, and the rest, including no doubt the art of thinking)."[121] In Smith's opinion, that such a dubious doctrine as straight photography could have become dominant in this country was the unfortunate result of historical circumstance, specifically, the monumental examples of energy and invention set by Strand and Stieglitz who had conceived of straight photography. Smith was not critical of Strand and Stieglitz themselves, but saw their very success as setting a standard that ossified in the hands of their followers.[122] On another level, straight photography had an inherent appeal to the rigid-minded. Its precision, clarity, and claim to purity were all qualities that conformed perfectly to what Smith called the WASP aesthetic. This he defined as a "puritanical view of life forces, over-preciseness, a tendency to be self-congratulatory, smugness, special concern for

surface appearance, and a willingness to bear the burden of judging every-one by inapplicable standards."[123]

Smith repudiated the straight photographers' obsession with purity, but he was no less interested than they in defining the essence of photography. To his mind, true clarity regarding that matter came from the tradition that embraced synthetic images, such as photomontages and photograms. This tradition had taken root in Europe in the 1920s, flourishing in close associ-ation with Constructivism, Dada, and Surrealism. Moholy-Nagy, who best articulated the theories and aims of the synthetic tradition, brought that tra-dition to the United States in 1937, and after his death in 1946, Smith became its most prominent spokesman.

As a Constructivist, Moholy's thinking was consistently reductionist. In other words, he was interested in art that does not create representa-tional illusions but that presents its materials and manner of fabrication openly for what they are in their most essential forms. Applying this idea to photography, he wrote in 1928, "The photographer is a manipulator of light; photography is manipulation of light. . . . It must be stressed that the essential tool of photographic procedure is not the camera but the light-sensitive layer. Specifically photographic laws and methods result from the reaction of this layer to light-effects which in their turn are influenced by the material, be it light or dark, smooth or rough."[124]

Smith may never have read the essay in which Moholy made this statement, but the same ideas are implicit in *The New Vision,* Moholy's book that had had a profound impact on Smith. Taking his cue from Moholy, Smith began to define photography in a series of published and unpublished articles. The definition he arrived at treats the medium quite literally as a process of marking with light. The process consists of four elements: radiation (this category includes x-rays, infrared, and ultraviolet radiation, as well as visible light), a substance sensitive to that radiation (in addition to the traditional silver salts, Smith named such substances as snail slime and melanin), a support for that substance (glass, metal, or ceramic would do as well as paper), and finally something—possibly the lens of a camera, perhaps one's hand—which modulates that radiation as it passes from its source to the sensitive surface.[125]

In Smith's eyes, to define photography in these terms was not the occasion for purification but an opportunity to break into a realm of tech-nical freedom. If one accepts his definition, then all varieties of camera-made images become legitimate as well as noncamera images such as "profiles of opaque or translucent objects on the [light sensitive] surface. A variety of light sources of varying intensity falling on microscopic por-

tions of the surface. . . . Any one of a variety of hand marks, especially with chemical liquids or fumes."[126] In addition, because Smith saw the support for light sensitive material as one of the essential variables in photography, processes which emphasize the photograph as a physical object, such as photomontage or photographic sculpture, are also legitimized. Within the bounds of photographic technology as he knew it, Smith's effort to get at the medium's essence is impressive, but even his definition of photography has been proven limited by the electronic processes now revolutionizing the medium.

The technical freedom Smith found in his definition of photography was important to him as a means to expressive freedom. Smith was frustrated by the unyielding expressive limitations of ordinary camera photographs. "Yet surely now we know and feel and *see* much more than the garden variety of photography can ever show us," he observed. Would it be too much to ask of photography to extend its powers more deeply into the inner regions of human experience?[127]

As with his understanding of the structure of the photographic medium, here too, in his desire to address psychological need with photography, Smith responded to Moholy-Nagy. Moholy was critical of capitalism for frustrating the individual's psychological fulfillment. He condemned the pervasive fragmentation in capitalist society produced by economic competition, alienated labor, and overspecialized education. He thought of art as a means to heal the wounds of fragmentation through its capacity to turn technology away from competition and toward genuine human need. He thought of art as capable of serving needs as basic as the biological need for food. He meant this quite literally. Moholy recognized that light, color, space, and motion are just as necessary for human well-being as food, air, and sleep. Art, nonobjective art in particular, was to his mind the most considered and satisfying way to provide these necessities. He thought that nonobjective art embodies color or space in a pure form, and that the human psyche understands this pure language of form directly. The process would be analogous to the way in which the body understands the chemical language of enzymes.

Smith also saw art as having therapeutic potential in its capacity to deal with universal aspects of the psyche, but he did not share Moholy's belief in nonobjective art as a universal language of form. Smith sought universality in myth and, therefore, in representational art with clear, culturally determined referents. He looked primarily to ancient Greek mythology and less frequently to the Judeo-Christian tradition as sources, but he believed that all religion and myth, even in its tremendous variety, is related

at its core, is the basis of all culture and all efforts to explain human experience. Ultimately he linked his concept of the universality of myth and religion to human biology, endorsing the ideas of anthropologist Weston La Barre who described religion as the consequence of human neoteny, as arising from one's experiences in the womb and of one's mother and father during infancy.[128] The therapeutic value of art, for Smith, came through its capacity to identify and clarify the powerful universal themes of the human predicament. Such clarification, Smith hoped, would release one from the destructive irrationality that so often accompanies the struggle to understand oneself.

The manner in which Smith searched for universal aspects of human experience points up a significant difference between him and Minor White. If it can be said of White that he made the secular sacred, then Smith made the sacred secular. Smith looked to the Judeo-Christian tradition and ancient Greek religion because he thought they touched on the realities of universal psychological experience. White, by contrast, looked for evidence of spirit in the quotidian. Both men were subjectivists, both believed in the almost sacred importance of the unencumbered, individual artist who seeks to make universal utterances from the private depths of the individual soul. Both thought of the social consequences of art as arising from individual action. Yet White sought to transcend the social world in order to cure it, while Smith focused on the social implications of personal, or interpersonal, psychological struggle.

Smith shared White's considerable contempt for the state of photographic criticism. He complained that most critics were not truly engaged, that they were flippant and petty, content to grind toy axes.[129] He laid much of the fault for these conditions at the feet of the popular and photojournalistic press. In Smith's opinion, publishers, advertisers, and editors, photography's most active and influential patrons, encouraged the production of photographs that pandered to the lowest common denominator of taste, thereby preventing the publication of rich, complex images and the maturation of public taste. In "Photographs and Public," which appeared in *Aperture* in 1953, Smith complained:

> Picture editors, working for a standard visual image that millions
> may relish in their haste or distraction, have fashioned a language
> of photography that approaches baby talk. . . . A photograph's
> "impact" turns out to be the visual equivalent of the exclamation
> or interjection and becomes as monotonous as a baby's cry in the
> night. A close look at the photograph's "story-telling" characteris-

tics reveals that photographs without words "tell" the general public only what is already completely familiar; this, then, resembles the meaningless repetitions of baby talk. A photograph's "appeal" usually shows itself to be the journalistic name for the sensational, trivial, cheaply sensual or banal and morbid. "Unlettered" children neither demand nor need baby talk; adults unskilled with pictures need even less these infantile visual equivalents.[130]

The situation was not about to improve, Smith lamented, because no one, not even those who were intellectually capable, was studying the problem of photographic meaning. As he pointed out in a later article, there was no economic incentive to do so: "At this time it is unfashionable to discourse on the art and meaning of photography; some persons assert it is neither possible nor desirable to do so. I see this condition, instead, merely as an index of a meager supply of collectors, dealers, curators, and others who really have their minds on photography. Briefly, photographs haven't the prestige and dignity accorded even postage stamps as items to collect."[131]

"Photographs and Public" was a two-part article, the first part written by Smith and the second by Wilson Hicks. Hicks agreed with Smith that audiences needed to be "induced" to engage photographs more deeply, but he was not about to take the responsibility for educating an audience if such an effort ran the risk of taxing them or losing their attention. "If you are obscure in a photograph," Hicks warned, "you are put down as dull, and today's viewers will stand for almost anything except dullness."[132] Hicks had no faith in the intellectual capacity of his audience and was not about to risk exploring its limits. He was content to justify the simplistic manner of the mass press on the grounds that the public will stand for nothing else. Smith insisted that the public is infantile because the press treats it that way.

Smith's virulent criticism of the mass press did not prevent him from addressing photojournalists and other professional photographers in their own forums where he urged them to exercise integrity, imagination, and depth of perception. Smith had a keen sense of the responsibility of photojournalism as a custodian of truth. He was acutely aware of both the authority of the journalistic photograph and the constructed nature of photographic truth, and he was apprehensive that professional photographers as a group were not sufficiently aware of these things and not sufficiently serious about their responsibilities. He exhorted professional photographers to examine their own motives and those of their employers and to be

stronger than their audience: "You must not let your audience attack you, erode you, any more than a doctor must let a patient infect him."[133]

Smith urged professionals not to perpetuate, in every instance, the assumption of photography's natural truthfulness but to tell the truth through the obvious use of the imagination and unconventional photographic techniques. Above all, photographers must not lie or tell half-truths; they must not, for example, represent a "boob as wise man." If such a lie is found out, said Smith, it will only engender public contempt for photography, and if such a lie succeeds, it will engender contempt for the public on the part of the photographer, advertiser, and publisher. All in all, lies in the photography of the mass press create a serious confusion of values and even threaten the "mental stability of the nation."[134] In Smith's view, then, photographic truth is constructed; it may be multiple, but still it exists; some things are true and others are not.

Smith demanded from critics very much the same thing as White: an educated, historical point of view as well as the capacity to respond to photographs in an immediate, ahistorical manner. In another sense, however, Smith's understanding of the critic's role was different from White's. Perhaps because he worked so much with students, White was convinced that photographers often do not understand their own pictures. For him, the critic was there to explain the photographer to himself, to nourish him, and enable him to continue to create. The critic or curator even took the photograph as his own in the process of responding to it. Smith believed firmly that mature artists are in control of their art and make their artistic statements with a high degree of awareness. The critic, for Smith, comes after the art. It is the critic's job to interpret the artwork for the public, and part of this job is to respect the intent of the artist.

Smith developed both historical and ahistorical approaches to criticism, but he kept them separate. In the fifties, he worked at ahistorical criticism—reading photographs—a process in which he relied entirely on intrinsic evidence to establish a photograph's meaning. In the sixties and seventies, he turned to historical criticism, dealing with issues such as a photographer's personal development, artistic purpose, and place in the photographic tradition and the larger culture. Unfortunately, he never included readings in his historical essays. Modified by what he knew of the contextual evidence of a picture's meaning, such readings could have been illuminating.

Smith saw his mission as a critic as being nothing less than the creation from the ground up of a critical vocabulary and methodology suitable for art photography. He looked to I. A. Richards's *Practical Criticism* for

guidance in developing his approach, paraphrasing and quoting Richards in a number of essays. Richards was attractive to Smith for several reasons. In contrast to the popular standard of immediate comprehension, Richards set an example of patient, close reading. In contrast to the popular standard of simplicity, Richards acknowledged the complexity of art and the difficulty of understanding it. In contrast to the common treatment of photographs as undistorted windows on the world, Richards emphasized that art offers an insight into the artist's mind.

This last point was of particular importance to Smith. He thought of the artist's mind as the origin of the most significant aspects of a photograph's meaning. He also recognized the role of subject matter in meaning, but it was a subordinate role to that of the artist. Paraphrasing Richards, Smith listed four kinds of meanings in photographs:

(1) *Sense.* (What we plainly *see* in a photograph.) . . . (2) *Feeling.* (What the photographer feels about the object he is photographing or what he thinks about it.) . . . (3) *Tone.* (The attitude of the photographer toward his audience.) . . . (4) *Intention.* (The photographer's purpose in making the photograph.)

Smith added a fifth meaning of his own having to do with "any implication as to the respect or disrespect [the photographer] feels for the medium."[135]

As Smith described it, then, a photograph's meanings do not lie in the world itself into which one looks through the transparent picture. They are not located in a transcendent realm of spirit into which the photograph is a passageway, as Minor White believed. Nor, as White thought, do meanings lie in the reader who interprets the photograph. And they are not in the photographic medium, as a formalist would insist. Instead, the photograph is an imprint of the photographer's mind on the medium of photography and on the world through photography.

It is instructive to compare Smith's theory to formalism because formalism dominated art criticism in general in the period Smith was active, and it was to dominate photographic theory under the influence of John Szarkowski. Smith would have agreed with the formalists that the evidence of a photograph's meaning lies in the material photograph, but the real issue for him was how to use that evidence to discover what the photographer was saying about the world. From the formalist point of view, Smith's intentional method is deeply flawed. A formalist would argue that when we approach a photograph as an object of interpretation, the photog-

rapher's mind is not available to us. We cannot see the photographer's mind through the photograph as something separate from it. All we see of a photographer's mind is the photograph itself, and the photograph is shaped as much by the medium of photography as it is by the photographer. Therefore, photography and the photograph itself ought to be the entire focus of our interpretation.

There is some question as to just how Smith understood the intentionality of photographs. Did he see photographs as a record of what photographers were thinking and feeling at the moment they made the exposure? Or did he think of the photographers' feelings and intentions as elements in the larger context of historical circumstances, which shaped them and in which they worked, so that in making a work of art they were responding to these circumstances out of the full development of their life and career as artists, just as much as they were responding to the subject before them and to their immediate interests? Smith never clarified this issue, but it appears that he fell somewhere between these poles. It might be best to say simply that he understood intentionality as a carefully constructed purpose evident in a work of art.

As difficult as he thought it was to understand a work of art, Smith assumed that critical interpretations are either successful or unsuccessful, that one interpretation may have "greater accuracy, reasonableness, or probability" than another.[136] This raises the obvious question as to how to measure the success of a given interpretation. How do we know when we have gone wildly off the track or when we have hit the mark? Smith was not altogether clear on this point either. Certainly, no interpretation should contradict the evidence of the photograph itself. Smith insisted repeatedly that a critic must constantly check his interpretation against the work. Also, he gave special privilege to the interpretation of the photographer. He acknowledged that even the artist cannot read into his own work what is not evident there, but he believed so thoroughly in the mastery of certain photographers who—in control of themselves, their medium, and their themes—can say clearly what they mean, that he accepted total congruity between their interpretations of their artworks and the works themselves.[137]

In one of his summer workshops devoted to the problem of reading photographs, Smith used "the photographer's suggested interpretation . . . as the standard of reference for [critical] accuracy."[138] This made criticism something of a guessing game for Smith, especially when dealing with a master artist. The artist had the right answer, and the photograph was a puzzle that contained enough information to guess the right answer if the

critic was clever enough to work it out. If the artist was obliging (and alive), he would tell the critic if he got it right. Some of these attitudes are apparent in a letter Smith wrote to Siskind: "I found your comments on your own picture of the 'R' the sort that put to rout the 'interpretations' in *Aperture*. . . . I have some later responses to 'Concerning Flight' which are eye-openers though. . . . I showed the photograph again last Fall. . . . and one student's first remark was a flock of 'prehistoric birds.' All these initial remarks were without any clues except the image before them."[139] In other words, the interpretations of the "R" were rendered inaccurate when Siskind revealed the correct answer, whereas the student looking at "Concerning Flight" guessed the "right answer" simply by looking at the photograph itself, without even having seen the title.

Smith played by the same rules in his own interpretations of Siskind's pictures originally published in *Aperture* in 1957 as part of "The Experience of Photographs," the article he wrote with White and others. In a revised version of the readings published in his *Collected Writings* (1986), Smith made it clear that he presented his interpretations with deference to the final authority of the artist. He wrote:

> It would be impertinent to impute these interpretations to the photographer, yet they have a certain resonance in view of the character of the central figure. . . . These readings begin to reveal the levels of interpretation inherent in each image. These remarks, however, cannot serve as a substitute for the original photograph, and they can never stand for the entire work. They may not, perhaps, even stand for that part of the work that the artist himself finds most important.[140]

To be fair to Smith, he does not suggest that any interpretation is final, even that of the photographer, but it is clearly implied here that what Siskind saw in his own photographs and what he considered important more closely define his work than whatever Smith might say.

Smith's major assumptions about meaning—that it is inherent in a photograph and that the artist knows better than anyone else what it is—put him in a bind. He could neither be free of the artist nor, because of the imperative to stick to the picture, could he use the artist freely. Had he let go of the latter assumption and embraced formalism, he would have been free of his deference to Siskind. Had he let go of the former assumption, he would have been free to pursue Siskind and use his ideas openly. Had he let go of both assumptions and come to the conclusion that a work's

meaning arises out of the entire context in which it is made, he would have been free to interpret both Siskind and his photographs (whatever Siskind did or did not say) in accordance with his own full understanding of the historical situation in which Siskind worked.

Because Smith's thinking was defined by the framework of modernism, he did not pursue the issues of intentionality very far. Instead he worked with the idea of inherent meaning, trying to define a system of visual symbols that would make that idea viable. As did Nathan Lyons, he thought of photography as a visual language, but in contrast to Lyons, Smith thought this language could be codified and regularized. To his mind, the ideal critical methodology would be one that would stabilize the code of visual symbolism in photographs so that it could be read in a universal way as written language is read. Smith acknowledged that the state of photography as a language was comparable to written language before the development of dictionaries and standardized spelling, but he contended that "it would be too soon to smear photography as a language because we as a group have not learned to read it, have not mastered its vocabulary."[141]

In "The Experience of Photographs," Smith defined five terms he considered basic to a language of visual symbolism: form, figure, simile, metaphor, and image. The first term, form, Smith described as corresponding roughly to the concept of musical or literary form and such entities as sonnets and limericks. Smith was hesitant to specify photographic forms, but he suggested snapshots, journalistic pictures, and works of art as possibilities. Photographic forms shape viewers' expectations of the kind of visual experience any given photograph will offer them. Smith felt that it was important to establish forms so that a viewer would know, for example, when to be prepared for a casual experience and when to be prepared for a difficult personal statement.

The smallest units of photographic forms are figures which are composed of the elemental visual constituents of a photograph, such as shape, texture, and tone, and of attributes of the objects pictured, such as gesture or expression. As an example of complete figures, Smith listed "mist" and "wet street." Smith said he had adapted the idea of the figure from music, but it also bears a close resemblance to what Erwin Panofsky has described in his famous definition of iconography as primary or natural subject matter.[142]

Looking to literary terms, Smith suggested that figures may constitute similes or metaphors. A photographic simile, he said, "is distinguished from metaphor in that the similarities pictured are basic and obvious, e.g., the geometrical similarity of a plate, a wheel, or the letter 'O.'" A metaphor

is "a visual figure in which one object is pictured as sharing or appearing to share *unexpected* but important qualities or attributes of some other unlike object."[143] Similes and metaphors, in turn, comprise an "image," which Smith defined as existing as sensations and feelings in the memory or imagination. If a photograph is to produce an insight into experience, it does so through an image. An image might be a culturally determined reference to a religious, historical, or literary tradition (as iconography is in Panofsky's scheme), or it can be a personal symbol. The point for Smith was to lay the groundwork for the identification and clarification of these images, particularly the personal ones, so that they might be read with at least the same degree of certainty as poetry.

Smith's idea of assimilating photography to a linguistic system of meaning has been taken up recently by postmodernist scholars, many of whom—under the banner of semiotics—also apply rhetorical forms, such as simile, metaphor, and synecdoche, to photographs. Such efforts have even been referred to as a "reading of the image."[144] This recent theory, however, differs from Smith's. Smith was concerned with the interpretation of personal symbolism. Part of what motivated him to look for regular forms of signification in photographs was that he was dealing with pictures about which there was very little agreement and for which he felt interpretations varied much too widely. If photographs by White, Siskind, or Frederick Sommer were to have any value as elucidations of the human experience, then tools had to be developed that would bring some kind of order to the interpretive process.

More recent scholars, by contrast, have not been interested in photographs imbued with personal symbolism. It has been their purpose to demonstrate, as Victor Burgin says, that the meanings of photographs are the function of ideology understood as "the sum of taken-for-granted realities of everyday life." In other words, meaning is inescapably social, it "depends not on something individual and mysterious but rather on our common knowledge of the typical representation of prevailing social facts and values."[145] Any photograph may be interpreted according to this concept of meaning, but those that lend themselves most easily to the demonstration of this idea are those used for advertisements and journalism and others that clearly rely on public imagery.

Furthermore, and perhaps most important, Smith thought that a photographic metaphor gains its meaning through a purely visual process of association. Implicit here is Rudolf Arnheim's contention that meaning, or more accurately thinking, is based on perception: "I assert not only that perceptual problems can be solved by perceptual operations, but that pro-

ductive thinking must solve any kind of problem perceptually because there exists no other arena in which true thinking can take place. . . . Productive thinking operates by means of the things to which language refers—referents that in themselves are not verbal, but perceptual."[146] In contrast to Smith's implicit, and Arnheim's explicit, point of view, post-modernists have generally argued against the very possibility of purely visual meaning. Alan Sekula writes that "photography is *not* an independent or autonomous language system, but depends on larger discursive conditions, invariably including those established by a system of verbal-written language. Photographic meaning is always a hybrid construction, the outcome of an interplay of iconic, graphic, and narrative conventions."[147]

Smith demonstrated his concepts of the visual simile and metaphor in his readings of Siskind's photographs of paint-splattered walls, torn posters, piled rocks, and water-damaged cement. In his reading of *Chicago 10, 1948* (the photograph in which White saw an image of a sexually frustrated woman flanked by an impotent man), Smith said:

> The principal figure is created by the water stain around a crack in the concrete wall. We find visual similes for a part of an almost human body. . . . One metaphor, derived from the shape of the stain and the muted tone of the concrete wall, is that of an apparition. . . . A second metaphor is based on the nature of the scrawls. They appear to be associated with the "body," perhaps as its "gesture," perhaps as its "language." Since scrawls and scribbles are the ultimate degradation of the sensemaking marks (letters, words, and sentences) upon which mankind depends for what he knows, we may think of scrawls as both the language and gesture of this strange body. . . . We may thus combine the metaphors of the apparition (which is a vision of dissolution) and the language and gesture of the apparition (which is a plain sign of idiocy). Seldom is the imagination offered such a clean-cut and powerful symbol of idiocy and destruction as is seen in this photograph.[148]

It is interesting that in working out his idea of a visual language Smith chose to interpret this photograph as a comment on language. He applied the process by which he hoped to codify a critical methodology to what he saw as an image of incoherence. Of course, Smith would have seen Siskind as the final judge of this interpretation.

In choosing to create an interpretive method for metaphorical pho-

tographs, Smith knew he had set himself a particularly difficult task. He also recognized that the definition of this task depended on making convincing distinctions between metaphorical photographs and other kinds of photographs. This raised the issue of photographic categories, an issue White had also dealt with. Smith agreed with White that if critics are to interpret a photograph sensibly, they must know what to expect from it. Approaching a symbolic work of art as if it were a piece of journalism, or a fashion photograph as if it were a family snapshot will end in frustration or nonsense.

Smith, like White, thought that the inherent traits of photographs would reveal their status. Snapshots usually pay minimal attention to organization "based on rules of 'art,'" Smith said, and journalistic photographs emphasize "the familiar, the public, and the conventional, or . . . the bizarre, the horrid, the vulgar novelty, and the banal sentiment. . . . We expect these to be pictured uncritically, even with a kind of morbid delight. Ultimately, it is this attitude toward the subjects that provides the appropriate image for journalistic form." The work of art may be mistaken for some other kind of picture, but "to attentive and patient viewers . . . the differences will eventually be perceived." An inspired master photograph will contain "something else" beyond the literal subject of the picture. This something else "may be a visual effect for which we have no vocabulary; it may even be one for which no vocabulary exists."[149] In other words, Smith accepted the modernist assumption that works of art have a special, inherent visual power that will declare itself if only we look carefully enough.

But Smith was not consistent in his modernist position on this issue. In "Models for Critics," written in 1963 and revised in 1975, he broke decisively from the modernist point of view by applying Thomas Kuhn's idea of the scientific paradigm to the problem of photographic categories. Kuhn defined paradigms as "universally recognized scientific achievements that for a time provide model problems and model solutions to a community of practitioners." Smith adapted this definition to read "a recognized, *if not universally recognized,* photographic achievement."[150] He named photojournalism, advertising illustration, and Pictorialism as examples of such paradigms. Paradigms are not necessarily determined by the formal structure and content of photographs but, as Smith described them, they may be defined by technological considerations, by the creative example of specific individuals or groups (Smith named Atget, Stieglitz, Strand, Weston, and the photographers of the American Civil War as paradigm givers), by "unabashed subservience to arbitrary preferences," or by other similar things, which Smith saw no need to enumerate.

Using the concept of the paradigm, then, one need not think of art photographs or journalistic photographs as necessarily declaring themselves as such solely on the basis of their appearance. One may look outside the photograph to historical circumstances to determine which pictures are art and which are journalism. The concept of the paradigm acknowledges that categories of photography are not natural and not purely visual but are artifacts of criticism and the writing of history, or the reading of history by photographers.

Smith turned away from the efforts to read photographs after 1957. He felt he was making no progress in establishing a critical method. White was turning more intensely toward mysticism, and Smith's other colleagues were simply not responding to him. It was pointless to read pictures in a vacuum, so he dropped the matter and turned to more historical criticism much of which was a vehicle for his angry attacks on American culture.

To a large degree, Smith's personal development may be understood as the struggle of a culturally isolated midwesterner immersed in what he felt to be the suffocating mores of the Bible belt, trying nevertheless to reach out for broader intellectual, artistic, and emotional horizons. Early on Smith developed a sense of a nastiness in American culture that stayed with him throughout his life. He took his revenge in his criticism. In one essay, he described the United States as "a scolding, punishing culture, obsessed with death and trash, unable to handle its life force, unwilling to use wisely the energy of youth, find a place for all the wisdom and time of old age and ignorant of what to do with special gifts of artists except make them merchandise or speculations."[151]

Writing of Moholy-Nagy he described the aesthetic climate that greeted the Hungarian on his arrival in this country in 1937: "It was a timid time visually; in general, only simpering and giggling were permitted; euphemisms were the way of the world, and the airbrush was reached for on occasions beyond counting. None of this would have interfered with Moholy's esthetic position, as I understand it, but it created an atmosphere that restricted the forms photography was encouraged to take."[152]

Moholy was a European bringing a foreign tradition to an unreceptive America. But Clarence John Laughlin, another photographer about whom Smith wrote a sympathetic essay, was an American who embodied some of what Smith considered the more appealing traits of American sensibility: "A deep yearning for a past more imagined than real . . . uneasy loneliness . . . hunger to collect. . . . A need to uncover or invent and pursue a variety of noble enterprises."[153] Still, said Smith, Laughlin was not

embraced by his culture. His openness to sources in literature, architecture, and painting alienated him from the mainstream of American photography. His visionary art, although allied with a visionary American tradition—Laughlin felt close to Lafcadio Hearn and Edgar Allan Poe—was too painfully insightful to be accepted. Laughlin's crime was that he was too honest, too faithful to America; he was "one of Mad Mother America's 'good sons,'" and this ensured his rejection.

In Smith's bitter critique of the American spirit, we see once more the anger of the alienated intellectual which had been articulated before in the photographic community by Stieglitz's defenders in the twenties. Silenced by the traumas of the thirties and forties and the optimism of popular photography in the forties and fifties, this alienation was reemerging in the sixties and seventies with Smith. Unquestionably, Smith's anger was fueled by the Vietnam War and the struggle for racial equality, but these issues never took center stage in what he wrote. Instead, when he wanted to address social issues directly, he wrote about the poor status of the American artist. This theme is implicit in his comments on Moholy-Nagy and Clarence Laughlin, but eventually it became quite explicit in an essay in which he cast the artist and the teacher of art as a kind of oppressed minority group:

> During my last years as a college teacher, I encountered many students who sought to claim control of their own lives. This was in keeping with the general movement of women's groups, those of arbitrarily segregated minorities—blacks, Americans of Indian or Spanish ancestry, the poor in general—and, equally interesting, that privileged minority attending college. In the light of such effort, it occurs to me, ought not that strange, barely accepted minority—the artist—and that still smaller group, the teachers of art, not seek similar goals? I think it not only appropriate but also possible.[154]

Smith railed passionately at the ill treatment of American artists, saying that they are denied even the status of legitimate professionals. As he pointed out more than once, artist-photographers were at the mercy of manufacturers who designed and sold equipment and material on the basis of mass-market demands, thus constraining artists' choices through a kind of technological censorship.[155] Artists were at the mercy of economic attitudes manifested in the tax code or in credit policies, all of which were geared toward the profit and loss of small businesses but which invested

no faith or value in the risks, the labor, or the insight of artists. Young art students were in the hands of teachers who had no idea how to teach art as a profession, who taught students to make pictures for exhibition, but did not or could not teach them what they needed to know to survive: strategies of pricing, handling dealers, collectors, and curators, writing grant applications, and courting wealthy patrons; the nature of fame, its costs and returns; strategies for exploiting cultural responses ranging from adulation to derision; how to survive rebuff, obscurity, and self-doubt. And finally, rather than participating in a community of collaborating professionals with common goals, most artists were at the mercy of an unfair hierarchy within the art community, the university, or both. Dominated by a relatively small group of curators, critics, dealers, scholars, and administrators, this hierarchy determined the worth of artists by the recognition and rewards it gave, the amount of work it displayed and praised. Smith acknowledged that this power structure could not reward everyone; his objection was to the very structure itself on the grounds that it exercised what amounts to censorship by position: those at the bottom are not free to make the art they wish and still survive.

In place of an art world based on the capitalist model of competition for scarce resources, Smith envisioned an ideal based on a democratic consensus. He imagined that artists might come together out of a sense of urgency to pursue mutually profitable goals, that they might agree democratically on rules for art, on who should command respect and authority, on who should play what parts in the community.

Needless to say, Smith's vision eluded him. He longed for the articulation by consensus of an overarching purpose for art (or art photography, at least), a paradigm that would give shape to art. It appears that he was looking for something equivalent to the rise of naturalism in the Renaissance. The evolution of naturalism generated investigations of perspective, anatomy, light and color, individual character, and narrative. The paradigm of naturalism gave a shape and a progressive history to Western art for almost five hundred years, but Smith saw that this kind of paradigm no longer existed. Instead there was chaos, which Smith described as "one-man bands, chamber groups, and small and large orchestras, many of them playing at the same time."[156]

It is possible that the order Smith desired so much cannot emerge from this cacophony. What Smith experienced as chaos may be what Arthur Danto has described in a Hegelian sense as the end of art history, the playing out of the last great historical project in art, the one that came after the pursuit of naturalism, that being the investigation by art of its own nature.

This was the defining project of modern art, and it was pursued with such doggedness from the late nineteenth century on, that by 1979 (the year Smith was writing about these issues) the investigation had finally reached a state of pure Hegelian self-consciousness, and art had dissolved into its own philosophy. According to Danto, having become thoroughly self-conscious, it is no longer possible for art to generate a defining paradigm that gives it a path of historical development. The development toward self-consciousness was the last possible paradigm of this kind. This does not mean, for Danto, that art will disappear, but that it has now begun to wander forever in a state of posthistorical pluralism.[157]

Despite the chaos Smith experienced and could not explain, he maintained his faith in the value and efficacy of art. Late in life he still believed that art is "mankind's best contact with one another . . . probably, man and woman's best road for exchange of life-supporting values."[158] As insensitive as this culture may be to artists, as lopsided and wrongheaded the art community, Smith firmly believed that the true artist is a survivor, a trickster, as he put it, whose message is heard in the end. With or without a cultural consensus on the purpose of art, the individual artist may serve the social function of a shaman whose job it is to attract and relieve cultural tension, to manipulate powerful cultural symbols for the purposes of healing. As Smith said, artists are "the culture's most long-lived and explosive psychological flash points."[159]

Smith found reinforcement for his idea of the artist as shaman in the work of Weston La Barre, who referred to shamans and artists alike as "deputy lunatics" for society.[160] Also important for Smith was the literary critic Kenneth Burke who thought of poetry as a symbolic enactment of the moral quest that lies at the center of the human condition. Through symbolism, the poet speaks indirectly to those essential emotional needs that have been suppressed by an overrationalized society, needs such as the expiation of guilt for common but taboo thoughts about murder or incest, or the venting of frustrations at not living up to society's norms. By handling such dangerous issues symbolically, the poet makes them public and renders them less volatile. Burke says that the poet performs the crucial social function of a shaman in becoming a "lightning rod" for what might otherwise become destructive energies.[161]

If the artist is like a shaman who focuses society's anxiety, Smith reasoned, then the critic is one who makes the artist's pronouncements intelligible and accessible, thereby deflecting some of the irrational anxiety directed at the artist.[162] In the role of mediator, the critic has real power but also tremendous responsibilities. In his last major article on criticism, pub-

lished in 1978, Smith spelled out the relationship of critic and artist, carefully underlining the critic's responsibilities. "Let us show ourselves for what we are," he wrote. "Let us be real people looking at real work made by human beings—work about which we have something real to say." To be authentic, critics must "confess early and often to the gaps in [their] education." Even more important, critics should take responsibility for their judgments:

> When the false judgment, the appraisal based on innocence or ignorance, is announced, the damage done, to whom is the apology owed? The public, the dealer, the museum with its archives full or scanty, even the artist? How is stupidity or arrogance punished in its own time? What damages exist within or outside the law for torts against the spirit? And, after all, whose spirit are we concerned with, if not the artist's? If apologies are the only damages, how can they be expressed, and to whom?

Above all else, the critic should be aware that it is the artist who gives him his very purpose: "The order of importance must be understood: where there is no art, the critic is helpless, as is the museum, and even the art historian. Without art, they are nothing, the critic most of all."[163] This was a basic truth Smith felt had been forgotten, a relationship that had become distorted.

To a large degree, Smith witnessed during his career the rise and fall of a photographic community he helped construct. He had set out to open up the technical and expressive possibilities in photography and to establish a serious discussion of the medium. He had some success in both these endeavors. He saw vigorous technical experimentation on the part of younger photographers during the sixties. He saw the beginning of serious discussions in *Aperture,* in his own workshops, and in the growing photographic press, which began in the seventies, to publish the work of many photographers who had previously been ignored. He saw a growing number of academic photography departments and the founding, in 1963, of the Society for Photographic Education.

Nevertheless, in the seventies, Smith felt that the new openness had collapsed and the new dialogue had turned petty. At the Museum of Modern Art, he saw the rising influence of John Szarkowski who "put down the narrowest kinds of rules, and all you can do is play his game or ignore it."[164] In academia, he saw art become embroiled in politics. He saw students indulging in what he considered to be an abuse of artistic free-

dom. And in criticism, he saw the emergence of the critic as star, eclipsing the art under discussion. As Smith summed things up, it was "a time of over-exposed critics and under-developed artists."[165]

Smith's bitterness eventually became as well known as his capacity to inspire. Perhaps by nature he could not have seen things go his way for long. He was, at bottom, a perpetual antiauthoritarian, an outsider grown accustomed to anger and frustration. And yet in his afterword for the volume of his collected essays, written in 1985, he still called with hope and reason for a mature discussion of photography: "If we can learn to recognize thoughtful talk and to consider opposing opinions for what they are and not a life-threatening poison, we might more easily find useful common ground for exchanging differences, perhaps even to our benefit."[166]

CHAPTER 6
AN INDEPENDENT VISION:
MARGERY MANN

Margery Mann is a critic who does not easily fit into any critical category. She was active from the early sixties to the late seventies, a time when both subjectivism and formalism were going strong, but Mann was largely unsympathetic to the subjectivist position, and her writing shows an almost complete lack of interest in Szarkowski's formalist theory and his curatorial activity at MOMA. She was overtly hostile to the subjectivists' efforts to read photographs, describing the readings of Siskind's pictures, published in *Aperture* in 1957, as "a quagmire of verbalization as thick and viscous as marshmallow syrup."[1] She was unmoved by photographic abstraction and refused, at first, to accept Siskind as an Abstract Expressionist. Eventually she admitted that he and the painters of the New York School had influenced each other, but rather than engaging in the psychological and formal implications of his images, she insisted instead on interpreting them as almost documentary essays on the ravages of time.[2] She did review Szarkowski's show, *The Photographer and the American Landscape,* interpreting his curatorial vision as rooted in the nineteenth century because he ignored contemporary landscape features such as freeways and suburbs. And she had occasion to criticize MOMA's presentation of Bruce Davidson's *East 100th Street,* complaining that the museum treated the photographs of Harlem poverty as precious, gemlike objects to be contemplated only as Art.[3] But Mann saw *The Photographer and the American Landscape* and Davidson's show only because they were traveling exhibits that came to San Francisco. Working in California, Mann either felt isolated from or largely uninterested in what was happening in the Midwest and on the East Coast. Minor White and his fellow subjectivists and John Szarkowski and MOMA were just not major reference points for her.

Mann's frame of reference as a critic was formed by the West Coast, specifically the landscape tradition of Ansel Adams and Edward Weston and the socially conscious work of Dorothea Lange. Perhaps to an even greater degree, she saw her critical position reflected in the creative stance

of Imogen Cunningham, for whom Mann wrote introductions to two books. Mann described Cunningham as one who never jumped on bandwagons and as "too independent a thinker to set up rules for herself and abide by them."[4] Mann's refusal to establish critical rules left her without a critical theory, but it also allowed her to concentrate on the specific photographs at hand with honesty and flexibility. Unlike many other critics, she always made sure the photographs she was writing about were present in her criticism.

Mann had an undergraduate degree in philosophy from Goucher College, and she studied art history for a time at the University of Chicago. She was a photographer with an eclectic style. Some of her work satirized consumer culture and was influenced by Pop Art. She also taught history of photography at the San Francisco Art Institute. Her criticism appeared mostly in *Artforum* from 1963 to 1968, in *Popular Photography* from 1969 to 1971, and in *Camera 35* from 1972 to 1976. She died in 1977.

Mann's column in *Popular Photography* was called "View from the Bay," a good indication of her awareness that she was writing from a specifically Californian perspective. She wrote several articles tracing the history of photographic exhibitions in the San Francisco Bay Area. She also kept an eye on the contemporary gallery and museum scene, praising farsighted and generous museum curators, lambasting well-intentioned but uninformed ones, and often fretting about the creative vitality of Bay Area photography. She once described the latter as a carp wriggling in a muddy pool of a drying stream, full of activity but making little progress.[5]

Such humorous images are common in Mann's criticism. She valued humor in general, using it in her art as well as her writing, and she praised it in others' photography as a too-rare commodity. The sharp-witted jab might be considered Mann's critical trademark. She could dispose of an unknown photographer having his first exhibit with the suggestion that he "seemed to have picked up a camera for the first time the week before, and didn't know what to do with it," or "certainly no human eye could have looked at the landscape and seen so little."[6] Her most elaborate ridicule was reserved for young photographers who imitated the grand, West Coast landscape tradition. Slavish imitation of the masters, seeing the world through photographs rather than one's own eyes utterly contradicted her ideal of the artist as an individual. "If every print of a weathered door that had been photographed after Edward Weston first saw and photographed the Church Door at Hornitos in 1940 were piled in a heap and burned," she wrote, "the bonfire would brighten the sky all over northern California. It might be a good idea."[7] Referring again to Weston imitations, she said,

"The dead pelicans photographed and exhibited within the past five years would stock a good-sized lagoon." Mann hammered away at the theme of independent vision, trying to throw off the weight of a suffocating tradition. She concluded one article with the remark, "But until Bay Region photographers face themselves in the mirror every morning as they brush their teeth, and intone solemnly three times: 'I am not Edward Weston; I am not Ansel Adams,' we shall see sterility. If photographers become individuals again, we shall see a new renaissance."[8]

Young West Coast photographers were not entirely to blame for their unthinking adherence to tradition. Their elders were just as mesmerized by the same tradition. When the Friends of Photography opened its gallery in Carmel in 1967, Mann complained that this was "one more attempt by the Old Guard to hobble creativity in California." Weston's vision, she said, had now been "perverted to a ritual of accepted subjects and forms."[9] She took to calling the Friends of Photography Gallery the Westman House.

Mann tended to explain West Coast aesthetic conservatism as a lack of imagination or a failure of nerve. She did not see this conservatism in economic terms, although she was acutely aware of how difficult it was for photographers and galleries to remain financially viable. Instead, she noted that photographers' visions remained largely static once they reached maturity and that established photographers had constructed a canon of their most accepted images, which they exhibited with monotonous predictability. This led her to ask whether the creative urge of photographers is more ephemeral than that of painters: "Is the artist-photographer inherently a different personality type [from] the artist-painter, a man who loses his curiosity and desire to explore once he has seen a few exciting things and made a few exciting images? Or is perhaps the desire to play it safe peculiar to the Bay Area?"[10]

Mann's impatience with aesthetic conservatism and the reverential treatment of the Adams/Weston tradition did not mean that she lacked respect for Adams and Weston or for those whom she felt added to the landscape tradition. She described Adams's photographs as "the soul of one man who is close to nature and who reveals it with rare sympathy and understanding."[11] She granted that Wynn Bullock had an independent vision, despite his debt to Weston.[12]

Mann tried to reconcile the landscape tradition with her social conscience. In a 1963 review of an exhibit of photographs by the $f/64$ Group she commented that the pictures showed no evidence of the social upheaval of the thirties, which had to be on the photographers' minds, and yet she thought that the $f/64$ style was a reflection of the times in its clarity and

directness. It was a break with the past and with the hazy Pictorialist way of viewing the world prompted by social crisis.[13] In 1970 Mann changed her mind and wrote that *f*/64 photography was "in no way a mirror of social upheaval and chaos occurring in the United States in the depths of the Depression." It had only to do with an upheaval in photography. Nevertheless, she acknowledged that Ansel Adams was an ecologist even then, forty years before most of the public had become aware of ecology.[14] The next year, without denying Adams's ecological motives, Mann wrote that she no longer saw him as a realist but as a sublime romantic, and she came to the conclusion (somewhat before the idea became standard fare) that realism itself as an aesthetic concept changes over time.[15]

Mann was not the least bit apologetic that her own judgments and positions changed. She never took herself too seriously as a critic, admitting that her criticism was opinion, and she saw changes in judgment as inherent to the critic's task. In one essay, she reported on a member of a panel discussion who "flagellated" her for her inconsistencies. Writing of herself in the third person, she responded, "Now, I know the work of this critic rather well, and I know that once in a while she tends to exaggerate to provoke reaction, and I know that she feels that in a world that is changing as rapidly as ours is, a judgment made a year ago could be foolish today. Any writing of opinion is invisibly prefaced by 'I think today—'"[16]

One issue on which Mann changed her mind quite dramatically over the years was that of photographic technique. When she began to write criticism in the early sixties, she repeated the orthodoxies of straight photography: "The absolute essence of photography is prevision, and the photograph is inescapably bound to reality." The entire rationale of photograms, she said, is painterly, not photographic.[17] By 1968 she saw that change in technical standards was inevitable and on reflection, not disturbing. Photographers were imitating painters, but this was mitigated by the fact that painters were imitating photographers. There seemed to be no way to keep the various media pure, so why try? Mann predicted that we would see combinations of photography, painting, and sculpture. She pointed out that already such combinations were appearing in the light shows at the Fillmore Auditorium. "The photographer in the future," she wrote, "will strain to release the photograph from the boundaries of realism and purity of vision. And the work of the *f*/64 Group will seem as dated as Photo-Secession."[18]

Mann was ready to accept synthetic photographs in 1968, but it was in a 1969 review of Frederick Sommer that she truly came to appreciate such work. Sommer struck her as having successfully translated the Surrealist idiom into photography. She said, "In my younger—more purist—days, I

would possibly have written him off as a frustrated painter or sculptor." But not now. She described his constructions of desiccated frogs, his prints made from painted or smoke-covered cellophane, his out-of-focus prints, his photographs of accordion-pleated reproductions of Dürer engravings, and his images of cut paper. These were amusing, somber, thought-provoking pictures many of which seemed to Mann to have been produced by ridiculous techniques but all of which followed the logic of the subconscious. The absurd processes only seemed to add to the power of the far from absurd results. When Mann asked herself if all these pictures were truly photographs, she had to answer, "I'm not sure anymore that it matters."[19]

One of the most important of Mann's qualities as a critic was her sense of social justice and her conviction that photographers ought to take the contemporary social world into account. Perhaps she could be seen as the first critic to pick up where Elizabeth McCausland had left off, championing socially conscious photography, but with far greater aesthetic awareness and broader taste than McCausland. Rather than redo Weston and Adams, she said, "the photographer today must reflect the world of the racial strife in Detroit, the war in Vietnam, and potential atomic disaster. . . . West Coast photographers need to be jolted into taking a long hard look at the plastic-coated, neon-blinking world that engulfs us."[20] It was unfortunate that Dorothea Lange had attracted no followers, she said. Apparently photographers lacked the courage to face the difficulties of the contemporary social world. The climate of the art world at large in the mid-sixties had discouraged social awareness. Painters, with the exception of Pop artists, had turned their backs on the real world in their exploration of formal interests. Photographers followed suit. Instead of pursuing "reality, truth, beauty, fantasy," or any other "honest and important" goal, photographers pursued the purely photographic.[21]

Mann was certain that photographers ought to be making socially concerned images, but she was not certain about how this ought to be done. She began to face this problem when a trickle of socially concerned work finally did begin to appear on the West Coast in the late sixties and early seventies. Mann had a lot to say about the failings of this work. Almost invariably, she thought, photographers discovering social issues approached them as a fad. "California photographers have discovered the Negro," she began one essay in which she went on to blast photographers for knowing nothing about their subjects, for equating poverty with reality, and blacks with poverty. She wrote, "In the Bay Area, it has become the fashion for photographers to drive in to town in their white Mustangs from the white suburbs to spend a couple of weekends walking up and down Fillmore

Street, and their Serious Social Statements, photographs of genuine, real-live Negroes . . . have been shown recently in too-frequent exhibits that mirror the condescension of both photographer and gallery director."[22] Mann dubbed the offending photographers "Tourists in Negroland."

By contrast, she praised *The Sweet Flypaper of Life*. First published in 1955 and reissued in 1967, this book is a fictional vignette of black family life in Harlem with a text by Langston Hughes and photographs by Roy DeCarava. Mann enjoyed the fact that the issue of integration appeared in the book but only as one thread in the fabric of daily life. The focus of the book was on individual characters, family relationships, and the approach of death for an elderly lady. For Mann, the book was an antidote of intimacy and sentiment in a society afflicted by sterility and stereotypes.[23]

Another problem with socially conscious photography that Mann identified concerned the relation of photographs and text. She did not think about this problem consistently and said nothing about it in her discussion of *The Sweet Flypaper of Life,* but raised the issue in the context of documentary photographs. Mann was embedded enough in a modernist point of view to think (some of the time) that documentary photographs ought to explain themselves visually, and she considered it one of the greatest pitfalls of documentary photography to rely on words.[24] (This despite the fact that she welcomed the synthesis of art photography with other media such as sculpture and music.) But she also recognized that social issues often require considerable verbal explanation.

Her resolution of this problem, in one instance, was to conclude that some subjects are not suitable for documentation with still photography. Such was the case with a show by Pirkle Jones and Ruth-Marion Baruch on the Black Panthers. Mann did not consider Jones and Baruch to be superficial "Street Corner Realists," and she admired their photographs, but the pictures alone simply could not convey enough of what the Panthers were about. Mann concluded that film was the proper medium for dealing with this particular issue.[25] In other cases, Mann readily accepted the presentation of documentary photographs in the company of words.

On several occasions, Mann had some perceptive things to say about the broad issue of how context—the context of words, of exhibition design, of the historical moment—affects the experience of photographs. One exhibit, which she praised for its photographs but criticized for its too aggressive design, presented work by Ernest Lowe, who had photographed the agricultural laborers of the San Joaquin Valley. Mann found Lowe to be knowledgeable about his subjects and to treat them with sensitivity and insight. He worked in the tradition of Lange—which is clearly one reason

Mann liked him. But the elaborate presentation of the show was a distraction. It included a worker's shack in the center of the gallery, covered with pamphlets, and blaring tapes of the voices of farm workers and managers. The tapes were useful but hard to hear clearly, the shack was unimaginatively literal, and the pamphlets were so profuse that one could not read them all. As paper objects too numerous to attend to, the pamphlets diminished the importance of the paper photographs. "The piles of paper," said Mann "detract from the photographs and make the photographs seem as unimportant as the pamphlets we cannot take the time to read."[26]

Mann saw curatorial aggressiveness of another sort in an exhibit of Dorothea Lange's work. Lange was presented as a feminist photographer in an exhibition at the Oakland Museum in 1972. To Mann, this was another form of faddishness. She acknowledged that women have fared badly in the visual arts and that Lange was an emancipated woman who understood the problems a woman artist faces. But she thought Lange's work had nothing to do with feminism. Rather, her theme was the significance of the mundane aspects of daily life. The women she photographed had generally come to peace with life in a traditional manner, "none of them in a way that would please a dedicated women's liberationist. The photographs are fine. The women's lib angle," she concluded, "was a mistake."[27]

Her response to the Lange exhibit notwithstanding, Mann was interested in a feminist approach to photographic history and criticism as she demonstrated in *Women of Photography,* a show she organized with Anne Noggle, which appeared at the San Francisco Museum of Art in 1975. Mann's catalogue essay belongs to what Thalia Gouma-Peterson and Patricia Mathews have characterized as the first generation of feminist art history and criticism; it is concerned with giving attention to neglected women photographers and pointing out sexism in the art world. Mann's thesis is that women have been significant artists and successful professionals in all areas of photography since the medium's invention. Her essay does not question the fundamental structure of art history from a feminist perspective and, therefore, does not belong to what Gouma-Peterson and Mathews have defined as the second generation of feminist criticism.[28]

In one of the more interesting parts of the essay, Mann demonstrated her sensitivity to the mind-set of women photographers in the early half of the twentieth century. These women (Frances Benjamin Johnston, Margaret Bourke-White, Berenice Abbott) were still pioneers in their field, and as such they possessed an uncommon strength and independence. Mann imagined that they felt "a little self-consciously different," and consequently flaunted their nonconformity as a way to come to terms with it.

Also of interest are Mann's comments about women photographers' tendencies toward particular subjects: people, pure light (her examples of photographers drawn to light are Lotte Jacobi, Carlotta Corpron, Barbara Morgan, and JoAnn Frank), and the relation of the self to the world, "both as a woman and as an inhabitant of increasingly bewildering society." Few women, Mann said, have focused on the landscape. These are intriguing comments, but Mann simply reported the tendencies she saw and posited no explanation of them.

The exhibit Mann praised most highly for its handling of a social issue was *Executive Order 9066* organized by Richard and Maisie Conrat and mounted at San Francisco's De Young Memorial Museum in 1972. This show dealt with the internment of Japanese Americans during World War II. Mann admired the clear editing and narrative structure of the show, as well as its reliance on the photographs themselves with sparse but effective elaboration provided by quotations from the evacuees, newspaper articles, and "wartime patriots." Most of all, she admired the show for its timing and its relation to the historical moment. The Conrats had had difficulty finding a museum willing to take the exhibit, and there had been public opposition to it, much of it coming from young Japanese Americans who felt that someone from their community should be the ones to tell this story. The Conrats had pointed out that both the aggressor and the victim are part of any crime; therefore, this episode of American history belongs to the dominant culture as well as to the Japanese American minority.

There was also tension within the Japanese community over the exhibit because the World War II generation of Japanese Americans had not discussed the episode of internment with the younger generation. When the show finally opened, it attracted enormous crowds, providing what Mann saw as a catharsis for everyone. The Japanese community was able to talk across generations about a painful experience, and the white community was made to face its inglorious past and "the crimes that can be committed in the name of security."[29] The exhibit not only portrayed a social issue, but also played a role in the process of coming to terms with that issue.

Eventually, Mann's interest in the social implications of images and the effect of context on their meaning led her to a discussion in 1974 of Daniel Boorstin's concept of the pseudoevent, now more commonly known as the photo-opportunity, or photo-op. Prompted by her shock that a well-informed friend was completely ignorant of pseudoevents, she explained in her essay how these events attain a level of reality only as they are transmitted through an information medium. She commented on how television news is only a part of a larger televised package, the other part consisting

of commercials carefully chosen to appeal to the particular audience most likely to be watching the show. And she made acute analyses of specific political images: the wealthy Shirley Temple Black, in the midst of a political campaign, shown washing the windows of her home; Edward Kennedy shown placing a rose on the grave of John Kennedy:

> Whose idea was it to place a rose on the grave? Did Senator Kennedy glance up in the midst of eating his morning scrambled eggs and announce to Mrs. Kennedy, "Well, dear, I guess I'll go and lay a rose on poor John's grave today?" Or did his press agent phone him and suggest that it would be good publicity to lay the rose? The press photographer wasn't there accidentally. Who called him, and how many photographers were there? Did the Senator go into his garden and pick the rose, or was some underling sent over to an expensive florist to buy the biggest and best rose in the shop? . . . How many times did Senator Kennedy replace the rose until the photographers were satisfied?[30]

Mann wrote with her usual sense of humor, but she found the manipulative power of the media frightening. She had pursued her idea that photography should grapple with social reality to the point at which she realized that photography was partly responsible for creating that reality, and she saw that the reality of the mass media was by no means benign.

At one point in 1974, the same year she wrote about pseudoevents, Mann feared that conceptual art was replacing the critic with the press agent. It looked as if the writer on art was no longer going to be one who analyzed and judged what artists had done but one who justified and promoted artists.[31] In turning her attention to the mass media, Mann found a new and vital task for the critic, that being the task of awakening the public to a world in which they are already immersed. This was a task Ralph Hattersley had also pointed to, and although neither he nor Mann developed their insights, this task has now become an important one for postmodernist artists and theorists.

CHAPTER 7
FORMALISM

John Szarkowski

The most powerful person in American photography from the mid-sixties to the mid-eighties was John Szarkowski, Steichen's successor as Director of the Department of Photography at the Museum of Modern Art. Szarkowski espoused a formalist theory that held the attention of the photography world, in part because of his eloquence, and in part because it dovetailed nicely with the formalism that dominated the entire art world at the time.

Interestingly, in spite of the broad attraction of formalist theory, Szarkowski had no formalist colleagues of significant impact other than the photographer Garry Winogrand. Winogrand was not a writer, however, nor did he say anything substantially different from Szarkowski. As Jonathan Green has suggested, Winogrand echoed Szarkowski in almost every aspect of his position, although he did so in a gruffer, less articulate style, and in a less systematic manner, a manner that even appears hostile to theory.[1]

Shortly after Szarkowski took his position at MOMA in 1962, he began to make his presence felt as an inventive theorist, historian, curator, and critic—and as an eloquent writer, perceptive discoverer of talent, and masterful tastemaker. Over the next several decades, he reigned as the undisputed leader of American photography, earning equal amounts of adulation and resentment. But as the formalism he adhered to began to decline in American art in general, his prominence waned. By the time he retired from his directorship in July of 1991, his voice had lost its commanding presence in an art world that had thoroughly changed shape.

Before he became a curator, Szarkowski had studied art history at the University of Wisconsin, taught photography and art history briefly at the Albright Art School in Buffalo, and worked as both a commercial and documentary photographer. He began to acquire a national reputation in the late fifties with two books: *The Idea of Louis Sullivan* (1956) and *The Face of Minnesota* (1958). The former, which Szarkowski completed with the

aid of a Guggenheim grant, includes a biographical essay on Sullivan and Szarkowski's thoughtful photographs of Sullivan's architecture accompanied by copious quotations from his writing. The latter book is a celebration of the centennial of Minnesota's statehood done in a style resembling the *National Geographic*. This book made *The New York Times* best-seller list. As Minor White put it, Szarkowski was a documentarian in the "humanitarian school—neither photojournalist nor sociologist."[2] When he went to MOMA to replace the retiring Steichen, he was thirty-six.[3]

Szarkowski shared many theoretical concerns with the subjectivists. Like them, he thought of himself as a spokesman for a medium of inestimable power, one that had shaped modern vision and radically revised the look of the world, one used with the greatest subtlety and profundity as a high art, but still, a medium not given its due. Szarkowski added his voice to the chorus of complaint about the absence of good photographic criticism and the slow theoretical progress in photography theory. Also, like White and Smith, he blamed the mass media for eroding the individual photographer's creative independence and for reducing him to "a supplier of parts." The mass media thrived on superficial inventiveness and facile taste but downplayed intelligence and vision. Using an analogy he might now regret, he said, "The good modern mass media picture . . . is less like seduction and more like rape. Its object is to make its point now and quickly."[4]

Szarkowski shared Smith's and White's concerns with the essence of photography and with the nature and meaning of photographic form. He shared the subjectivist insight that photographs paradoxically contain an "irreducible kernel" of external reality while simultaneously standing as independent aesthetic objects. Just as White, Smith, and Lyons found the latter part of this dual nature the more compelling one, so did Szarkowski. Faced with photographs as independent aesthetic objects, Szarkowski confronted the same dilemma as the subjectivists regarding the relationship of photographs and words. If photographs are truly independent visual objects, then how can one write about them? On this issue, Szarkowski was perhaps closer in spirit to Lyons than to Smith or White. He wrote about photographs brilliantly, doing formal analysis and historical criticism, but all the while he shared much of Lyons's sense that to apply words to pictures is futile, even wrongheaded.

Within the broad context of these shared concerns, there are some dramatic differences between Szarkowski and the subjectivists. Szarkowski did not share White's spiritual motivation in the least. He also disagreed sharply with Smith regarding the technical expression of photography's

essence. He was a supporter of straight photography. He could never completely ignore nonstraight techniques, but he consistently treated these as peripheral practices, whereas Smith saw them as central to the very nature of the medium. Szarkowski was also more interested than Smith in establishing the uniqueness of photography. Whereas Smith was ready to consider the similarities between the impulses of painters and photographers, Szarkowski wanted to distinguish between the properties of these media.[5]

Szarkowski also diverged from the subjectivists in his approach to the meaning of photographs. The subjectivists saw the artist or the viewer as the source of a photograph's meaning. Szarkowski, however, was both a realist and a formalist. Although never denying the presence of artists' insights in their work, he consistently emphasized the importance of external subject matter and, above all, the photograph itself and the medium of photography as the sources of meaning.

The inspiration and reinforcement for Szarkowski's theoretical views came from many different sources. Formalism was such a dominant theory in the sixties that specific influences would be hard to pin down. The formalist attitude was everywhere in American art, embodied in what Irving Sandler has described as the sensibility of antianthropocentrism, a concern with objects above human emotion and human experience.[6] No doubt Szarkowski responded to the New Criticism in literature and to Clement Greenberg. He has acknowledged that he agreed with Greenberg's judgment "without paying a good deal of attention to his thought."[7] He also responded to George Kubler's idea that art history is a process of formal evolution carried forward by artists but largely independent of the personalities of artists.[8] And of course he responded to Louis Sullivan.

In his book on Sullivan, Szarkowski analyzed the changing meanings of function in the architect's famous phrase about form following function. Sullivan himself thought of function in art as having to do with the search of the spirit for substantial form. After Sullivan, said Szarkowski, the most common understanding of function had become, first, the utilitarian purpose for which a given medium is employed, and later, the way in which the medium itself functions in accordance with its essential nature.[9] If form follows function according to this last formulation, then it is the very purpose and meaning of form to express the nature of a medium. Szarkowski adopted this understanding for himself.

Consistent with formalism, Szarkowski attended to what might be called intrinsic factors, rather than extrinsic ones, in his theoretical and historical discussions. He wanted to see photography first and foremost as itself, as something unique, independent, and concrete. He tended to avoid

historical or critical explanations that rely on concepts that encompass rather than emanate from photography. In other words, he avoided explanations based on worldview, ideology, broad economic forces, or broad aesthetic impulses. Instead, he saw photographic history as driven by a reciprocal relationship between specifically photographic aesthetic ends and photographic technological means. He defined these technological means broadly as including not only chemistry and optics but also "methods of distribution of photographic imagery, economic constraints, and professional structures."[10] For example, Szarkowski explained the qualities of popular pictorial journalism as the result of technology and the economic necessities that governed the structure of magazines. Mass media photography is possible in the first place, he said, only because of the invention of sophisticated small cameras and modern reproduction methods, such as halftone prints and billboard blowups. This technology gave mass media photography certain stylistic qualities; it "put a premium on simplicity and force, and a handicap on complexity and subtlety."[11] In addition, the fact that mass media pictures had to appeal to a large audience set certain standards of subject matter. Subject matter was also governed to a large degree by the preconceived ideas of editors rather than the more spontaneous encounters of photographers with the world. As picture magazines succeeded and grew, it became necessary to organize them as rational bureaucracies, emphasizing specialization, teamwork, and efficiency. This reduced the tolerance for spontaneity and unpredictability and put a premium on predetermined visual material. The eventual death of pictures magazines, said Szarkowski, was largely the result of technological developments just as their birth had been. Their audience was drained away by television and inexpensive air travel, which allowed people to experience exotic places and events more satisfyingly than magazines did.[12] Szarkowski's explanation of popular photojournalism contrasts with what he might have considered a more extrinsic account, such as the one given by Smith, who thought of the quality of the mass media as a direct result of the values of the publishers, editors, and advertisers who shaped it: their aesthetic conservatism and their desire for social control achieved through imposed conformity.

Szarkowski's treatment of mass media photography is a good point of entry into his thought, because it reveals his intellectual personality and several of the issues at the heart of his critical stance. Despite his criticisms of the mass media and his commitment to high art, Szarkowski never attacked popular photography with either White's spiritual passion or Smith's moral conviction. He was at ease with the mass media. This may be attrib-

uted in part to the circumstances of his career. Personally and professionally, he was not threatened by the mass media as White and Smith were. As a photographer, he was not ill at ease doing commercial work, and by the time he became a spokesman for photography as an art, the subjectivists had already gained ground in their battle with popular photography. The superficiality of mass taste no longer threatened the very possibility of serious discussion of the medium. In 1962 when Szarkowski went to MOMA, *Aperture* was ten years old, and the founding of the Society for Photographic Education was only a year away.

Szarkowski also accepted mass media photography because he was simply less interested than White and Smith in the distinctions between photographic categories. Taking his cues from Steichen, who had shown that a major museum need not draw a sharp line between popular and high-art photography, and from John Kouwenhoven, who wrote about the influence of vernacular art on high art, Szarkowski defined his object of interest as photography in its entirety (within the bounds of his technical prejudices).[13]

Unlike Smith, who was concerned with the paradigms that distinguish photojournalism from snapshots and so forth, Szarkowski looked for characteristics common to all photographs, and when he looked for individual photographs of interest, he turned to the work of anyone from photojournalists to anonymous amateurs. This is not to say that Szarkowski refused to recognize categories of photography, but like White, who was willing to annul any category so as to appropriate a picture for consideration as an equivalent, Szarkowski was willing to appropriate any photograph as art on the grounds of formal interest. He was consistently as willing to exhibit an interesting fashion or news photograph as he was an art photograph.

Although willing to exhibit a photograph from a picture magazine in an art museum, Szarkowski was very critical of the way such photographs were used in the context of the magazines for which they were made. One of the reasons picture magazines collapsed was that they were founded on a misunderstanding of the nature of photography. These magazines attempted to treat photographs as news or commentary, as part of a narrative structure; this was a grave mistake. Photographs, Szarkowski insisted, cannot narrate either singly or in groups because they cannot explain what they show. They are very specific in terms of showing appearances but utterly ambiguous with regard to saying what those appearances mean. As Szarkowski put it, "the photograph may suggest, but cannot define, intellectual or philosophical or political values."[14]

Captions, of course, provide explanations or narrative structure to

photographs, but captions are an imposition on what is really a visual object. When one strips away the captions from news photographs, their true nature becomes clear. One sees that they do not treat a specific event but a broad idea: "catastrophe and progress, pleasure and pain, victory and defeat, villainy and altruism." At the same time, they "deal not with the intellectual significance of facts, but with their emotional content." They are "mysterious, elliptical, and fragmentary, reproducing the texture and flavor of experience without explaining its meaning."[15] In sum, news photographs are poetry, not history, and they are bad poetry at that. Most news photographs, said Szarkowski, portray events "no more newsworthy than tears," have "generic morals . . . simple to the point of banality," and retell "the silly old story with a slightly different set of specifics." The best of these photographs, however, "come together with perfect economy and surprise to create not merely a catalogue of visual description, but a picture."[16] In other words, they are art.

Picture magazines were more interested in human interest stories than visual art, and acknowledging implicitly that photographs cannot effectively tell a story by themselves, they thrust words and pictures together in an effort to build a symbiotic narrative structure. The goal of the photo story was to create a new form of expression that truly synthesized the two media, but Szarkowski thought this was never successfully done. In his opinion, the most successful efforts to use words and pictures together were books, such as *Let Us Now Praise Famous Men* and *The Inhabitants,* that recognized "the relationship between words and pictures is complementary rather than supplementary" and accordingly maintained a high degree of independence or even total separation between the two.[17]

Szarkowski saw the relation of words and photographs as intensely problematic, much more so than did Smith or White. Although both White and Smith deeply respected what they thought of as purely visual experience beyond the reach of words, both also thought that language could in some way grasp the photograph. White considered verbalization an important aspect of responses. Much as Baudelaire thought that corresponding meanings among painting, poetry, and music converge at the same point in the imagination, or as Kandinsky thought that art produces synaesthetic experience, White thought that a verbal response to a photograph may be one of several possible manifestations of one's inner experience of it, others being physical or visual. And he thought of all these manifestations as arising from the same inner source. Smith thought that one could find in photographs visual structures that parallel verbal ones and that even if these structures gain their meanings through a purely visual process, they

can be verbalized; the symbolism of the photograph can be put into language. Szarkowski, however, remained entirely skeptical about the capacity to touch the visual with the verbal. He wrote, "But the meanings of words and those of pictures are at best parallel, describing two lines of thought that do not meet; and if our concern is for meanings in pictures, verbal descriptions are finally gratuitous."[18]

Not only was the relation of photographs and language problematic for Szarkowski, so was the relationship between photographs and everything else. The photograph is linked by a chemical and optical process to the world it depicts, and that process is manipulated by the photographer. But the photograph itself is an independent pattern of tones and colors. It is not what it represents; it is not the mind of the photographer; it is certainly not spirit. Its meaning, then, is within itself and has largely to do with itself. The photographer's mind and the world are not irrelevant to photographs, but they are not present in them: "Whatever else a photograph may be about, it is inevitably about photography, the container and the vehicle of all its meanings. Whatever a photographer's intuitions or intentions, they must be cut and shaped to fit the possibilities of his art. Thus if we see the pictures clearly as photographs, we will perhaps also see, or sense, something of their other, more private, willful, and anarchic meanings."[19]

Clearly, Szarkowski does not deny associations between photographs and other things—language, cultural context, the artist's intentions, the viewer's interpretations—but he thinks photographs' meanings do not lie in their relationships to these other things. The meanings of photographs lie in the concrete reality of photographic form. Szarkowski even went so far as to say that the form and content of a photograph are one.

Szarkowski's formalism gave him a different understanding from White and Smith of the motivating force of artistic creation. Smith and White created out of a need to grapple with internal experience. To them, photographic form was a means to this end. Szarkowski, on the other hand, saw the external world as a motivation for making photographs, and he took a deep interest in photographs that show something new about reality. But the most engaging artistic vision, for him, was one that says something about the external world while using the formal properties of photography in a powerful and novel way. The reality Szarkowski was most interested in is the reality of photography. To him, formal invention was not simply a means to an expressive end but the substance of the photographic tradition.

Many of the differences between the subjectivists and Szarkowski may be attributed to fundamentally different assumptions about the nature of reality. Smith and White, but probably not Lyons, believed in an a pri-

ori unity of reality: language, visual art, the intentions of the artist, the experience of the viewer, everything may ultimately be reconciled either (as in White's view) on some transcendent plane or (as in Smith's view) through our basic humanity and the fundamental structures we impose on the world or those that our biology imposes on us. Smith's and White's critical task was, in the largest sense, to demonstrate the existence of the unity they assumed to be there.

For the most part, Szarkowski rejected any a priori unity, seeing reality instead as fragmented and contingent. His vision of a fragmentary reality—a reality in which photographs, language, and the mind of the photographer do not interpenetrate each other—called into question the very enterprise of theory and criticism in which he was engaged. Having implied that this enterprise is futile, his task was to justify its continuation.

The differences between Szarkowski and White and Smith were not overlooked by the three men, although only Szarkowski and White wrote about each other. Smith said very little about Szarkowski in print, but was bitter about his prejudices and his power. Szarkowski acted as if he were totally ignorant of Smith's existence.

White published three reviews of Szarkowski's books and exhibitions. In the first, concerning *The Face of Minnesota,* White was clearly charmed. The review is full of phrases such as "lyrical and informative," "underlying current of love," and "fresh, simple, unpretentious."[20] The second review treated Szarkowski's first major exhibit at MOMA, *The Photographer and the American Landscape* (1963). Here, White was uneasy. First, he detected a rejection of past metaphorical uses of photography in Szarkowski's treatment of Stieglitz. Then he noticed evidence of an effort to nudge contemporary photography away from metaphor. White quoted Szarkowski's summation of a recent trend in photography: "Even more recent work might suggest a revolt from symbol and the abstracted detail, an *insistence* that the surface of the earth be seen not as it can be imagined, but as it has survived." (The emphasis is White's.) White complained that the word *insistence* was an expression of Szarkowski's personal preference, and he asked if the "revolt" Szarkowski saw might not be the result of "Szarkowski himself bringing to museum walls support of his own type-of-man preference?"[21] Would it not be possible, White continued, to mount an exhibit proving that there is a revolt against objectivity? White's third review was of *The Photographer's Eye* (1966), Szarkowski's effort to define photographic form, which White also found lacking in its disregard for the possibilities of photographic symbolism.

White's prominence as a photographer was such that Szarkowski could

not possibly have ignored him the way he did Smith, and he made no effort to. In *Mirrors and Windows* (1978), a major report on the state of photography in the United States, Szarkowski described White as the seminal figure in one of the two principal streams of contemporary work. Szarkowski truly respected White, but only as a photographer, not as a theorist, and only on his (Szarkowski's) own terms. In his review of White's major monograph, *Mirrors Messages Manifestations* (1969), he called White "an important modern artist" who has made "some of the medium's most memorable pictures." But he explicitly rejected White's sense of his own work. For White, the poetic sequence was of paramount importance with regard to the presentation of his work and the manifestation of his aesthetic ideas, but Szarkowski dismissed sequences in his review, calling them a "device" useful to the artist but likely to be ignored by future students of White's work. Of those photographs Szarkowski considered White's best, he said, "Although their meaning seems at first to be wrapped in metaphor, we see finally that they are frank and open records of discovery."[22]

Szarkowski's power as a tastemaker stemmed largely from his curatorial position, but his writing has played no small part in his reputation. He has written articles for newspapers and popular journals, numerous introductions to monographs and exhibition catalogues, and there have been a number of published interviews with him. The development of his theory and criticism may be traced in greater detail through a chronological consideration of some of his major essays.

The Photographer's Eye

The Photographer's Eye (1966) was Szarkowski's first theoretical statement. Appearing both as an exhibition at MOMA and as a book, it was meant to be an objective examination of the fundamentals of photographic form, or as Szarkowski put it, "what photographs look like" and "why they look that way." Specifically, he described five "characteristics and problems that have seemed inherent in the medium": the thing itself, the detail, the frame, time, and vantage point.[23] Whether consciously or not, Szarkowski was setting out to do for photography what Clement Greenberg had done for painting when he identified "the ineluctable flatness of the support" as the "unique and exclusive" quality of that medium.[24] Just as flatness was meant to characterize all painting, so were Szarkowski's five items meant to characterize all photography. And just as Greenberg's analysis of painting turned out to be more prescriptive (or proscriptive) than descriptive, so was Szarkowski's analysis of photography, because it was in fact an analysis of only some photography.

Having explicitly stated that photography is a selective (analytical) medium and not a synthetic one, Szarkowski proceeded to ignore or disparage, with the exception of in-camera multiple exposures, all synthetic procedures: any kind of sequencing of photographs, the creation of something specifically to be photographed, all color processes, multinegative printing, photograms, and photomontage, the latter two of which he thought of as standing in a "halfway house between photography and painting."[25] In effect, what photographs look like and why, turned out to apply only to a narrow range of black-and-white camera images.

Szarkowski's five characteristics were meant to be universal, but also to reflect a historical process. For example, in his discussion of "The Thing Itself" Szarkowski explained that first photographers had to learn that photography, unlike painting, resists preconceptions of the ideal and treats only the actual, and then they had to recognize that "the factuality of [their] pictures, no matter how convincing and unarguable, was a different thing from the reality itself." Having discovered the independence of the photograph from what it represents, they were then free to go on to discover the significance of detail, then the frame, time, and vantage point. Szarkowski organized his essay to reflect this chronology of formal discovery, his purpose being to demonstrate that "like an organism, photography was born whole. It is in our progressive discovery of it that its history lies."[26]

Furthermore, Szarkowski wanted to show that this history led toward an increasingly modern way of seeing, a modernity he conceived of as parallel to the modernity of painting, although this is not something he would have said explicitly. He did say in another essay that the essence of modern seeing is not to see objects but their projected images.[27] This is similar to the idea that the modernist painter does not direct attention to an illusion of the world but to the painting itself. For Szarkowski, the quintessential modern photographer was one whose problem was "to find a way in which the real world might be transposed into something very different—a clear photograph."[28] To concentrate on the thing itself or on details is to concern oneself with objects, but to concentrate on stopping motion or unusual vantage points, is to engage in the more modern practice of discovering radical appearances divorced from familiar conceptions of objects. As Szarkowski explained in the section on time, "there was a pleasure and a beauty in this fragmenting of time that had little to do with what was happening. It had to do rather with seeing the momentary patterning of lines and shapes that had been previously concealed within the flux of movement."[29]

The Photographer's Eye was a statement of Szarkowski's conviction

that photography is virtually a natural phenomenon, an organism, a discovery more than an invention, and that its history has been shaped by our gradual recognition of its inherent potentials, not, as others have argued, by the way we have actively constructed the medium and used it to fulfill our needs and desires.

In opposition to Szarkowski's view of photography as a discovery born whole is the view that it is an invention deliberately designed piece by piece in almost every respect. According to this position, photography was made to produce positive images rather than negative ones, and to produce rectangular images rather than the circular ones naturally produced by lenses. What were considered the linear distortions of lenses were corrected so that their images would conform to Renaissance perspective. Tremendous effort was expended to make the medium produce images increasingly quickly; and to make color photographs, a way was found to couple the light sensitive properties of silver salts to colored dyes. The list could go on. Of course, no one could immediately understand the implications of so profound an invention as photography; therefore photographers had to discover and learn to accept photography's potentials as Szarkowski says. But this process did not proceed along a path preordained by photography's inherent nature; the path was laid down by human choices about what photography should be and do. Eventually Szarkowski recognized the degree to which photography has been deliberately shaped and retreated from the idea that it is a natural phenomenon and a discovery. In 1989 he wrote of the invention of photography as arising from a "complex ecology of ideas," which included Renaissance perspective drawing and mapmaking.[30]

Another major issue in *The Photographer's Eye* has to do with the relationship of art photography to vernacular photography, that is, the photography of untrained, unpretentious amateurs and professionals who see themselves only as craftsmen without any artistic aspirations. Responding in part to George Kubler's idea that the evolution of form may be studied in all areas of material culture and not just art, Szarkowski reasoned that if the history of photography lies in the discovery of the medium's innate characteristics, then a proper historian will recognize those discoveries in any kind of photograph no matter who has made it or in what context. Furthermore, he thought, the vernacular practitioner was actually better equipped to discover the reality of photography than the artist-photographer. Free of both the knowledge of art and self-conscious artistic motives, naive photographers would not impose their preconceptions on the medium and could let it lead them.

The five characteristics of photography that Szarkowski defined in *The Photographer's Eye* are, in fact, meant to be understood as the discoveries of naive photographers, discoveries that artists only later came to employ. For example, in their acceptance of the fact that the camera records the trivial, naive photographers discovered the importance of the detail. In their acceptance of the camera's tendency to produce abrupt, chaotic, and precariously balanced compositions, naive photographers revealed the importance of the frame. Szarkowski summed up his idea about the relation between art photography and vernacular photography in *Looking at Photographs,* a book that followed *The Photographer's Eye.* He wrote:

> Most of the countless millions of little pictures that were made with George Eastman's new Kodak were so sketchy and obscure that only with the help of the legend on the back could one distinguish confidently between Aunt Margaret and the native guide. They were, however, pure and unadulterated photographs, and sometimes they hinted at the existence of visual truths that had escaped all other systems of detection.
>
> It was many years before sophisticated photographers began to pursue with intention the clues that the casual amateur had provided by accident. When the attempt was finally made, it meant the beginning of a new adventure for photography. Characteristics of the medium that had formerly been only problems to avoid were now potential plastic controls, adding a new richness to the ways in which a photographer could describe the look and feel of experience.[31]

As a curator Szarkowski took this insight to mean that any vernacular photograph that demonstrated a striking and progressive use of some formal characteristic deserved to be treated as a work of art. Like White in his search for equivalents, Szarkowski was willing to ignore the intentionality and historical context of photographs for what he considered a higher purpose.

Szarkowski was constantly on the lookout for masterworks by anonymous picture makers. He was also captivated by the idea of the naive genius whose entire oeuvre could be elevated to the status of art, and in a series of articles, most of which were published before *The Photographer's Eye,* he proposed several candidates for this role. One was Jacques Henri Lartigue who took his best photographs as a child. Because of Lartigue's youth, Szarkowski was confident that his genius was natural,

not "the product of a conscious concern with formal values." Szarkowski called Lartigue "a true primitive" and explained that the radical visual characteristics of his work were not his invention but "basic to the discipline of the camera."[32]

Timothy O'Sullivan was another photographer Szarkowski celebrated as a primitive genius. "He was protected from academic theories and artistic postures by his isolation, and by the difficulties of his labors. . . . He was true to the essential character of his medium."[33] Despite his naiveté, Szarkowski considered O'Sullivan to be the best artist among the nineteenth-century American landscape photographers.

Whether O'Sullivan should, in fact, be considered an artist, he should probably not be considered naive. Rick Dingus eventually demonstrated that O'Sullivan deliberately tilted his camera when making photographs, a practice Szarkowski felt compelled to acknowledge as "an act of almost willful aggression toward the principles of record-making." Although he still admired O'Sullivan, Szarkowski had to conclude that he was not a purely intuitive genius.[34]

Second to naive geniuses, Szarkowski admired the art photographers who learned from them. These photographers practiced the best kind of self-conscious style: the "style that conceals style: [a] personal vision . . . successfully disguised as objective fact."[35] Walker Evans was Szarkowski's master of this concealed style. He was also the artist who had learned the most from the vernacular tradition. He had "reclaimed for the use of sophisticated, introspective, modernists the clues provided by the 19th-century primitives."[36] In an introductory essay to a 1971 book on Evans, Szarkowski explained how Evans rejected Stieglitz's openly artistic self-consciousness, how he took inspiration from postcards and photojournalism and arrived at a sophisticated style such that his pictures seem both "unchallengeable fact" and simultaneously "possess a taut athletic grace, an inherent structure."[37] Szarkowski understood Evans precisely the way Evans's critics of the thirties failed to understand him.

One thing Szarkowski found particularly appealing about an artistic tradition based on the vernacular was that it seemed to exemplify something especially American. This was an idea Szarkowski got from John Kouwenhoven's book *Made in America* (1948) in which Kouwenhoven described a "democratic-technological vernacular" tradition in this country arising from "the unself-conscious efforts of common people to create satisfying patterns out of the elements of their environment."[38] According to Kouwenhoven, this tradition accounted for the high quality of the design of nineteenth-century American tools and machines, but its greatest achieve-

ment was realized when it merged with high art, specifically in the Chicago School of Architecture. For Kouwenhoven, this upward mobility of aesthetic values from tools to architecture was an expression of American cultural democracy and economic freedom, and it gave the United States an artistic identity independent of Europe.

Szarkowski took up Kouwenhoven's idea in an essay of 1979 in which he described the nineteenth-century tradition of vernacular photography as uniquely American, free of the baggage of European culture. This was the rough-and-ready tradition of itinerant daguerreotypists, Civil War photographers, and explorers of the western landscape. And it made photography a force of "creative anarchism" in American visual art just as the American frontier—as Szarkowski understood it in terms of Frederick Jackson Turner's thesis—served as a creatively anarchistic force in American social history. Photography, said Szarkowski, was ideal for America, a "country based on the principles of individual freedom, political equality, cultural diversity, centrifugal movement, constant experiment, extemporization, and quick results."[39]

Setting aside the obvious objections to Szarkowski's description of the United States as founded on the principles of individual freedom and political equality, it is strange that he chose to describe the nineteenth-century tradition of primitive American photography with reference to Turner's frontier thesis, as that thesis had long been discredited by 1979.[40] Also, Szarkowski may have overstated the independence of American photography from European art, especially with regard to western landscape photography. He discussed only Timothy O'Sullivan, whose relation to any artistic tradition is problematic, but certainly western landscape photographers such as Eadweard Muybridge and Carlton Watkins responded to both the romantic concept of the sublime in nature and the seventeenth-century Claudian formula for landscape composition.

In any case, Szarkowski's purpose in this essay was to bring to culmination the idea he had introduced in *The Photographer's Eye* and that served as the core of his most important historical and curatorial construct. This was the idea that a tradition of primitive photography, founded on the genius of naive photographers, had come to enlighten the work of a few attentive artists and had thus produced a great, independent, and quintessential American photographic tradition. Using this historical structure as a foundation, he designed a curatorial policy meant to encourage and celebrate the continuation of photographic art based on the vernacular tradition. Diane Arbus, Garry Winogrand, Lee Friedlander, and William Eggleston all figured prominently in this project. Their work often emphasized banal

subject matter, seemingly naive or chaotic composition, and apparently perfunctory craftsmanship, aspects of what came to be known, rightly or wrongly, as the snapshot aesthetic.

Looking at Photographs

Looking at Photographs (1973) is perhaps the most influential anthology of photographs ever published. As of 1994 it was still in print, unlike *The Photographer's Eye* and many of Szarkowski's other major books. The anthology contains one hundred reproductions by as many photographers, printed one to a page, each accompanied by a page of text. The photographs are Szarkowski's statement of the canon of significant photography, and the text is an exploration of what Szarkowski saw as the limits of what is appropriate to say about photographs.

Szarkowski's canon gives a significant position to vernacular photography in the form of anonymous snapshots and utilitarian photographs, such as World War I aerial reconnaissance pictures. Many of his choices from among contemporary photographers, for example, Lee Friedlander, Garry Winogrand, Diane Arbus, Joel Meyerowitz, Henry Wessel, Jr., were meant to show that artist-photographers were continuing to integrate the discoveries of vernacular photography into their work and that the snapshot aesthetic was a forceful contemporary presence. At the same time, Szarkowski attempted to broaden the canon he had outlined in *The Photographer's Eye* by publishing a number of photographs produced by synthetic procedures, including work by Man Ray, Jerry Uelsmann, Frederick Sommer, and Duane Michals. The inclusion of this work did not mean that Szarkowski considered it to be a vital aspect of the current scene, however. He said elsewhere of such pictures that they "were made with much more passion and invention when these [synthetic] devices were new than they are likely to be today."[41]

To many, Szarkowski's canon appeared tendentious, and this raised the question Minor White had asked in 1964 about the extent of such a highly visible curator's influence on the direction of contemporary photography. This issue came up repeatedly in interviews with Szarkowski in the seventies and early eighties.[42] Consistently, Szarkowski denied that he was in any way a leader in his role as curator. He argued that the photographers he promoted who became famous were inherently worthy of recognition and would have received it even had he ignored them, and he pointed out that many photographers he exhibited did not become famous. He claimed a high degree of objective disinterest in his curatorial evaluations and likened his role of curator to that of a taxonomist in a natural his-

tory museum. Apparently he did not see himself as a leader in a community full of political forces, but of course, he was. He was the leader of the most visible and respected of the tiny group of photographic institutions with a national reputation, and his curatorial choices had tremendous impact on the photographic community in terms of what was discussed, exhibited, published, and sold.

It is true that Szarkowski did not invent the snapshot aesthetic he promoted. There had to be photographers working in an appropriate way for him to be able to define and promote that aesthetic, and their work had to be of interest to the public and to other photographers for his efforts to have been as successful as they were. But to promote that work and not other kinds of work—such as the synthetic photography Lyons exhibited, which Peter Bunnell also exhibited during his brief time as curator in the Department of Photography at MOMA—was Szarkowski's choice. Perhaps Szarkowski's stance of objectivity was meant to be politic; possibly he thought that to admit to any degree of subjectivity and power would have opened a floodgate of accusations, but his denials had exactly the same effect. They probably led to as much resentment of Szarkowski as there would have been had he made an open declaration of personal taste.

Part of Szarkowski's purpose in *Looking at Photographs* was to further explicate his concept of photographic history, which he had described in *The Photographer's Eye* as a self-contained process shaped by the progressive discovery of the possibilities of photographic form. In *Looking at Photographs* Szarkowski wished to emphasize this self-containedness by detaching photographic history from social reality. For instance, in his discussion of Walker Evans, he denied that the demise of abstraction in photography at the end of the twenties and the rise of realism in the thirties had anything to do with the Depression. There is "no dependable correlation between realism and social commitment, or between abstraction and social indifference," he said, and to support this point he cited the formalism of Moholy-Nagy, who was socially committed, and the realism of Edward Weston, who was apolitical. Szarkowski concluded that the realism of the thirties did not result from "a heightened awareness among artists of social and political priorities," but that, "it seems likely that the change that occurred in photography around 1930 was fundamentally a matter of formal evolution—the result of what had gone before in photography."[43]

In making this argument, Szarkowski assumed that for a relationship between artistic form and social conditions to be valid it must appear with perfect correlation. But one does not have to establish the equivalent of a scientific law to say that the realism of much of the photography of the

thirties was a response to the Depression; one only has to demonstrate that this is what was happening in specific cases. And there are many such specific cases in the photography of the period, to say nothing of the literature, painting, and film. The validity of these instances is not undermined by counterexamples, as Szarkowski would have it, because each case is specific to the experience of a given artist, at a given time; no case defines a universal truth.

After the publication of *Looking at Photographs,* Szarkowski continued to elaborate on his view of art history as a self-contained process by describing the engine that drives it: formal evolution. To begin with, he made it clear that everything is subordinate to the evolution of form, including the artist's personality:

> Obviously . . . it would be exceedingly difficult, if not impossible, to expunge the personal perspectives and personality and particular talents and particular limitations of whoever it is that's doing the work. That you get free, in my view. But the center line of a problem and the most interesting part of it, you know, is not the question of what is unique to the individual, because, hell, we've all got that to begin with. But rather, it's how those energies are used to further explore the potentials of that line, that evolutionary line of being.[44]

This evolutionary line, he explained, advances according to the law of survival of the newest. Describing each artist's bid for recognition as a kind of game, Szarkowski wrote, "The chief arbiter of the game is Tradition, which records in a haphazard fashion the results of all previous games, in order to make sure that no play that won before will be allowed to win again."[45] This is a history of photography without photographers. Of course, individual photographers advance the history of photography, but their task is not to grapple with themselves or with experience, but to work within the confines of the logic of photographic form, looking for the next new thing, the next step in formal evolution. Their success or failure as artists has nothing to do with their personalities or identities; it is governed only by their capacity to succeed at the game of formal innovation.

In addition to being a statement about tradition and the canon, *Looking at Photographs* is also a demonstration of how Szarkowski confronted individual images. His commentary is largely formal analysis. For example, he pointed out how Timothy O'Sullivan could use the sky as "a shape,

enclosed in tension between the picture's visual horizon and the edges of the plate." Addressing a picture by André Kertész, he described a similar kind of tension between flat pattern and the illusion of space: "half of the lines converge toward a vanishing point in deep space; the other half knit the image together in a pattern as shallow as a spider web, in which the pedestrian dangles like a fly."[46]

Looking at a photograph by Jacob Riis, Szarkowski mused about how "a man who was presumably disinterested in pictures as pictures made so many great ones." Despite the fact that Riis "considered photography a useful but subservient tool for his work as reporter and reformer," and was only "intuitively interested in the problems of form without identifying these as artistic problems," he was nevertheless consistently lucky. In the picture under discussion, it is probable that

> Riis did not intend to include the hand in the upper right (not the hand of fate, but that of his assistant, who has just lighted the flash powder). It would strain credibility to believe that he anticipated the forms created by the shadows cast by the flash, or that he considered the amorphous plaster patch to be a part of his picture, or even that he visualized the powerful and mysterious graphic force of the dark plank, standing like a nameless monument beside the almost spent human life.[47]

And yet, Szarkowski implies, this is one of Riis's great pictures worthy of consideration as a work of art.

Szarkowski gives us the title and date of Riis's work, *Police Station Lodger, Eldridge Street*, c. 1890, and he tells us that Riis was a reformer, but he chooses to say nothing about what police station lodgings were, who slept in them, who this woman might be, what exactly Riis intended to reform, or how he used his photographs in the process. Nor, for that matter, does he say anything about the character of Riis's reformist vision as it is apparent in the photograph itself: in the composition in which the woman is centered and confronted head-on as she half sits, half stands with her back against the wall, her plank beside her, and her eyes closed against the flash.

Perhaps Szarkowski reasoned that Riis's "personal perspectives and personality" came "free" with the picture and are not its source of interest, and further, that while the historical context in which the picture was made may be interesting, it is not part of the picture. The picture may eloquently suggest some things about poverty, fate, and suffering, but it does so in the most

Jacob A. Riis, Police Station Lodger, Eldridge Street, *c. 1890. Courtesy of the Museum of the City of New York, Jacob A. Riis Collection.*

general way. The photograph can reproduce the texture and flavor of experience, but cannot explain its meaning. It cannot tell us the history of police lodging houses in late nineteenth-century New York. Therefore, since the object of the critic's interest is the picture itself, what is not in the picture is irrelevant.

But, one may ask, where does one draw the line between what the picture itself tells us and what is irrelevant knowledge from elsewhere? How, for example, would we even know that the plank in the picture was used as a bed without the "external" information provided by the title? Why does Szarkowski consider it permissible to tell us that the hand appearing at the right edge of the image is that of Riis's assistant? The picture certainly does not tell us that itself. If Szarkowski is willing to allow these bits of information into his discussion, as well as the information that Riis was a social reformer, why draw an arbitrary line there? Why not engage the full historical context of the picture?

Although from Szarkowski's point of view, form rather than historical context makes the picture interesting, one may argue that form cannot be divorced from context. We cannot appreciate the form of the dark plank as a "nameless monument" without understanding the association of namelessness with poverty, of monuments with death, of death with sleep, and without knowing that this plank is a bed for a homeless woman. None of this is explained by the picture itself, but it is part of the broad context of our culture and the historical context of the photograph.

If pressed, perhaps Szarkowski would admit that the picture does not tell us that Riis was a reformer, that the hand is that of his assistant, or that the plank is a bed. He might decide that even these pieces of information are irrelevant to an analysis of the photograph. Szarkowski has consistently been uncertain about what might legitimately be said about photographs because of what he sees as the tenuous, even unjustified, relation of words and pictures.

In his discussion of a Joel Meyerowitz picture in *Looking at Photographs,* Szarkowski made a set of four varied and adroit, if a bit tongue-in-cheek, interpretations ranging from "Cultural," to "Sociological," "Formalist," and "Symbolist, or Psychoanalytical." But at the outset of these interpretations, he announced that they are all ultimately irrelevant. And in another section of the book he wrote, "one discusses not the picture but some question of formal mechanics or intellectual posture related more or less closely to it. . . . Such discussions should not be scorned, for they can lead us closer to the picture's habitat. But the issue of the picture itself must finally be met without words."[48]

In a number of essays that followed *Looking at Photographs,* Szarkowski continued to work with the problem of the disjuncture of photographs and language. In "A Different Kind of Art" (1975), he explained that to photograph is to define a subject and that the subject of a photograph is not something that exists prior to the photograph, which the photographer then acts on, but that the subject is the end result of the photographer's actions: the photograph itself. Szarkowski said of a Harry Callahan picture of his wife, "The subject . . . is not the figure, or the room, or the shape and graphic weight of the light window against the dark ground, but every element within the frame, and their precisely just relationship." He continued, "For one cannot say the same thing in two ways. A change in form is a change in content." In other words, form and content are one.[49]

When Szarkowski says that a change of form is a change of content and that one cannot say the same thing in two different ways, he is also saying that a change from photography to language is a change in form and

that the same things cannot be expressed in both media. To say anything about the content of a picture—to say it contains a woman—is to violate the picture's subject; it is to divide it into discrete parts as language divides the world. But according to Szarkowski's terms, the subject of a picture is indivisible, consisting of all the things in the picture, their relationships, and visual qualities.

In his 1976 essay on William Eggleston, Szarkowski stipulated that the identification of form and content implies the disjuncture of language and photographs when he called photographs "irreducible surrogates for the experience they pretend to record." He wrote, "One can say then that in these photographs form and content are indistinguishable—which is to say that the pictures mean precisely what they appear to mean. Attempting to translate these appearances into words is surely a fool's errand, in the pursuit of which no two fools would choose the same unsatisfactory words."[50]

Szarkowski's position is a difficult one because we continue to talk and write about pictures and want to feel that our words are not gratuitous. Szarkowski acknowledged the discomfort: "In the end, form and content are inseparable and indistinguishable, for it is not possible to say precisely the same thing in two different ways. Nevertheless, for convenience (while keeping at arm's length the unwelcome presentiment that the pictures will not give up their secrets to analysis), we may pretend that fact and aspect can be cut asunder."[51] Even here, he gives the verbal analysis of pictures no theoretical justification. Are we simply pretending to be able to talk about pictures? Is criticism futile? Is it simply an irrational urge to assault the visual world with language?

The art historian, Michael Baxandall, who has also addressed the relation of words and pictures, may be of some help here. He might agree with Szarkowski that language cannot grasp pictures in their visual being, but he is more at ease than Szarkowski with the indirect relationship of language and pictures. Unlike Szarkowski, Baxandall is not concerned with the problem of grasping pictures in their very essence; he is interested instead in the way pictures exist within a web of relationships. He does not think of pictures primarily as independent objects to be contemplated for their appearance alone, but as objects that are intimately bound to a historical process that produced them. This process and its relation to the appearance of pictures are within the grasp of language even if the picture itself is not. As Baxandall puts it, "If we wish to explain pictures, in the sense of expounding them in terms of their historical causes, what we actually explain seems likely to be not the unmediated picture but the picture as considered under a partially interpretive description."

He identifies three aspects of this description all of which emphasize the relationship of the picture to something else. First, the description is less a representation of the picture than a representation of "thinking about having seen the picture." Second, the description is often indirect, referring not to the physical picture so much as to the effect of the picture on the viewer. And third, the description depends for its precision on the presence of the picture; it works demonstratively by pointing to the picture.[52]

Baxandall is saying that words never grasp a picture; they cannot substitute for, translate, or convey a picture, but they can establish a set of relationships with a picture such that the words and picture together have meaning. To understand the meaning of pictures as arising out of relationships is not to treat pictures as independent visual objects in the modernist sense, but as visual objects deeply embedded in and connected to a cultural context. From this point of view, we might say not that form equals content, but that form and content together equal context.

Mirrors and Windows

In the catalogue of his exhibit *Mirrors and Windows* (1978), Szarkowski set out to define American photography since 1960. In large part, his aim was to make sense of the chaotic landscape of photographic practice in broad conceptual terms that would transcend the confining and worn distinctions made on the basis of technical practices, that is, straight versus manipulated, or synthetic, photography. But he also used this occasion to articulate the differences between his own worldview and that of the subjectivists.

His essay begins with a historical sketch of the collapse of the mass circulation magazines, the demise of photojournalism as the pole star of American photography, and the rise of photography in the universities after World War II. After the war, photography became less engaged with the social world, he says, and more personal in scope, but as it did so, it branched into two major currents, or rather aligned itself along a continuum stretching between two opposing impulses. Szarkowski identified Robert Frank's "searing personal view of this country during the Eisenhower years" and his "radical understanding of the potentials of the small camera" as the definitive gesture for one of these impulses, which he named realism. The other impulse, romanticism, was defined by Minor White's "intense sensitivity to the mystical content of the natural landscape, a belief in the existence of a universal formal language, and a minimal interest in man as a social animal."[53]

Further defining his conceptions of romanticism and realism, Szarkow-

ski described the former as arising from the urge toward self-expression and the latter as arising from an urge toward exploration:

> The distinction may be expressed in terms of alternate views of the artistic function of the exterior world. The romantic view is that the meanings of the world are dependent on our own understandings. The field mouse, the skylark, the sky itself, do not earn their meanings out of their own evolutionary history, but are meaningful in terms of the anthropocentric metaphors that we assign to them. It is the realist view that the world exists independent of human attention, that it contains discoverable patterns of intrinsic meaning, and that by discerning these patterns, and forming models or symbols of them with the materials of his art, the artist is joined to a larger intelligence.[54]

Realism is not to be confined to the description of the surfaces of things but is also meant to stand for an interest in "objective structure and the logic of process and system," so that an x-ray, for example, might be considered a realist form of photography. Szarkowski unquestionably identified himself with realism.

Mirrors and Windows met with mixed reviews. One common criticism was that although Szarkowski purported to be surveying photography from 1960 to 1978, his show actually dealt only with the art photography he himself had taken an interest in as a curator during that period. He ignored "everything that has happened in 20 years of newspaper and magazine photography, not to mention scientific, industrial and popular photography."[55]

His treatment of photojournalism was a particularly sore point for some critics because Szarkowski not only excluded it from the show but suggested in his essay that it had failed. It had increasingly revealed an incapacity to explain important public issues, such as the war in Vietnam, he said, and it had become peripheral to the vital course of photography. Therefore it did not warrant close curatorial attention. In fact, Szarkowski thought that the war, in particular, might better be addressed by art than journalism, because the war's meaning for most Americans was not political, military, or ethical, but psychological: "It brought to us a sudden, unambiguous knowledge of moral frailty and failure. The photographs that best memorialize the shock of that new knowledge were perhaps made halfway around the world, by Diane Arbus."[56]

These claims infuriated Howard Chapnick who saw the war as precisely a social, ethical, military, and political issue, and thought the still

and television photographs of "Larry Burrows and Horst Fass and Eddie Adams and Robert Ellison and Cathy LeRoy" had had a direct impact on American perception of "the senseless involvement and slaughter. . . . To ignore photojournalism in an exhibition of photography of the last two decades," said Chapnick, "is to ignore history."[57]

In general, critics saw Szarkowski's conception of photography as too hermetic, too aesthetic, ahistorical, involved with a narrow band of art photography that only pretended to engage the real world. Leo Rubinfien noted that Szarkowski's distinction between romanticism and realism would have meant more had he not treated it ahistorically but explained it in the specific historical terms of the period 1960 to 1978, and had he explained why the period needed "two almost symmetrically different modes."[58] Gene Thornton mocked Szarkowski's praise for art photography which feigned concern with subject matter while putting formal issues first. Szarkowski had praised Lee Friedlander's "false documents," which were really uncompromising works of art. In addition, scoffed Thornton, he had promoted "the false photojournalism of Winogrand and the false passport photos of Arbus . . . the false snapshots of Emmet Gowin, the false picture postcards of Stephen Shore, the false candid camera shots of Mark Cohen and the false tourist snapshots . . . of William Eggleston."[59] Thornton sensed a pattern of enervation in the art photography which borrowed from vernacular forms. As these forms were made into art, they became denatured and stripped of their vital contact with the world.

Such responses to *Mirrors and Windows* were part of a large and growing reaction against Szarkowski's formalism. In 1972 A. D. Coleman had written scathingly about Szarkowski's exhibit of Atget's tree photographs: "I am unalterably opposed to the prevalent misconception that the ideal end result of creative struggle should be a self-contained and sealed system referring only to itself, communicating only with its maker, and permitting no dialogue with its audience. . . . Yet Szarkowski is out to prove, in this show, that Atget's work is about itself—not about Paris, or Atget's life, or being enchanted by reality and trying to preserve some slice of it."[60]

One of the most interesting rejections of the formalist ethos came from the photographer Chauncey Hare, a refugee from the world of corporate engineering and a rising star at both MOMA and the post–Minor White *Aperture*. Hare rejected what he saw as the emotional constipation of formalism even as it was applied with approbation to his own work:

People at MOMA and *Aperture* seemed to be overlooking the meaningful in the immediate while searching for the superficial in

the obscure. When I saw my photographs at the MOMA exhibit (I was surprised how much the hallways and offices at MOMA looked like those at Standard Oil), it was clear the pictures were not being presented so that they could be understood. The photographs were hung so as to highlight the formal or intellectual "art" elements of the pictures and to downplay the more meaningful subject content. The dehumanizing process, denial of heart values in favor of the hard, intellectual and unsentimental, is familiar to me. I recognize this emotional immaturity as characteristic of my experience while a Standard Oil engineer.[61]

Szarkowski's critics saw his interests as too narrow. They saw him as concerned only with art and not the whole of photography, and they saw him as treating art photography only in terms of form and not its relation to the larger world. But despite these criticisms, they still shared at least one of Szarkowski's fundamental assumptions. His critics never questioned his concept of art photography as distinct from other kinds of photography and as having inherent qualities by which it might be identified as art. As postmodernist thought began to engage photography in the 1980s, however, the distinction between art and nonart photographs became a central issue, and the idea that this distinction is based on any kind of inherent qualities in images was seriously challenged.

In a 1984 essay Abigail Solomon-Godeau noted the presence in *Mirrors and Windows* of works by Robert Rauschenberg, Andy Warhol, and Ed Ruscha.[62] Szarkowski, no doubt, had included these works as a sign of his growing flexibility and pluralism, but in Solomon-Godeau's postmodernist terms, these images signaled, here in Szarkowski's own exhibit, a new worldview that would undermine his own. As Solomon-Godeau pointed out, appropriation of mass media images for high art (something done by Rauschenberg and Warhol) calls into question the boundaries between popular photography and high art. But it does not do so on the grounds that some popular images deserve to be treated as high art because of their formal interest or inventiveness, grounds on which Szarkowski himself appropriated images from another context into the high art canon. Rather, postmodernist appropriation repeats Duchamp's demonstration that art status is not an inherent quality in objects but is determined by the will of the artist. Any photograph, from an advertising picture to a nondescript snapshot totally devoid of aesthetic grace, may be art if that photograph embodies an idea that an artist wants to exploit.

In addition, for postmodernist artists, appropriation of someone else's

photograph often signals a denial of the possibility of originality and an acceptance of the idea that we live in an all-encompassing world of symbols beyond which we cannot reach into a raw, unmediated reality. The postmodernist proposition is that anything said or shown in a picture is a collage of quotations of what has already been said or shown. The appropriated image is meant to make this condition of inescapable quotation explicit. In this respect appropriation is a fundamental blow at Szarkowski's concept of realism according to which we may discover new things about an independent, exterior world. If one is to see the exterior world through photography, then one must be able to see something out there that is new and independent of what has been seen before. And if one is to participate in the evolution of photographic history, one must be able to discover new aspects or applications of photographic form. Photography itself must be something we can continue to discover. But if our experience is bounded by culturally determined symbols that we constantly reshuffle, then this cannot be. Appropriation is meant to draw attention to a prison of culturally mediated experience.

Photography Until Now

By the late 1980s, it looked as if Szarkowski and the modernist tradition in photography had become almost irrelevant, blindsided and swept out of the way by ideas and practices that had not even arisen within the photographic tradition but in the context of nonphotographic art. Conceptual and performance artists who had first produced photographic documents of their ephemeral works were now exhibiting photographs of constructions and events staged for the camera. Artists interested in postmodernist theory were using photography as the medium that might best undermine the modernist concepts of subjectivity, originality, and the purity of artistic media. Other artists trained in other media picked up photography as just another medium of expression. One began to encounter writers on photography who could quote Walter Benjamin but had never read Beaumont Newhall, and photographers who knew the work of Anselm Kiefer but had never heard of Jerry Uelsmann. By 1989 when Szarkowski published *Photography Until Now,* his last book before he retired from MOMA, a new statement from the doyen of photography curators was no longer an eagerly anticipated event. Nevertheless, Szarkowski remained unbowed and as feisty as ever, using *Photography Until Now* to make some pointed responses to the postmodernists.

Photography Until Now is not so much a history of photography as a historical essay in which Szarkowski draws out the implications of the the-

ory that photographic practice and aesthetics have been shaped by photographic technology and by the economics and organization of the production and distribution of photographic imagery. This idea is a much broader explanatory tool than Szarkowski had used in the past when he wrote of photographic history as the evolution of form, but it still conforms to his determination to explain photography in terms of things photographic.

Sometimes his explanations are farfetched, as when he describes the emergence of straight photography as a reaction to the photomechanical revolution on the part of skilled craftsmen who wanted to preserve the subtle tonal scale of photographic prints, which the common reproduction processes could not imitate. In other cases his analyses are trenchant, as when he applied his theory to two major manifestations of postmodernist practice. Specifically, he explained the breakdown of boundaries between photography and other media and the recent ubiquitousness of synthetic photographic techniques not in terms of a theoretical rejection of modernism but, as the result, in part, of the entry of photography into the universities and the mingling of photographers with traditional art faculties. He said these postmodernist phenomena were also the result of an effort to make large, colorful, painterly images to satisfy the tastes of the art market in which small, monochromatic, pure photographs sell poorly.[63]

In effect, Szarkowski reduced important aspects of postmodernism to functions of the economic expansion in the postwar period (it was this expansion that brought photography into the universities) and competition in the art market. Szarkowski meant to undermine the theoretical foundations of postmodernism and its power to comment on contemporary culture by describing postmodernism itself as a symptom of larger cultural forces.

When he turned to postmodernist art, Szarkowski found it lame. A good deal of postmodernist art deals with issues such as race, gender, and our concepts of history and culture, and it attempts to show how our understanding of these issues and of ourselves is constructed and manipulated by media that carry the dominant ideologies of the culture. This art is meant to call attention to the way in which institutions shape what we take as given reality. But Szarkowski dismissed this work as bad art, too simplistic and misguided to take seriously. Recent efforts to use photomontage (such as Barbara Kruger's work), he saw as mere satire of advertising techniques. And he called recent work with overtly political or social content utterly shallow. For Szarkowski, the political and social motivation for such work was an insufficient basis on which to produce art. "Two-dimensional ideas," he wrote, "lend themselves to two-dimensional treatment."[64]

Szarkowski contended that in the heyday of photojournalism, when there was the illusion that photography told the truth, photographers shared a sense of community and common purpose. Now the illusion has been shattered and with it a sense of power and commonality. In compensation, we have learned more of the truth about photography itself, and the truth is that photography at its best is art, not politics or social activism. On this point Szarkowski is adamant. To maintain itself as art, "to avoid unnecessary misunderstandings," to avoid the illusion of social power, the distractions of good intentions and grand ambitions, or the foolishness of chasing after collectors' money, photography should be a small art in both the literal sense that photographs should be made for books rather than wall display, and in the sense that its subjects should be immediate and not presumptuous. At the end of his book, Szarkowski sums up his vision of photography's present course:

> This is not to say that photography does not still have work of importance to do for the great world, perhaps including even more thrilling pictures of Neptune, and pictures of subatomic events in bubble chambers, and closer to home, pictures of the rain forests and the whales. There is no reason why we should shrink from making such large issues the pretext for picture-making . . . but it is not clear that all the best photographers will feel the need to travel so far, or to choose subjects that carry with them bonus points for good intentions, since their real intentions may be more difficult to explain and not quite so simply honorable. Like Captain Ahab, they might rather know the whale than save him. . . . [M]ost photographers of ambition and high talent would prefer today to serve no instrumental functions—no "useful" goals. They wish simply to make pictures that will—if good enough—confirm their intuition of some part or aspect of quotidian life.[65]

Gene Thornton
Gene Thornton is not a formalist, like John Szarkowski, but rather a humanist who labored in the climate of formalism that Szarkowski encouraged. Thornton was the photography critic for *The New York Times* in the seventies, and he wrote a photography column for *Artnews* in the same period. He had training as a painter and had been an art critic for *Time,* so he had no trouble developing an agile understanding of photography's relation to formalism and the broader context of modern art. But mod-

ernism largely dismayed Thornton. He had abandoned his study of painting at the Art Students League because modern art had abandoned the great themes and functions he thought art should serve: mass communication, recording history, maintaining tradition, and binding community.[66] In turning to photography, a medium necessarily bound to worldly subject matter, Thornton expected to find art that better served these aims than painting, but this expectation was often frustrated as he found photography chasing after modernist ideals of purity and form. To Thornton, the greatest works of art, photographs included, balance human interest and formal beauty, but he rarely found this balance in the photography he reviewed.

Thornton recognized the dominance of Szarkowski's viewpoint in the photography world. "Szarkowski," he wrote, "has almost single-handedly called into being a new type of art photography that is comparable to modern painting in its striving for fidelity to the medium at the expense of subject matter."[67] Later Thornton softened this position when he conceded that Szarkowski did not really create a photographic movement single-handedly so much as he recognized the logic of modernism as it unfolded along a possibly inevitable course.[68] In any case, keeping an eye on Szarkowski was crucial to Thornton's task as a critic.

In 1978 Thornton came to a clear definition of the formalism Szarkowski endorsed. In "The New Photography: Turning Traditional Standards Upside Down," Thornton explained the snapshot aesthetic of photographers admired by Szarkowski—Garry Winogrand, William Eggleston, Lee Friedlander, Mark Cohen, Stephen Shore—as a new kind of formalism unlike the older formalism of Strand, Stieglitz, and Siskind. The new work avoided the abstract look borrowed from painting, which marked the older work, and looked instead to snapshots and "functional" photographs for a uniquely photographic vocabulary of "distorted scale, artificial lighting, tilted horizons, blurred or out-of-focus images, information overload as a result of congested detail, random framing and unexplained fragments of arms and legs at the edges of pictures." The use and development of this vocabulary was the central purpose of the new formalist photographers, said Thornton. One might admire some documentary aspect of their work, as indeed Szarkowski himself did at times, but this was beside the point. Any "emphasis on subject matter distorts the real significance of the work of these photographers. Their photographs are not about the objective world or even their subjective reactions to that world, but photography itself."[69]

Thornton generally did not like formalistic photography. For formalism truly to succeed, it somehow had to suppress subject matter, but as

Thornton saw it, this was one thing photography resists by its very nature. The traditional formalists, such as Strand and Siskind, doggedly tried to obscure subject matter by getting close to it or by approaching it from an unexpected vantage point. Others, such as Alvin Langdon Coburn, Man Ray, and Laszlo Moholy-Nagy, attempted to distort subject matter by "playing" with synthetic techniques, but none of this in Thornton's estimation was successful photography because it strained so hard to overcome what it simply could not overcome.

The new formalists accepted the inevitability of subject matter but tried, nevertheless, to transcend it by choosing quintessentially banal subjects. This ploy worked no better for Thornton than that of the older formalists. He could not happily look past these banal subjects to issues of form. He was either constantly dismayed by the banality or intrigued by unintentional invasions of human interest. When Szarkowski described Irving Penn's platinum prints of cigarette butts as inconsequential subjects transformed into art through enormously sophisticated handling, Thornton objected. The subjects were central to Penn's images, he countered. If Penn had photographed roses in the same manner, the pictures would have been dull. It was the perversity of handling such "revolting" subject matter in such a grand manner that gave the pictures their interest.[70]

Thornton was not dogmatic. He could praise formalist photography when it showed signs of drama or social comment, as he did in reviews of Henry Wessel, Jr., and Lee Friedlander, or simply when it was well done, as he did in a review of Mark Feldstein. Nevertheless, to make formalist pictures was an unnatural act with a camera. Thornton called Feldstein a "dancing dog that can do a somersault as it jumps through a hoop," and when he defended Aaron Siskind against those who objected to his "poaching" on painting's territory, he used the word poaching himself to describe what Siskind was doing.[71]

Subjectivism was no more satisfying to Thornton than formalism. He tended to see subjectivism as an indulgence and a refusal to communicate. When Robert Frank turned from social comment to the introspective pictures of *Lines of My Hand* (1972), Thornton deplored Frank's "preoccupation with himself."[72] Thornton had no more patience with academic photographers who photographed their "private realities." This was pure indulgence. It was also a gimmick forced on these artists by the pressures of the academy to be productive and to "be themselves." Such personal photography was fatally flawed by its uncommunicativeness and the unreasonable if not impossible demands it placed on any public it might have. Thornton did not reject the importance of interior experience or the existence of the

unconscious—he praised Jerry Uelsmann as a successful latter-day surrealist—but he considered it a primary duty of the artist to communicate with the public, and he insisted that any meaningful private vision must have a public dimension.[73]

Some of the photography Thornton approved of most was that which sought the truth, as he put it. The truth Thornton was thinking of was a social one. Few landscape photographers interested him, and the whole West Coast tradition of landscape photography was a bit suspect. Ansel Adams and Edward Weston were not so much interested in the truth, he thought, as they were virtuoso aesthetes interested in Art. What Thornton liked was opinionated photography that engaged the social world, photography best exemplified by Frank's *The Americans.* Other photographers Thornton approved of included Gene Smith, whose Minamata photographs he praised for their "high-minded partisanship"; Margaret Bourke-White; Diane Arbus, in whose work Thornton saw "the classic, calm finality of truth"; Lee Friedlander, at times; and Larry Clark, whose *Tulsa* bravely bucked the current of formalism to tell a moral tale of destroyed young lives.[74]

Although Szarkowski was a leader in a wrongheaded age, Thornton did find value in some aspects of his theory. In shows and books such as *From the Picture Press, The Photographer's Eye,* and *Looking at Photographs,* Szarkowski broadened the field of photographs worthy of serious consideration so that it extended well beyond the narrow band of high art photography to include vernacular and functional photographs. Thornton's particular interest in this move was that it opened the way for the serious consideration of fashion photography, for which he had a special taste. After fashion photography had served its function of selling clothes, he said, it remained a delightful and charming evocation of a world of dreams.

Thornton was indignant that fashion photographs and mass media photographs in general were treated as second-class work and not given the serious attention that art photography received; just because commercial photography is made for money and to satisfy a client rather than the artist's personal interests does not mean it cannot be art. (Thornton is reminiscent of Steichen here.) Most of Western art, Thornton pointed out, has been made on commission to satisfy the demands of powerful and wealthy clients such as the church and the aristocracy. This issue was of such importance to him that he put it at the center of his historical survey, *Masters of the Camera, Stieglitz, Steichen and Their Successors* (1976): "Must the maker of an artistic masterpiece have worked primarily to gratify his own creative urge? Or can a masterpiece result when a photograph-

er is meeting the requirements of a client: a magazine or newspaper editor, an advertiser, a government or social agency, or a private portrait client?"[75]

Clearly, part of what must have appealed to Thornton about mass media photography was that, like Renaissance art, it was thoroughly integrated with life; it was not an isolated and alienated activity. In sharp contrast to the art photography of academics, mass media photography is made by crafts-men-businessmen who perform a well-defined and financially valued func-tion in the culture, and their work reaches a huge audience that understands and responds to it. Art made for a responsive public was far more attractive to Thornton than art made in what he thought of as the academy of the self.

Photographers who do not earn a living with their work, but teach, or live on grant money are free of the demands of clients and editors, free to do as they choose, free to be themselves. But Thornton saw this as a false freedom, particularly for those photographers in universities:

> There are times when I wonder if "free" really is the right word. There are times when I wonder if "bound" would not be more apt; if university photographers are not as bound to photograph "as they please" as any press or advertising photographer is bound to photo-graph as someone else pleases. Just as academic scholars are bound to "publish or perish" whether or not they have anything to say, it sometimes seems to me that university photographers are bound to "be themselves" whether or not there is really a self to be.[76]

The rise of personal photography, Thornton explained, had been brought about by the death of the great picture magazines at the hands of television. This had severed photography from its foundations in the great tales of emotion, history, and tradition and had made photographers depen-dent on a handful of critics, dealers, and "the director of the photography department of one major art museum" for public recognition.[77]

Meanwhile, commercial photography—by which Thornton meant advertising and public relations photography, not photojournalism—had continued to reach a huge audience on a regular basis, and in doing so, it had performed "what has traditionally been one of the principal functions of the art of museums: it gives pictorial expression to the dreams and ideals of its time and place." Furthermore, Thornton thought that mass media photography should be celebrated as a phenomenon unique to middle-class, democratic societies "where everyone is free to live as he pleases, so long as he can find the money to do it, and where there is a positive stimulus for everyone to live as well as he can."[78]

In short, mass media photography, advertising photography, is an art of democracy and social mobility; it appeals to the public because it embodies the public dreams of a good life. In saying this, Thornton made the profound error of mistaking capitalism for democracy; he confused democratic freedom of expression with corporate manipulation of desire. Advertising is not a democratic process designed to amplify the public's dreams, but an entirely capitalistic one designed to stoke the fires of consumption.

Thornton is correct that mass media photography is worthy of serious study, but the question nevertheless remains as to whether it is art. And although he thinks it should be considered as such, he is never quite able to say why. Thornton recognized that when Szarkowski expanded the museum's canon of photography, he was raising the question of what makes a photograph a work of art. Thornton also acknowledged explicitly that Szarkowski's inclusiveness, and the inclusiveness he wished to promote on behalf of mass media photography, ignored the photographer's intention as the factor that determines which photographs are art. Thornton had no qualms about this. He wrote in an essay on fashion photography, "Obviously art is in need of a new definition that will bypass the question of the artist's intention."[79]

If the artist's intention is not the factor that determines which photographs are art, then what is? Thornton grappled with the question in a review of Szarkowski's *Looking at Photographs*. The book struck Thornton as a grab bag of fascinating pictures, but among the various kinds of photographs presented as art—news photographs, topographical pictures, scientific records, fashion photographs—he saw no unifying factor in the photographs themselves that justified their presence in an art museum's collection. And much to Thornton's dismay, Szarkowski did not explain what it was about these pictures that made them art. In wrestling with the question, Thornton toyed with an institutional theory of art, whereby something becomes art when a museum or some other cultural institution accepts it as such, but he was unsatisfied with this solution because the judgment of history might contradict the institution. Thornton pursued the discussion no further and left the problem hanging.

Despite his readiness to override photographers' intentions in the case of fashion photographs, Thornton was not at all eager to do so in another instance. When NASA photographs were exhibited at Light Gallery in New York, Thornton refused to accept them as art. To do so, he felt, would have meant seeing them in primarily formal terms, but he found these pictures formally uninteresting. In addition, they were not art because "pic-

tures taken by scientists and automatic cameras cannot be thought of as expressing an artist's intention."[80] These photographs only have value, said Thornton, when they are considered as scientific documents, that is, in a manner consistent with the intent with which they were made. In this case, Thornton used the photographers' intentions to define the status of the photographs.

The matter of a photographer's intent is relevant not only to the question of whether a given photograph is art but also to the issue of the meaning of a photograph that is already established as art. The question of intent is one part of a larger question about whether the source of a photograph's meaning lies entirely in the photograph or is also generated by the historical context in which the photograph is made, a context of which the photographer's intentions are an important part. Thornton made some strong statements denying the significance of a photographer's intentions in determining the meaning of photographs. For example, he praised Edward Lucie-Smith's *Invented Eye* (1975) for putting an emphasis on "the work of art and its meaning to the viewer, rather than on the artist and its meaning to him."[81] But at other times Thornton appealed to the artist's intentions as a guide for the interpretation of a body of work. On at least two occasions he fretted that the display practices at MOMA, which emphasized the formal aspect of photographs, were at odds with the intentions of photographers who were concerned with human drama more than form. By countering the photographers' intentions, MOMA's displays distorted the meanings of the photographs.[82]

With regard to the broader issue of the relation of historical context to meaning, Thornton was also contradictory. He complained that Josef Koudelka's photographs of Gypsies were opaque without captions and explanatory text and that they failed to make the Gypsies' lives intelligible to viewers. But he refused to allow Roman Vishniac's photographs of Eastern European Jews on the eve of the Holocaust to be illuminated by the historical context he was aware of. Of Koudelka's pictures he said, they "are presented so shorn of context that one would have to know a lot about Gypsy life to make sense of them."[83] By themselves, Vishniac's pictures were similarly opaque. Thornton said of them, "Except for some items of dress, hair style and writing, there is not even anything especially Jewish in them. To a naive American, they could be pictures of the daily life of any poor ethnic group in Eastern Europe in some unspecified time in the 20th century. Life is poor, but it goes on."[84] Thornton, however, was not naive. He understood the larger reality present in Vishniac's pictures, but he refused to let it enrich his experience of them. He explicitly accused Vishniac of asking the viewer to see

events not visible in his work, events Thornton understood. But it was precisely that which was not visible in Koudelka's work that Thornton wanted an explanation for so as to better appreciate Koudelka's pictures.

In the review of Vishniac's pictures, which Thornton wrote after his review of Koudelka, he sensed the contradiction he was stepping into and backed away from his earlier criticism of Koudelka, saying that the photographer of Gypsies was emphasizing the universal and timeless while Vishniac, with less justification, was emphasizing the specific and historic. But Thornton was often critical of art for being separate from life. He could write with contempt that "nobody knows that art is art until it has been removed from everyday surroundings and placed in a museum; until it becomes something not for use but purely for aesthetic contemplation."[85] Given these sentiments, one would expect him to have praised Vishniac for presenting his photographs in such a way as to emphasize their connections to the specific and historic.

Clearly, Thornton was not consistent in his criticism. His criticism often has the air of someone feeling his way as he goes along and writing to meet a deadline. This does not mean that Thornton had no convictions. He wished for an art that dealt with the great themes of life, and he wanted art to touch people in their daily lives. He thought photography might produce such an art and was disappointed that it had taken a turn toward formalism. Though he found himself caught in a time when his ideas were not in style, he was too open to reject everything he faced or to wrap himself in a protective dogma. He was also perceptive enough to recognize and grapple with crucial theoretical issues regarding the very nature of art and the grounds for critical interpretation. Thornton was not equipped to deal with these issues in a profound way, but he shows us his honest struggle with them, and this is perhaps his greatest value as a critic.

When in the late seventies there appeared a revived interest in subject matter, Thornton rejoiced at the end of formalism and the dawn of postmodernism.[86] As postmodernism took shape in photography, however, it did not follow the path that Thornton must have hoped it would. Postmodernism has rejected the grand, universal themes of the human saga and the celebration of tradition that Thornton so enjoyed in art.

CONCLUSION: MODERNISM AND POSTMODERNISM

The high modernist vision in photography, which Szarkowski so success-fully championed at MOMA, started to give way in the 1970s. Throughout the sixties, committed modernist theorists had been struggling with mod-ernism's internal dilemmas. White had tussled with the concept of inher-ent meaning, and had then turned away from it; Smith had abandoned the concept of art as an inherent status with his investigation of artistic para-digms. Szarkowski himself asserted but could not maintain the unity of form and content and the absolute independence of the photograph as a visual object. In the seventies, younger critics began to lay siege to the for-malist separation of art and social reality.

There were also significant changes in photographic practice. A num-ber of artists began to use photography without much concern for crafts-manship, personal vision, or formal invention. These artists were interested in photography as a broad social phenomenon, and they saw photographs as mass-produced objects, as documents of artistic ideas expressed in another medium, or as a quick and easy method of notation. In the late fifties and early sixties, Robert Rauschenberg and Andy Warhol, work-ing outside the photographic tradition, had begun to appropriate mass media photographs for use in their collages and silk screens as a way of commenting on mass media processes of reproduction and distribution and on the photograph as a ubiquitous and inexpensive object. Robert Heinecken began to investigate some of the same issues from within the photographic tradition in the early sixties. Conceptual artists such as Ed Ruscha and John Baldessari began to make photographs that were meant to eschew the qualities of precious art objects while functioning simply as conveyors of ideas. They conceived of the object value of a photograph as roughly equivalent to that of a typed manuscript. All these artists regarded the cultural environment of imagery as the raw material of art in the way earlier artists had regarded nature. The photograph, for them, was not so much a way to investigate something else—interior or exte-

rior experience—but something to investigate in itself, not for its formal aspects but as it operated in the cultural mechanisms of information, consumption, celebrity, and sexual desire.

By the seventies, artists were using photographs to convey information about artworks in other media. Photography was used to document inaccessible or ephemeral creations—earthworks, body art, or performance art. As it became clear that photographs would be the only records of such art, that the documentation would, for all practical purposes, replace the work of art, artists began to make art specifically designed for the camera. Hence the elaborate tableaux of artists such as Laurie Simmons, Sandy Skoglund, and Bruce Charlesworth exist primarily as photographs, but photographs made not to be admired for their formal organization or their specifically photographic vision, but to be the essentially transparent medium through which we receive artistic ideas.

Other artists, such as Cindy Sherman, Barbara Kruger, Sherrie Levine, and Richard Prince, have distilled the practice of appropriation begun by Rauschenberg, Warhol, and Heinecken. Sherman has appropriated the visual techniques of film, advertising, and Old Master painting. The others have appropriated the techniques and the images of advertising, journalism, art photography, and painting. Their work deals with issues such as the exhaustion of artistic invention, the constructed nature of the self, and the culturally mediated nature of experience, issues inextricably bound up with postmodernist theory.

It is precisely in theory and criticism that postmodernism has taken its most powerful form, for postmodernist theory and criticism have not only explained new photography and encouraged its production but also made a bid to equal it in importance, and even to assert the primacy of language over the visual image. In some cases, the theory is an inseparable aspect of the art. Sherrie Levine's appropriations of Edward Weston's photographs, for example, are utterly dependent on theory. Without it, her pictures are merely theft, infringement of the copyright law. Her work only becomes art when it is called appropriation. The theory of appropriation is the difference between the objects' status as art and nonart.

Postmodernist theory has drawn on a variety of sources in Marxism, semiotics, poststructuralism, feminism, and psychoanalysis. It is complex and by no means monolithic. In some forms, postmodernist thought is almost nihilistic in its attacks on the concepts of self, immediate experience, and truth. In other forms, it is a version of political criticism, giving special emphasis to issues of race, ethnicity, gender, and sexual orientation. Perhaps the greatest source of consistency in postmodernism is its

opposition to basic tenets of modernism. In place of the modernist idea of inherent meaning in works of art, postmodernists have proposed an idea of contingent meaning. In place of a hermetic formalism, postmodernists have asserted the inescapably social nature of all art. The modernist concern for the essence and purity of artistic media has been overturned by a concerted effort to dissolve all boundaries of artistic practice and to look beyond the boundaries of art to understand the functioning and significance of any given medium of communication. The modernist respect for purely visual meaning has been rejected for a belief that meaning can exist only in language or in structures derived from language. The primacy of originality has been rejected through an attack on the very possibility of originality; the respect for subjective expression has been undermined with a theory of subjectivity as a social construct. The modernist belief in universality has been replaced by an emphasis on the historically specific. And the modernist pursuit of transcendence has been scoffed at as a distraction from the more worthy investigation into the material conditions in which art is produced.

Postmodernism has spread through most of the arts and most corners of the academy, but photography has been particularly fertile ground for postmodernist ideas, and they have flourished here with special vigor. One of the consequences of postmodernism for photographic theory is that the paradox of trace and transformation, so central to modernist theory, has been rendered peripheral. The paradox gains its importance in modernism through the attempt to define the ontological status of photographs as it is determined by what one sees in or through them. Does one see in a photograph an automatic trace of reality or a transformation of reality through which one detects the creative vision of the photographer? Modernism treats the photograph as an image into which one looks for meaning. Postmodernism, however, treats the photograph less as an image than as an object and is less concerned with what one sees in it than with the relationships into which it enters. Postmodernists are interested in who sees a photograph and where, who buys or sells it, and what people say or write about it. For postmodernists, meaning does not arise from what one sees in a photograph so much as from how the photograph is used, so postmodernists are not much concerned with the paradox of trace and transformation.

This does not mean that the paradox of trace and transformation has disappeared entirely from postmodernism. One cannot discuss the way a photograph functions in discourse without having some assumption about the nature of what photographs contain, and because postmodernists are generally hostile to notions of the subjectivity and individuality of the

artist, they tend, without much discussion of the matter, to emphasize the photograph as a trace rather than a transformation. Perhaps Allan Sekula best summed up the postmodernist position on the issue when he said, "The only 'objective' truth that photographs offer is the assertion that somebody or something . . . was somewhere and took a picture. Everything else, everything beyond the imprinting of a trace, is up for grabs."[1]

A. D. Coleman

On the basis of the criticism he published between 1968 and 1978—the years covered in his book of collected essays *Light Readings,* published in 1979—A. D. Coleman might be considered either the most important transitional figure between modernist and postmodernist criticism or the first postmodernist critic of photography. Coleman has articulated a vision of photography as a necessarily social medium, both in terms of the ideas expressed in its imagery and as a powerful means of communication, the control of which—in exhibitions, publications, and so on—has social implications. He has considered photography in its entirety as it stretches beyond the boundaries of art, boundaries that he viewed with some impatience as obstructions to an understanding of the vast and profound impact the medium has had on contemporary culture.

Mostly, however, Coleman has written about art photography, showing an acute awareness of the politics of the art world as well as a sensitivity to the visions of particular artists and the meanings of their images. Unlike some postmodernists, Coleman has not rejected the possibilities of originality, subjectivity, and individuality. Unlike some modernists, he has rejected the idea that photographs are purely visual objects beyond the reach of words. As a critic, he has put the photograph first, considering it his task to address the photograph in words, but he has not wished to dominate the image with words. He wrote of criticism as the "intersection" of images and language. Coleman has said that he has no formal methodology for criticism and no systematic aesthetic. He wrote, "I merely look closely at and into all sorts of photographic images and attempt to pinpoint in words what they provoke me to feel and think and understand."[2] Whether he has a formal methodology or not, Coleman has written with a consistent purpose, seeking always to expand our grasp of photography as it works its power in a myriad of ways on all the corners of contemporary culture.

Coleman's university education was in English literature and creative writing. He earned his M.A. in 1967 at San Francisco State College, and the next year began to publish criticism of photography in *The Village*

Voice. He wrote a regular column there until 1973 when he resigned over a controversy stirred up by his criticism of Minor White. From 1970 to 1974, he wrote a biweekly column for *The New York Times,* alternating with Gene Thornton. He also published in *Popular Photography* in this period. After 1974 he published mostly in *Camera 35.* In his own estimation, by 1978 he had written more than four hundred articles. Such a prodigious output was the result of his commitment to consider anything "that seemed even remotely pertinent" to photography, and he says that until the mid-seventies, he maintained at least the illusion that he did see everything photographic there was to see on the East Coast.

Coleman entered photographic criticism in John Szarkowski's neighborhood when Szarkowski was at the height of his power. But rather than following the development of Szarkowski's theory, Coleman decided almost immediately that Szarkowski stood for an impossibly narrow purism, a hermetic formalism, and an arrogant curatorial style. There was a moment when Coleman might have tolerated Szarkowski because of the balancing presence at MOMA of Peter Bunnell. In his brief tenure as Curator of Photography from 1966 to 1972, Bunnell had mounted *Photography as Printmaking* (1968) and *Photography into Sculpture* (1970). But when he left for Princeton, the most visible photography exhibition program in the country came under the thumb of Szarkowski alone whose curatorial policy was self-consciously "autocratic, elitist, and . . . limited by the curator's own ideas and taste patterns, the narrower the better."[3]

Coleman thought Szarkowski focused narrowly on the documentary tradition and its ramifications, showing little interest in synthetic techniques or in any kind of work that demands a visceral rather than an intellectual response. As he indicated in his criticism of *Atget's Trees,* Coleman thought Szarkowski's formalism could drain the vitality from anything he touched. Indeed, Szarkowski forced everything he touched into conformity with his vision. When he exhibited *New Japanese Photography* in 1974, said Coleman, it just happened to look like everything else exhibited at MOMA for the previous ten years, despite the evidence in magazines, books, and published portfolios that the Japanese were doing quite a bit else.[4]

Coleman felt that Szarkowski's formalism was socially insensitive. The pursuit of formal invention above all else denies the significance of the source of a work of art, and Coleman believed in postmodernist fashion that an artwork's source is and should be a significant factor in how it is treated. He thought it important to make a deliberate effort to look at the artistic expressions of those who have been ignored by the dominant culture, because such expressions will enlarge the society's knowledge of itself. Coleman took up

this issue with regard to African American photographers and particularly Roy DeCarava, whose art expresses a specifically black awareness and whom Coleman considered to be one of the premier photographers of the time.[5] That DeCarava was not on the cutting edge of formal invention—a reason for Szarkowski to discount him as old-fashioned—was irrelevant to Coleman; DeCarava had something important to show us.

MOMA, Coleman noted in 1970, had not only slighted DeCarava but also never given a one-person show to any nonwhite photographer. The museum had given a one-man show to Bruce Davidson, a white photographer, for his photographs of East 100th Street in Harlem. To give a black photographer the same attention, Coleman acknowledged, might seem forced and politically motivated, but it was still imperative to do so. This was not simply a matter of fairness in Coleman's eyes, but a necessity if even Davidson's images were to be understood by their predominantly white audience. Until we see photographs of black experience made by black photographers, "all photographs of non-whites made by whites . . . will be suspect, for we ourselves, as audience, will continue to lack the knowledge and understanding necessary to gauge their true merits and flaws. Thus we are not only deprived of the view from one side, but are in fact being cheated out of both."[6]

Part of what made Coleman so impatient over the political implications of MOMA's curatorial policy was that they remained unacknowledged. As far as he was concerned, political motivations are inescapably present in virtually any curatorial policy, any photographs, and any criticism. Photographers, he said, clung to the idea that what is visual cannot be political, but he countered in his review of Davidson's *East 100th Street* that the political and the aesthetic cannot be divorced:

> Yet, at the risk of being accused as I often am of "injecting politics into aesthetic criticism" (conjuring up images of myself as a mad doctor out of a Terry Southern novel, poised above the typewriter, cackling maniacally and wielding a gigantic hypodermic), I must make clear my belief that "East 100th Street" cannot, by its very nature, be discussed as though its aesthetic import were completely divorced from its "political" significance, for the two are very much intertwined—inseparably so, in fact.[7]

What made this so in the case of Davidson's work, of course, was that Davidson was a white man recording a white man's view of black inner-city life in a culture in which race and class are politically charged issues.

The inescapably political nature of photography is a theme that appears repeatedly in Coleman's writing. On several occasions he made his case by noting that censorship politicized even photographs with no overtly political content.[8] And in one essay, he argued that simply to become an artist in a society as corrupt as ours is a revolutionary act because it lets loose an "anarchic impulse," an impulse easily absorbed in a healthy society but one that threatens the status quo in ours.[9] This seems an uncharacteristically naive and romantic statement for Coleman. He apparently failed to consider that art might serve the status quo or the forces of oppression as easily as it might embody a healthy anarchy.

A more considered formulation of the necessarily political nature of photography arises from Coleman's sense of how deeply enmeshed the medium is in all aspects of contemporary culture. He defined the photographic community as including everyone who deals with photography on a regular basis, and thus he defined the entire culture as a photographic community. This community is an organism, he said, that is "engaged in nothing less than the creation/ingestion/digestion/excretion/re-creation of as much of interior and exterior reality as it can gulp down."[10] This organism is entirely dependent on photography. If all traces of photography were to disappear over night, the society would be paralyzed.[11] Even our sense of self and our location in the social fabric is dependent on photography as we demonstrate by the determination with which we preserve family snapshots and grieve at their destruction. A cardinal rule in brainwashing, Coleman pointed out, is to remove from the victim all photographs of familiar people.[12]

It was Coleman's own dawning comprehension of photography from what he described as a McLuhanesque point of view that drove him to study the medium in the first place. He had come to think of photography as a force which "shaped me, my culture, my world, and my understanding of all three," and he had recognized his ignorance of this force and hence his powerlessness in the face of it.[13] Coleman wrote repeatedly that photography is an inherently democratic medium because everyone has access to it, and yet, he said, the public is so terribly casual about its efforts to understand photography. The public has the tremendous power of photography within its grasp, yet most people remain, in Moholy-Nagy's terms, photographically illiterate and vulnerable to manipulation by the photographic media.

Coleman often addressed his observations about the vast influence of photography on culture to academic audiences because the academy is the institution best equipped to take on photography whole and because it has

consistently failed to do so, championing photography as an art while generally ignoring the medium's larger implications. Coleman did not oppose the teaching of photography as art, but he was distressed that only art photography is taught in the university, and he called for a much broader agenda for photographic education.

Even in its teaching of photography as art, the academy perturbed Coleman. The very nature of an academy, he said, is to establish and propagate standards, but standards are necessarily set so as to be achievable, and once set, they tend to become static. In other words, academic standards promote a level of mediocrity and conventionality. But creativity, he argued, depends not on standards and convention but on a degree of anarchy, risk, and accident.[14]

Furthermore, the academy produces photographers who know only how to make their own art and how to teach others to do the same. The photography boom of the late sixties and early seventies had quickly produced an oversupply of such people. Coleman saw something dishonest in continuing to train students for a career that was becoming increasingly constricted. He thought the academy should face this problem directly if it was going to continue to train artists. Art students should be warned about the limitations of their career; they should be trained in ancillary skills necessary for artist-photographers, such as book and exhibit design; and they should be encouraged to get training for some other means of support outside of art. Or students ought to be trained to use photography in conjunction with some other academic discipline such as history, sociology, psychology.[15]

True to his own commitment to the whole of photography, Coleman made it a point to review a number of exhibitions that presented photographs outside the context of high art, often as history and often in a vernacular form. In 1970 he reviewed an exhibit on Hiroshima and Nagasaki. It was an exhibit of ordinary news photographs, said Coleman, pictures that dozens of competent journalists might have made, not at all special in any stylistic or technical sense. Yet the pictures had tremendous power for him precisely because they were photographic documents of an inherently horrifying event. Certainly Coleman was sensitive to the constructed nature of the documentary vision. He wrote more than once of how photographs lie but are nevertheless "the most factual fictions, the most credible prevarications" we have.[16] But in the face of the unassuming documents of nuclear devastation, the reality of the images dominated Coleman's attention. He saw in these pictures a warning for the present. Similarly, Coleman admired Jan van Raay's photographs of the demonstrations, meetings, and petition drives of artist-

activists in the early seventies. Once again, these pictures were utterly ordinary in their style, but valuable as "a vital record of what is almost certainly a major transitional stage in art history."[17]

The practitioner whom Coleman most admired for his use of photographs as historical documents was Michael Lesy. Coleman reviewed *Wisconsin Death Trip* (1973) and *Real Life* (1977). In these books, Lesy used photographs, newspaper clippings, court records, transcriptions of interviews, police files, and the files of mental institutions to tell a tale of violence, alcoholism, racism, sexism, insanity, greed, and corruption in the daily life of the 1890s and 1920s. He demonstrated, said Coleman, that these social ills were so commonplace as to be taken for granted. Lesy's history, he thought, was a history of truisms, but tremendously valuable because it brought to life part of the texture of the past. This undertaking was different from the construction of traditional history, said Coleman, because traditional history is coherent and linear. Traditional history generalizes, whereas Lesy's work particularized. The latter told no story and proved no theory, but it reconstructed the feel of past experience.

Whether dealing with photography as art or as history, Coleman always attended to the question of what makes a photographic vision socially potent. His taste certainly did not run to agitprop, but he firmly believed that socially concerned photography could be efficacious if it embodied the right qualities. He thought that mass-circulation magazines might have had that effectiveness once but had lost it. In 1972 when *Life* magazine collapsed, Coleman was actually relieved. In his opinion, *Life* had ceased to serve as an outlet for vital photojournalism sometime around 1960, and since then it had been nothing more than "a complacent house organ for the middle and upper management of corporate America."[18]

The mainstream photojournalism that continued after the death of the picture magazines was ineffectual for a different reason. This work, Coleman said, was hampered by a false objectivity and a lack of imagination about how to engage social issues. Most photojournalists repeated a formula that stood for objective reporting, consisting of images of the victims of oppression or images of confrontation, for example, demonstrations in the streets. Such imagery, thought Coleman, aroused sympathy for victims or rigidified one's anger at political opponents but did not lead to action or suggest solutions to problems. What Coleman wished to see were photographers who rejected any notion of objectivity in favor of commitment, who photographed the perpetrators of injustice as well as its victims, and who concentrated not so much on the helplessness of

victims as on the ways they had found to struggle against injustice. The work that engaged its subjects on these levels Coleman called "tools for change."

Coleman saw a body of such work emerging in what he named the new photojournalism: "extended, probing explorations of cultural microcosms."[19] This new work appeared often in books, a form that freed photographers from the meddlesome interventions of a magazine's editorial hierarchy and allowed them to tell the truth, as they saw it, with maximum autonomy and at maximum length. Coleman acknowledged that the control photographers gained by turning from magazines to books was partly offset by the fact that books have a much smaller circulation than magazines, but he pointed out that the broad extent of magazine exposure was, in turn, offset by its ephemerality. Books last much longer than magazines. One particularly successful example of the new photojournalism, in Coleman's assessment, was Michael Abramson's *Palante: Young Lords Party* (1971), an account of the radical Puerto Rican political party active at the end of the sixties and the beginning of the seventies.[20] Abramson's work succeeded because he rejected any notion of objectivity in favor of intimacy and partisanship. He also concentrated on the work of activists who refused to be victimized.

Coleman drew a clear distinction between formulaic, mainstream photojournalism, committed to telling both sides of a story, and partisan photojournalism committed to change. But whether this distinction truly defines the difference between photography that merely arouses the viewer's sympathy and anger, and photography that stimulates the viewer to action is not so clear. The question of which photographs move whom to what action seems almost impossibly complex to answer definitively. If such questions are to be answered at all, the answers will have to come from exacting and subtle empirical investigation. What Coleman described as a tool of change was, in fact, photography that fit his concept of the best posture for social commitment.

Coleman's sense of social commitment was not overly narrow; he admired but was not fixated on socially instrumental photography. In the absence of photographic calls to action, he praised photojournalism that promoted understanding across the boundaries of cultural microcosms. For example, Geoff Winningham's book on professional wrestling in Texas, *Friday Night in the Coliseum* (1971), struck Coleman as being open to its subject and without condescension or stereotypes. Winningham treated his topic thoroughly and with specificity. All in all, he produced a humanizing bridge between one segment of the culture and anyone "open enough to cross it."[21]

The matter of specificity is of particular importance here. This quality and a sense of immediacy were the two things Coleman most valued in photojournalism. Both Abramson and Winningham succeeded because they maximized these qualities in their work. Neither photographer formularized his subjects, set them at a distance, or treated them primarily as symbols. Photojournalism that universalized its subject through generalization or that undermined the immediacy of its subject through aestheticization, Coleman deemed a failure. These were precisely the shortcomings he saw in Danny Lyon's book on Texas prison life, *Conversations with the Dead* (1971), and Bruce Davidson's *East 100th Street*. Lyon never confronted the issues of brutality, homosexuality, and racial segregation in prison and thereby failed to come to grips with the reality of his subject. In Coleman's opinion, the book neither arouses its viewers nor illuminates its subject, but turns that subject into art through a kind of bland aestheticization.[22] Davidson also fails because he turns his subject into art. In Davidson's hands, even the most rat-infested garbage heap becomes an exquisite photograph, and as a beautiful object, it transcends the subject it is meant to reveal.[23]

Coleman's emphasis on specificity over universality is at odds with modernist criticism. Modernist critics traditionally praised photographs that transcended the specific, that spoke not of a particular family, for example, but of all families. The mark of universality is what made the difference between an ephemeral bit of photographic news and a lasting work of art. Coleman, however, saw universality as destructive of the photograph's capacity to enlighten or to move one to action. He did not always reject symbolic or generalized implications in photographs, but he thought the best way to reach the general was to perceive specificities clearly, not to blur them.

Coleman did not reject every artistic vision on the grounds that it necessarily loses touch with reality through aestheticization and universalization. Without worrying the exact nature of the distinction between journalism and art, he praised artists whose work he saw as sufficiently specific. In one essay, he explained how DeCarava's photographs are responsive to the nuances of the moment, in a way which parallels the improvisational nature of jazz, and that this responsiveness makes his people distinct individuals, not "specimens, symbols, or social phenomena." The pictures are filled with "love, soul, and compassion."[24] In another essay, Coleman praised Judy Dater's portraits of women not for revealing a general feminine sensibility but for making acute renditions of women as individuals.[25] Writing of Manuel Alvarez Bravo, he said,

But the work is free of slogans and generalities. Viewers of photographs may tend to generalize from them—sometimes at the photographer's instigation, often independently, and always at their own risk. But one of photography's unique functions is to describe particulars. That aspect of the medium is essential to Alvarez Bravo, for he uses photography as a probe, an incisive tool for uncovering the heart of a culture embodied in the individual people who form its base.[26]

In his emphasis on the specific, Coleman is consistent with that strain of postmodernist criticism inspired by Marxism, but his position is not entirely congruent with postmodernism. Many postmodernist critics, in their effort to articulate the political implications of images, find it necessary to equate the specific with language. Only that which can be said is precise enough. Photographs by themselves, without the interpretation of words, are too ambiguous to explain a specific political circumstance. These critics are uninterested in the purely visual or the preverbal meanings of pictures. Coleman did not go this far. He retained his commitment to photography in its entirety and refused to sacrifice an appreciation for its purely visual qualities to his political impulses. Consequently, he could admire Uelsmann's art for its irrationality. He could describe this work as not to be "'understood' in any cognitive sense" because the photographs "have no literal meaning, make no narrative sense, cannot be defined."[27] Similarly he wrote of Les Krims's photographs that they "very rarely made 'sense' to me; they are difficult to describe because their subject matter is usually their own precise absurdity."[28] By preserving an appreciation for the nonverbal meanings of photography, Coleman maintained a reference point in the modernist critical position even as he reached out to define a postmodernist position that addresses the work of art in the context of its specific historical moment.

Coleman straddled modernism and postmodernism in another important respect. In postmodernist fashion he celebrated the fall of aesthetic boundaries erected by modernism. He attempted to broaden the consideration of photography beyond the boundaries of art, and within the artistic tradition, he applauded the dissolution of boundaries that had separated one image from another, one medium from another, and the photographer from his or her subject. Nevertheless, unlike many postmodernists, he continued to respect the tradition of art photography that had been established in the modernist context.

Reviewing *Photography into Sculpture* in 1970, he characterized the melting of boundaries between media as a needed redefinition of art that

would eliminate intermedia competition and bigotry.[29] Further attacking photographic purism in 1971, he praised Jerry Uelsmann and his "impure" combinatory printing technique. Uelsmann's success, Coleman said, rested on his recognition that the failure of Henry Peach Robinson and Oscar Gustave Rejlander (the most famous and most belittled combination printers of the nineteenth century) lay in their hackneyed aesthetic sensibilities, not in their technique.[30] Uelsmann's more compelling sensibility had legitimized the technique.

In a different kind of repudiation of purism, Coleman praised photographers, such as Duane Michals and Ralph Gibson, who rejected the notion of the photograph as a single masterwork, choosing instead to work in sequential imagery and book form.[31] In 1976 Coleman defined an alternative to purism in an important essay on the directorial mode in photography, a term he used to refer to all the various ways of deliberately impinging on or arranging the world in order to photograph it.[32] Directorial practices violate what Coleman saw as the self-righteous principle of straight photography that prohibits interaction between photographer and subject.

Coleman was also pleased to see the boundary between the traditional art world and photography crumble even more than it had in the past as photographs began to attain a more important place in the work of artists not trained as photographers. In an essay of 1974, "'From Today, Painting Is Dead': A Requiem," he briefly traced the entry of photography into works of art, from Dada collages of the 1910s and Bauhaus graphics of the twenties, to the collages of Robert Rauschenberg and Romare Bearden of the fifties and sixties, to the use of photographs in the sixties and seventies to document ephemeral or inaccessible art.[33]

But the incorporation of photography into the art tradition produced some serious problems in Coleman's eyes. He recognized that many contemporary artists were making inaccessible or ephemeral art because they did not want their work to be treated with the precious commodity status of more traditional art. They did not want to feed the elitist gallery and museum system or produce trinkets or investments for the wealthy. But when these artists documented their art with photographs, the photographs themselves became by proxy, works of art. As permanent records of art, the photographs attained value in the galleries, museums, and the hands of collectors. Coleman thought most artists were not facing up to the reality of this process. They were having it both ways, claiming to make art that could not be commodified and happily selling the documentation of this art. Coleman concluded that he "would look askance at photographs documenting works by any artist claiming to be in total revolt against muse-

um/gallery/critic-imposed attitudes concerning permanence, financial value, and object fetishism."[34]

Another problem Coleman identified had to do with a lingering elitist attitude in the art world toward photography. Some writers, he noted, continued to maintain a distinction—based on little more than the fact that "art" sells for more than "photography"—between photographs as art world art and photographs as photographic art. The most significant consequence of this distinction was that those who wrote about photographs in the art world remained almost entirely ignorant of the history of photography, capable of appreciating little else beyond the work of a few masters such as Strand, Weston, and Adams. The ignorance of the critics infected their audience and the (art world) artists, leading the latter unknowingly to produce derivative work, which they blissfully passed off as innovative. From Coleman's perspective, the entire situation of false distinctions and arrogant ignorance was nothing less than ludicrous. As he put it, "Many contemporary artists appear to believe that photography is a virgin territory without a history (beyond Westonism, at least), free from relevant precedents and prior accomplishments: a brand new field of ideas which have not even been touched on by the medium's own practitioners, in which any small step breaks new ground."[35]

Other writers, more firmly in the postmodernist camp than Coleman, have been content to jettison the entire photographic tradition which Coleman regarded as still having the capacity to inform contemporary art. They have not seen the possibility for continuity between modernism and postmodernism that Coleman saw, defining postmodernism as a complete break with the past.

Susan Sontag
Susan Sontag's seven articles on photography—first published in the *New York Review of Books* from 1973 to 1977 and republished in book form in 1977—may be seen as the first full-blown American statement of postmodernist photographic theory. Her book, *On Photography,* rocked the photographic community. Here was a respected intellectual finally paying close attention to a medium whose advocates had been yearning for such attention, but she seemed to ignore or discount everything serious photographers held dear. In fact, she denied the very basis on which photography had been established as art, the capacity of photographers to go beyond the mere recording of reality to a level of personal expression. In comparison to the literal subject of a photograph, she said, issues of style, perception, and form are always secondary.

Even as she acknowledged photography as being worthy of critical attention, she belittled it in comparison to writing. In literature "one has the right to, may feel compelled to, give voice to one's own pain—which is, in any case, one's own property." The photographer, however, can only be a parasite who "volunteers to seek out the pain of others."[36] No wonder defenders of the medium concluded, as Gene Thornton did, that Sontag "has not been sufficiently interested in photography to find out what it is" or as Henry Holmes Smith did, in more pungent terms, that "Sontag behaves in the manner of a stubborn anatomist who, having decided that the human male is a triped, spends a lifetime seeking confirmation by attempting to establish there are toenails on the penis."[37]

Instead of aesthetic issues, Sontag was concerned with how photography functions in a social context and how it mediates our experience of reality. She wrote with a strong political consciousness unfamiliar to art photographers who had largely remained politically aloof during the turbulent sixties. As Jonathan Green has pointed out, Sontag was part of the revival of Marxist criticism that emerged in the antiwar counterculture of the seventies among a generation too young to have been cowed by McCarthyism.[38]

In part of her critique, Sontag described photography as a tool of capitalism and social control. Photographs are used to stoke the engines of consumption by stimulating desires with alluring imagery. They also stimulate the endless consumption of images that serve to entertain people and distract them from the inequalities of class, race, and gender. At the same time, photography serves as a tool of information gathering, surveillance, and the maintenance of power. Ultimately, says Sontag, the production of images not only serves the ruling ideology but also creates a ruling ideology. Social change itself is replaced by a change of images.[39]

Another major aspect of Sontag's critique is her argument that photographs have no stable meaning and, therefore, contribute to a general erosion of the very concept of meaning.[40] First, Sontag argued that photographs cannot explain anything by themselves. To photograph something is apparently to appropriate it and to gain knowledge of it, but Sontag said, this is only an illusion. "Strictly speaking, one never understands anything from a photograph."[41] Understanding is based on how things function, and functioning is only explained in time. Because photographs are not narrative, they cannot serve understanding. Sontag sounds much like Szarkowski in her emphasis on the non-narrative nature of photographs, but unlike Szarkowski, who celebrated the purely visual nature of photographs, Sontag sees this quality as worthy of attention only for its perniciousness.[42] By giving the illusion of capturing the world and making available the

experience and knowledge of it, photographs satisfy without nourishing. "By furnishing this already crowded world with a duplicate one of images, photography makes us feel that the world is more available than it really is."[43] Photographs substitute a world of illusory experience and knowledge for substance.

Sontag goes on to say that photographs are not only unable to explain things, as language does, but also lack inherent and stable aesthetic qualities of the kind paintings have, which would allow one to make critical distinctions among them. There is no true style in photography as there is in painting, she says. Style might arise from formal treatment, but it does not. There are formal differences among photographs and formal innovations in photography, Sontag admits, but these do not serve as a basis for style partly because form is invariably overwhelmed by subject matter. Paintings are very much a product of a painter's intentions, but photographs respond very little to the intentions of their makers. The subject remains dominant in any photograph, whatever the photographer's intent and however the photographer attempts to overcome it through formal treatment.

In addition, formal innovation in photography has no grounding in individuality in the way the formal innovations and idiosyncracies in painting are grounded in the individuality of the painter. Formal innovations in photography are easy to repeat after one has seen them just once, and innovations may even be discovered by accident rather than through a thorough knowledge of what has come before or a profound act of imagination. Given no style in photography, there can be no distinction between art photography and other kinds of photography. A naive snapshot may be as visually exciting as the work of a renowned artist. Any photograph may be a work of art; criticism is essentially arbitrary; and taste is necessarily eclectic.[44]

Insofar as photographs have meaning as art or history, or in any other way, they gain it through context. But this is a slippery and unsatisfactory state of affairs. A photograph of a politically charged event may initially carry the meaning bestowed on it by the context of its making, but in time this initial historical context fades, and the photograph retains only a "generalized pathos of time past"; it acquires an aesthetic distance from history and becomes art.[45] One may attempt to nail down the meaning of photographs with language, but this is only a temporary remedy. Captions change, the context of display changes, the times change. In the end, photographs have no fixed meaning; they float free of any anchor in discourse, offering endless possibilities for speculation.

Photographs blanket the world and have even created a substitute world of images. For Sontag, this is a dangerous world. Standing alone,

photographs promise an understanding they cannot deliver. In the company of words, they take on meaning, but they slough off one meaning and take on another with alarming ease. Ultimately they resist any meaning attached to them by discourse. All this, Sontag sees as a serious threat to our capacity for reasoned action, our sense of reality, and the very notion of meaning itself.

Allan Sekula

Another theorist and critic who responded to many of the same ideas as Sontag, but with somewhat less pessimism, is Allan Sekula. Sekula agrees with Sontag that photographs acquire meaning as part of a discourse. Taken as purely visual objects, they have only the potential for meaning, but in association with a text (not necessarily a written text, but a set of "linguistic propositions"), photographs do become meaningful. But Sekula says, in much the same manner as Sontag, "Any given photograph is conceivably open to appropriation by a range of 'texts,' each new discourse situation generating its own set of messages."[46] Unlike Sontag, however, Sekula thinks it is possible to anchor a photograph in history, to define the original historical context in which the photograph was made, and thereby attach to it a meaning that arises from the intentions with which it was made.

Sekula is particularly interested in applying his historical method of interpretation to the discourse of art photography, especially as it was developed in *Camera Work* and later taken up in *Aperture,* because this discourse served as a primary source of misunderstanding about photographic meaning. This discourse of art denied its own existence and denied that photographic meaning is a product of discourse, asserting instead that meaning is inherent in the photographic image. But the assertion that meaning is inherent in an image, according to Sekula, was in itself an essential part of the discourse of art photography. In other words, discourse was still operative in art photography, still creating meaning for art photographs, but the process was camouflaged and essentially covert.

Sekula is not simply making a theoretical point by uncovering the discourse of art photography; he sees some serious social consequences in this discourse and its covert nature. In short, he sees art photography as an attempt to transcend social reality. As such, it is an endorsement of the social status quo.

The effort at transcendence takes at least two forms. First, it is embodied in the very concept that meaning is inherent in photographs and not a product of discourse. Discourse is inescapably social. Sekula defines it as necessarily rhetorical and tendentious, as always invested with interest,

and never neutral.[47] It is imbued with the push and pull of the social world. To insist that meaning is stable, universal, and inherent in photographs is to remove the creation of meaning from the processes of social interaction.

Second, in Stieglitz's and White's hands, the discourse of art encouraged viewers to see photographs as abstractions, metaphors, equivalents, and to overlook the representational qualities of photographs. A photograph perceived as representational is more easily connected to the world of social relations than one perceived as abstract. In emphasizing abstraction, art discourse attempted to pry photography away from social realities in the very perception of images. Sekula discusses this process with regard to Stieglitz's photograph *The Steerage,* a picture that when seen as representational speaks of class hierarchy as it is manifested in the organization of a ship. But Stieglitz presented this photograph as an image dealing with geometric shapes and feelings.[48] In sum, says Sekula, the discourse of art offers an imaginary transcendence to viewers, which may distract them momentarily from their "knowledge of the fragmentation, boredom, and routinization of labor, knowledge of the self as commodity."[49]

As an alternative to the aesthetic discourse in photography, Sekula describes an art with its own built-in, self-conscious, social discourse. Artists involved in this kind of work refuse to treat photographs as privileged objects, treating them instead as "common cultural artifacts." They are well aware that photographs may convey many different messages, depending on the context in which they are presented, and they acknowledge this in their art by creating the context for it. They rely heavily on written or spoken language; they may "openly bracket their photographs with language, using texts to anchor, contradict, reinforce, subvert, complement, particularize, or go beyond the meanings offered by the images themselves." They often exhibit their photographs in a context outside the existing art world, a context that aims toward a wide audience, and toward considerations of "concrete social transformation." Documentary photography, says Sekula, has "contributed much to spectacle, to retinal excitation, to voyeurism, to terror, envy and nostalgia, and only a little to the critical understanding of the social world."[50] He wants to see a documentary art that combines photographs and discourse in such a way that this situation will be remedied. Like many before him, Sekula yearns for a political art capable of effecting change, an art that leaps the bounds of the art world, overcomes the division between art and life, and moves people to action.

As admirable as Sekula's vision of a politically efficacious art may be, it reveals a deep-seated uneasiness with photography as he understands it. Sekula understands photographs, by their very nature, to have no fixed

meanings, but he wants to see an art that establishes its meaning in no uncertain terms. At the very least, he wants to see this art establish an unmistakably critical stance toward capitalist culture. Sekula is critical of the modernist art discourse for failing to acknowledge that the meanings of photographs are contextual, but having acknowledged this condition himself, he wants to overcome it. Unlike Sontag, who was convinced that even photographs of powerful political impact eventually drift into a benign aestheticism, Sekula is convinced that language can be used to bludgeon photography into submission, fixing a political meaning to it that cannot be pried off.

There is an ironic relationship between Sekula's theory of photographic art and that of the Pictorialists: both theories work against the essential nature of photography as the theorists understand it. Just as the Pictorialists understood photography to be essentially objective and struggled to make it subjective, Sekula understands photography to be indeterminate and struggles to give it determinacy. He is suspicious of the visual nature of photography and the values offered by its visual qualities, such as beauty, a full range of unarticulated feeling, free association.

Douglas Crimp and Abigail Solomon-Godeau

To understand the full shape of postmodernist theory as it began to emerge in the early eighties, one must look briefly at Douglas Crimp and Abigail Solomon-Godeau, two writers motivated by poststructuralism who articulated the theory of appropriation as it applies to work by artists such as Sherrie Levine, Richard Prince, Barbara Kruger, and Vikky Alexander. For Solomon-Godeau and Crimp, appropriation is the quintessential postmodernist activity.

According to its theorists, appropriation is a challenge to central modernist values. It challenges the value of creativity by refusing to create more images in a world already cluttered with imagery. It is a suggestion that we already have all the images we need to say whatever we wish. In fact, it is not only unnecessary to create more images, it is actually impossible to do so. All we can do is rearrange the images we already have in endless combinations. Appropriation is a recognition of the fact that all experience and even the subjective self are mediated by preexisting imagery, and it is meant to challenge the central modernist assumptions that artworks can be original and that they are the product of the independent and subjective vision of an artist.

We and our creations are necessarily quotations, and appropriation calls attention to this condition by openly taking someone else's image to

make a work of art. In addition, by drawing attention to the nature of imagery in general and not just high art images, by freely using imagery that originates in the mass media, and by using it *as* mass media imagery, appropriation challenges the modernist distinction between high art and low art. By drawing attention to the way imagery functions rather than the way individual images are put together, appropriation challenges the centrality of formal analysis in modernism. By asserting that all imagery is quotation and, therefore, that meaning arises from quotation, from the relationship of one image to other images, and by taking an image from one context and using it in a different context where it acquires a different meaning, appropriation undermines the modernist assumption that the meaning of an image is inherent and asserts the contingency of meaning.

Appropriationists see photography as perfectly suited, by its very nature, to their theory and practice. Photography has created the conditions that make appropriation necessary; it has duplicated the world and created a surrogate world of images.[51] In so doing, photography has demonstrated that our experience is mediated through imagery, that we cannot experience the world directly or make original images of it. In addition, photography is ubiquitous at all levels of culture, and therefore ties these levels together across artificial boundaries, such as the one between high art and popular culture. Furthermore, photography itself is necessarily a form of appropriation. It is, by nature, a way of *taking* pictures, of appropriating appearances. And photography is an inherently multiple and multiplying process; it copies and multiplies everything including other works of art. In this respect, it renders irrelevant the fixation on unique art objects.

For Solomon-Godeau, that deliberate appropriation first arose and spread in the art world and not in the photographic community is an important historical point.[52] Artists, not photographers, were aware of how Rauschenberg and Warhol had used photography and began to use it themselves to investigate the implications of conceptual art and to document their ephemeral or inaccessible works. Appropriation came out of this background, and not the photographic tradition that extends back through Frank, White, Adams, Weston, and Stieglitz. Traditional art photography, says Solomon-Godeau, remained virtually oblivious to the groundswell of postmodernist thought. As a result, the photographic mainstream hit a cul-de-sac of academicism and exhaustion. For her, appropriation is not a new development in the photographic tradition, but a critique of that tradition arising entirely outside it.

It is ironic that Solomon-Godeau hails appropriation as an escape from "the conceptual cul-de-sac that contemporary art photography represents,"

an escape from the "general state of exhaustion, academicism and repetition evident in so much art photography."[53] She sees appropriation—the art of quotation and repetition, the art that demonstrates that nothing can be new—as a refreshing, new idea.

But novelty is not the main attraction of appropriation. Both Solomon-Godeau and Crimp see in it an element of social critique and a democratizing value. In making their case for these qualities, both theorists have been careful to acknowledge that not all appropriationist art necessarily takes a critical stance. Appropriationist practices are manifested in many forms, and serve different agendas. Crimp wrote:

> For appropriation, pastiche, quotation—these methods can now be seen to extend to virtually every aspect of our culture, from the most cynically calculated products of the fashion and entertainment industries to the most committed critical activities of artists, from the most clearly retrograde works (Michael Graves' buildings, Hans Jurgen Syberberg's films, Robert Mapplethorpe's photographs, David Salle's paintings) to the most seemingly progressive practices (Frank Gehry's architecture, Jean-Marie Straub and Danièle Huillet's cinema, Sherrie Levine's photography, Roland Barthes' texts).[54]

Crimp distinguished between regressive and progressive appropriation, using Mapplethorpe and Levine as examples. Mapplethorpe, he said, borrowed from Weston, from the stylized studio photography of George Platt Lynes, and from the prewar fashion photography of *Vanity Fair* and *Vogue*. Most important, Mapplethorpe synthesized his sources into his own style and thus assimilated and perpetuated their values. Levine, by contrast, appropriated whole photographs by Edward Weston. She simply rephotographed a Weston—the famous portrait of his young son Neil's nude torso, for example—and presented the copy as her work of art without any effort to change the Weston or synthesize it with other sources of imagery. By so doing, Crimp said, Levine bypasses the meanings of Weston's image to reveal the meanings of appropriation. Specifically, she reveals that there is no original Weston, that she has appropriated her image no more than Weston has appropriated his.

Solomon-Godeau has taken up this issue at length.[55] She points out that there are many prints from Weston's negative of Neil, and because they all come from the same source, no single one can be considered the original. She does acknowledge that there is a single negative but does not

address its status as an original. Ansel Adams said that a negative is like a musical score and the prints from it, like performances, an idea that suggests that the negative is both an original object and the bearer of an original image. Solomon-Godeau says nothing about Adams's idea, but she does object to the idea that Weston's image might be original—the image in distinction to any print that might bear that image—on the grounds that Weston could not have created the image without knowledge of classical Greek sculpture. Weston appropriated his image from another source. Neither Crimp nor Solomon-Godeau make a distinction between the degree to which Weston appropriated from Greek sculpture and the degree to which Levine appropriated from Weston. Instead, Solomon-Godeau goes on to pursue the issue of originality beyond the photographic image to its literal source in Neil's body. This is not the original either, she says, because the original we are after is Weston's original work of art, and Neil is not a work of art. She concludes that the Weston photograph has no original, that originality may be pursued unsuccessfully through an endless chain of quotations and associations.

For the appropriationist theorists, the value achieved by this futile pursuit of originality is a democratization of art and expression in general. Everyone is leveled in the field of expression when it is revealed that the idea of authorship is false, that the apparently special insight or privileged subjectivity of an artist is not special or privileged after all but a rehash or re-presentation of what has already been a part of the culture in a public form for a long time. In particular, Solomon-Godeau sees the destruction of authorship as a blow against patriarchal hierarchy. Also, in its blatant illegality—something the appropriationist theorists do not blink at— Levine's theft is a blow against the concept of property and, presumably, a blow for socialism.[56]

Finally, there is meant to be a democratizing element in appropriation; it cleanses from the art object the aura of authenticity that gives it its preciousness. Crimp refers to Walter Benjamin's concept of the aura as having to do with the sense of presence in an original object.[57] By demonstrating that Weston's photograph is not original, appropriation strips away the aura and the preciousness of that work of art. The same may be done with a painting by appropriating it photographically, and indeed Levine has photographed paintings. The intended result, when appropriation has stripped the aura of uniqueness and authenticity from works of art, is the collapse of the art museum conceived of in elitist terms as a vault for precious objects.

There are some problems with the appropriationist argument up to this

point. To begin with, the theory says that Levine's act of appropriation undermines the concept of authorship by invoking Roland Barthes's idea of the death of the author. But this is not actually the case. Barthes attempted to dissolve authorship by explaining all writing in terms of quotation rather than creation. He suggested a paradigmatic shift in the understanding of the relation of the self to language and to culture, which would render the concept of authorship irrelevant. But far from rendering authorship irrelevant, appropriation reinforces it by attacking it frontally. How can one appropriate a Weston without necessarily acknowledging that Weston is the author of the image one is appropriating? Just as theft is dependent on property, appropriation is dependent on authorship. Theft does not destroy the concept of property, but merely affronts it; appropriation does not dissolve the concept of authorship, but merely serves as a gesture of anger and disrespect toward it.

Second, just as Solomon-Godeau treats the idea of appropriation as new and original, thus contradicting its intended thrust, Crimp and Solomon-Godeau treat Levine as an insightful, special, and original artist. But, of course, her art is meant to deny originality, insight, and specialness. And interpreting the introduction of appropriationist art into the museum as a threat to the museum's elitism, seriously underestimates this institution's capacity to absorb the most hostile artistic gestures, something it has done successfully from Dada onward. Benjamin and his followers have considered it perverse to attach an aura of authenticity to photographs when photographs are inherently multiple objects, but this has not stopped the creation of such an aura for photographs or even for Sherrie Levine's appropriated photographs, which are specifically meant to undermine the sense of aura. When one sees a Levine hanging in a museum where there are uniformed guards and an elaborate electronic security system, one cannot help but feel a presence, a preciousness, a celebration of the authentic Levine, in short, an aura.

There is one more socially worthy function claimed for appropriation by its theorists. As Solomon-Godeau says, the artists who practice it "may be seen as continuing that tradition of art-making which views as its mission the unmasking of appearance by revealing its codes." In other words, when an artist such as Richard Prince exhibits rephotographed and enlarged fragments of advertisements, he is showing how the attributes of male and female fashion and sensuousness are not natural but are culturally constructed codes propagated through the media, and he is revealing how we are encouraged to associate these attributes of personal desirability with commodities. Solomon-Godeau says, "Much of the power of Prince's

work derives from his ability to make the concept of the commodity fetish · at once concrete and visible. The hyped-up, almost hallucinatory quality of his details of cigarette ads, expensive watches, shimmering whiskey logos, et al., are made to reveal their own strategies of overdetermination."[58] But Prince has done very little to alter the original advertisements. As Linda Andre has pointed out, advertising pictures, even when cropped, enlarged, and shown in a gallery with Richard Prince's name attached, are still pretty and seductive.[59] They do not necessarily reveal their ideological construction and self-deconstruct. To any viewer not already thoroughly versed in appropriationist theory, they may actually appear to assert rather than critique the societal norms of desirability and commodity fetish.

Of course, it is a basic principle of postmodernist thought that the meaning of a work of art arises from discourse, and appropriation theory is a discourse that tells us which way Richard Prince's images are meant to point. But perhaps this is an example of an idea taken too far. Perhaps this is a good point at which to remember the modernist concern for criticism that is true to the image it addresses. That meaning arises in discourse does not mean that one can sensibly contradict an image through interpretive discourse. An object's visual properties may resist or gainsay certain interpretations; these visual properties cannot be infinitely bent to any critical purpose.

Any subtle theory recognizes limits to its basic principles. It is true that postmodernist thought has revealed the blindness of modernism to the role of discourse in the establishment of meaning in visual art, but having revealed this, postmodernists should not assume that inherent, nonverbal meaning does not exist at all. As an example of the utter dependency of images on language for a meaningful context, Allan Sekula cites the experiments of the anthropologist Melvin Herskovits in which a bush woman was unable to recognize a meaningful image in a snapshot of her son until Herskovits explained what the image was supposed to be. "For this woman," said Sekula, "the photograph is unmarked as a message, is a 'non-message,' until it is framed linguistically by the anthropologist.[60]

But Arthur Danto has cast doubt on the validity of this interpretation of Herskovits's report. He has written on the capacity of animals to understand visual imagery with a high degree of sophistication and without any discourse.[61] And Ellen Dissanayake, in *What Is Art For?* (1988), discusses the work of Howard Gardner who suggests that basic modes of bodily experience in the preverbal infant may be the foundation for aesthetic experience. The oral, anal, and genital zones are the source of an infant's experience of modes of passivity or activity, retention or expulsion, intru-

sion or inclusion, experiences that occur with vectorial properties involving speed, regularity, spatial configuration, facility, and so on. Dissanayake concludes:

> Experience literally comes to us *as* open or closed, expanded or contracted, fast or slow, regular or irregular; and, however this is mentally processed and preserved, it occurs experientially in ways that we are not likely to be able to articulate consciously or precisely after we have learned individual words and particular culturally defined ways of discussing, understanding, or explaining them. Later experiences of nonverbal phenomena, particularly the kinds of devices that are traditionally used in the arts, seem especially akin to the processes and qualities of modes and vectors.[62]

Danto and Dissanayake reveal the continuing value of modernist theory in the postmodern world. Modernism remains a point of view that may serve to balance the assertions of postmodernism. If postmodernism reveals the blindness of modernism to the importance of discourse in the creation of meaning, then a modernist point of view may remind us that nonverbal meanings still exist in art. If postmodernism posits a fragmented, unoriginal self constructed from already given codes and symbols propagated by the mass media, then modernism may serve as a reference point for the inventive, subjective self, which is not only capable of formulating postmodernist theory, but which also refuses to be subdued by media-propagated codes.

If postmodernism seeks to reveal the indefinite nature of meaning in art through the endless multiplicity of interpretation even to the point at which meaning threatens to fragment irrevocably, then modernism may serve as a reminder that the concept of utter fragmentation itself cannot be communicated without the possibility of limitation and coherence. If postmodernists convince us that the pursuit of purity in photographic practice is bigoted and that the concept of a stable essence of photographic technique is untenable, then modernism can remind us that even without an immutable essence and even as it is mixed with other media, photography is a discernable medium with distinctive qualities. If postmodernists insist that the pursuit of the aesthetic and the transcendent are politically irresponsible, then modernism may remind us of our aesthetic and spiritual needs.

The tensions between postmodernism and modernism are the tensions of dualities: unity/fragmentation, interior/exterior, immanent/contingent,

universal/specific, private/public, unique/common. These tensions cannot be resolved; they are inherent in the dualities themselves, and as long as the human mind thinks in dualities, they will be with us. The tensions between postmodernism and modernism are of the same kind as the tension in photography between trace and transformation. The photograph is neither one nor the other, but both.

NOTES

Introduction
1. Greenberg, "The Camera's Glass Eye," 295.
2. Arnheim, "On the Nature of Photography," 159, 160.
3. Snyder and Allen, "Photography, Vision, and Representation," 151.
4. Ward, *The Criticism of Photography As Art,* 1.

Chapter 1
1. Early observers who mentioned the unforeseen possibilities of photography are of some interest. One was Edgar Allan Poe who noted that any new scientific invention will "exceed, by very much, the wildest expectations of the most imaginative." "The Daguerreotype," first published in 1840, reprinted in *Classic Essays on Photography,* ed. Trachtenberg, 38. François Arago made a similar point in his "Report" delivered to the Chamber of Deputies of 1839, also reprinted in *Classic Essays on Photography,* 15–25.
2. Daguerre is quoted by Beaumont Newhall in *The History of Photography* (New York: Museum of Modern Art, 1964), 17. *The Spectator* (London); Philip Hone, mayor of New York; and *Le Moniteur Universel* are all quoted in Rudisill, *Mirror Image,* 38, 42, 53.
3. Robert Taft, *Photography and the American Scene* (1938; reprint, New York: Dover, 1964), 70.
4. Albert Sands Southworth, "The Early History of Photography in the United States," in *Photography: Essays and Images,* ed. Beaumont Newhall (New York: Museum of Modern Art, 1980), 40, 41.
5. Coleman, "The Directorial Mode, Notes toward a Definition," in *Light Readings,* 246–57.
6. The pseudoscience of physiognomy informed much thought about photographic portraiture. For a discussion of this issue see Elizabeth Anne McCauley, *Likenesses: Portrait Photography in Europe, 1850–1870* (Albuquerque: Art Museum/University of New Mexico, 1980).
7. The London *Journal of Commerce* is quoted by Beaumont Newhall in *The History of Photography,* 35.
8. The jury is quoted by Taft in *Photography and the American Scene,* 70.
9. Walter Benjamin, "A Short History of Photography," in *Classic Essays on Photography,* ed. Trachtenberg, 206. Benjamin cites his source only as "an English professional journal."
10. Root, *The Camera and the Pencil,* 25. Emphasis is in the original, here and elsewhere, unless otherwise noted.
11. Ibid., 71.
12. Ibid., 34.
13. Ibid., 87.

14. Agee, in Levitt, *A Way of Seeing*, vi.

15. Delaroche is quoted by Beaumont Newhall and Richard Doty in "The Value of Photography to the Artist, 1839," *Image* 11:6 (June 1962), 26.

16. Gabriel Weisberg, *The Realist Tradition: French Painting and Drawing, 1830–1900* (Bloomington: Indiana University Press, for the Cleveland Museum of Art, 1980), 1. Not all nineteenth-century realists wanted to interpret nature. Eventually the camera's seeming objectivity became a standard for some of them. Charles Herbert Moore, of the New Path painters, said in the 1860s, "The best artist is he who has the clearest lens, and so makes you forget now and then that you are looking through him." Moore is quoted by Arthur C. Danto in *State of the Art* (New York: Prentice Hall, 1987), 86–87.

17. My discussion of effect in photography is based on Crawford, *The Keepers of Light*, 31–34. For further discussion of effect see Albert Boime, *The Academy and French Painting in the Nineteenth Century* (New York: Praeger, 1971).

18. Hill is quoted by Colin Ford in *An Early Victorian Album* (New York: Knopf, 1976), 30.

19. Wey is quoted by Andre Jammes and Eugenia Parry Janis in *The Art of the French Calotype* (Princeton: Princeton University Press, 1983), 4, 97.

20. Sir William Newton, "Upon Photography in an Artistic View, and Its Relation to the Arts," in *Photography: Essays and Images,* ed. Beaumont Newhall, 79.

21. Robinson, *Pictorial Effect in Photography,* 21.

22. Ibid., 191.

23. A good account of Emerson's life appears in Nancy Newhall, *P. H. Emerson.*

24. This essential contradiction in Ruskin's naturalism is pointed out by Solomon Fishman in *The Interpretation of Art* (Berkeley: University of California Press, 1963), 15.

25. Emerson, *Naturalistic Photography,* 27.

26. Ibid., 22.

27. Ibid., 114, 119, 120.

28. Ibid., 184.

29. Root, *The Camera and the Pencil,* 432.

30. This occurrence has been described by John Szarkowski in *Photography Until Now,* 126.

31. For a discussion of Aestheticism and photography see Keller, "The Myth of Art Photography: A Sociological Analysis," 250–52.

32. John Tagg, *The Burden of Representation* (Amherst: University of Massachusetts Press, 1988), 56–58.

33. Clarence B. Moore, "Leading Amateurs in Photography," *Cosmopolitan* 12 (1892): 422.

34. Alfred Stieglitz, "A Plea for Art Photography in America," in Sarah Greenough and Juan Hamilton, *Alfred Stieglitz: Photographs and Writings,* 181.

35. Ibid., 182.

36. Stieglitz, "Pictorial Photography," in *Alfred Stieglitz: Photographs and Writings,* 185–89.

37. Stieglitz, "The Hand Camera—Its Present Importance," in *Alfred Stieglitz: Photographs and Writings,* 182–84.

38. Keller, "The Myth of Art Photography: An Iconographic Analysis," 3.

39. Keller, "The Myth of Art Photography: A Sociological Analysis," 257.

40. A good source of biographical information on Caffin is Underwood, *Charles Caffin: A Voice for Modernism,* 7–13.

41. Caffin, "The Arts and Crafts Movement of To-day: 2," *Harper's Weekly* 43 (4 March 1899): 224.

42. Caffin, "The Arts and Crafts Movement of To-Day: 3," *Harper's Weekly* 43 (1 July 1899): 656; Caffin, *Photography As a Fine Art,* 28.

43. Underwood, *Charles Caffin,* 207–9.

44. Milton Brown, *American Painting from the Armory Show to the Depression*

(Princeton: Princeton University Press, 1955), 44.

45. Caffin, "Tweedledum and Tweedledee," 27.

46. Caffin, "Edward J. Steichen's Work—An Appreciation," 22.

47. Caffin, "The Development of Photography in the United States," 4–5.

48. Caffin, "Is Herzog Also among the Prophets?" in *Camera Work: A Critical Anthology,* ed. Green, 109.

49. Caffin, *Photography As a Fine Art,* 175.

50. Caffin, "Symbolism and Allegory," 20, 22.

51. Caffin, "Is Herzog Also among the Prophets?" in *Camera Work,* ed. Green, 110.

52. Underwood discusses the influence of Ruskin on Caffin in *Charles Caffin,* 42–46.

53. Caffin, *Art for Life's Sake,* 11.

54. Ibid., 12.

55. Ibid., 30.

56. Caffin, *Photography As a Fine Art,* vii.

57. Ibid., 10.

58. Caffin, "Progress in Photography, with Special Reference to the Work of Eduard J. Steichen," *Century* 75 (February 1908): 483–84.

59. Caffin, *Photography As a Fine Art,* 16, 18.

60. Ibid., 17.

61. F. C. Lambert made reference to Ruskin in this context in 1896 when he wrote, "Now, Mr. Ruskin has laid it down again and again that, while there are certain underlying principles common to all forms of art, yet each has its own special excellences and limitations; that, when work by one art method resembles work by another method, it is a symptom of weakness, showing that the virtues of the material are not known or appreciated, or properly used. . . . Furthermore, he says that an art is bare if it does not properly employ the special and distinctive qualities of its materials and methods." "Judging Photographs," *British Journal of Photography* 43 (25 September 1896), reprinted in *A Photographic Vision,* ed. Peter C. Bunnell, 45.

62. Caffin, *Photography As a Fine Art,* 34, 36.

63. Ibid., 39, 87, 100.

64. Ibid., 100–101.

65. Ibid., 161–62.

66. Caffin, "Of Verities and Illusions," in *Camera Work,* ed. Green, 58.

67. Caffin, "Of Verities and Illusions, Part 2," 43–44.

68. Caffin, "Henri Matisse and Isadora Duncan," in *Camera Work,* ed. Green, 177, 178.

69. Caffin, "The Camera Point of View in Painting and Photography," 26. Caffin indicated that he associated the division between photographic art and art of the imagination directly with Matisse when he wrote, "He and all the new men have this at least in common: that they are sick of the photographic side of modern painting; the outcome of naturalism and impressionism, satisfied to give the actual appearance of an object. They affirm, with truth, that the camera has invaded this field and is capable of thoroughly exploring it; that the painter, if he is to recover an exclusive territory for his art, must push those means at his disposal in which the camera cannot emulate him." *The Story of French Painting* (New York: Century, 1911), 213.

70. Caffin, "Some Impressions from the International Photographic Exhibition, Dresden," 33–34.

71. Ibid., 39.

72. Caffin, "The Exhibition at Buffalo," 22.

73. The exhibit of Strand's photographs in 1916 was the first photographic exhibit at "291" since Stieglitz showed his own straight photographs in 1913 concurrently with the Armory Show. Caffin did not review Stieglitz's 1913 show.

74. Caffin, "'Straight' Photography," 205.

75. Sydney Allan [Sadakichi Hartmann], "The 'Flat-Iron' Building—An Esthetical Dissertation," *Camera Work* no. 4 (October 1903): 37.

76. Homer, *Alfred Stieglitz and the American Avant-Garde,* 282 n. 28.

77. Hartmann, "Puritanism, Its Grandeur and Shame," in *Camera Work,* ed. Green, 206.

78. Hartmann, "That Toulouse-Lautrec Print!" in *Camera Work,* ed. Green, 190, 191, 192.

79. A good source of biographical information on Hartmann is editors' introduction to *The Valiant Knights of Daguerre,* ed. Lawton and Knox, 1–31; and Knox's introduction to *The Life and Times of Sadakichi Hartmann,* ed. Knox, 1–9.

80. Lawton and Knox, eds., editors' introduction to *Valiant Knights of Daguerre,* 11–12.

81. Allan [Sadakichi Hartmann], "The Value of the Apparently Meaningless and Inaccurate," *Camera Work* no. 3 (July 1903): 17.

82. Allan [Sadakichi Hartmann], "The Technique of Mystery and Blurred Effects," *Camera Work* no. 7 (July 1904): 26.

83. Hartmann, "A Plea for Straight Photography," in *Valiant Knights of Daguerre,* ed. Lawton and Knox, 108. This quote actually comes from a passage in which Hartmann was critical of the Photo-Secession, but it is still an accurate summation of the Symbolist qualities that had initially attracted him to Pictorialism.

84. Hartmann, "The Photo-Secession Exhibition at the Carnegie Art Galleries, Pittsburgh, Pa.," in *Valiant Knights of Daguerre,* ed. Lawton and Knox, 107.

85. Allan [Sadakichi Hartmann], "Edward Steichen: A Visit to Steichen's Studio," in *Valiant Knights of Daguerre,* ed. Lawton and Knox, 204.

86. Hartmann, "Dawn Flowers," in *Camera Work,* ed. Green, 32.

87. Hartmann, "Random Thoughts on Criticism," in *Valiant Knights of Daguerre,* ed. Lawton and Knox, 68.

88. Hartmann, "Portrait Painting and Portrait Photography," in *Valiant Knights of Daguerre,* ed. Lawton and Knox, 48.

89. Hartmann, "On Plagiarism and Imitation," in *Valiant Knights of Daguerre,* ed. Lawton and Knox, 65.

90. Hartmann, "Portrait Painting and Portrait Photography," in *Valiant Knights of Daguerre,* ed. Lawton and Knox, 54.

91. Hartmann, "Alfred Stieglitz: An Art Critic's Estimate," in *Valiant Knights of Daguerre,* ed. Lawton and Knox, 162.

92. Hartmann, "Portrait Painting and Portrait Photography," in *Valiant Knights of Daguerre,* ed. Lawton and Knox, 46.

93. Hartmann, "On Originality," *Camera Work* no. 37 (January 1912): 21.

94. Hartmann, "What Remains," in *Valiant Knights of Daguerre,* ed. Lawton and Knox, 151.

95. Hartmann, "Random Thoughts on Criticism," in *Valiant Knights of Daguerre,* ed. Lawton and Knox, 68.

96. Allan [Sadakichi Hartmann], "Edward Steichen: A Visit to Steichen's Studio," in *Valiant Knights of Daguerre,* ed. Lawton and Knox, 202.

97. Hartmann, "Random Thoughts on Criticism," in *Valiant Knights of Daguerre,* ed. Lawton and Knox, 69.

98. Walter Pater, *The Renaissance,* 6th ed., (New York: Macmillan, 1901), viii.

99. Allan [Sadakichi Hartmann], "Edward Steichen: A Visit to Steichen's Studio," in *Valiant Knights of Daguerre,* ed. Lawton and Knox, 209.

100. For a discussion of the Hartmann-Stieglitz feud see Roger P. Hull, "The Stieglitz-Hartmann Letters: The Toy Balloonist and the Great Aerialist," *Sadakichi Hartmann Newsletter* 2 (fall 1971): 1–7; and Hull, "Rudolf Eickemeyer Jr. and the Politics of Photography," *New Mexico Studies in the Fine Arts* 2 (1977): 20–25.

101. Hartmann, "A Plea for Straight Photography," in *Valiant Knights of Daguerre,* ed. Lawton and Knox, 114.

102. Perhaps the best contemporary definition of the straight photograph comes from Aaron Siskind who described it as "sharp all over, . . . with a full tonal range, . . . made with the light present at the scene, . . . using the largest possible camera, preferably on a tripod, . . . the negative is printed by contact to preserve utmost clarity of definition, . . . and the look of the finished photograph is pretty well determined by the time the shutter is clicked." Quoted by Henry Holmes Smith in "New Figures in a Classic Tradition," in Siskind, *Aaron Siskind, Photographer,* 15.

103. Hartmann, "On the Possibility of New Laws of Composition," in *Valiant Knights of Daguerre,* ed. Lawton and Knox, 133.

104. Ibid.

105. Ibid.

106. Hartmann is quoted by Wanda Corn, in "The New New York," *Art in America* 61 (July–August 1973): 64.

107. Hartmann, "On the Possibility of New Laws of Composition," in *Valiant Knights of Daguerre,* ed. Lawton and Knox, 134.

108. As Milton Brown explains, Americans regarded Cubism as "a search for funda-mentals, for the essential truths of the material world. This search for what was basic rather than peripheral seemed to place the artist on a solid footing, almost comparable to the scientist." *American Painting from the Armory Show to the Depression,* 104. Abstraction and objectivity were seen as compatible. In a review of Strand's most abstract photographs, Edward Alden Jewell wrote, "far from denying the validity of what we call the objective world, [abstraction] proves to be objectivity's very core." "Strand: Three Decades," *The New York Times,* 29 April 1945, sec. 2, p. 5.

Chapter 2

1. Weston is quoted by Beaumont Newhall in "Edward Weston in Retrospect," in *Edward Weston Omnibus,* ed. Newhall and Conger, 78.

2. Clive Bell, "The Aesthetic Hypothesis," in *Art* (London: Chatto and Windus, 1931), 3–30.

3. Walter Benjamin, "A Short History of Photography," in *Classic Essays on Photography,* ed. Trachtenberg, 213.

4. Stieglitz, "Our Illustrations," in *Camera Work,* ed. Green, 329.

5. Pultz and Scallen, *Cubism and American Photography 1910–1930,* 30.

6. See especially Strand, "The Art Motive in Photography," in *Photographers on Photography,* ed. Lyons, 144–54.

7. Strand, "Photography," in *Photographers on Photography,* ed. Lyons, 136.

8. Ibid.

9. See Strand, "Photography and the New God," in *Photographers on Photography,* ed. Lyons, 138–44.

10. Naomi Rosenblum, "Paul Strand: Modernist Outlook/Significant Vision," *Image* 33 (fall 1990): 10.

11. Strand, "Photography," in *Photographers on Photography,* ed. Lyons, 136.

12. Mike Weaver, "Paul Strand: Native Land," *Archive* no. 27 (1990): 7–8.

13. Strand, "The Art Motive in Photography," in *Photographers on Photography,* ed. Lyons, 150.

14. Ibid., 154.

15. Strand, "Photography," in *Photographers on Photography,* ed. Lyons, 137.

16. Strand, "Aesthetic Criteria," *Freeman* 2 (12 January 1921): 426.

17. Clurman, "Photographs by Paul Strand," 735.

18. Ibid., 736.

19. Ridge, "Paul Strand," 313, 316.

20. Carey, "The World of Art," 10.

21. Seligmann, *Alfred Stieglitz Talking,* 82.

22. Lowe, *Stieglitz: A Memoir/Biography,* 162, 210.

23. Bergson is quoted by T. A. Goudge in *The Encyclopedia of Philosophy* (1967; reprint, New York: Macmillan, 1972), 291.

24. Kandinsky is quoted by Herschel B. Chipp in *Theories of Modern Art* (Berkeley: University of California Press, 1968), 154–55.

25. Stieglitz is quoted by Seligmann in *Alfred Stieglitz Talking,* 61.

26. Stieglitz is quoted by Norman in *Alfred Stieglitz: An American Seer,* 144.

27. See Seligmann, "A Photographer Challenges"; Strand, "Alfred Stieglitz and a Machine"; and Rosenfeld, "Stieglitz."

28. Lowe, *Stieglitz: A Memoir/Biography,* 209.

29. Rosenfeld, "Stieglitz," 399, 400, 408.

30. Rosenfeld, "The Boy in the Darkroom," in *America and Alfred Stieglitz,* ed. Frank et al., 69–70.

31. Rosenfeld, "Stieglitz," 405, 409.

32. The story of *The Dial* in New Bedford and the quotation by McBride are both found in Charlotte Devree, "Profile: Henry McBride, Dean of Art Critics," *Art in America* 43 (October 1955): 61.

33. Frank, "The Art of the Month: Alfred Stieglitz," 108.

34. Craven, "Art and the Camera," 457.

35. McBride, "Modern Art," 480–81.

36. Weston is quoted by Frances D. McMullen, in "Lowly Things That Yield Strange, Stark Beauty," in *Edward Weston Omnibus,* ed. Newhall and Conger, 43.

37. Critics who spoke of significant form were Merle Armitage, "The Photography of Edward Weston," Arthur Millier, "Some Photographs by Edward Weston," and McMullen, "Lowly Things," all in *Edward Weston Omnibus,* ed. Newhall and Conger, 24, 32, 41. The Mexican painter David Siqueiros suggested that Weston's style owed something to the influence of advertising and industrial photography, but his view was unique. See Siqueiros, "A Transcendental Photographic Work: The Weston-Modotti Exhibition," in *Edward Weston Omnibus,* ed. Newhall and Conger, 20.

38. McMullen, "Lowly Things," in *Edward Weston Omnibus,* ed. Newhall and Conger, 41.

39. Lewis Mumford, "The Metropolitan Milieu," in *America and Alfred Stieglitz,* ed. Frank et al., 58.

40. Weston, *Daybooks,* 2:32.

41. Weston is quoted by Maddow in *Edward Weston: His Life,* 157, 255.

42. Anna C. Chave, "O'Keeffe and the Masculine Gaze," *Art in America* 78 (January 1990): 115–24, 177–79.

43. Maddow, *Edward Weston: His Life,* 220–21.

44. Weston, *Daybooks,* 2:154.

45. Adams, "Photography," in *Edward Weston Omnibus,* ed. Newhall and Conger, 46, 47.

46. Weston to Adams in *Edward Weston Omnibus,* ed. Newhall and Conger, 48.

47. Ibid.

48. Adams to Weston in *Ansel Adams: Letters and Images,* 164.

49. Adams is quoted in an interview by Herm Lenz, 87.

50. Adams to Nancy Newhall in *Ansel Adams: Letters and Images,* 198.

51. Adams, "An Exposition of My Photographic Technique," 20.

52. Adams, *Making a Photograph* (New York: Studio Publications, 1935), 60.

53. Beaumont Newhall, review of *Making a Photograph, American Magazine of Art* 28 (August 1935): 508, 512.

54. Beaumont Newhall, "Toward the New Histories of Photography," *Exposure* 21:4 (1983): 7.

55. Beaumont Newhall, *Photography 1839–1937,* 43.

56. Ibid., 44.

57. In the spirit of historical objectivity, Newhall did include two photograms and a solarized image in his catalogue, but he considered photomontage to be so unphotographic that he excluded it entirely.

58. Nancy Newhall, "What Is Pictorialism?" 653.

59. See Ansel Adams, "An Exposition of My Photographic Technique," a four-part article appearing in *Camera Craft* in 1934; and William Mortensen, "Venus and Vulcan: An Essay on Creative Pictorialism," a five-part article appearing in *Camera Craft* in 1934. Adams also published a number of letters in *Camera Craft* in the same year.

60. Mortensen, "Venus and Vulcan, part 4, 260.

61. Mortensen, "Come Now, Professor!" 70.

62. Adams, "Pure Photography," letter to the editor, *Camera Craft* 41 (June 1934): 297.

63. Adams, *Ansel Adams: An Autobiography,* 244.

64. Adams to Cedric Wright and Nancy Newhall in *Ansel Adams: Letters and Images,* 37, 198.

65. Adams to Eldridge T. Spencer in *Ansel Adams: Letters and Images,* 183.

66. Adams is quoted by Christina Page in "The Man from Yosemite: Ansel Adams," *Minicam Photography* 10 (September–October 1946): 34.

67. Adams, "Some Definitions," *Image* 8 (March 1959): 22.

68. Christina Page, "Camera v. Brush," *Time,* 2 June 1947, 53.

69. Page, "Realism with Reverence," *Time,* 4 June 1951, 69.

70. Nancy Newhall, review of *My Camera in Yosemite Valley,* by Ansel Adams, *Magazine of Art* 43 (December 1950): 309.

71. Anne Hammond, "Ansel Adams: Natural Scene," *Archive* no. 27 (1990): 22.

72. Unidentified seventeenth-century source quoted by Louis Hawes in *Presences of Nature: British Landscape 1780–1830* (New Haven: Yale Center for British Art, 1982), 1–2.

73. Adams is quoted by Nancy Newhall in "Ansel Adams, *The Eloquent Light,*" in *From Adams to Stieglitz,* 11.

74. Ibid., 14.

75. Adams to Weston in *Ansel Adams: Letters and Images,* 73–74.

76. Hammond, "Ansel Adams: Natural Scene," 19.

77. Adams to David McAlpin in *Ansel Adams: Letters and Images,* 141.

78. Adams, *Ansel Adams: An Autobiography,* 146.

79. Hammond, "Ansel Adams: Natural Scene," 24.

80. Jack Weatherford, *Native Roots* (New York: Fawcett Columbine, 1991), 228.

Chapter 3

1. Stott, *Documentary Expression and Thirties America,* 72.

2. Alfred Kazin, *On Native Grounds* (New York: Harcourt Brace, 1942), 209.

3. Adams is quoted by Russell Lynes in *Good Old Modern* (New York: Atheneum, 1973), 158.

4. Adams, "A Letter from Ansel Adams," *Photo Notes,* June–July 1940, 5. All *Photo Notes* articles may be found in the reprint edition, *Photo Notes,* ed. Nathan Lyons.

5. Lange, "Documentary Photography," in *A Pageant of Photography.*

6. Stange, *Symbols of Ideal Life,* 117–28.

7. Hurley, *Portrait of a Decade,* 128; Stange, *Symbols of Ideal Life,* 108–9.

8. Hurley, *Portrait of a Decade,* 60–64. Further discussion of the tensions between Stryker, Evans, Lange, and Ben Shahn appears in Stange, *Symbols of Ideal Life,* 113–17.

9. Stange, *Symbols of Ideal Life,* 89–90.

10. Curtis, *Mind's Eye, Mind's Truth.* Peeler expresses a view similar to Stott's in *Hope among Us Yet.*

11. Howe, "You Have Seen Their Pictures," 238.

12. Fulton, *The Eyes of Time: Photojournalism in America,* 135.

13. Quoted by Stott in *Documentary Expression and Thirties America,* 130.

14. Luce is quoted in *The Ideas of Henry Luce,* ed. John K. Jessup (New York: Atheneum, 1969), 44.

15. Kael is quoted in Fulton, *The Eyes of Time,* 141.

16. Moeller, *Shooting War,* 189.

17. Luce, "America's Boys, Deep in Real War, Start Telling What Real War Is," *Life,* 9 November 1942, 40.

18. Much of my discussion of censorship during World War II is based on Roeder, *The Censored War.*

19. Ibid., 5–6, 10, 25.

20. Steinbeck is quoted by Moeller in *Shooting War,* 190–91.

21. Jewell, "Portrait of the Spirit of a Nation," 5.

22. Moeller discusses the dehumanizing presentation of the Japanese in American photojournalism in *Shooting War,* 229–31; Roeder discusses the double standard with regard to tears in *The Censored War,* 124–25. Other related issues are treated in both books.

23. Silk is quoted by Moeller in *Shooting War,* 240–41.

24. Miller is quoted by Christopher Phillips in *Steichen at War* (New York: Abrams, 1981), 34.

25. Curtis, *Mind's Eye, Mind's Truth,* viii–ix.

26. Ibid., 56, 100.

27. Peeler, *Hope among Us Yet,* 82.

28. Stryker and Wood, *In This Proud Land,* 14.

29. Ibid., 17.

30. The philosopher John Dewey, who had a tremendous impact on Tugwell and, through him, Stryker, was most likely the source of the conviction that one must teach and persuade through symbolism. See Stange, *Symbols of Ideal Life,* 90, 104–5.

31. Stryker, "Documentary Photography," *Encyclopedia of Photography,* 1372.

32. Rothstein, "Direction in the Picture Story," *Encyclopedia of Photography,* 1356, 1357.

33. Curtis, *Mind's Eye, Mind's Truth,* 76–78.

34. Strand and Steiner are quoted by Alexander in *Film on the Left,* 53, 79.

35. Tucker, "Photographic Crossroads," 3.

36. Alexander, *Film on the Left,* 33, 35, 52, 57.

37. Strand and Hurwitz were intimately connected with the Photo League as members of the group's advisory board. Rothstein was also a member of the League.

38. Luce is quoted by Richard Whelan in *Robert Capa* (New York: Knopf, 1985), 119.

39. Hicks, *Words and Pictures,* 129.

40. The cow skull story is told with variations in Hurley, *Portrait of a Decade,* 86–92, and in Curtis, *Mind's Eye, Mind's Truth,* 75–76.

41. Lyons, notes and acknowledgments, in Lyons, ed., *Photo Notes.*

42. Tucker, "Photographic Crossroads," 4.

43. "For a League of American Photographers," *Photo Notes,* August 1938, 1.

44. Chiarenza, *Aaron Siskind: Pleasures and Terrors,* 48.

45. Albert Fenn, "U.S. Camera—1940," *Photo Notes,* February 1940, 2.

46. "For a League of American Photographers," 4.

47. Morris Engel, "Review of *U.S. Camera Annual 1939*," *Photo Notes,* January 1939, 4.

48. The Feature Group produced "Portrait of a Tenement" (1936), "Harlem Document" (mostly done from 1937 to 1940), "Dead End: The Bowery" (1937), "Park Avenue North and South" (1938), and "The Catholic Worker Movement: St. Joseph's House" (1939–1940).

49. Chiarenza, *Aaron Siskind: Pleasures and Terrors,* 33.

50. Siskind is quoted by Chiarenza in *Aaron Siskind: Pleasures and Terrors,* 43.

51. Leo Hurwitz, "On Paul Strand and Photography," *Photo Notes,* July–August 1941, 3, 4.

52. Evans is quoted by Stott in *Documentary Expression and Thirties America,* 269.

53. Curtis, *Mind's Eye, Mind's Truth,* 23-44. Stott also refers to Evans's manipulative practices, 350–51 n. 6.

54. The description of McCausland was made by Louis Stettner in "Cezanne's Apples and the Photo League," 33. Elizabeth McCausland discussed the photographic spirit of realism in "Documentary Photography," *Photo Notes,* January 1939, 7.

55. Lorentz, "Putting America on Record," 6.

56. Lorentz, "Dorothea Lange: Camera with a Purpose," 95.

57. Alexander, *Film on the Left,* 106–7.

58. Norman Cousins, "Book of the Future," *Current History* 47 (December 1937): 8.

59. Van Gelder, "A Compelling Album of the Deep South," 11.

60. Bourke-White is quoted by May Cameron in an article first published in the *New York Post* and reprinted by James Agee in *Let Us Now Praise Famous Men* (Boston: Houghton Mifflin, 1960), 453.

61. Williams, "Sermon with a Camera," 282–83.

62. Van Dyke, "The Photographs of Dorothea Lange," 464. Van Dyke was not the only writer to use the idea of a blank and sensitized mind to characterize a photographer's state of awareness. The idea has appeared in several contexts. Minor White wrote of a "specially blank" mind to refer to a state of sensitivity in a photographer akin to that attainted through meditation. "Camera Mind and Eye," *Magazine of Art* 45 (January 1952): 17. John Szarkowski also used the idea of a blank and sensitized mind in an essay on Walker Evans: "Perhaps the best photographers in their best years come to resemble their unexposed film—passive, unprejudiced, patient, waiting for the revelation that will open the shutter." Introduction to *Walker Evans* (New York: Museum of Modern Art, 1971), 14. Unlike Morgan, Szarkowski did not think the result of this passivity would be objective vision, and unlike White, he was not interested in photography as meditation. Szarkowski was probably thinking about what he described elsewhere as the exercise of intelligence at a visceral level.

63. Howe, "You Have Seen Their Pictures," 237.

64. Beaumont Newhall, "Documentary Approach to Photography," 3–6.

65. Evans is quoted in an interview by Leslie Katz, 84, 85.

66. Kirstein, "Photographs of America," in Evans, *American Photographs,* 191, 194.

67. Ibid., 197.

68. Mabry, "Walker Evans' Photographs of America," 140.

69. Davidson, "Evans' Brilliant Camera Records of Modern America," 12–13.

70. Kirstein, "Photographs of America," in Evans, *American Photographs,* 194, 197.

71. Edward Alden Jewell, "Aspects of America in Three Shows," *The New York Times,* 2 October 1938, sec. 9, p. 9.

72. Trilling, "Greatness with One Fault in It," 99, 100–101.

73. Kirstein, "Photographs of America," in Evans, *American Photographs,* 193, 195, 196–97.

74. Williamson, "American Photographs by Walker Evans," 6.

75. Szarkowski, introduction in Evans, *Walker Evans,* 20.

76. Elizabeth McCausland, "Documentary Photography," *Photo Notes,* January 1939, 8.

77. McCausland, "Photographic Books," in Peters, "Elizabeth McCausland on Photography," 12.

78. McCausland, "The Photography of Berenice Abbott," *Trend* 3 (March–April 1935): 15.

79. Ibid., 21.

80. McCausland, "Paul Strand," *U.S. Camera* 1 (February–March 1940): 65.

81. Jewell, "Portrait of the Spirit of a Nation," 5.

Notes *279*

82. Quoted in "The Road to Victory," *Museum of Modern Art Bulletin* 9 (June 1942): 21.

83. Ibid., 10–11, 14.

84. Beaumont Newhall to Adams in *Ansel Adams: Letters and Images,* 134. In his role as a curator, Steichen was encroaching on Newhall's turf—and was soon to usurp Newhall's position at the museum—but Newhall's response to the exhibit was not entirely sour grapes; it reflected a fundamental difference between Newhall's scholarly approach to photography and Steichen's popularizing one.

85. McCausland, "Photographs Illustrate Our 'Road to Victory,'" *Photo Notes,* June 1942, 4.

86. Ibid., 5.

87. The question of the role that imagery plays in cognition has experienced something of a comeback since the waning of behaviorism. A good summary of the relevant issues may be found in Ned Block, *Imagery* (Cambridge: MIT Press, 1981), 1–16.

88. Rudolf Arnheim has been a long-standing advocate of this position in his work on visual thinking. For example, see "A Plea for Visual Thinking," in *New Essays on the Psychology of Art* (Berkeley: University of California Press, 1986), 135–52.

89. Agee in Levitt, *A Way of Seeing,* xv.

90. McCausland, "Photographic Books," in Peters, "Elizabeth McCausland on Photography," 13.

91. Walter Benjamin, "The Author As Producer," in *Thinking Photography,* ed. Burgin, 24. Postmodernist theorists, such as Victor Burgin, argue that our experience of photographs is always "transversed by language," which is saturated with cultural meanings. See "Looking at Photographs," in *Thinking Photography,* 143–44.

92. McCausland, "Photographic Books," in Peters, "Elizabeth McCausland on Photography," 13.

93. Hicks, *Words and Pictures,* 17.

94. Ibid., 7, 19.

95. Nancy Newhall, "The Caption," in *From Adams to Stieglitz,* 135.

96. Ibid., 136.

97. Ibid., 140.

98. Hicks, *Words and Pictures,* 72–73.

99. Ibid., 110–11.

100. The demise of Stryker's photography unit and his efforts to save his file are recounted by Hurley in *Portrait of a Decade,* 160–70.

101. Strand, "Address by Paul Strand," *Photo Notes,* January 1948, 3.

102. For more on the demise of the Photo League see Anne Tucker, "The Photo League."

103. Cameron, in *Let Us Now Praise Famous Men,* 451.

104. John E. Abbott, "Contemporary Photography," *Bulletin of the Museum of Modern Art* 11 (October–November 1943): 2.

105. Alfred Barr, Jr., Statement in *Bulletin of the Museum of Modern Art* 11 (October–November 1943): 2–3.

106. Ibid., 3.

107. Willard D. Morgan, Statement in *Bulletin of the Museum of Modern Art* 11 (October–November 1943): 4.

108. Russell Lynes, *Good Old Modern,* 259.

109. Brown, "Badly Out of Focus," 5.

Chapter 4

1. Agha, "Vogue's-Eye View of Photography," *Vogue,* 15 June 1941, 17.

2. Agha, "Raphaels without Hands," 19.

3. Ibid., 77.

4. Penn is quoted in "What Is Modern Photography?" 148.

5. Penn is quoted by Jonathan Tichenor in "Irving Penn," *Graphis* 6:33 (1950): 396.

6. Milton Brown, "Badly Out of Focus," *Photo Notes,* January 1948, 5–6.

7. Agee, in Levitt, *A Way of Seeing,* vii.

8. Kirstein, "Photographs of America," in Evans, *American Photographs,* 191.

9. Another writer who held a similar opinion was Gilbert Seldes in "No Soul in the Photograph," 121.

10. Steichen is quoted by Paul Strand in "Steichen and Commercial Art," 21.

11. Rosenfeld, "Carl Sandburg and Photography," *The New Republic* 61 (22 January 1930): 252.

12. Strand, "Steichen and Commercial Art," 21.

13. Ibid.

14. "'De Lawd' of Modern Photography" is the title of an article by Gilbert Millstein published in *The New York Times Magazine.*

15. Sandburg, *Steichen the Photographer,* 56.

16. Josephson, "Profiles: Commander with a Camera, pt. 1," 34; Clare Boothe Brokaw, "Edward Steichen, Photographer," 60. Alan Sekula has written that there is evidence that although Steichen was in command of aerial photography in France, he did not, himself, take the World War I aerial photographs that have been widely attributed to him. See "The Instrumental Image: Steichen at War," in *Photography against the Grain,* 40.

17. Steichen, introduction to *The Family of Man,* 4.

18. Sandburg, prologue to Steichen, *The Family of Man,* 3.

19. Kramer, "Exhibiting the Family of Man," 364.

20. George Wright and Cora Wright, "One Family's Opinion," 20.

21. McKenna, "Photography," 30.

22. Phoebe Lou Adams, "Through a Lens Darkly," 69.

23. Rosskam, "Family of Steichen," 64.

24. Ibid., 64, 65.

25. John Stanley, "Love and Praise," review of *The Family of Man, Commonweal* 62 (1 July 1955): 333–34.

26. Kramer, "Exhibiting the Family of Man," 365, 366, 367.

27. Steichen is quoted in "Steichen Seeking Prints for Museum's *Family of Man* Show," *Popular Photography* 34 (March 1954): 120.

28. Rosskam, "Family of Steichen," 64.

29. Phoebe Lou Adams, "Through a Lens Darkly," 70.

30. Smith is quoted in an interview by Ted Hedgpeth and Craig Morey, 8. For further discussion of the political implications of the show, see Allan Sekula, "The Traffic in Photographs," in *Photography against the Grain,* 88–90.

31. "We Look Back on a Great Era," *Popular Photography* 30 (May 1952): 39.

32. All statistics on circulation are taken from the appropriate years of *Ayer Directory of Newspapers, Magazines, and Trade Publications* (Philadelphia: Ayer and Sons).

33. Deschin is quoted by John Durniak in "The Deschin Contribution," *Infinity* 18 (October 1969): 6.

34. Deschin, "Galleries Needed," *The New York Times,* 1 August 1954, sec. 2, p. 12.

35. Deschin, "Teaching New Ways," *The New York Times,* 28 March 1954, sec. 2, p. 15; "Picture Meanings: University Course in How to Read Photos," *The New York Times,* 1 April 1956, sec. 2, p. 19.

36. Deschin, "Two New Shows," [review of Harry Callahan exhibit at A Photographer's Gallery, New York], *The New York Times,* 14 April 1957, sec. 2, p. 17.

37. Deschin, *Say It with Your Camera,* v.

38. Ibid., 4, 15–16.

39. Ibid., 21–22.

40. Ibid., 26.

41. Ibid., 48, 57–58.

42. Halsman, "Bruce Downes, 1964," *Infinity* 13 (September 1964): 24.

43. Downes, "Wanted: Critics for Photography," 40.

44. Ibid., 75–76.

45. Downes, "Werner Bischof's Japan," *Popular Photography* 36 (March 1955): 72.

46. Downes, "The Museum of Modern Art's Photography Center," 25.

47. Downes, "Exhibit of the Month," 32, 33, 96.

48. Downes, "Warning to Young Photographers," 18.

49. Downes, "New Books," review of *The Family of Man* by Edward Steichen, *Popular Photography* 37 (November 1955): 130.

50. Downes, "Let's Talk Photography," *Popular Photography* 27 (November 1950): 87.

51. Downes, "Warning to Young Photographers," 18.

52. Downes, "Photography: A Definition," 10, 12.

53. Downes, "The Photo Bohemians," 40.

54. Downes et al., "An Off-beat View of the U.S.A.," 104.

55. William Hogan, "A Bookman's Notebook," *San Francisco Chronicle,* 27 January 1960, 25.

56. Downes et al., "An Off-Beat View of the U.S.A.," 105.

57. Unsigned review of *The Americans,* in *New Yorker,* 14 May 1960, 204.

58. Donald Gutierrez, "The Unhappy Many," *Dissent* 8 (autumn 1961): 515.

59. Walker Evans, "Robert Frank," *U.S. Camera Annual 1958* (1957): 90.

60. Frank, "Guggenheim Fellowship Application Form," in Anne Tucker, *New York to Nova Scotia* (Boston: New York Graphic Society, 1986), 20.

61. Chiarenza discusses Siskind's relationships with the painters of the New York School, showing that he was very much of their milieu and in a position to influence them as well as to be influenced by them. At the same time, Siskind held a somewhat ambiguous and inferior status as a photographer among painters. See *Aaron Siskind: Pleasures and Terrors,* chaps. 4 to 6, passim. On Siskind's influence on the painters see also Hess's introduction to *Places: Aaron Siskind Photographs* (New York: Farrar, Straus and Giroux, 1976), esp. p. 6. On the criticism of Siskind, see Chiarenza, "Siskind's Critics, 1946–1966."

62. Siskind is quoted by Chiarenza in *Aaron Siskind: Pleasures and Terrors,* 65.

63. Rothko's and Gottlieb's letter is quoted and discussed by Dore Ashton in *The New York School: A Cultural Reckoning* (New York: Penguin Books, 1979), 127–29.

64. Chiarenza, "Siskind's Critics, 1946–1966," 12.

65. Downes, "Let's Talk Photography, review of *Korea—The Impact of War,* 22.

66. Rosenberg, "Evidences," in Siskind, *Aaron Siskind, Photographer.*

67. Ibid.

68. Hess, "The Walls," 65.

69. Ibid., 109.

70. Smith, "New Figures in a Classic Tradition," in Siskind, *Aaron Siskind, Photographer,* 19.

71. Ibid., 19, 20.

72. Downes, "The Siskind Canonization," 36.

73. Ibid.

74. Downes, "Out of the Basement," 48.

75. Downes et al., "Critics at Large," four reviews of *The Photographer and the American Landscape,* curated by John Szarkowski, *Popular Photography* 54 (January 1964): 119–20.

76. Downes, "The Art of Photography in 1965," *Popular Photography* 56 (February 1965): 20.

Chapter 5

1. Agha, "Horseless Photography," 119, 120.

2. Maddow, *W. Eugene Smith: Let Truth Be the Prejudice,* 38.

3. Durniak, "The Vanishing Pro in Photography," 21.

4. A good description of the formation and functioning of Magnum appears in Richard Whelan's biography, *Robert Capa* (New York: Knopf, 1985), 251–52, 272–73.

5. Hy Peskin and Ben Somoroff are quoted in "We Asked the Pros," *Popular Photography* 50 (May 1962): 132.

6. "The ASMP Bill of Rights of 1967," *Infinity* 17 (January 1968): 5.

7. A. Hyatt Mayor, "A Matter of Opinion," *The Saturday Review,* 18 May 1963, 41.

8. Alfred Frankfurter, "The Photographs Viewed As Pictures," *The Saturday Review,* 16 May 1959, 57. Frankfurter was editor of *Art News.*

9. Among the objections to PFA was an open letter sent to the Metropolitan Museum and signed by nine working photographers: Robert Frank, Lee Friedlander, Ray Jacobs, Simpson Kalisher, Saul Leiter, Jay Maisel, Walt Silver, David Vestal, and Garry Winogrand. The letter is quoted in *The New York Times.* "Camera Notes, Photographers Question Fine Arts Project," *The New York Times,* 8 May 1960, sec. 2, p. 17.

10. Dmitri is quoted by Deschin in "PFA Exhibit," *The New York Times,* 22 May 1960, sec. 2, p. 19.

11. Rorimer is quoted by Jerome Beatty, Jr. in "The Fulfillment of an Idea," *The Saturday Review,* 16 May 1959, 39.

12. Ivan Dmitri, "The Jury and the Charge," *The Saturday Review,* 28 May 1960, 36.

13. Weiss, "Photography in the Fine Arts 4," 39.

14. Downes, "PFA Revisited," *Popular Photography* 47 (August 1960): 44.

15. The other founders of *Aperture* were Ansel Adams, Melton Ferris, Dorothea Lange, Ernest Louie, Barbara Morgan, Nancy Newhall, Beaumont Newhall, and Dody Warren.

16. White to Adams, 31 March 1954, Ansel Adams Papers, Center for Creative Photography, University of Arizona, Tucson. With the financial backing of Shirley C. Burden, White continued *Aperture* after the initial group of founders pulled out.

17. Adams to White, April 1954, Ansel Adams Papers, Center for Creative Photography, University of Arizona, Tucson.

18. James Baker Hall, biographical essay in Minor White, *Minor White: Rites and Passages* (Millerton, N.Y.: Aperture, 1978), 19.

19. A good source of biographical information on White is Peter Bunnell's chronology in *Minor White: The Eye That Shapes,* 1–13.

20. Green, *American Photography,* 76–77.

21. The depoliticization of American art in the late thirties and early forties is discussed at length by Serge Guilbaut in *How New York Stole the Idea of Modern Art* (Chicago: University of Chicago Press, 1983).

22. White discussed Underhill's book *Mysticism* (1911; reprint, London: Methuen, 1967) in "Ten Books for Creative Photographers," 67.

23. White to Smith, 25 June 1957, Henry Holmes Smith Collection, Center for Creative Photography, University of Arizona, Tucson.

24. White to Smith, 8 April 1961, Henry Holmes Smith Collection, Center for Creative Photography, University of Arizona, Tucson.

25. Sam Tung Wu [Minor White], "Proverbs of Hell," *Aperture* 7:1 (1959): 38.

26. Siskind to Smith, [1958?], Henry Holmes Smith Collection, Center for Creative Photography, University of Arizona, Tucson.

27. Michael E. Hoffman, preface to the second edition, Minor White, *Mirrors Messages Manifestations* (Millerton, N.Y.: Aperture, 1982).

28. Paul Caponigro, "A Multiple Legacy," in *Minor White: A Living Remembrance,* ed. Holborn, 58.

29. White, "Futures," *Aperture* 13:2 (1967).

30. White first dealt with the idea of equivalence in "Are Your Prints Transparent?" He discussed the history of the idea in "On the Strength of a Mirage." His most thorough treatment of equivalence appears in "Equivalence: The Perennial Trend," in *Photographers on Photography,* ed. Lyons.

31. Norman, *Alfred Stieglitz: An American Seer,* 144.

32. White, "Equivalence: The Perennial Trend," in *Photographers on Photography,* ed. Lyons, 171.

33. White, "The Camera Mind and Eye," in *Photographers on Photography,* ed. Lyons, 166.

34. White, "Equivalence: The Perennial Trend," in *Photographers on Photography,* ed. Lyons, 170.

35. White, "Criticism," *Aperture* 2:2 (1953): 28.

36. White, "Photographs in Boxes," 23.

37. White, "The Educated Audience," 3.

38. White, review of *Japan,* by Werner Bischof, *Aperture* 3:3 (1955): 33, 34.

39. White, review of *The Decisive Moment,* by Henri Cartier-Bresson, *Aperture* 1:4 (1953): 42.

40. White, review of *New York,* by William Klein, *Image* 6:7 (1957): 174.

41. White, review of *Les Americains,* 127.

42. Downes and White, "Photography Redefined," 77.

43. White, "Equivalence: The Perennial Trend," in *Photographers on Photography,* ed. Lyons, 173. See also White, "A Name for It," *Aperture* 3:4 (1955): 35–36.

44. White wrote about letting the subject dictate composition in, "Your Concepts Are Showing," 294. Scholars who have analyzed White's pictures in terms of abstract painting are Janet E. Buerger, "Minor White (1908–1976): The Significance of Formal Quality in his Photographs," *Image* 19:3 (1976), 20–32, and John Pultz, "Equivalence, Symbolism, and Minor White's Way into the Language of Photography," *Princeton Museum Record* 39:1–2 (1980), 28–39.

45. White and Chappell, "Some Methods for Experiencing Photographs," 165.

46. White, "Lyrical and Accurate," 13, 10.

47. Myron Martin [Minor White], "Of People and for People," *Aperture* 4:4 (1956): 140.

48. Smith et al., "The Experience of Photographs," 130.

49. White acknowledged Smith's influence on his own attitudes toward technique in a letter of 1 March 1961, which is quoted by Smith in "Aperture," letter to the editor, *Afterimage* 7 (summer 1979): 2. White acknowledged Smith's influence on the technical experimentation of young photographers in a letter to Smith of 18 March 1968, Henry Holmes Smith Collection, Center for Creative Photography, University of Arizona, Tucson.

50. White, "Be-ing Without Clothes," 86.

51. White, "Amateur Photocriticism," 62, 63.

52. White, "Call for Critics," 5.

53. Szarkowski, *Mirrors and Windows,* 21.

54. Smith, "Reading the Photograph," in *On Photography* (Bloomington, Ind., 1953).

55. White to Smith, 8 February 1953, Henry Holmes Smith Collection, Center for Creative Photography, University of Arizona, Tucson.

56. A letter from White to Smith of 9 December 1955 refers to Smith's idea of publishing readings of the same photographs by more than one person. Henry Holmes Smith Collection, Center for Creative Photography, University of Arizona, Tucson. Smith used Richards's procedures at the first workshop at Indiana University in the summer of 1956. He reported on this in "Image, Obscurity, and Interpretation," *Aperture* 5:4 (1957): 136–47.

57. Smith, "Aperture," 2.

58. White and Chappell, "Some Methods for Experiencing Photographs," 161, 171.

'59. Ibid., 171.

60. Ibid., 169.

61. White, "A Motivation for American Photographers," 123.

62. Mann and Ehrlich, "The Exhibition of Photographs: Northern California," 16; White, "A Balance for Violence," 1.

63. White, Editorial on over-population, 91.

64. White, "A Balance for Violence," 1.

65. Smith et al., "The Experience of Photographs," 121.

66. Ibid.

67. Aaron Siskind to Henry Holmes Smith, [1958?]; Henry Holmes Smith Collection, Center for Creative Photography, University of Arizona, Tucson. White published the picture in "On the Strength of a Mirage," 55. He titled the Siskind photograph *Pertaining to Change.*

68. Smith et al., "The Experience of Photographs," 129.

69. Miller is quoted by M. H. Abrams in "The Deconstructive Angel," in *Modern Criticism and Theory,* ed. David Lodge (New York: Longman, 1988), 267.

70. White, "Extended Perception through Photography and Suggestion," 35.

71. White, "Varieties of Responses to Photographs," 117.

72. Prediction of responses is the main issue in White, "Varieties of Responses to Photographs."

73. Barthes, "Rhetoric of the Image," in *Image Music Text,* 46.

74. White, "Extended Perception through Photography and Suggestion," 44.

75. Barthes, "The Death of the Author," in *Image Music Text,* 146. Barthes's idea of the death of the author has been applied to photography by Douglas Crimp in "The Photographic Activity of Postmodernism," and by Rosalind Krauss in "The Originality of the Avant-Garde: A Postmodernist Repetition," *October* 18 (fall 1981): 47–66.

76. White, "Silence of Seeing," in *One Hundred Years of Photographic History,* ed. Coke, 172.

77. Ibid.

78. Ward, *The Criticism of Photography As Art,* 23, 24.

79. Hattersley, "How to 'Read' a Photograph," *Popular Photography* 42 (March 1958): 104.

80. Burgin, "Photography, Phantasy, Function," in *Thinking Photography,* ed. Burgin, 177–216.

81. White, "Te Deum Zeitgeist Drift," *Aperture* 11:2 (1964): 47, 48.

82. Coleman and White, "Debate," 37, 38.

83. Ibid., 45.

84. White, "The Pursuit of Personal Vision," *Aperture* 4:1 (1956): 3.

85. Hattersley, *Discover Your Self through Photography,* 76.

86. Ibid., 156.

87. White, "Exercises to Meet and Deflate Your Ego By," review of *Discover Your Self through Photography,* by Ralph Hattersley, *The New York Times,* 3 September 1972, sec. 2, p. 15.

88. Hattersley, *Discover Your Self through Photography,* 304.

89. Ibid., 10.

90. Ibid., 79.

91. Ibid., 213.

92. A source of biographical information on Lyons is an interview by Thomas Dugan 33-45.

93. Lyons, interview by Alex Sweetman, 11.

94. Ibid., 3.

95. Ibid.

96. Lyons, "the outline of its mountains, will be made familiar to us," in *The Great*

West: *Real/Ideal* (Boulder: Department of Fine Arts, University of Colorado, 1977).

97. Lyons, *Photography in the Twentieth Century,* viii.

98. Lyons, review of *Form and Art in Nature,* ed. George Schmidt and Robert Schenk, *Aperture* 9:1 (1961): 40.

99. Lyons, "The Workshop Idea in Photography," *Aperture* 9:4 (1961): 163.

100. Lyons, interview by Alex Sweetman, 8.

101. Lyons, Labrot, and Chappell, *Under the Sun.*

102. Lyons, interview by Alex Sweetman, 8.

103. Lyons, *Toward a Social Landscape,* 5–6.

104. Lyons, "Photographic Books," in *Encyclopedia of Photography,* vol. 14 (New York: Greystone Press, 1963), 2682.

105. Lyons, "Critic's Choice," *Popular Photography* 57 (September 1965): 61.

106. Ibid., 105.

107. Lyons, interview by Dugan, 44.

108. Lyons, "Symposium on Photography 2," 22.

109. Pei is quoted by Lyons in "Symposium," 19.

110. Ibid., 18.

111. Lyons, interview by Dugan, 37. Lyons also expressed skepticism about the verbal interpretation of photographs in "The Workshop Idea in Photography" and in *Vision and Expression.*

112. Lyons, "An Interview with Nathan Lyons."

113. Henry Holmes Smith, "XI Zero in Photography," in *Collected Writings,* 66.

114. Ibid.

115. A good source of biographical information on Smith is Bossen, *Henry Holmes Smith: Man of Light.*

116. Smith, "My Year with Moholy-Nagy: A Brief Memoir," 1976, *The Complete Available Writings of Henry Holmes Smith,* compiled by Dru Shipman (Bloomington: Indiana University Art Library), typescript, 3.

117. Smith told more than once of how he came across this book in 1933, and how deeply it influenced him. See interview by Hill and Cooper, 137–43, and interview by Hedgpeth and Morey, 3–6. Smith has also written that *The New Vision* had a more enduring influence on him than his actual contact with Moholy in the hectic atmosphere of the new school. Nevertheless, Smith called Moholy "a great man, a man of magic energy and generous to me as few others outside my family have been." "Statement Accompanying First Major West Coast Exhibition, September 1972 at Phos Graphos Gallery, San Francisco," *The Complete Available Writings of Henry Holmes Smith,* compiled by Dru Shipman (Bloomington: Indiana University Art Library), typescript.

118. Smith, "My Year with Moholy-Nagy," *The Complete Available Writings of Henry Holmes Smith,* compiled by Dru Shipman (Bloomington: Indiana University Art Library), typescript, p. 5.

119. Jack Welpott, "Yesterday I Lost a Friend (A Tribute to Henry Holmes Smith)," *Photo Metro* 4 (May 1986): 21.

120. Smith, "Photography in Our Time," in *Collected Writings,* 71.

121. Smith, "Museum Taste and the Taste of Our Time," in *Collected Writings,* 78.

122. Smith, "Across the Atlantic and Out of the Woods," and "New Figures in a Classic Tradition," both in *Collected Writings,* 134–35, 92–93.

123. Smith, "The WASP Esthetic and the Vanishing Photograph," 1972, Henry Holmes Smith Papers, Center for Creative Photography, University of Arizona, Tucson, typescript, p. 1. For a more explicit association of this aesthetic with straight photography see "Improving My Criticism, 1970," in *Collected Writings,* 103.

124. Laszlo Moholy-Nagy, "Photography Is Manipulation of Light," in Andreas Haus, *Moholy-Nagy: Photographs and Photograms,* trans. Frederic Samson (New York: Pantheon Books, 1980), 47.

125. Smith developed his definition of photography in several places: "Light Study, 1947," in *Collected Writings,* 7–17; "Visual Communication," 1950, Henry Holmes Smith Papers, Center for Creative Photography, University of Arizona, Tucson, typescript; and "Photography: Its Undiscovered Arts, 1968–1973," in *Collected Writings,* 109–13.

126. Smith, "Photography: Its Undiscovered Arts," in *Collected Writings,* 110.

127. Smith, "Representation in Photography," *Quartet* 2 (winter 1963).

128. Weston La Barre, *The Ghost Dance,* (Garden City, N.Y.: Doubleday, 1970). Smith wrote of his agreement with La Barre's ideas in a letter to the author.

129. Smith, "Improving My Criticism," in *Collected Writings,* 103.

130. Hicks and Smith, "Photographs and Public," 9–10. A different version of this essay is reprinted under the title "The Photograph and Its Readers, 1953," in *Collected Writings.* All references to this article are to the version in *Aperture.*

131. Smith, "Image, Obscurity, and Interpretation," in *Collected Writings,* 51.

132. Wilson Hicks, "Photographs and Public," 7.

133. Smith, "Communication through the Photographic Image: The Role of the Imagination," *National Photographer,* suppl. to vol. 9 (1958): 64.

134. Smith, "The Fiction of Fact and Vice Versa," in *Collected Writings,* 77.

135. Ibid., 75–76.

136. Smith, "Image, Obscurity, and Interpretation," in *Collected Writings,* 57.

137. Smith, "Iconography in the Abstract, 1956–1985," in *Collected Writings,* 34.

138. Smith, "Image, Obscurity, and Interpretation," in *Collected Writings,* 58.

139. Smith to Siskind, 14 March 1958, Henry Holmes Smith Papers, Center for Creative Photography, University of Arizona, Tucson.

140. Smith, "Iconography in the Abstract, 1956–1985," in *Collected Writings,* 42, 47.

141. Smith, "Visual Communication," Henry Holmes Smith Papers, Center for Creative Photography, University of Arizona, Tucson, typescript, p. 7A.

142. Erwin Panofsky, "Iconography and Iconology: An Introduction to the Study of Renaissance Art," in *Meaning in the Visual Arts* (Garden City, N.Y.: Doubleday Anchor Books, 1955), 40–41.

143. Smith et al., "The Experience of Photographs," 118. The definitions of visual forms are reprinted in Smith, *Collected Writings* as "A Note on Photographic Form," 47–50.

144. Burgin, "Photographic Practice and Art Theory," in *Thinking Photography,* 82. This article is a good summary of efforts to assimilate photography to linguistics and semiotics, taking into account the work of several theorists such as Roland Barthes, Umberto Eco, and Jacques Durand.

145. Ibid., 41, 46.

146. Arnheim, "A Plea for Visual Thinking," in *New Essays on the Psychology of Art,* (Berkeley: University of California Press, 1986), 139, 138.

147. Sekula, "The Traffic in Photographs," in *Photography against the Grain,* 81.

148. Smith et al., "The Experience of Photographs," 118.

149. Smith, "Iconography in the Abstract," in *Collected Writings,* 33, 34, 36.

150. Kuhn is quoted by Smith in "Models for Critics," in *Collected Writings,* 124.

151. Smith, "An Access of American Sensibility," 3.

152. Smith, "Across the Atlantic and Out of the Woods," in *Collected Writings,* 133.

153. Smith, "An Access of American Sensibility," 3.

154. Smith, "What Have the Old to Tell the Young?" in *Collected Writings,* 149.

155. Smith, "The Academic Camera Club," in *Collected Writings,* 162.

156. Smith, "What Have the Old to Tell the Young?" in *Collected Writings,* 168.

157. See Arthur Danto, "The End of Art," in *The Philosophical Disenfranchisement of Art* (New York: Columbia University Press, 1986), 81–115.

158. Smith, "The WASP Esthetic and the Vanishing Photograph," Henry Holmes Smith

Papers, Center for Creative Photography, University of Arizona, Tucson, typescript, p. 6.

159. Smith, "Critical Difficulties," 18.

160. La Barre, *The Ghost Dance,* 351.

161. William H. Rueckert, *Kenneth Burke and the Drama of Human Relations,* 2d ed. (Berkeley: University of California Press, 1982) 34–63.

162. Smith may have been responding once more to Burke. Rueckert described Burke's idea of the social role of the poet and the critic as follows: "A wise man, prophet, and medicine man, the poet will perform those charismatic symbolic acts which are the means of man's salvation; priest-like, the critic will mediate between the redeemers and those seeking redemption, interpreting the holy texts and preaching the gospel of the new secular religion." *Kenneth Burke,* 63.

163. Smith, "Critical Difficulties," 17, 18, 19.

164. Smith is quoted in an interview by Hedgpeth and Morey, 9.

165. Smith, "Critical Difficulties," 17.

166. Smith, "Afternote, 1985," in *Collected Writings,* 169.

Chapter 6

1. Margery Mann, "The Controversial Aaron Siskind," 16.

2. Mann, "View From the Bay: In Siskind's Vision," 23.

3. Mann, "Photography [The Photographer and the American Landscape]," *Artforum* 4 (October 1965): 47–48; "West: It Did Happen Here," 24.

4. Mann, introduction in Cunningham, *Imogen Cunningham: Photographs.*

5. Mann, "Photography [On the state of Bay Area photography]," 74.

6. Mann, "Photography [various reviews]," *Artforum* 3 (September 1964): 50–51.

7. Mann, "Photography [Walnut Grove: Portrait of a Town]," *Artforum* 2 (May 1964): 20.

8. Mann and Erhlich, "The Exhibition of Photographs," 13, 17.

9. Mann, "Photography [On the Friends of Photography Gallery]," 67.

10. Mann, "Photography [Ruth Bernhard]," *Artforum* 5 (November 1966): 61. See also "Photography [Ideas in Images]," *Artforum* 2 (March 1964): 54; and "Photography [various reviews]," *Artforum* 4 (December 1965): 57.

11. Mann, "Photography [Ansel Adams]," *Artforum* 2 (December 1963): 55.

12. Mann, "'In the Midst of Life We Are in Death,' Wynn Bullock," *Popular Photography* 67 (July 1970): 132.

13. Mann, "Photography [The Henry F. Swift Collection of Photographs by the f/64 Group]," *Artforum* 2 (November 1963): 53.

14. Mann, "View From the Bay: Revolutions in Medium—But What About Message?" *Popular Photography* 67 (August 1970): 25.

15. Mann, "View From the Bay: Ansel Adams Revisited: Something Old, Something New," *Popular Photography* 68 (May 1971): 49.

16. Mann, "View From the Bay: SRO for Uelsmann, Davidson at S.F. Museum of Art," *Popular Photography* 65 (September 1969): 116.

17. Mann, "Photography [The World of Werner Bischof]," *Artforum* 2 (September 1963): 60; "Photography [Ideas in Images]," 54.

18. Mann and Erhlich, "The Exhibition of Photographs," 17.

19. Mann, "Frederick Sommer," *Popular Photography* 65 (October 1969): 82, 133.

20. "Photography [On the Friends of Photography Gallery]," 68.

21. "Photography [various reviews]," *Artforum* 4 (December 1965), 57.

22. Mann, "Photography [review of *The Sweet Flypaper of Life*]," 72.

23. Ibid., 73.

24. Mann, "View From the Bay: A Modern Challenge: Pictures That Persuade and Convince," *Popular Photography* 68 (March 1971): 117.

25. Mann, "Can Whitey Do a Beautiful Black Picture Show?" 82, 137.

26. Mann, "Photography [review of 'Don't Cry for Me Babey']," *Artforum* 5 (December 1966): 67.

27. Mann, "West: Lange Mislabeled," 20.

28. Thalia Gouma-Peterson and Patricia Mathews, "The Feminist Critique of Art History," *Art Bulletin* 69 (September 1987): 326–27, 346.

29. Mann, "West: It Did Happen Here," 24, 65–66.

30. Mann, "West: Much Ado . . ." 17.

31. Mann, "West: The Emperor's New Game," 12.

Chapter 7

1. Jonathan Green, *American Photography,* 96. Green makes an insightful analysis of Szarkowski's theory, as does Christopher Phillips in "The Judgment Seat of Photography."

2. White, review of *The Face of Minnesota,* by John Szarkowski, *Aperture* 6:2 (1958): 94.

3. For a biographical sketch of Szarkowski, see Sean Callahan, "The First Viceroy of Photography."

4. Szarkowski, "Photography and the Mass Media," 182.

5. Szarkowski discusses these distinctions in "A Different Kind of Art." He says that photography is analytic and painting, synthetic. He also distinguishes photography from literature on the grounds that photographs cannot be narrative. Describing the unique qualities of photography he says, "It is mechanically quick and easy, and it is the best method so far devised for the precise description of the most complex, specific, private, and ephemeral matters of visual experience" (64).

6. Irving Sandler, *American Art of the 1960s* (New York: Harper and Row, 1988), 60–88.

7. Letter to the author.

8. Ibid. Szarkowski mentioned the influence of George Kubler's book, *The Shape of Time* (New Haven: Yale University Press, 1962).

9. Szarkowski, *The Idea of Louis Sullivan,* 26.

10. Szarkowski, *Photography Until Now,* 9.

11. Szarkowski, "Photography and the Mass Media," 182.

12. Szarkowski, *Mirrors and Windows,* 13.

13. Bruce Downes, in his own way, also entertained the idea of a universal vision of photography that would transcend the boundaries between art, snapshots, etc.: "But photography, like life itself, is a unity, a vast and sprawling thing of infinite variety. . . . But whether art or not, it is all, every last fixed and washed vestige of a print of it— Photography!" ". . . this is PHOTOGRAPHY," *Popular Photography* 15 (November 1944): 53

14. Szarkowski, "A Different Kind of Art," 64.

15. Szarkowski, ed., *From the Picture Press,* 4, 6.

16. Szarkowski, in *Photography within the Humanities,* ed. Janis and MacNeil, 83–84.

17. Szarkowski, *Photography Until Now,* 228.

18. Szarkowski, *William Eggleston's Guide,* 13.

19. Ibid., 6.

20. White, review of *The Face of Minnesota,* 94.

21. White, review of "The Photographer and the American Landscape," 54, 55.

22. Szarkowski, review of *Mirrors Messages Manifestations, The New York Times Book Review,* 8 March 1970, pp. 6, 33.

23. Szarkowski, *The Photographer's Eye,* 6, 7.

24. Clement Greenberg, "Modernist Painting," in *Modern Art and Modernism: A Critical Anthology,* ed. Francis Frascina and Charles Harrison (New York: Harper and Row, 1982), 6.

25. Szarkowski, *Looking at Photographs,* 88.

26. Szarkowski, *The Photographer's Eye,* 8, 11. Szarkowski rehearsed many of the

ideas in *The Photographer's Eye* in Szarkowski et al., "A Symposium on Photographic Style," using the discovery and exploitation of the formal qualities of straight photography to correspond to a Wölfflinian notion of a history of seeing as it applies to an evolving period style.

27. Szarkowski, "The Photographs of Jacques Henri Lartigue," *Bulletin of the Museum of Modern Art* 30:1 (1963): 4.

28. Szarkowski, *Mirrors and Windows,* 24.

29. Szarkowski, *The Photographer's Eye,* 10.

30. Szarkowski, *Photography Until Now,* 11–19.

31. Szarkowski, *Looking at Photographs,* 182.

32. Szarkowski, "The Photographs of Jacques Henri Lartigue," 4.

33. Szarkowski, *The Photographer and the American Landscape,* 3.

34. Szarkowski, *American Landscapes* (New York: Museum of Modern Art, 1981), 9. Alan Trachtenberg discusses the question of whether O'Sullivan should be considered an artist. See "Naming the View," in *Reading American Photographs* (New York: Hill and Wang, 1989), esp. 127–32. Dingus's findings appear in *The Photographic Artifacts of Timothy O'Sullivan* (Albuquerque: University of New Mexico Press, 1982), xiii, 29, 49.

35. Szarkowski, "August Sander," 23.

36. Szarkowski, "American Photography and the Frontier Tradition," 104.

37. Szarkowski, introduction in Evans, *Walker Evans,* 13.

38. Szarkowski mentioned Kouwenhoven's influence on him in his acknowledgments for *The Photographer's Eye.* Kouwenhoven is quoted from his book *Made in America* (Garden City, N.Y.: Doubleday, 1948), 15. The hero of Kouwenhoven's book, the independent mechanic, is something of a myth to begin with as Anthony Wallace has demonstrated in *Rockdale: The Growth of an American Village in the Early Industrial Revolution* (New York: Knopf, 1978). Alan Trachtenberg has also undermined the image of the unself-conscious inventor/folk artist in *The Incorporation of America* (New York: Hill and Wang, 1982), 65–68.

39. Szarkowski, "American Photography and the Frontier Tradition," 99.

40. Turner saw the frontier as a place of great freedom and social experimentation, but historians have largely concluded that those who settled on the frontier were actually intent on transplanting and reconstructing the values and institutions they had known in the east or in Europe. See Robert E. Riegel and Robert G. Athearn, *America Moves West,* 4th ed. (New York: Holt, Rinehart and Winston, 1964), 629–33.

41. Szarkowski, "The Photography Collection of The Museum of Modern Art," in *20th-Century Photographs from the Museum of Modern Art* (New York: Museum of Modern Art, 1982).

42. See Callahan, "The First Viceroy of Photography"; Maren Stange, "Photography and the Institution"; Szarkowski, interview by Andy Grundberg; Szarkowski, interview by Michael Kimmelman.

43. Szarkowski, *Looking at Photographs,* 116.

44. Szarkowski is quoted by Stange in "Photography and the Institution," 701. One hears in Szarkowski's statement the influence of George Kubler's idea of formal sequences: "Every important work of art can be regarded both as a historical event and as a hard-won solution to some problem. . . . As the solutions accumulate, the problem alters. The chain of solutions nevertheless discloses the problem." *The Shape of Time,* 33.

45. Szarkowski, *Looking at Photographs,* 204.

46. Ibid. 34, 92.

47. Ibid., 48.

48. Ibid., 186, 208.

49. Szarkowski, "A Different Kind of Art," 65, 66. The idea of the unity of form and content is not new with Szarkowski. It was articulated by Benedetto Croce in *Aesthetic As*

Science of Expression and General Linguistic, 2d ed., trans. Douglas Ainslie (London: Macmillan, 1922), 67–73.

50. Szarkowski, *William Eggleston's Guide,* 12, 14.

51. Szarkowski and Hambourg, *The Work of Atget,* vol. 1, *Old France,* 12.

52. Michael Baxandall, *Patterns of Intention,* (New Haven: Yale University Press, 1985), 10–11.

53. Szarkowski, *Mirrors and Windows,* 17.

54. Ibid., 18–19.

55. Gene Thornton, "Murky," 26.

56. Szarkowski, *Mirrors and Windows,* 13.

57. Howard Chapnick, "Markets and Careers," review of *Mirrors and Windows, Popular Photography* 83 (November 1978): 90, 92.

58. Leo Rubinfien, "Reflections on *Mirrors and Windows," Art in America* 67 (January 1979): 38.

59. Thornton, "Murky," 28.

60. Coleman, "Not Seeing Atget for the Trees," in *Light Readings,* 111.

61. Hare, *This Was Corporate America,* 8–9.

62. Solomon-Godeau, "Photography after Art Photography," in *Art after Modernism,* ed. Brian Wallis, 75.

63. Szarkowski, *Photography Until Now,* 232, 272–76.

64. Ibid., 281.

65. Ibid., 291, 293.

66. Henry, "Gene Thornton—Photography Today," 1.

67. Thornton, "Murky," 28.

68. Thornton, "Post-Modern Photography," 67.

69. Thornton, "The New Photography," 76.

70. Thornton, "Photography View: Penn Transforms Cigarette Butts into Works of Art," *The New York Times,* 6 July 1975, sec. 2, p. 21.

71. Thornton discussed Wessel in "Drama with His Camera," *The New York Times,* 29 October 1972, sec. 2, p. 36. He reviewed Friedlander in "Personal Encounters," *The Saturday Review,* 2 December 1972, 66; Feldstein in "Photography View: Acrobatics vs. Pastoral Poetry," *The New York Times,* Sec. 2, 24 April 1977, p. 36; the comments on Siskind appear in "Avedon's Father, Adams' Nature, Siskind's Homage," *The New York Times,* 12 May 1974, sec. 2, p. 29.

72. Thornton, "Frank's Dilemma," *The New York Times,* 20 August 1972, sec. 2, p. 13.

73. Thornton's praise for Uelsmann appears in "Photography View: New Focus on an Old Idea," *The New York Times,* 14 September 1975, sec. 2, p. 31. His critique of private visions appears in "How Far Must We Go to Understand Them?" 26.

74. Thornton praised Smith in "Photography View: Minamata Victims Transformed," *The New York Times,* 11 May 1975, sec. 2, p. 31; the comments on Arbus appear in "Avedon's Father, Adams' Nature, Siskind's Homage," 29; Clark is reviewed in "Photography View: Practitioners with a Story to Tell," *The New York Times,* 30 September 1979, sec. 2, p. 31.

75. Thornton, *Masters of the Camera,* 7.

76. Thornton, "How Far Must We Go to Understand Them?" 26.

77. The indirect reference to Szarkowski's influence at MOMA appears in Thornton, *Masters of the Camera,* 25.

78. Thornton, "Photographis '77," 133.

79. Thornton, "Photography View: Fashion Pictures Taken Seriously," 36.

80. Thornton, "Photography View: When Scientists Take the Shots," *The New York Times,* 14 January 1979, sec. 2, pp. 27, 32.

81. Thornton, "Gypsies and Girl Watching," *Art News* (February 1976):96.

Notes

82. Thornton, "Photography View: How Display Selection May Distort Artistic Intent," *The New York Times,* 13 February 1977, sec. 2, pp. 33–34; "Photography View: Deepening the Definition of the Art," 21.

83. Thornton, "Photography View: Documentary Photos without Captions Leave Us in the Dark," *The New York Times,* 6 April 1975, sec. 2, p. 29.

84. Thornton, "Photography View: Lynes's Surrealist Jokes and Vishniac's Sympathetic Studies," *The New York Times,* 10 April 1977, sec. 2, p. 29.

85. Thornton is quoted by Henry in "Gene Thornton—Photography Today," 5.

86. Thornton, "Post-Modern Photography," 64–68.

Conclusion

1. Sekula, "Dismantling Modernism, Reinventing Documentary," in *Photography against the Grain,* 57.

2. A. D. Coleman, "Because It Feels So Good When I Stop," in *Light Readings,* 204.

3. Coleman, "Where's the Money?" in *Light Readings,* 219.

4. Coleman, "New Japanese Photography," in *Light Readings,* 175.

5. See Coleman, "Roy DeCarava: 'Thru Black Eyes,'" in *Light Readings,* 18–28. Coleman also wrote about photographers he thought DeCarava had influenced, such as Fundi and Beauford Smith, and he attempted to define a school of black photography as it descended from DeCarava.

6. Coleman, "Bruce Davidson: *East 100th Street,*" in *Light Readings,* 48.

7. Ibid., 45–46.

8. Coleman, "Richard Kirstel (2): Is This the Scopes Trial of Photography?" and "No Future for You? Speculations on the Next Decade in Photography Education," both in *Light Readings,* 54, 279.

9. Coleman, "Shouldn't We Be More Concerned?" in *Light Readings,* 156.

10. Coleman, "Jan Van Raay," in *Light Readings,* 70.

11. Coleman, "A Manifesto for Photography Education," in *Light Readings,* 89.

12. Coleman, "Robert Delford Brown," in *Light Readings,* 131–32.

13. Coleman, "Because It Feels So Good When I Stop," in *Light Readings,* 203.

14. Coleman, "My Camera in the Olive Grove," in *Light Readings,* 196, 200–201.

15. Coleman, "No Future for You?" in *Light Readings,* 275–76.

16. Coleman, "Robert Delford Brown," in *Light Readings,* 130.

17. Coleman, "Jan Van Raay," in *Light Readings,* 69.

18. Coleman, "*Life* May Have Died, But Photography Lives On," in *Light Readings,* 136.

19. Coleman, "Bob Adelman and Susan Hall: *Down Home,*" in *Light Readings,* 128.

20. Coleman, "Michael Abramson: *Palante,*" in *Light Readings,* 82–85.

21. Coleman, "Danny Lyon and Geoff Winningham," in *Light Readings,* 95.

22. Ibid., 93–94.

23. Coleman, "Bruce Davidson," in *Light Readings,* 47.

24. Coleman, "Roy DeCarava," in *Light Readings,* 19, 23.

25. Coleman, "Judy Dater," in *Light Readings,* 107.

26. Coleman, "The Indigenous Vision of Manuel Alvarez Bravo," in *Light Readings,* 222.

27. Coleman, "Jerry Uelsmann (2)," in *Light Readings,* 57.

28. Coleman, "Lucas Samaras and Les Krims," in *Light Readings,* 241.

29. Coleman, "Photography into Sculpture," in *Light Readings,* 29.

30. Coleman, "Jerry Uelsmann (2)," in *Light Readings,* 56.

31. Coleman, "Duane Michals (2): *The Journey of the Spirit after Death,*" and "Ralph Gibson: *Deja-Vu,*" both in *Light Readings,* 101–2, 137–40.

32. Coleman, "The Directorial Mode," in *Light Readings,* 246–57.

33. Coleman, "'From Today, Painting Is Dead': A Requiem," in *Light Readings,* 182–88.

34. Coleman, "Photography and Conceptual Art," in *Light Readings,* 73.

35. Coleman, "Reinventing Photography," in *Light Readings,* 194.

36. Sontag, *On Photography,* 39–40.

37. Thornton, "Susan Sontag's Unwelcome Truth," *Art News* 77 (February 1978): 130–31; Smith, "Is the Sky Really Falling?" in *Collected Writings,* 161.

38. Green, *American Photography,* 194.

39. Sontag, *On Photography,* 178.

40. Ibid., 106.

41. Ibid., 23.

42. Green argues that although Sontag denied the meaningfulness of the purely visual quality of photographs, she also responded to it. See Green, *American Photography,* 199–200.

43. Sontag, *On Photography,* 24.

44. Ibid., 131–44.

45. Ibid., 21.

46. Sekula, "On the Invention of Photographic Meaning," in Burgin, *Thinking Photography,* 91.

47. Ibid., 84–85.

48. Ibid., 100.

49. Sekula, "Dismantling Modernism," in *Photography against the Grain,* 53–54.

50. Ibid., 56, 57, 60.

51. Sontag discusses the logic by which everything becomes material for the camera in *On Photography,* 175–80.

52. Solomon-Godeau, "Playing in the Fields of the Image," 10.

53. Solomon-Godeau, "Winning the Game," 8, 11.

54. Crimp, "Appropriating Appropriation," 27.

55. Solomon-Godeau, "Winning the Game," 6.

56. Solomon-Godeau, "Winning the Game," 7–8.

57. Crimp, "The Photographic Activity of Postmodernism," 94.

58. Solomon-Godeau, "Winning the Game," 12–13.

59. Andre, "The Politics of Postmodern Photography," 14. Andre's article is a thorough critique of appropriationist theory.

60. Sekula, "On the Invention of Photographic Meaning," in Burgin, *Thinking Photography,* 85.

61. Arthur Danto, "Animals As Art Historians," in *Beyond the Brillo Box: The Visual Arts in Post-Historical Perspective* (New York: Farrar Straus Giroux, 1992), 15–31.

62. Ellen Dissanayake, *What Is Art For?* (Seattle: University of Washington Press, 1988), 146.

SELECT BIBLIOGRAPHY

Books and Exhibition Catalogues

Abbott, Berenice. *Changing New York.* Text by Elizabeth McCausland. 1939. Reprint, *New York in the Thirties,* New York: Dover, 1973.

Adams, Ansel. *Ansel Adams: Letters and Images, 1916–1984.* Edited by Mary Street Alinder and Andrea Gray Stillman. Boston: New York Graphic Society, 1988.

Adams, Ansel, with Mary Street Alinder. *Ansel Adams: An Autobiography.* Boston: Little, Brown, 1985.

Agee, James, and Walker Evans. *Let Us Now Praise Famous Men.* Boston: Houghton Mifflin, 1960.

Alexander, William. *Film on the Left.* Princeton: Princeton University Press, 1981.

Barrow, Thomas F., Shelley Armitage, and William E. Tydeman, eds. *Reading into Photography.* Albuquerque: University of New Mexico Press, 1982.

Barthes, Roland. *Image Music Text.* Translated by Stephen Heath. New York: Hill and Wang, 1977.

Bossen, Howard. *Henry Holmes Smith: Man of Light.* Studies in Photography, no. 1. Ann Arbor, Mich.: UMI Research Press, 1983.

Bunnell, Peter C. *Minor White: The Eye That Shapes.* Boston: Little, Brown, 1989.

———, ed. *A Photographic Vision: Pictorial Photography, 1889–1923.* Salt Lake City: Peregrine Smith, 1980.

Burgin, Victor, ed. *Thinking Photography.* London: Macmillan, 1982.

Caffin, Charles. *Art for Life's Sake.* New York: Prang, 1913.

———. *Photography As a Fine Art.* Facsimile. Hastings-on-Hudson: Morgan and Morgan, 1971.

Chiarenza, Carl. *Aaron Siskind: Pleasures and Terrors.* Boston: New York Graphic Society, 1982.

Coke, Van Deren, ed. *One Hundred Years of Photographic History: Essays in Honor of Beaumont Newhall.* Albuquerque: University of New Mexico Press, 1975.

Coke, Van Deren, with Diana C. Du Pont. *Photography: A Facet of Modernism.* New York: Hudson Hills, 1986.

Coleman, A. D. *Light Readings.* New York: Oxford University Press, 1979.

Crawford, William. *The Keepers of Light.* Dobbs Ferry, N.Y.: Morgan and Morgan, 1979.

Cunningham, Imogen. *Imogen! Imogen Cunningham Photographs, 1910–1973.* Introduction by Margery Mann. Seattle: University of Washington Press, 1974.

———. *Imogen Cunningham: Photographs.* Introduction by Margery Mann. Seattle: University of Washington Press, 1970.

Curtis, James C. *Mind's Eye, Mind's Truth: FSA Photography Reconsidered.* Philadelphia: Temple University Press, 1989.

Deschin, Jacob. *Say It with Your Camera.* New York: Whittlesey House, 1950.

Doty, Robert. *Photo-Secession: Stieglitz and the Fine-Art Movement in Photography.* New York: Dover, 1978.

Emerson, Peter Henry. *Naturalistic Photography for Students of the Art.* 1889. Reprint, New York: Arno Press, 1973.

Evans, Walker. *American Photographs.* Essay by Lincoln Kirstein. New York: Museum of Modern Art, 1938.

———. *Walker Evans.* Introduction by John Szarkowski. New York: Museum of Modern Art, 1971.

Frank, Waldo, Lewis Mumford, Dorothy Norman, Paul Rosenfeld, and Harold Rugg, eds. *America and Alfred Stieglitz: A Collective Portrait.* New York: Literary Guild, 1934.

Fulton, Marianne. *The Eyes of Time: Photojournalism in America.* Boston: New York Graphic Society, 1988.

Gassan, Arnold. *Report: Minor White Workshops and a Dialogue Failed.* Sun Prairie, Wisc.: Baumgartner, 1983.

Gee, Helen. *Photography of the Fifties.* Tucson: Center for Creative Photography, University of Arizona, 1980.

Green, Jonathan. *American Photography: A Critical History 1945 to the Present.* New York: Harry N. Abrams, 1984.

———, ed. *Camera Work: A Critical Anthology.* Millerton, N.Y.: Aperture, 1973.

Greenough, Sarah, and Juan Hamilton. *Alfred Stieglitz: Photographs and Writings.* Washington, D.C.: National Gallery of Art, 1983.

Grundberg, Andy, and Kathleen McCarthy Gauss. *Photography and Art: Interactions since 1846.* New York: Abbeville, 1987.

Hare, Chauncey. *This Was Corporate America.* Boston: Institute of Contemporary Art, 1984.

Hartmann, Sadakichi. *The Valiant Knights of Daguerre.* Edited by Harry W. Lawton and George Knox. Berkeley: University of California Press, 1978.

Hatterlsey, Ralph. *Discover Your Self through Photography.* Dobbs Ferry, N.Y.: Morgan and Morgan, 1976.

Hicks, Wilson. *Words and Pictures.* New York: Harper, 1952.

Holborn, Mark, ed. *Minor White: A Living Remembrance.* Millerton, N.Y.: Aperture, 1984.

Homer, William Innes. *Alfred Stieglitz and the American Avant-Garde.* Boston: New York Graphic Society, 1977.

———. *Alfred Stieglitz and the Photo-Secession.* Boston: New York Graphic Society, 1983.

Hurley, F. Jack. *Portrait of a Decade.* New York: Da Capo Press, 1977.

Janis, Eugenia Parry, and Wendy MacNeil, eds. *Photography within the Humanities.* Danbury, N.H.: Addison House, 1977.

Levitt, Helen. *A Way of Seeing.* Essay by James Agee. 1946. Reprint, New York: Horizon Press, 1981.

The Life and Times of Sadakichi Hartmann, 1867–1944. Introduction by George Knox. Riverside, Calif.: Rubidoux Printing Co., 1970.

Lowe, Sue Davidson. *Stieglitz: A Memoir/Biography.* New York: Farrar, Straus and Giroux, 1983.

Lyons, Nathan. *Photography in the Twentieth Century.* New York: Horizon Press, 1967.

———. *Toward a Social Landscape.* New York: Horizon Press, 1966.

———, ed. *The Persistence of Vision.* New York: Horizon Press, 1967.

———. *Photographers on Photography.* Englewood Cliffs: Prentice-Hall, 1966.

———. *Vision and Expression.* New York: Horizon Press, 1969.

Lyons, Nathan, Syl Labrot, and Walter Chappell. *Under the Sun.* New York: George Braziller, 1960.

Maddow, Ben. *Edward Weston: His Life.* New York: Aperture, 1989.

———. *W. Eugene Smith: Let Truth Be the Prejudice.* New York: Aperture, 1985.

Mann, Margery. *California Pictorialism.* San Francisco: San Francisco Museum of Modern Art, 1977.

Moeller, Susan D. *Shooting War.* New York: Basic Books, 1989.

Newhall, Beaumont. *The History of Photography.* Revised ed. New York: Museum of Modern Art, 1982.

———. *Photography, 1839–1937.* New York: Museum of Modern Art, 1937.

Newhall, Beaumont, and Amy Conger, eds. *Edward Weston Omnibus.* Salt Lake City: Peregrine Smith Books, 1984.

Newhall, Nancy. *From Adams to Stieglitz.* Aperture Writer and Artists on Photography Series. New York: Aperture, 1989.

———. *P. H. Emerson.* Millerton, N.Y.: Aperture, 1975.

Norman, Dorothy. *Alfred Stieglitz: An American Seer.* New York: Random House, 1973.

A Pageant of Photography. San Francisco: Golden Gate International Exposition, 1939–1940. San Francisco: Crocker-Union, 1940.

Panzer, Mary. *Philadelphia Naturalistic Photography, 1865–1906.* New Haven: Yale University Art Gallery, 1982.

Peeler, David P. *Hope among Us Yet.* Athens: University of Georgia Press, 1987.

Photo Notes. (February 1938–spring 1950); *Filmfront.* (December 1934–March 1950). Reprint. Edited by Nathan Lyons. Rochester, N.Y.: Visual Studies Workshop Reprint, 1977.

Pultz, John, and Catherine B. Scallen. *Cubism and American Photography, 1910–1930.* Williamstown, Mass.: Sterling and Francine Clark Art Institute, 1981.

Robinson, Henry Peach. *Pictorial Effect in Photography.* 1869. Reprint, Pawlet, Vt.: Helios, 1971.

Roeder, George H. *The Censored War.* New Haven: Yale University Press, 1993.

Root, Marcus A. *The Camera and the Pencil.* 1864. Reprint, Pawlet, Vt.: Helios, 1971.

Rosenblum, Naomi. "Paul Strand: The Early Years, 1910–1932." Ph.D. diss., City University of New York, 1978.

Rudisill, Richard. *Mirror Image: The Influence of the Daguerreotype on American Society.* Albuquerque: University of New Mexico Press, 1971.

Sandburg, Carl. *Steichen the Photographer.* New York: Harcourt, Brace, 1929.

Sekula, Allan. *Photography against the Grain.* Halifax: Nova Scotia College of Art and Design, 1984.

Seligmann, Herbert J. *Alfred Stieglitz Talking.* New Haven: Yale University Press, 1966.

Siskind, Aaron. *Aaron Siskind, Photographer.* Edited and with an introduction by Nathan Lyons, essays by Henry Holmes Smith and Thomas B. Hess. Rochester: George Eastman House, 1965.

———. *Aaron Siskind Photographs.* Essay by Harold Rosenberg. New York: Horizon Press, 1959.

Smith, Henry Holmes. *Henry Holmes Smith: Collected Writings, 1935–1985.* Edited by James Enyeart and Nancy Solomon. Tucson: Center for Creative Photography, University of Arizona, 1986.

Sontag, Susan. *On Photography.* New York: Farrar, Straus and Giroux, 1977.

Stange, Maren. *Symbols of Ideal Life: Social Documentary Photography in America, 1890–1950.* New York: Cambridge University Press, 1989.

Steichen, Edward. *The Family of Man.* New York: Museum of Modern Art, 1955.

———. *A Life in Photography.* Garden City, N.Y.: Doubleday, 1963.

Stott, William. *Documentary Expression and Thirties America.* Chicago: University of Chicago Press, 1986.

Strand, Paul. *Paul Strand: Sixty Years of Photographs.* Millerton: N.Y.: Aperture, 1976.

Stryker, Roy E., and Nancy Wood. *In This Proud Land.* Boston: New York Graphic Society, 1973.

Szarkowski, John. *American Landscapes.* New York: Museum of Modern Art, 1981.

———. *The Face of Minnesota.* Minneapolis: University of Minnesota Press, 1958.

———. *The Idea of Louis Sullivan.* Minneapolis: University of Minnesota Press, 1956.

————. *Looking at Photographs*. New York: Museum of Modern Art, 1973.

————. *Mirrors and Windows: American Photography Since 1960*. New York: Museum of Modern Art, 1978.

————. *The Photographer's Eye*. New York: Museum of Modern Art, 1966.

————. *Photography Until Now*. New York: Museum of Modern Art, 1989.

————. *William Eggleston's Guide*. New York: Museum of Modern Art, 1976.

————. *Winogrand: Figments from the Real World*. New York: Museum of Modern Art, 1988.

————, ed. *From the Picture Press*. New York: Museum of Modern Art, 1973.

————. *The Photographer and the American Landscape*. New York: Museum of Modern Art, 1963.

Szarkowski, John, and Maria Morris Hambourg. *The Work of Atget*. Vol. 1, *Old France*. New York: Museum of Modern Art, 1981.

Thornton, Gene. *Masters of the Camera: Stieglitz, Steichen, and Their Successors*. New York: Holt, Rinehart and Winston, 1976.

Trachtenberg, Alan, ed. *Classic Essays on Photography*. New Haven: Leete's Island Books, 1980.

Tucker, Anne Wilkes, ed. *Robert Frank: New York to Nova Scotia*. Boston: New York Graphic Society, 1986.

Underwood, Sandra Lee. *Charles H. Caffin: A Voice for Modernism, 1897–1918*. Studies in the Fine Arts: Criticism, no. 15. Ann Arbor, Mich.: UMI Research Press, 1983.

Wallis, Brian, ed. *Art after Modernism: Rethinking Representation*. Boston: Godine, 1984.

Ward, John L. *The Criticism of Photography As Art*. Gainesville: University of Florida Press, 1970.

Weston, Edward. *The Daybooks of Edward Weston*. 2 vols. Edited by Nancy Newhall. Millerton, N.Y.: Aperture, 1973.

Women of Photography: An Historical Survey. Essay by Margery Mann. San Francisco: San Francisco Museum of Art, 1975.

Articles and Essays

Adams, Ansel. "An Exposition of My Photographic Technique." *Camera Craft* 41 (January 1934): 19–25; (February 1934): 72–8; (March 1934): 114–22; (April 1934): 173–83.

Adams, Phoebe Lou. "Through a Lens Darkly." Review of *The Family of Man*. *Atlantic* 195 (April 1955).

Agha, M. F. "Horseless Photography." *Harper's Bazaar* 78 (November 1944).

————. "Raphaels without Hands." *Vogue*, 15 June 1941.

Anderson, Sherwood. "Alfred Stieglitz." *The New Republic*, 25 October 1922, 215–17.

Andre, Linda. "The Politics of Postmodern Photography." *Afterimage* 13 (October 1985): 14–17.

Arnheim, Rudolf. "On the Nature of Photography." *Critical Inquiry* 1 (September 1974): 149–61.

Beatty, Jerome, Jr. "The Fulfillment of an Idea." *The Saturday Review*, 16 May 1959.

Benjamin, Walter. "The Work of Art in the Age of Mechanical Reproduction." In *Illuminations*, 217-51. New York: Schocken, 1969.

Brokaw, Clare Boothe. "Edward Steichen, Photographer." *Vanity Fair* 38 (June 1932).

Burgin, Victor. "Something about Photography Theory." In *The New Art History*, edited by A. L. Rees and Frances Borzello, 41–54. Atlantic Highlands, N.J.: Humanities Press International, 1988.

Caffin, Charles. "The Camera Point of View in Painting and Photography." *Camera Work*, no. 24 (October 1908): 23–26.

————. "The Development of Photography in the United States." *International Studio* (special summer number 1905): 1–7.

———. "Eduard J. Steichen's Work—An Appreciation." *Camera Work,* no. 2 (April 1903): 21–24.

———. "The Exhibition at Buffalo." *Camera Work,* no. 33 (January 1911): 21–23.

———. "Of Verities and Illusions, Part 2." *Camera Work,* no. 13 (January 1906): 41–45.

———. "Some Impressions from the International Photographic Exhibition, Dresden." *Camera Work,* no. 28 (October 1909): 33–39.

———. "'Straight' Photography." *Camera Craft* 5 (23 May 1916): 205. First published as "Paul Strand in Straight Photographs," *New York American,* 20 March 1916.

———. "Symbolism and Allegory." *Camera Work,* no. 18 (April 1907): 17–22.

———. "Tweedledum and Tweedledee." *Camera Work,* no. 19 (July 1907): 26–27.

Callahan, Sean. "The First Viceroy of Photography: A Full-Length Portrait of MOMA's John Szarkowski." *American Photographer* 1 (June 1978): 24–31.

Carey, Elizabeth Luther. "The World of Art: Recent Pictorial Photography at the Camera Club Exhibition." Review of exhibit, by Paul Strand. *The New York Times Book Review and Magazine,* 10 September 1922, 10.

Chiarenza, Carl. "Siskind's Critics, 1946–1966." *Center for Creative Photography,* nos. 7/8 (September 1978): 3–47.

Clurman, Harold. "Photographs by Paul Strand." *Creative Art* 5 (October 1929): 735–38.

Cohen, Susan E. "The Critic's Tale: A Commentary on Henry Holmes Smith's Writing on Photography." In *Henry Holmes Smith Papers,* compiled by Charles Lamb and Mary Ellen McGoldrick, 7–16. Guide Series, no. 8. Tucson: Center for Creative Photography, University of Arizona, 1983.

Coleman, A. D., and Minor White. "Debate: A. D. Coleman vs. Minor White." *Camera 35* 17 (November 1973).

Craven, Thomas. "Art and the Camera." *The Nation* 16 April 1924, 456–57.

Crimp, Douglas. "Appropriating Appropriation." In *Image Scavengers: Photography,* 27–34. Philadelphia: Institute of Contemporary Art, University of Pennsylvania, 1982.

———. "The Photographic Activity of Postmodernism." *October* 15 (winter 1980): 91–101.

———. "Pictures." *October* 8 (spring 1979): 75–88.

Crowninshield, Frank. "Vogue . . . Pioneer in Modern Photography." *Vogue,* 15 June 1941.

Davidson, Martha. "Evans' Brilliant Camera Records of Modern America." *Art News* 37 (October 1938): 12–13.

Dell, Virginia. "John Szarkowski's Guide." *Afterimage* 12 (October 1984): 8–11.

Dmitri, Ivan. "Photography in the Fine Arts." *The Saturday Review,* 28 May 1960, 35.

Downes, Bruce. "Exhibit of the Month: Captured Light, Experimental Photography." *Popular Photography* 15 (September 1944).

———. "Let's Talk Photography." Photography is the people's art. *Popular Photography* 27 (July 1950).

———. "Let's Talk Photography." On the nature of photography. *Popular Photography* 28 (March 1951).

———. "Let's Talk Photography." Review of *Korea—The Impact of War* at MOMA and the Aaron Siskind exhibition at the Egan Gallery, New York. *Popular Photography* 29 (July 1951).

———. "The Museum of Modern Art's Photography Center." *Popular Photography* 14 (February 1944).

———. "Out of the Basement." *Popular Photography* 44 (March 1959): 48.

———. "The Photo Bohemians." *Popular Photography* 45 (October 1959): 40.

———. "Photography: A Definition." *Photography Annual 1962* (1961).

———. "The Siskind Canonization." *Popular Photography* 57 (August 1965): 36.

———. "Wanted: Critics for Photography." *Popular Photography* 13 (October 1943).

———. "Warning to Young Photographers." *Popular Photography* 32 (June 1953): 18.

Downes, Bruce, Les Barry, John Durniak, Arthur Goldsmith, H. M. Kinzer, Charles Reynolds, and James M. Zanuto. "An Off-beat View of the U.S.A." *Popular Photography* 46 (May 1960): 104–6.

Downes, Bruce, and Minor White. "Photography Redefined." *Popular Photography* 50 (April 1962).

Durniak, John. "The Vanishing Pro in Photography." *Infinity* 13 (November 1964): 21.

Frank, Waldo. "The Art of the Month: Alfred Stieglitz, The World's Greatest Photographer." *McCall's Magazine* 54 (May 1927).

Green, Jonathan. "Aperture in the 50's: The Word and the Way." *Afterimage* 6 (March 1979): 8–13.

Greenberg, Clement. "The Camera's Glass Eye." *The Nation,* 9 March 1946, 294–96.

Henry, Diana Mara. "Gene Thornton—Photography Today." *Women Artists Newsletter* 2 (December 1976).

Hess, Thomas B. "The Walls." *Portfolio,* no. 7 (winter 1963).

Hicks, Wilson, and Henry Holmes Smith. "Photographs and Public." *Aperture* 2, no. 3 (1953): 4–17.

Howe, Hartley. "You Have Seen Their Pictures." *Survey Graphic* 29 (April 1940): 236–38.

Jewell, Edward Alden. "Portrait of the Spirit of a Nation." Review of *Road to Victory. The New York Times,* 24 May 1942, sec. 8.

Josephson, Matthew. "Profiles: Commander with a Camera." *New Yorker,* 3 June 1944, 30–36; 10 June 1944, 29–41.

Keller, Ulrich F. "The Myth of Art Photography: An Iconographic Analysis." *History of Photography* 9 (January–March 1985): 1–38.

———. "The Myth of Art Photography: A Sociological Analysis." *History of Photography* 8 (October–December 1984): 249–75.

Kramer, Hilton. "Exhibiting the Family of Man." *Commentary* 20 (October 1955): 364–67.

Lorentz, Pare. "Dorothea Lange: Camera with a Purpose." *U.S. Camera Annual 1941* (1940).

———. "Putting America on Record." *The Saturday Review of Literature,* 17 December 1938, 6.

Lyons, Nathan. "Symposium on Photography 2." *Profile* 2, no. 5 (September 1982): 17–22.

Mabry, Thomas Dabney. "Walker Evans's Photographs of America." *Harper's Bazaar,* 1 November 1938.

Mann, Margery. "Berenice Abbott . . . Realist." *Photo Arts* (spring 1948).

———. "Can Whitey Do a Beautiful Black Picture Show?" *Popular Photography* 64 (May 1969).

———. "The Controversial Aaron Siskind." *Infinity* 17 (March 1968).

———. "Photography." On the Friends of Photography Gallery. *Artforum* 6 (October 1967): 67–70.

———. "Photography." Review of *The Sweet Flypaper of Life,* by Roy DeCarava and Langston Hughes. *Artforum* 6 (April 1968): 72–73.

———. "Photography." On the state of Bay Area photography. *Artforum* 6 (summer 1968): 74.

———. "Too Many Tide Pools, Too Much Sun." *Popular Photography* 64 (January 1969).

———. "View From the Bay: In Siskind's Vision, a Sense of Man's Impermanence." *Popular Photography* 67 (October 1970).

———. "West: It Did Happen Here." *Camera 35* 16 (September 1972).

———. "West: Lange Mislabeled." *Camera 35* 16 (June 1972): 20.

———. "West: Much Ado . . ." *Camera 35* 18 (November 1974).

———. "West: Sommertime." *Camera 35* 17 (March 1973).

———. "West: The Emperor's New Game." *Camera 35* 18 (July 1974).

Mann, Margery, and Sam Ehrlich. "The Exhibition of Photographs: Northern California." *Aperture* 13, no. 4 (1968): 10–17.

McBride, Henry. "Modern Art." *The Dial* 70 (April 1921): 480–82.

———. "The Paul Strand Photographs." *New York Sun,* 23 March 1929, 34.

McCausland, Elizabeth. "100 Years of the American Standard of Photography." *U.S. Camera Annual 1940* (1939): 11–18.

———. "Paul Strand." *U.S. Camera* 1 (February–March 1940).

McKenna, Rollie. "Photography." Review of *The Family of Man. The New Republic,* 14 March 1955, 30.

Millstein, Gilbert. "'De Lawd' of Modern Photography." *The New York Times Magazine,* 22 March 1959.

Moholy-Nagy, Laszlo. "Photography Is Manipulation of Light." In Andreas Haus, *Moholy-Nagy: Photographs and Photograms,* translated by Frederic Samson, 47–50. New York: Pantheon Books, 1980.

Mortensen, William. "Come Now, Professor!" *Camera Craft* 47 (February 1940): 68–72.

———. "Venus and Vulcan: An Essay on Creative Pictorialism." *Camera Craft* 41 (March 1934): 103–10; (April 1934): 153–62; (May 1934): 205–15; (June 1934): 257–65; (July 1934): 309–17.

Newhall, Beaumont. "Documentary Approach to Photography." *Parnassus* 10 (March 1938): 2–6.

———. "Dual Focus." *Art News* 45 (June 1946): 37–39, 54.

Newhall, Nancy. "What Is Pictorialism?" *Camera Craft* 48 (November 1941): 653–63.

Peters, Susan Dodge. "Elizabeth McCausland on Photography." *Afterimage* 12 (May 1985): 10–15.

Phillips, Christopher. "The Judgment Seat of Photography." *October* (fall 1982): 27–63.

Ridge, Lola. "Paul Strand." *Creative Art* 9 (October 1931): 312–16.

Rosenfeld, Paul. "Stieglitz." *The Dial* 70 (April 1921): 397–409.

Rosskam, Edwin. "Family of Steichen." *Art News* 54 (March 1955).

Rothstein, Arthur. "Direction in the Picture Story." In *The Encyclopedia of Photography,* edited by Willard Morgan, vol. 4, 1356–63. New York: National Educational Alliance, 1949.

Saarinen, Aline B. "The Camera Versus the Artist." *The New York Times* 6 February 1955, sec. 2.

Seldes, Gilbert. "No Soul in the Photographs." Review of *American Photographs,* by Walker Evans. *Esquire,* 1 December 1938.

Seligmann, Herbert J. "A Photographer Challenges." *The Nation,* 16 February 1921, 268.

Smith, Henry Holmes. "An Access of American Sensibility: The Photographs of Clarence John Laughlin." *Exposure* 11 (November 1973): 2–5.

———. "Critical Difficulties: Some Problems with Passing Judgment and Taking Issue." *Afterimage* 6 (summer 1978): 17–19.

Smith, Henry Holmes, George Wright, Barbara Morgan, John Upton, and Robert Forth. "Frederick Sommer: Collages of Found Objects/Six Photographs with Reactions by Several People." *Aperture* 4, no. 3 (1956): 103–17.

Smith, Henry Holmes, Myron Martin [Minor White], Sam Tung Wu [Minor White], Kurt Safranski, and Walter Chappell. "The Experience of Photographs." *Aperture* 5, no. 3 (1957): 112–30.

Snyder, Joel, and Neil Walsh Allen. "Photography, Vision, and Representation." *Critical Inquiry* 2 (autumn 1975): 143–69.

Solomon-Godeau, Abigail. "Conventional Pictures." *Print Collector's Newsletter* 12 (November–December 1981): 138–40.

———. "Playing in the Fields of the Image." *Afterimage* 10 (summer 1982): 10–13.

———. "Winning the Game When the Rules Have Been Changed: Art Photography and

Postmodernism." *Exposure* 23 (spring 1985): 5–15.

Stange, Maren. "Photography and the Institution: Szarkowski at the Modern."
Massachusetts Review 19 (winter 1978): 693–709.

Stettner, Louis. "Cezanne's Apples and the Photo League." *Aperture,* no. 112 (fall 1988):
14–35.

Strand, Paul. "Aesthetic Criteria." *Freeman,* 12 January 1921, 426–27.

———. "Alfred Stieglitz and a Machine." *MSS* 2 (March 1922): 6–7.

———. "Steichen and Commercial Art." Letter to the editor. *The New Republic,* 19
February 1930, 21.

Stryker, Roy E. "Documentary Photography." In *The Encyclopedia of Photography,* edited
by Willard Morgan, vol. 4, 1364–74. New York: National Educational Alliance, 1949.

Szarkowski, John. "American Photography and the Frontier Tradition." In *Symposium on
Photography,* edited by Manfred Willmann and Christine Frisinghelli, 98–107. Graz:
Fotogalerie im Forum Stadtpark, 1979.

———. "August Sander: The Portrait As Prototype." *Infinity* 12 (June 1963).

———. "A Different Kind of Art." *The New York Times Magazine,* 13 April 1975.

———. "Photography and the Mass Media." *Aperture* 13, no. 3 (1967): 182–84.

Szarkowski, John, Walter Rosenblum, Gordon Parks, and David Vestal. "A Symposium on
Photographic Style." *Contemporary Photographer* 4 (summer 1963).

Thornton, Gene. "'From the Picture Press': Is News Photography Art, Non-Art, or Anti-
Art?" *Art News* 72 (December 1973): 86–87.

———. "How Far Must We Go to Understand Them?" *The New York Times,* 9 June 1974,
sec. 2.

———. "It's a Fine Photograph but Is It a Work of Art?" *Art News* 72 (January 1973): 74–76.

———. "Murky." *Art News* 77 (October 1978): 26–28.

———. "The New Photography: Turning Traditional Standards Upside Down." *Art News*
77 (April 1978): 74–78.

———. "Photographis '77: The Dream and Ideal of Mass Media Photography." *Graphis*
33 (1977–78).

———. "Photography's Shootout at the O.K. Corral." *Art News* 77 (December 1978): 76–78.

———. "Photography View: Deepening the Definition of the Art." *The New York Times,*
31 December 1978, sec. 2.

———. "Photography View: Fashion Pictures Taken Seriously." *The New York Times,* 11
December 1977, sec. 2.

———. "The Place of Photography in the Western Pictorial Tradition: Heinrich Schwartz,
Peter Galassi, and John Szarkowski." *History of Photography* 10 (April–June 1986): 85–98.

———."Post-Modern Photography: It Doesn't Look 'Modern' at All." *Artnews* 78 (April
1979): 64–68.

Tomkins, Calvin. "Profiles: Look to the Things around You." On Paul Strand. *New Yorker,*
16 September 1974.

Trilling, Lionel. "Greatness with One Fault in It." Review of *Let Us Now Praise Famous
Men,* by James Agee and Walker Evans. *Kenyon Review* 4 (winter 1942): 99–102.

Tucker, Anne. "Photographic Crossroads: The Photo League." In *The Journal,* a special
supplement to *Afterimage.* Ottawa: National Gallery of Canada, 1978.

———. "The Photo League." *Creative Camera* nos. 223–24 (July–August 1983): 1013–17.

Van Dyke, Willard. "The Photographs of Dorothea Lange—A Critical Analysis." *Camera
Craft* 41 (October 1934): 461–67.

Van Gelder, Robert. "A Compelling Album of the Deep South." Review of *You Have Seen
Their Faces,* by Margaret Bourke-White and Erskine Caldwell. *The New York Times Book
Review,* 28 November 1937, 11.

"Vogue's–Eye View of Photography." *Vogue,* 15 June 1941, 17.

Weiss, Margaret R. "Photography in the Fine Arts." *The Saturday Review,* 16 May 1959, 35.

————. "Photography in the Fine Arts 3." *The Saturday Review,* 17 June 1961, 35–37.

————. "Photography in the Fine Arts 4." *The Saturday Review,* 18 May 1963, 39–40.

"What Is Modern Photography? A Symposium at the Museum of Modern Art, November 20, 1950." *American Photography* 45 (March 1951): 146–53.

White, Minor. "Amateur Photocriticism." *Aperture* 11, no. 2 (1964): 62–72.

————. "Are Your Prints Transparent?" *American Photography* 45 (November 1951): 674–76.

————. "A Balance for Violence." *Aperture* 13, no. 4 (1968): 1.

————. "Be-ing without Clothes." *Aperture* 15, no. 3 (1970): 1–96.

————. "Call for Critics." *Infinity* 9 (November 1960): 4–5.

————. "Ducks and Decoys." *Aperture* 8, no. 4 (1960): 171–73.

————. Editorial on over-population. *Aperture* 7, no. 3 (1959): 91.

————. "The Educated Audience." *Aperture* 2, no. 1 (1953): 3.

————. "An Experiment in Reading Photographs." *Aperture* 5, no. 2 (1957): 51–75.

————. "Extended Perception through Photography and Suggestion." In *Ways of Growth,* edited by Herbert Otto and John Mann, 34–48. New York: Grossman, 1968.

————. "How Concepts Differ for Two Cameras." *American Photography* 45 (September 1951): 546–51.

————. "How to Find Your Own Approach to Photography." *American Photography* 45 (July 1951): 406–10.

————. "Lyrical and Accurate." *Image* 25, nos. 3/4 (1982): 9–16. First published in *Image* 5, no. 8 (1956): 172–81.

————. "A Motivation for American Photographers." *Aperture* 4, no. 4 (1956): 123.

————. "The Myth of the Soulless Black Box." *Aperture* 3, no. 1 (1955): 3.

————. "On the Strength of a Mirage." *Art in America* 46 (spring 1958): 52–55.

————. "Photographs in Boxes." *Aperture* 7, no. 1 (1959): 22–24.

————. Review of *Les Americains,* by Robert Frank. *Aperture* 7, no. 3 (1959): 127.

————. Review of *The Photographer and the American Landscape,* curated by John Szarkowski. *Aperture* 11, no. 2 (1964): 52–55.

————. Review of *The Photographer's Eye,* by John Szarkowski. *Aperture* 13, no. 3 (1967).

————. "The Secret of Looking." *The New York Times,* 21 November 1971, sec. 2.

————. "Ten Books for Creative Photographers." *Aperture* 4, no. 2 (1956): 58–67.

————. "Varieties of Responses to Photographs." *Aperture* 10, no. 3 (1962): 116–28.

————. "The Way through Camera Work." *Aperture* 7, no. 2 (1959): 46–84.

————. "What Is Meant By 'Reading' Photographs." *Aperture* 5, no. 2 (1957): 48–51.

————. "When Is Photography Creative?" *American Photography* 37 (January 1943): 16–17.

————. "Who Owns the Photograph?" *Aperture* 10, no. 1 (1962): 3.

————. "Your Concepts Are Showing." *American Photography* 45 (May 1951): 290–97.

White, Minor, and Walter Chappell. "Some Methods for Experiencing Photographs." *Aperture* 5, no. 4 (1957): 156–71.

Williams, William Carlos. "Sermon with a Camera." Review of *American Photographs,* by Walker Evans. *The New Republic,* 12 October 1938, 282–83.

Williamson, S. T. "American Photographs by Walker Evans." *The New York Times Book Review,* 27 November 1938, 6.

Wright, George, and Cora Wright. "One Family's Opinion." Review of *The Family of Man,* curated by Edward Steichen. *Aperture* 3, no. 2 (1955): 19–23.

Interviews

Adams, Ansel, Imogen Cunningham, and Dorothea Lange. Interview by Herm Lenz. "Interview with Three Greats." *U.S. Camera* 18 (August 1955): 84–87.

Evans, Walker. Interview by Leslie Katz. "Interview with Walker Evans." *Art in America* 59 (March–April 1971): 82–89.

Lyons, Nathan. Interview by Thomas Dugan. In *Photography between Covers,* 33–45. Rochester, N.Y.: Light Impressions, 1979.

———. Interview by Alex Sweetman. "On Art and Artists." *Profile* 2, no. 5 (September 1982): 1–15.

———. Interview by Barry Perlus and Judith Mallinson. "An Interview with Nathan Lyons." In *Alternatives 1983.* Athens: School of Art, Ohio University, 1983.

Smith, Henry Holmes. Interview by John Bloom. *Photo Metro* (February 1985): 3–13.

———. Interview by Ted Hedgpeth and Craig Morey. *San Francisco Camerawork Newsletter* 9 (July 1982).

———. Interview by Paul Hill and Thomas Cooper. In *Dialogue with Photography,* 132–59. New York: Farrar, Straus and Giroux, 1979.

Szarkowski, John. Interview by Andy Grundberg. "An Interview with John Szarkowski." *Afterimage* 12 (October 1984): 12–13.

———. Interview by Nat Herz. "Steichen's Successor: John Szarkowski." *Infinity* 11 (September 1962).

———. Interview by Michael Kimmelman. "Director Photography, John Szarkowski." *Art News* 83 (May 1984): 68–70.

———. Interview by Rob Powell. "John Szarkowski." *British Journal of Photography,* 20 December 1985.

INDEX

"A Different Kind of Art," Szarkowski, 229
"A Plea for Art Photography in America,"
 Stieglitz, 25
"A Plea for Straight Photography," Hart-
 mann, 46–47
"A Plea for the Picturesqueness of New
 York," Hartmann, 50
Abbott, Berenice, 103–4, 207
Abbott, John, 114
Abramson, Michael, 254, 255
absolute, experience of the, 61
Abstract Expressionism, 8, 132–36, 144
abstraction, 37, 51, 129, 133, 149
"Abstraction in Photography," 120
academic art, 15, 18, 27, 31
Acconci, Vito, 14
action, photography of, 69, 70, 219
Adams, Ansel, 10, 67–77, 81, 102, 106,
 129, 143, 182, 201, 203, 204, 240, 266
Adams, Phoebe, 122–23, 124
advertising, 82, 118–19, 164, 194, 242, 267
aerial photographs, 119–20, 224
Aesthetic Movement, 24–28
aesthetics, 21, 41, 58, 70, 155
Afterimage, 11, 152, 171
Agee, James, 17, 100, 107, 108, 113, 118
Agha, M. F., 116, 138
Alberti, Leon Battista, 25
Albright Art School, 210
Alexander, Vikky, 263
Alfred University, 171
alienation, 59, 196
allegory, 31, 43; metaphor, 7, 65–67, 136,
 146, 175, 178, 191–94, 217
Allen, Neil Walsh, 6
allusion, 135–36
Alvarez Bravo, Manuel, 255–56
amateurs, 23–27, 50, 71, 114, 116, 125–27,
 167, 172, 220–24

American Amateur Photographer, 27
American Association of Magazine
 Photographers, 140
*American Economic Life and the Means of
 Its Improvement,* 88
American Photographs, Evans, 81, 98–99, 102
American Photography, 125, 143
Americans, The, Frank, 130–32, 176, 240
An American Exodus, Lange and Taylor, 107
"An Off–Beat View of the U.S.A.," 130
Andre, Linda, 268
animism, 132–33; naturalism, 4, 7, 21,
 35–36, 65–68, 70, 72, 75, 77, 197
*Annie Mae Gudger, Hale County, Alabama,
 1936,* Evans, 101
Aperture, 11, 121, 135, 143–47, 152, 157,
 163, 165, 185, 190, 214, 233, 261
Apples and Gable, Lake George, 1922,
 Stieglitz, 62
appropriation, 234–35, 246, 263–68
Arbus, Diane, 223, 224, 232, 240
Archer, Frederick Scott, 19
archetypes, 175
Arnheim, Rudolf, 6, 192
art, aesthetics and, 23–28, 41, 58, 70, 155;
 commercial art, 118; criticism as viola-
 tion of, 74; defining, 244, and redefining
 art, 256–57, and principles/ properties of,
 31–33, 60, 74; democraticization of, 266;
 depoliticization of, 144; labeling, 173;
 designed for the camera, 246; photogra-
 phy as, 2–6, 12, 14–23, 59, 80–81, 90,
 91, 114, 116–18, 129, 134, 135, 142,
 143, 155, 195, 221, 227, 234, 237,
 240–42, 255, and photographs used as
 parts of art, 245, 257, and photography
 of art as art, 257; propaganda and art,
 89; psychological use of, 184–85, 198;
 role and status of, 188, 196, 232, 234,

238; the vernacular and, 12, 214
Art Institute of Chicago, 180
Art for Life's Sake, Caffin, 32, 33
Art News, 135
artifact, photograph as, 150
artist, duty of the, 240; role of the, 170, 198; status of the, 24–25; and artistic free dom, 82
Artforum, 202
Artnews, 237
Arts and Crafts movement, 30, 41
Atlantic Monthly, 123
Atget, Eugène, 233
Atget's Trees, 249
audience, 122, 126, 145, 147, 154, 159–60, 186, 209, 213, 239–42, 262
aura, 266, 267
authorship, 88, 106, 113, 121, 139–40, 176–77, 266, 267

Baldessari, John, 245
Barbizon painting, 22
Barr, Alfred, 114, 122, 134
Barry, Les, 131
Barthes, Roland, 159, 160, 161, 265, 267
Baruch, Ruth–Marion, 206
Baudelaire, Charles, 147, 215
Baudrillard, Jean, 134
Baxandall, Michael, 230–31
Bayard, Hippolyte, 19
Bayer, Herbert, 105
Bearden, Romare, 257
Be–ing Without Clothes, 150, 165
Bell, Clive, 32, 54, 65, 155
Benjamin, Walter, 44, 54, 109, 266, 267
Bergson, Henri, 60
Bischof, Werner, 128, 147
Black Panthers, 206
black photography, 250
Blumberg, Donald, 173
books, photographs in, 107–12, 254, 257
Boorstin, Daniel, 208
Bourke–White, Margaret, 8, 96, 107, 113–14, 120, 207, 240
Brady, Mathew, 14
Brown, Milton, 115, 117
Bruguière, Francis, 180
Bullock, Wynn, 203
Bunnell, Peter, 225, 249
Burgin, Victor, 164, 192
Burke, Kenneth, 198
Busch, Arthur, 127

Caffin, Charles, 7, 10, 29–39
Caldwell, Erskine, 107
California School of Fine Arts, 144
Callahan, Harry, 120, 126, 229
calotype, 18–19, 69
Camera and the Pencil, The, Root, 15
Camera Club of New York, 27
Camera Craft, 71
Camera Notes, 27
"Camera Point of View in Painting and Photography, The," Caffin, 37
Camera 35, 165, 202, 249
Camera Work, 28, 30, 36, 43, 45, 48, 55, 60, 127, 261
cameras, 12, 27, 70, 118, 222, 243; candid camera, 118; hand camera, 27; small–camera, 12, 70, 71, 125, 130
Cameron, May, 114
candid photography (candid camera), 71, 118
Capa, Robert, 139
capitalism, 103–4, 119, 242, 259
Caponigro, Paul, 145
captions, 82, 88, 110, 111, 177, 214; additive caption, 111; text for books on photography, 107–12, 214–16
Carey, Elizabeth Luther, 59
Cartier–Bresson, Henri, 139, 147
Celebrations, 165
censorship, 84–85, 196, 251
Changing New York, Abbott, 103
Chapnick, Howard, 232
Chappell, Walter, 11, 153, 157, 175
Charlesworth, Bruce, 246
Chiarenza, Carl, 93, 132
Chicago 10, 1948, Siskind, 158, 193
Clark, Larry, 240
Clark, Tom C., 113
class, 100
Claudet, Antoine, 14
Clurman, Harold, 59, 61
Coburn, Alvin Langdon, 239
cognition, imagery and, 108–10; perception and, 192–93; visual thinking and, 177–78. *See also* language
Cohen, Mark, 238
Cold War, 113, 123, 144
Cole, Henry, 24
Coleman, A. D., 12, 14, 165–67, 233, 248–58
collage, 59, 245, 257
Collected Writings, Smith, 190
College Art Association, 82
Colliers, 127

collodion process, 19
Columbia University, 87, 144
combination printing, 20–21
Communist Party, 91
composition, 20, 27, 48–49, 97–99; form
 and content, 65, 68, 148, 152, 172, 175,
 178–79, 184, 191–92, 194, 216, 226,
 229–31, 238–39, 260
Concept of Essence, 149
Concept of Experience, 150
Conrat, Richard, and Maisie Conrat, 208
conservation, issues of, 77
Constructivism, 11, 183
Conversations with the Dead, Lyon, 255
Corpron, Carlotta, 129, 208
correspondences, theory of, 147
Cousins, Norman, 96
Craven, Thomas, 64
Crimp, Douglas, 12, 263, 265–67
Critical Inquiry, 6
criticism, 8, 9, 30–31, 44–45, 59, 128, 151–53,
 160, 185–90, 194, 198–99, 230, 248, 259;
 photography as, 263, 267, 268
Criticism of Photography as Art, The,
 Ward, 9, 163
Cubism, 51, 59
culture, 5, 54, 75, 164, 251, 267; defining
 American, 58, 80, 131, 184–85, 195–96,
 222–23
Cunningham, Imogen, 202
Curtis, James, 82–83, 87, 94

daguerreotypes, 18, 69
Daily Worker, 105
Danto, Arthur, 197, 268
Dater, Judy, 255
Davidson, Bruce, 172, 201, 250, 255
Davidson, Martha, 99
"Dawn-Flowers," Hartmann, 43
Dawn-Flowers, Steichen, 46
Day, F. Holland, 27, 43
Daybooks, Weston, 67
"Death of the Author, The," Barthes, 161
DeCarava, Roy, 206, 250, 255
Decisive Moment, Cartier–Bresson, 147
Degas, H. G. E., 99
deKooning, Elaine, 133
Delaroche, Paul, 18
Depression, the, 7, 80
depth of field, 69
Derrida, Jacques, 161
Deschin, Jacob, 11, 125–27, 141

detail, 69
De Young Memorial Museum, 208
Dial, The, 55, 63
Dingus, Rick, 222
direct positive print, 19
directorial mode, 14
Discover Your Self through Photography,
 Hattersley, 164, 167–68
displaying photographs, 121
Dissanayake, Ellen, 268
Dmitri, Ivan, 140–42
documentaries, 7–8, 79; defining, 10, 76,
 82, 86, 88, 91, 94–98, 103, 153, 201,
 206, 252, 262; the new, 254
*Documentary Expression and Thirties
 America,* Stott, 80
Downes, Bruce, 11, 127–37, 143, 148
dualities, 269–70
Du Camp, Maxime, 19
Duchamp, Marcel, 155, 234
duplication or limited edition, 44
Durniak, John, 139
Dustbowl, the, 89

East 100th Street, Davidson, 201, 250, 255
editing, 86. *See also* authorship
education, 126, 147
effect, 18, 20, 26, 34, 69. *See also* expres-
 sion; tonality
Eggleston, William, 223, 230, 238
Ehrlich, Sam, 156
Einstein, Albert, 177
Eisenstein, Sergei, 89
Eloquent Light, The, 75
Emerson, Peter Henry, 21
Engel, Morris, 92–93
entelechy, 57
environment, 175–76
equivalent, the, 7, 8, 61, 64, 146–47, 152–55,
 175
esoterica, 129
essay, photographic, 177. *See also* photo-
journalism
essence, 31, 36. *See also* medium, essence
 of the
Eugene, Frank, 35
Europe, 10, 132, 183
Evans, Walker, 10, 81–82, 86, 94, 97,
 98–102, 107, 129, 131, 222, 225
"Exact Instant, The," 120
Executive Order 9066, 208
exhibits, 82, 120, 165, 172, 173, 174,

181–82, 201, 203, 206–8, 242, 252.
See also galleries
"Experience of Photographs, The," 157,
163, 191
experiencing photographs, 150, 153, 164,
179, 192, 264, 268–69
exposures, multiple, 49. *See also* technique
expression, 56, 68, 71, 75, 93, 126–27. *See
also* effect
extraction, 149

f/64 Group, 68, 203–4
Face of Minnesota, The, Szarkowski, 210, 217
family, 123, 169, 251
Family of Man, The, 120–24, 129, 130
Farm Security Administration, 10, 82–83,
87–90, 92–93, 97, 103, 112
fashion photography, 240
Feature Group of the Photo League, 93
Federal Art Project (FAP), 103
Feldstein, Mark, 239
feminism, 207
Fenn, Albert, 92
film, 10, 57, 89, 206
Film and Photo League, 89, 90
filmmaking, 89; film, 10, 57, 206
Flaherty, Robert, 89
flash, using the, 98. *See also* technique
Flaubert, Gustave, 98, 99
form, 65, 68, 226; composition, 20, 27,
48–49, 97–99; form and content, 148,
152, 172, 178–79, 184, 191–92, 194,
216, 229–31, 238–39, 260; form and
function, 212; significant form, 65, 155
Form and Art in Nature, 174
form and content, 65, 68, 148, 152, 172,
175, 178–79, 184, 191–92, 194, 216,
226, 229–31, 238–39, 260; composition,
20, 27, 48–49, 97–99
form and function, 212
formal analysis, 4, 5–6, 144
formalism, 9, 12, 20, 70, 188; defining,
212, 238, and critics on, 232–33
Fortune, 82
Frank, JoAnn, 208
Frank, Robert, 11, 120, 130–32, 148, 172,
176, 231, 239, 240
Frank, Waldo, 64
Fraprie, Frank R., 71
Friday Night in the Coliseum, Winningham,
254
Friedlander, Lee, 12, 172, 223, 224, 233,

238, 239, 240
"'From Today, Painting Is Dead': A
Requiem," Coleman, 257
Frontier Films, 90, 91
Fry, Roger, 31, 100
function and form, 212

galleries, 61, 125, 133, 203, 242. *See also*
exhibits
Gardner, Howard, 268
Gauguin, Paul, 39, 147
Gee, Helen, 125, 182
Gehry, Frank, 265
George Eastman House, 115, 135, 144,
171, 173, 174, 182
Germany, 65, 83
Ghandi, Mahatma, 157
Gibson, Ralph, 257
Gill, Charles, 173
Goethe, Johann, 65
Goldsmith, Arthur, 130
Gottlieb, Adolph, 133
Goucher College, 202
Gouma–Peterson, Thalia, 207
government, 82–83. *See also* politics
Graves, Michael, 265
Great Depression, 7, 80
Green, Jonathan, 144, 210, 259
Greenbelt, 87
Greenberg, Clement, 4, 122, 173, 212, 218
Grierson, John, 98
Grossman, Sid, 91
Group f/64, 68, 203–4
Gurdjieff, G. I., 144
Gutierrez, Donald, 131

Halsman, Philippe, 128
hand–coloring, 49. *See also* technique
Hare, Chauncey, 233
Harper's Weekly, 30
Hartmann, Sadakichi, 6, 10, 39–51
Hattersley, Ralph, 11, 164, 167–70, 209
Hearn, Lafcadio, 196
Heinecken, Robert, 173, 245
Helmholtz, Hermann von, 22
Henri, Robert, 32
Herskovits, Melvin, 268
Hess, Thomas, 135
Hicks, Wilson, 11, 90, 108–11, 186
Hill, David Octavius, 18, 58
Hine, Lewis, 57, 79
history, art, 212; formal evolution and, 226;

of photography, 9, 69, 116, 142, 151, 164, 171–73, 187, 195; photography and history, 71, 77–78, 87, 102, 109, 164, 219, 220, 223, 225–26, 249–56, and context, 164, 176–77, 206–7, 227–37, 240, 243–44, 260, 261; posthistorical pluralism, 198
History of Photography, The, 69
Hoban, Tana, 120
Hoffman, Michael, 145
Hogan, William, 131
Howe, Hartley, 83, 97
Hughes, Langston, 206
Huillet, Daniele, 265
Hurwitz, Leo, 89, 93, 94

iconography, 191
Idea of Louis Sullivan, The, Szarkowski, 210
ideography, 177–78
ideology, 96, 123, 236, 259. *See also* politics
Illinois Institute of Technology, 126
Illinois State Normal University, 180
Image, 171
imagery, 76, 108, 192, 245, 263–64; associations from, 65–66; changing social, 259; equivalents and, 146; formal analysis of, 226–27, 239; language(text) and visual, 107–12, 177–78, 248; manipulating, 6, 87, 88, 94 183–84; revelationary, 70; technique and, 134–36
imagination and perception, 174–75. *See also* cognition
Impressionism, 33
Indiana University, 126, 152, 181
industrialization, 6–7, 24
industry, the photographic, 23, 126
Inhabitants, The, 215
intellect and intuition, 60; intuition, 63
intentions, 45, 154, 164, 187–91, 242–43, 260, 261. *See also* authorship
International Photographic Exhibition, Dresden, 38
interpretation, 153, 159, 178–79, 188–89, 192, 193, 230–31, 268
intrusion, 259
intuition, 63; and intellect, 60
Invented Eye, Lucie–Smith, 243

Jackson, William Henry, 75
Jacobi, Lotte, 208
Japan, Bischof, 128, 147
Japanese art, 36–37

Jewell, Edward Alden, 85, 100, 105
Johnston, Frances Benjamin, 207
Jones, Owen, 24, 30
Jones, Pirkle, 182, 206
Journal of Commerce, London, 14
judgment, 163

Kael, Pauline, 84
Kandinsky, Wassily, 60, 147, 215
Käsebier, Gertrude, 43
Kazin, Alfred, 80
Keiley, Joseph, 35
Keller, Ulrich, 28
Kepes, Gyorgy, 129
Kertész, André, 227
King, Martin Luther, Jr., 157
Kirstein, Lincoln, 98–100, 102, 118
Klein, William, 148
Korea, 127
"Korea," 120
Korean War, 133
Koudelka, Josef, 243
Kouwenhoven, John, 214, 222
Kramer, Hilton, 121, 123
Krims, Les, 256
Kruger, Barbara, 236, 246, 263
Kubler, George, 212, 220
Kuhn, Thomas, 194

LaBarre, Weston, 185, 198
La Lumiere, 19
Land of the Free, MacLeish, 107, 111
landscapes, 20, 75, 172, 201–9, 223, 240
Lange, Dorothea, 54, 76, 81, 82, 94–95, 97, 107, 129, 201, 205, 207
Langer, Suzanne, 108
language, 4–5, 60, 107–12, 122, 159, 161, 177–78, 184, 191–92, 227–30, 247, 248, 256, 261–62, 268. *See also* cognition
Larsen, Frieda, 120
Larsen, Hazel, 120
Lartigue, Jacques Henri, 221
Laughlin, Clarence John, 195
Lavater, Johann Kaspar, 16
Lawrence, M. M., 13
LeGray, Gustave, 19
Lerner, Irving, 89
Lesy, Michael, 253
Let Us Now Praise Famous Men, Evans and Agee, 100, 107, 114, 215
Levine, Sherrie, 246, 263, 265–66

Levitt, Helen, 17, 120
libraries, removal of magazines from, 63
Library of Congress, 113
Libsohn, Sol, 91
Life, 10, 82–84, 90, 109–10, 114, 124, 130, 138, 177, 253
light, 6, 19, 27, 168; lighting, 183. *See also* technique
Light Readings, Coleman, 248
Light⁷, 165
Limelight Gallery, 125–26, 130
Lines of My Hand, Frank, 239
Linked Ring, 25
Literary Digest, 82
literature, 40
Look, 82, 124
Looking at Photographs, Szarkowski, 221, 224–31, 242
Lorentz, Pare, 89, 94–96
Lowe, Ernest, 206
Luce, Henry, 83–84, 90
Lucie-Smith, Edward, 243
Lynes, George Platt, 265
Lyon, Danny, 172, 255
Lyons, Nathan, 5, 11, 135, 150, 170–79, 191, 211, 225

Mabry, Thomas Dabny, 99
MacDonald, Pirie, 71
MacLeish, Archibald, 107, 111
Made in America, Kouwenhoven, 222
Maddow, Ben, 90
Maeterlinck, Maurice, 40, 43
magazines, 8, 55, 83, 108, 111–17, 124, 140, 213–15, 241, 253
Magnum, 139
Making a Photograph, Adams, 69
Mallarme, Stephane, 42
Maloney, Tom, 115
Mann, Margery, 11, 156, 201–9
Mapplethorpe, Robert, 265
March, Michael, 127
March of Times, 90
Marxists, 57
Masters of Modern Art, 134
Masters of the Camera, Stieglitz, Steichen and Their Successors, Thornton, 240
materialism, 23, 36, 56, 63
Mathews, Patricia, 207
Matisse, Henri, 37
McAlpin, David, 105
McBride, Henry, 64

McCausland, Elisabeth, 10, 94, 102–9, 205
McKenna, Rollie, 121
McMullen, Frances, 65
meaning, 264; contingent meaning, 247, 260; fragmentary meaning, 269
medium, elasticity of, 17; essence of the, 2–3, 6, 34, 38, 39, 44, 47–48, 56, 70, 103, 122, 173–76, 183–84, 188–91, 194, 212, 214, 218–19, 229–30, 251–52, 262; evolution of form as, 226; plasticity of, 26. *See also* technique
"Memorable Life Photographs," 120
Merriam, John C., 75
metaphor, 7, 65–67, 136, 146, 175, 178, 191–94, 217; allegory, 31, 43
Metropolitan Museum, 11, 141, 143
Metzker, Ray K., 173
Mexico, 104
Meyerowitz, Joel, 224, 229
Michals, Duane, 14, 172, 224, 257
Miller, Hillis, 159
Miller, Wayne, 86, 120
Millet, Jean–François, 22
Millier, Arthur, 65
Minicam, 124, 180
Minicam Photography, 132
Mirrors and Windows, 218, 231–35
Mirrors Messages Manifestations, White, 165, 218
mobility, 27; camera mobility, 70
"Models for Critics," Smith, 194
Modern Photography, 124
modernism, defining, 1, 31, 54, 70, 72, 91, 103, 147, 151, 153–59, 161, 170, 176, 179, 191, 194, 206, 219, 235, 237–38, 247, 255, 269; postmodernism and, 245–70
Moholy–Nagy, Laszlo, 70, 103, 129, 176, 181, 183, 184, 195, 225, 239
morality, 99–100, 102, 155–57
Morgan, Barbara, 111, 208
Morgan, Willard, 114, 129
Morris, William, 24
Mortensen, William, 71–73
Mortimer, F. J., 71
movement, photographing, 69, 70, 219
MSS, 55
Muir, John, 75
Mumford, Lewis, 66
Museum of Modern Art (MOMA), 11, 12, 69, 85, 98, 102, 106, 112, 114–15, 118, 120, 122, 129, 133, 134, 136, 199, 201,

210, 233, 243, 249, 250
museums, the role for, 121, 122, 136, 141, 224, 241
Muybridge, Eadweard, 75, 223
My Camera in Yosemite Valley, Adams, 74
Mydans, Carl, 86
mysticism, 76, 143–45, 156–57, 163

NASA, 242
narrative, 214–16. *See also* captions; language
Nation, The, 55
National Arts Club, 28
nationalism, 25, 58
Nation's Business, 82
naturalism, 4, 7, 21, 35–36, 65–68, 70, 72, 75, 77, 197; animism, 132–33
Naturalistic Photography, Emerson, 21
negatives, 19, 70, 265–66
Nègre, Charles, 19
Neue Sachlichkeit, 65
New Bauhaus, 181
New Criticism, 212
New Japanese Photography, 249
"New Photography, The: Turning Traditional Standards Upside Down," Thornton, 238
New Republic, The, 55, 121
New Vision, The, Moholy–Nagy, 181, 183
New York, 103
New York Camera Club, 27
New York Post, 113
New York Review of Books, 258
New York Times, The, 82, 96, 105, 125, 133, 168, 211, 237, 249
New Yorker, 131
Newhall, Beaumont, 10, 69–71, 98, 106, 114, 115, 129, 141
Newhall, Nancy, 11, 67, 68, 71, 74–76, 108, 110–11, 114, 182
newsreels, 89
Newton, William J., 19
Noggle, Anne, 207
noncamera photography, 49. *See also* technique
Notations in Passing, Lyons, 177
nudity, 168
Nykino, 89

objectivity, 7, 21, 39, 40, 47, 49–51, 53, 56–57, 68, 71, 74, 75, 86, 94, 97–99, 148
observation, 175
Octave of Prayer, 165, 166

"Of Verities and Illusions," Caffin, 36
Office of War Information, 76, 113
Ohio State University, 180
O'Keeffe, Georgia, 61, 67
On Photography, Sontag, 258
"On the Possibility of New Laws of Composition," Hartmann, 48–50
On the Spiritual in Art, Kandinsky, 60
O'Sullivan, Timothy, 222, 223, 226

Page, Christina, 74
painting, 31, 44, 70, 71, 75, 129, 132–33, 149, 150, 182, 204, 212, 218, 260
Paiute, the, 77
Palante: Young Lords Party, Abramson, 254
Panofsky, Erwin, 191
papers, textured, 26. *See also* technique
paradigm, 194–95, 197
paradox, the photographic, 6, 182, 211, 247, 269–70
Pater, Walter, 45
Peeler, David, 88
Pei, Mario, 178
Penn, Irving, 116, 140, 239
Pennsylvania Academy of Fine Arts, 25
perception, a theory of, 22; imagination and, 174–75, and thinking, 192–93. *See also* cognition; imagery
Persistence of Vision, The, 150, 173
personality, 104, 113
perspective, 76, 99, 220
Philadelphia Photographic Salon, 25, 30
Phillips, Christopher, 12
Photo Arts, 127
Photo–Beacon, 45
Photo League, 10, 80, 90–94, 102, 113
Photo Notes, 91, 93, 103, 115, 117
photo–opportunity, 208
Photo–Secession, 10, 27–28, 30–31, 38–39, 40, 42–43, 45-47, 118
photograms, 70, 127. *See also* technique
Photographer and the American Landscape, The, 201, 217
Photographer's Choice, 181
Photographer's Eye, The, Szarkowski, 217, 218–24
photographers, status of, 112
Photographers on Photography, 171
Photographic Society of America, 141
photographs, meaning in, 160–61, 188, 192, 193, 211, 212, 214–16, 220,

227–28, 230–31, 239, 243, 247, 258, 259–63, and changed status of, 245, as "tools for change," 254; purpose of, 168; reproduction and sale of, 64. *See also* art, photography as; imagery; negatives
"Photographs and Public," 152, 185, 186
"Photographs as Christmas Gifts," 120
photography, 10; commercial, 52, 117, 139–40, 240–42; defining, 148, 183–84, as democratic, 80, 125, 126, 142, 241–42, 251, and popularization of, 106–7, 112–15; status of, 147; vernacular, 224
"Photograhy," Strand, 56
Photography Annual, 148
Photography as a Fine Art, Caffin, 33–36
Photography as Printmaking, 249
Photography in the Fine Arts, (PFA), 140–43
Photography in the Twentieth Century, 173
Photography into Sculpture, 249, 256
Photography Until Now, 235–37
photojournalism, 84, 109–18, 138–39, 147, 168, 186, 194, 213, 232, 237, 253–55; paradigm and, 194
photomontage, 49, 236. *See also* technique
physiognomy, 16
Pictorial Effect in Photography, Robinson, 20
"Pictorial Photography," Stieglitz, 26
pictorialism, defining, 10, 13–51, 132; as paradigm, 194; resurgence of, 71, 124; Pictorialists, 2, 6, 69, 91, 263
pigment, layering, 26. *See also* technique
Pit and the Pendulum, The, Mortenson, 73
Plow That Broke the Plains, The, Lorentz, 89, 94
pluralism, posthistorical, 198
Poe, Edgar Allan, 196
Police Station Lodger, Eldridge Street, c. 1890, Riis, 227, 228
politics, 8–9, 41, 54, 57, 77, 81–83, 87–88, 91, 92, 112, 113, 123–24, 144, 156–57, 209, 250–51, 256, 262. *See also* society
Pop Art, 172
popular photography, defining, 11
Popular Photography, 11, 124, 125, 127, 130–31, 139, 148, 164, 167, 202, 249
pornography, 155
portraiture, 14–16, 255
postmodernism, defining, 5, 12, 54, 151, 170,179, 192–93, 234–36, 244, 246–47, 258, 263–65, 268
poststructuralism, 159–63

poverty, 92
"Power in the Pacific," 120
Practical Criticism, Richards, 152–53, 187
preciousness, 44, 54, 89, 201, 257, 266
Prendergast, Maurice, 39
press, popular, 8, 9, 124
preverbal meaning, 110, 177, 256, 268
previsualization, 47
Prince, Richard, 246, 263, 267–68
prints, burned–in, 53; combination, 20–23, 49, 257; glycerine, 35; gum bichromate, 26, 70; negative, 70; reproducing, 109, 134. *See also* technique
Professional Photographers of America, 141
propaganda, 83–85, 87–89, 90
pseudoevents, 208
Puritanism, 41

radiation, the manipulation of, 183
"Random Thoughts on Criticism," Hartmann, 44
Rauschenberg, Robert, 234, 245, 257
Ray, Man, 70, 103, 129, 224, 239
reading photographs, 11, 110, 148, 151–59, 163–64, 187, 189–90
Real Life, Lesy, 253
realism, 18, 80, 94, 103, 204, 225–26, 231–32, 235; reality for photography, 216–17
record, photograph as, 6, 64, 91, 94, 98, 246, 257
Rejlander, Oscar Gustave, 20, 257
representation, 262
Resettlement Administration (RA), 87
response, 160–62, 215, 255–56
retouching, 23, 44. *See also* technique
reverence, 74
Reynolds, Charles, 131
Reynolds, Joshua, 15
"Rhetoric of the Image, The," Barthes, 160
Richards, I. A., 152–53, 187
Ridge, Lola, 59
Riis, Jacob A., 79, 227, 228
Road to Victory, 85, 105–7, 114, 121
Robinson, Henry Peach, 20, 257
Rochester Institute of Technology, 164
Rodger, George, 139
romanticism, 231–32
Roosevelt administration, 82, 84, 87, 92
Root, Marcus A., 15–17, 23
"Roots of French Photography," 120

"Roots of Photography: Hill–Adamson, Cameron," 120
Rosenberg, Harold, 134
Rosenfeld, Paul, 61, 63, 66, 118
Rosskam, Edwin, 122, 123
Rotha, Paul, 98
Rothko, Mark, 133, 144
Rothstein, Arthur, 89, 90
Rubinfien, Leo, 233
Rudolf, Paul, 120
Ruscha, Ed, 234, 245
Ruskin, John, 21, 32, 34

sacrifices, theory of, 19
Safranski, Kurt, 157
Salle, David, 265
salon, 25, 82, 125
San Francisco Art Institute, 202
San Francisco Chronicle, 131
San Francisco State College, 248
Sandburg, Carl, 105, 119, 120, 123
Sandler, Irving, 212
Saturday Review, The, 140–43
Say It with Your Camera, Deschin, 126
Schapiro, Meyer, 144
Schweitzer, Albert, 138
science, 2, 14, 22, 32–33, 50–51, 57, 60, 82, 242–43
Science and Poetry, 153
Second World War, 10, 76, 84, 144, 208
Sekula, Allan, 12, 193, 248, 261–63, 268
Seligmann, Herbert, 61
sequence, 176–78, 218, 257; series and sequence, 177
Seurat, Georges, 99
Seven Arts, 55
sex and art, 67
Seymour, David (Chim), 139
Sheeler, Charles, 50, 51
Shells, Weston, 66
Sherman, Cindy, 14, 246
Shore, Stephen, 238
Sierra Club, 77
significant form, 65, 155
Silk, George, 86
Simmons, Laurie, 246
Siskind, Aaron, 11, 92, 93, 120, 132–36, 145, 157–59, 182, 190, 201, 238, 239
Skoglund, Sandy, 246
skull, the photograph of the, 90
small–camera photography, 12, 70, 71, 125, 130

Smith, Eugene, 138
Smith, Gene, 240
Smith, Henry Holmes, 5, 9, 11, 124, 126, 135–36, 145, 150, 152, 157, 163, 179–200, 211, 215, 216, 259
snapshots/snapshot aesthetic, 12, 172, 194, 224, 225, 238
Snyder, Joel, 6
socialism, 266
society, art and, 32–33, 198, 238, 247, 251; photographic theory and, 23, 54, 76–81, 99, 103–4, 129–31, 148, 156, 162, 172, 192, 203–9, 225–26, 236, 240, 247–54, 259, 261–62. *See also* politics
Society for Photographic Education (SPE), 171, 181
Society of Amateur Photographers, 27
soft–focus, (softness), 20, 22–23, 70
Solomon–Godeau, Abigail, 12, 234, 263–68
"Some Methods for Experiencing Photographs," White and Chappell, 153–55
Sommer, Frederick, 120, 204, 224
Sontag, Susan, 12, 258–61
soul and art, 60
Southworth, Albert Sands, 14
specificity, 255–56
spirit in photography, 53
spiritualism, 143, 146, 156, 167–69
spontaneity, 44
Springfield Republican, 102
Stange, Maren, 82–83
Steerage, The, Stieglitz, 262
Steichen, Edward J., 8, 11, 28, 36, 43, 45, 46, 85, 86, 105, 114–15, 118–24, 126, 129, 136, 141, 214
Stendhal, 99
Stieglitz, Alfred, 7, 10, 25–27, 30, 34–35, 40, 45, 50, 55, 60–64, 74, 91, 99, 126, 127, 135, 145–47, 182, 217, 238, 262
Steinbeck, John, 85
Steiner, Ralph, 89
Still, Clyfford, 144
stop–motion, 69
Stott, William, 80
straight photography, 7, 35, 38–39, 40, 46–50, 91, 127, 132, 135, 149, 173, 182–83, 204, 212, 257; defining, 10, 55, 56, 65, 68, 69, 74, 75, 149–50
Strand, Paul, 10, 39, 50, 55, 56–59, 68, 89, 90, 93, 94, 104, 111, 113, 119, 147, 150, 182, 238, 239

Straub, Jean–Marie, 265
Stryker, Roy, 82, 87–89, 112
style, 86, 95–99, 222, 260; stylelessness, 98–99
subconscious, 67
subjectivism, 3–4, 5, 8, 11, 22, 33–34, 40, 53, 78, 86, 129, 138, 143, 172, 201, 211, 239, 247, 266
Sullivan, Louis, 212
Summer's Children, Morgan, 111
Surrealism, 67, 204
Survey Graphic, 82
Sweet Flypaper of Life, The, Hughes and DeCarava, 206
Syberberg, Hans Jurgen, 265
Symbolism, 31, 33, 36, 40, 42, 102, 192; Symbolists, 28
symbols, photographs as, 88. *See also* language
Symposium on Photography II, Austria, 177
synaesthetics, 147
synedoche, 102. *See also* technique
synthetic tradition, 183. *See also* technique
syntheticism, 33, 34, 147
Szarkowski, John, 5, 9, 12, 102, 136, 151, 188, 199, 201, 210–18, 240, 242, 249, 259

Tabernacle City, Siskind, 92
tabula rasa, 97
Tagg, John, 24
taste, democratization of, 7, 185
Taylor, Frederick Winslow, 82
Taylor, Paul, 107
technique, 53, 70, 81, 89, 91–92, 96, 97, 98, 121, 129–30, 133, 134, 149, 150, 164, 173, 183–84, 213, 220, 238, 246, 257; synthetic, 173, 183, 204–5, 219, 224, 225, 239
technology (industrial/scientific), 13–14, 24, 26, 30–36, 47–50, 57, 77
television, 213, 241
texture, 59. *See also* technique
Theater Arts Monthly, 180
Thornton, Gene, 12, 233, 237–44, 259
Time, 74, 82, 109–10, 237
Time in New England, Strand and Newhall, 111
tonality, 68–72. *See also* effect
Toward a Social Landscape, 172
trace, 6, 13, 150
Transcendentalism, American, 40

transcendence, 53–54, 59, 75, 77–78, 102, 104, 150, 162, 175, 247, 255, 261
transformation, 6, 13, 150
Trilling, Lionel, 100, 102
truth, 79, 84, 87–90, 93, 96, 100, 102, 103, 113, 122, 187, 240
Tucker, Anne, 91
Tugwell, Rexford, 87
Tulsa Clark, 240
Turner, Frederick Jackson, 223
12 Million Black Voices, Wright, 107

Uelsmann, Jerry, 173, 224, 240, 256, 257
Under the Sun, Lyons, 175
Underhill, Evelyn, 145
U.S. Camera, 82, 115, 124, 132
U.S. Camera Annual 1940, 92
United States Information Agency, 121
unity of art and life, 32
universality, 7, 32, 53–54, 61, 74–78, 123, 149, 170, 184–85, 247, 255
universities, photography in, 147, 196–97, 236, 241, 251–52
University of Florida, 163
University of Minnesota, 144
University of Wisconsin, 210
urbanism, 50–51
Urformen, 65

Van Dyke, Willard, 97
Van Gelder, Robert, 96
Van Raay, Jan, 253
Vandivert, Bill, 139
"Vanishing Pro in Photography, The," Durniak, 138
Vanity Fair, 118, 265
Verbal Landscape, Dinosaur Sat Down, Lyons, 177
vernacular photography, 233
Vienna Salon, 25
Vietnam War, 156, 232
viewpoint, 97
Village Voice, The, 165, 248–49
Vishniac, Roman, 243
Vision and Expression, 174
Visual Studies Workshop, 11, 91, 171
vitalist movement, 57
Vogue, 116, 118, 265

war, photographing, 84–86, 105–7, 133, 232
Ward, John L., 9, 163
Warhol, Andy, 234, 245

Watkins, Carlton, 223
Way through Camera Work, The, 145
Weber, Max, 39
Weiss, Margaret, 143
Welpott, Jack, 181
Wessel, Henry, Jr., 224, 239
West Coast, 65, 201
Weston, Edward, 10, 53, 54, 65–68, 72, 76,
 91, 92, 129, 201–3, 225, 240, 246, 265
Wey, Francis, 19
What Is Art For? Dissanayake, 268
Whistler, James McNeill, 39; Whistlerian
 Aesthetic, 21, 22
White, Minor, 7, 8, 11, 143–67, 170–71,
 175, 176, 182, 185, 187, 194, 211,
 215–18, 224, 231
Whitman, Walt, 42
Williams, William Carlos, 96
Williamson, S. T., 102
Winningham, Geoff, 254, 255
Winogrand, Garry, 12, 172, 210, 223, 224,
 238
Wisconsin Death Trip, Lesy, 253
Wolfflin, Heinrich, 144
*Woman of the High Plains, Texas Panhandle,
 1938,* Lange, 95
women in photography, 207–8, 255
Women of Photography, 207
Wood, John, 171, 173
World War I, 224
World War II, 10, 76, 84, 144, 208
words and photographs, 107–12. *See also*
 captions; language
Words and Pictures, Hicks, 108, 111
Wright, George, and Cora Wright, 121, 122
Wright, Richard, 107

"XI Zero in Photography," Smith, 180
x–ray, the, 232

Yosemite (National Park), 74, 77
You Have Seen Their Faces, Bourke–White
 and Caldwell, 96, 107, 113

Zanutto, James, 130, 131
Zola, Emil, 98